Tom Benton and His Drawings

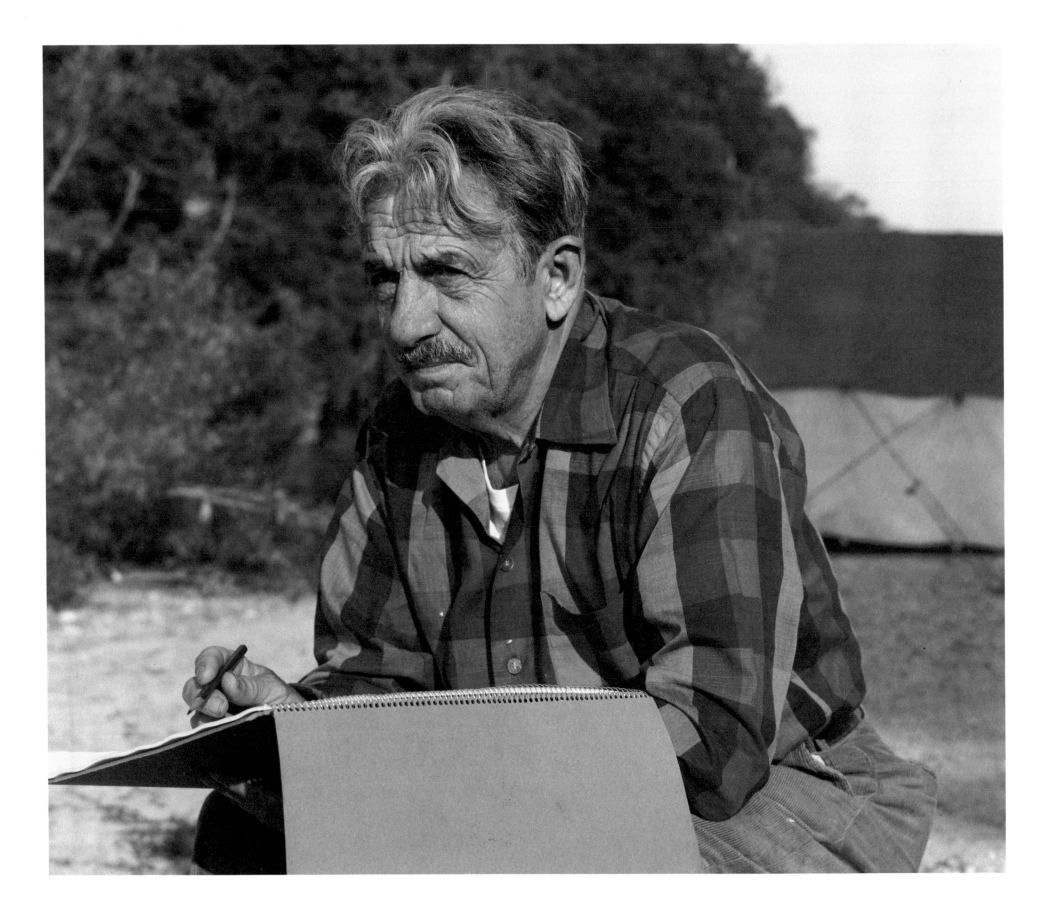

Tom Benton and His Drawings

A Biographical Essay and a Collection of His Sketches,

Studies, and Mural Cartoons

Karal Ann Marling

University of Missouri Press

Columbia, 1985

For the Missouri Marlings—Steve and Joan, Elizabeth and Rachel

Copyright © 1985 by
The Curators of the University of Missouri
University of Missouri Press, Columbia, Missouri 65211
Printed and bound in Japan

Library of Congress Cataloging in Publication Data

Benton, Thomas Hart, 1889–1975.
 Tom Benton and his drawings.
 Includes index.
 1. Benton, Thomas Hart, 1889–1975. I. Marling,
Karal Ann. II. Title.
NC139.B45A4 1985 741.973 85–992
ISBN 0–8262–0480–5

Frontispiece photograph courtesy of
the Missouri Division of Tourism.

Publisher's Foreword

In 1982, the University of Missouri Press decided to issue a new edition of Thomas Hart Benton's autobiography, *An Artist in America*. In order to improve the reproductions in that book, it was desirable to locate the originals of the drawings. At that time, Lyman Field, Tom Benton's good friend and individual trustee of the Benton Testamentary Trusts, and the United Missouri Bank of Kansas City, corporate trustee of the Benton Trusts, generously allowed the Press staff access to the collection of drawings in the Trust holdings. During the search through the collection, it became clear that there existed a vast quantity of high-quality work. The idea for this book developed from that first acquaintance with the art in the Trusts, which own all the drawings reproduced in this book.

This volume would not have been possible without the cooperation and invaluable help received from Lyman Field. In addition, Stephen J. Campbell, trust counsel for the United Missouri Bank, was always cooperative in allowing physical access to the drawings for the purposes of selecting and photographing them. He was generous with his time and knowledge.

A substantial subvention from The Samuel H. Kress Foundation helped fund the publication of this book. For this funding, the Press is grateful to the Kress trustees and in particular to Franklin D. Murphy, Chairman, and Marilyn Perry, President of the Foundation. As Karal Ann Marling and the Press began to select the two hundred drawings from the collection of two thousand works, it became obvious that one special quality of Benton's work is his use of color. Subtle washes or brilliant accents of color were frequently employed in the drawings and studies. Everyone agreed that it would be impossible to appreciate fully the drawings from black-and-white reproductions, that the only way to do full justice to their richness and subtlety was to reproduce them in full color. Fortunately, The Samuel H. Kress Foundation agreed with this assessment and provided additional monies to make the use of color possible. These additional monies were also matched by the Office of the President of the University of Missouri.

The photographs of the drawings used in the production of this book were taken by Russell Nall, using facilities provided by the Museum of Art and Archaeology of the University of Missouri–Columbia. Thanks are due to Osmund Overby and Richard Baumann for the arrangements that enabled the drawings to be brought to Columbia for photographing. Thanks are also due to Thomas Krens and Lise Holst of the Williams College Museum of Art for their assistance in sending to Columbia, Missouri, drawings on loan to them from the Benton Trusts for an exhibition in connection with the restoration work at Williams College on Benton's famous murals, *America Today*.

Without the efforts of all these people, this volume would not have been possible.

It is gratifying to see the renewed interest in the works of our state's native son; just as the revision of the autobiography led to the publication of this book of drawings, our interest in Benton's oeuvre will continue. In particular, we have a dream here at the Press of publishing a catalogue raisonné of Thomas Hart Benton's work. The task of finding and researching all the works of an artist as prolific as Benton will be monumental, but locating the forgotten and missing treasures will be easier in this decade than in those to come.

Preface

I SAW my first Benton when I was just a little girl, about seven or eight. And I saw it again, every Saturday morning, for the next decade. The painting was *Boomtown*, and it hung—still does, I'm sure—in the cavernous American room at the Memorial Art Gallery in Rochester, New York, my hometown. It was huge, and it looked like no other painting in that estimable museum with its medieval baptismal fonts, its local stabs at Abstract Expressionism, and its iffy Botticellis. For one thing, this *Boomtown* was very large and colorful and fun to look at; just when you thought you'd picked out every last tiny sign, each bearing a tiny message just for you, you'd find another one, and just when you thought you'd finally figured out who was who, it would suddenly dawn on you that the angry lady in the low-cut black garment probably wasn't the schoolmarm after all. For another thing, the painting was chockful of cowboys and old cars, like a scene from a Roy Rogers movie. (There was another nice picture nearby of a gas station, by Stuart Davis—nice, but just the pumps; no cars! no story! and no cowboys!)

In those days, I liked cowboy movies better than anything, even better than my Saturday morning classes in drawing and painting at the Memorial Art Gallery. But that painting by Mr. Thomas Hart Benton (American School, b. 1889) was a close second. As I said before, I went to see it every Saturday morning for the next ten years, without fail. I never did learn to draw cars, or much of anything else, like Mr. Benton did, though God knows I tried. That ambition was, in any case, regarded as somewhat quixotic by the weekend teachers at the art gallery; by the time I gave up the lessons and went off to college, I could do a pretty passable imitation of a Stuart Davis.

Thomas Hart Benton was no better thought of by my art history professors, who, when they had to devote a hasty day or two to American painting—mostly at the tag end of the course—were high on people like Davis or Jackson Pollock. When I decided to tempt fate and write a term paper on Benton anyway, I found almost nothing to read about him, except reviews of long-ago exhibitions, moldering away in old magazines from the twenties and thirties. It took some time to find out that he was still alive, and still working. For doggedness alone (and seeing as how it was the last semester of my senior year), my puzzled instructor passed the paper.

You could say that I've been waiting to write a book about Tom Benton ever since, that whatever minor deity looks out for old Regionalist painters arranged for *Boomtown* and me to meet in Rochester, New York, back when. But I am grateful to Edward D. King, director of the University of Missouri Press, for asking me to do it, for his help along the way, and for the splendid design of the final product. I'm grateful to Bob Gambone, my ace research assistant and sometime chauffeur, for weeks of digging in the library, interrupted only by lightning dashes to Missouri; I'm sorry his car died, too. Ed King and I both owe thanks to Stephen J. Campbell, trust counsel for the United Missouri Bank of Kansas City, for giving us access to the drawings in the Thomas Hart Benton and Rita P. Benton Testamentary Trusts. The bank is the corporate trustee; Tom Benton's good friend, Lyman Field, is the individual trustee. He has been a constant source of support and encouragement to all of us, throughout this project.

Finally, I must acknowledge the generous financial support of the Graduate School of the University of Minnesota, as well as the sabbatical leave from the university that made the writing easier.

K. A. M.
Minneapolis
March 1985

Contents

Note on Illustrations

All the drawings reproduced in this volume are among the holdings of the Thomas Hart and Rita P. Benton Trusts and are reproduced with the kind permission of Lyman Field and the United Missouri Bank of Kansas City, cotrustees.

Murals, oils, lithographs, and other works by Benton not specifically assigned to another collection are also the property of the Trusts. The names of buildings, collections, and institutions that house works by Benton are listed in the first citation of a given object.

Notes on the physical properties of drawings in the Benton Trusts were made by Professor Sidney Larson, director of the art department at Columbia College, Columbia, Missouri, a painter and longtime friend who served as Benton's mural assistant on the Truman Library commission.

That information is listed as follows: Medium; dimensions of support in inches, height preceding width; inscriptions (if any) on recto and verso.

When a drawing floats in a large sheet of paper, excess white space has been omitted.

The dates, titles, and notations on locale for the drawings are the author's and occasionally differ from Benton's own jottings. His spelling, especially of proper names, was always shaky, and the dates he assigned to his drawings in the mid- and late sixties are often contradicted by the published record and by strong stylistic evidence.

Thomas Hart Benton and the Art of Drawing

IT WAS a good Sunday, that last one. All morning, Tom Benton had worked away in the old carriage barn, just twenty steps from the big stone house on Belleview Avenue in Kansas City, where he and Rita had lived for thirty-five years, in a sometimes bitter, sometimes gleeful exile from the "*ass*thetes" of New York City. At eighty-five, he'd outlived most of his enemies—the leftists, the "museum boys," the facile intellectuals who had once dismissed his all-American, hell's-a-poppin' murals of the early 1930s as chauvinistic cant. Nowadays, the old epithets were hurled more softly, as backhanded tributes to a crusty character, a midwestern original who took some pride in calling himself "an old S.O.B." Why, a couple of summers back, he'd just laughed when they needled him—on national TV, no less, on the "Sixty Minutes" show—about a big New York critic who dubbed Thomas Hart Benton a "patriarchal cornball." "Are you a cornball?" asked Mike Wallace. "Probably," Tom replied. "What of it?" "Unafraid of death," droned the voice-over, as harmonica music whined in the background, "he can hardly be expected to walk in fear of lesser adversaries—like art critics."[1]

Neither death nor the critics meant much to a man who had painted his "last" mural in 1972, for the city of Joplin, in the southwest corner of Missouri, not far from his birthplace. In the Joplin picture, an old man had looked back at his own sturdy roots, in "the corner" of the last century. Across the background of the mural stretched Joplin's Main Street, as it looked in 1906, the tower of the Keystone Hotel leading the eye to the fancy signboard of the House of Lords saloon. It was in this saloon, beneath a lurid barroom nude, that Colonel Benton's eldest son had decided to be an artist, egged on by the taunts of the older fellows who saw him staring in wide-eyed fascination at that dubious masterpiece. A teenage "Shorty" Benton, with glossy black hair, sat in the foreground of the picture, hunched over his cartoonist's desk at the old *Joplin American*, drawing something on his sketchpad.[2]

He'd gotten the job, at fourteen dollars a week, by making an on-the-spot likeness of the man who ran the drugstore down the street. Perhaps his is the face that young Tom is drawing, from distant memory, in the Joplin mural. Perhaps it's the face of John Callison, who's cranking the Armstrong hoist at a lead mine off in the right-hand corner. Back in 1972, John was practically a kid, the same kid who used to live in the Belleview Avenue house in the summers, when the Bentons went to Martha's Vineyard; the elegant lady with the parasol on the opposite side of *Joplin at the Turn of the Century* is Kay Callison, John's new bride. Now, of course, John's a big business executive, an old friend, a summertime companion on long, raucous floats down the Buffalo River. Or maybe the face young Tom's drawing in the mural is that of Merle Welsh, who lives just across Belleview Avenue and frames Benton's pictures as a hobby. How Tom had chuckled when he'd talked Mel Welsh, that respectable stockbroker and pillar of the community, into posing for the figure of the Joplin cardshark in the fancy yellow pants and the vest! Mel and Randall, John and Kay, and old Rolla Stephens, the real estate man. Tom Benton always drew his friends into his pictures; or, if they weren't his friends when the drawing started, they were afterward. They were all good friends, the folks in the Joplin mural, the "last" mural.

"Last" mural, hell! It was 1975 now, three years after the "last" mural, and he was still going strong. Today, another mural teetered on the easel in the carriage house, a big one for the Country Music Hall of Fame down in Nashville. Mel had dropped by to take a look at it a while ago. In honor of the occasion, Tom had had himself a little martini, at eleven o'clock in the morning: he figured he'd be done by suppertime. In its own way, this new picture—*Sources of Country Music*, he called it—was another backward glance over a long life, full of music and rambles down dirt roads and friends. One of Benton's earliest exploratory trips back into the heartland took him to Galena, Missouri, in 1931, to hear the famous Leverett Brothers. Homer played the fiddle. Wilbur picked guitar, sang, and yodeled. The Leveretts wore striped overalls and carried their instruments in flour sacks, and the

1. Robert Wernick, "Down the Wide Missouri with 'an Old S.O.B.,'" *Saturday Evening Post* 238, no. 21 (1965): 96, and transcript, "60 Minutes" 5, no. 18 (Sunday, April 8, 1973), 6–7 P.M., EST, p. 10. An excellent, but by no means comprehensive bibliography on Thomas Hart Benton is Mary Scholz Guedon, *Regionalist Art, Thomas Hart Benton, John Steuart Curry, and Grant Wood: A Guide to the Literature*, with a foreword by Karal Ann Marling (Metuchen, N.J.: The Scarecrow Press, 1982). Wernick's article appears in that bibliography as no. 331, p. 90; the television transcript is not included. A fine basic bibliography appears in Thomas Hart Benton, *An Artist in America*, 4th rev. ed. (Columbia: University of Missouri Press, 1983), pp. 390–95.

2. Mary Curtis Warten, ed., *Thomas Hart Benton: A Personal Commemorative* (Joplin: Spiva Art Center, Missouri Southern State College, 1973), esp. pp. 11–12, 20, and 34–37. Benton describes the years of his youth as "the corner of the century" in the title of the first chapter of his autobiography, *An Artist in America* (1983), pp. 3–22. First published in 1937, it was reissued in 1951 and 1968 with substantial additions by the author.

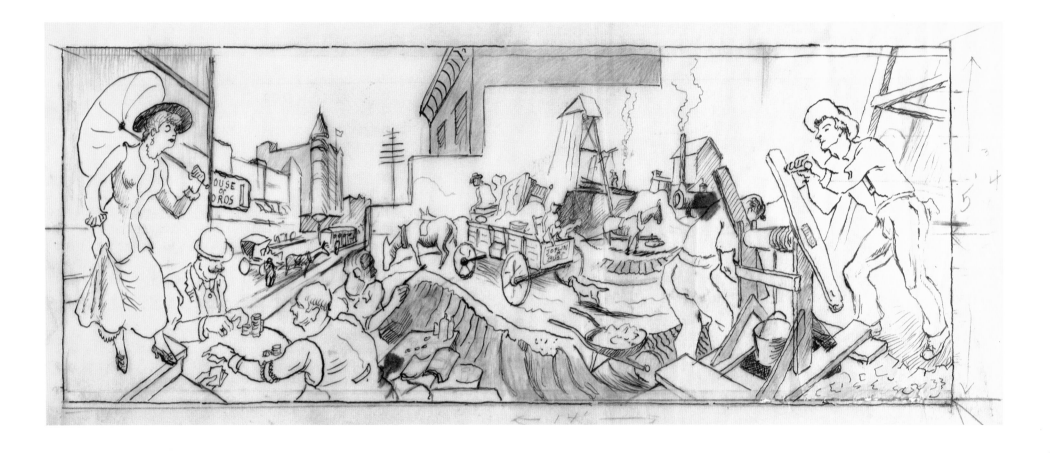

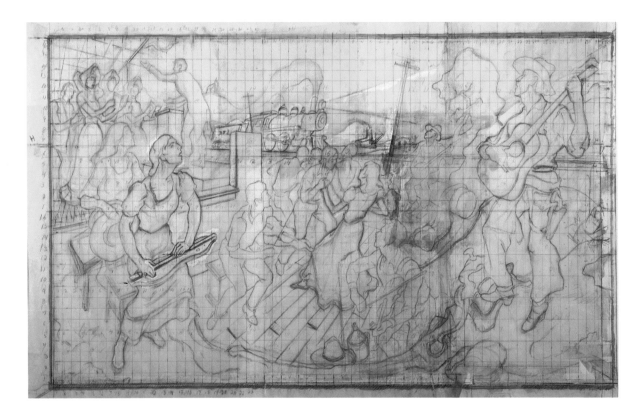

1. Rough preliminary drawing for the mural *Joplin at the Turn of the Century, 1896–1906* (The Municipal Building, Joplin, Missouri). 1971; ink, pencil; 5¾ x 14¾; inscribed, No. 1.

Benton did this pencil drawing to clarify the thematic concept. For the final version, Kay Callison posed for the figure of the lady on the far left, realtor Rolla E. Stephens of Joplin for the man in the derby hat, Merle Welsh for the second poker player, and John Callison for the man turning the hoist at the left. Benton, the fledgling journalist for the *Joplin American*, appears just to the right of the card table.

2. Squared study for the mural *The Sources of Country Music* (The Country Music Hall of Fame and Museum, Nashville, Tennessee). 1974–1975; pencil, ink; 16 x 25; inscribed with numbers for measurement.

The young singer from the School of the Ozarks was the model for the faces of the women. Sammie Feeback posed for both fiddlers, and Melvin Deaver for the banjo player. The figure of the cowboy-singer was suggested by Tex Ritter.

best songs in their repertoire were "The Jealous Lover of Lone Green Valley" and "Engine One-Forty-Three."[3]

Tom drew pen-and-ink portraits of Wilbur and Homer right on the spot. For years afterward, he plunked the boys from Galena down in his paintings whenever he needed the twang of a guitar, the screech of a fiddle. That was easy enough to do, once those precious firsthand sketches were sorted out, cleaned up, labeled, and salted away for reference. In his controversial murals for the high-toned Whitney Museum of American Art in New York, Wilbur Leverett stood for one of the grass-roots "Arts of the West," one of the vital people's arts Tom increasingly preferred to the embalmed culture of the concert halls and the museums. Tom Benton's "Arts of the West" included poker playing and bronco busting, shootin' and whiskey drinkin', and a little horseshoe pitchin': Wilbur and his guitar stood for country music, the kind they played on the radio.[4]

There was a country singer with a guitar in a prominent spot in the Nashville mural, too, to remind folks that the old tunes on the radio were one of the greatest sources of country music. The singing cowboy with the round stomach and the snub nose in the Nashville picture was Tex Ritter, the country-western star who'd visited Tom in Kansas City to talk him into doing one last "last" mural for Nashville. "Sipping on some good ole Jack Daniels," it hadn't been hard to do. "Tom an' Tex began to hit it off with some salty language, and . . . they both came on the idea for the mural at the same time. Tex said it might be about the roots of country music. Tom responded, 'The source of country music—that's it.'" The cowboy singer in the mural was a nostalgic portrait, Tom's tribute to Tex, who died right after the first sketches were finished.[5]

But his music hadn't died, and that was the point of the Nashville mural. The old songs brought back memories of old times, and old friends. Of Wilbur playing "The Jealous Lover," way back in '31. Tom had gone right home to New York and started to paint that ballad, and he'd worked at it, on and off, for a couple of summers, putting in the heads of friends who came to visit. The beautiful victim, slain by her jealous lover "Down in the lone green valley/ Where violets bloom and fade," was Rita's sister-in-law, Lucy; her killer was a boy who took one of Tom's classes at the Art Students League. What was his name? The others were easy. The singer, clutching a jug and wailing the ballad in the foreground, was Glen Rounds from Colorado, another pupil, who came to Kansas City with Tom and Rita and modeled for

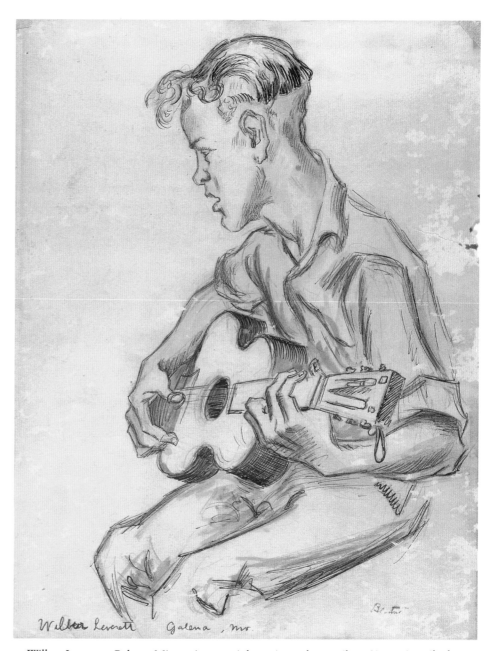

3. Wilbur Leverett, Galena, Missouri. 1931; ink, sepia wash, pencil; 11 5/8 x 9; inscribed, Benton, Wilbur Leverett Galena, Mo.; verso, Missouri guitarist.

3. Wayne King, "Friends Recall Benton at Memorial," *New York Times*, Late City Edition (January 23, 1975), sec. 1, p. 36, cols. 3–5. See also Esther Singer Forman, "Thomas Hart Benton: Still Youthful at 85," *American Artist* 38, no. 388 (1974): 98.

4. See Pete Lippincott, album notes for the Leverett Brothers, *Lonesome Mandolin*, Birch 1947 (recorded in Lamar, Mo., and Urbana, Ill.). I am grateful to Judith McCulloh for calling this document, to which she contributed, to my attention. One or both of the brothers are clearly visible, for instance, in *Missouri Musicians* (1931, oil: Dr. Abraham Feingold, Sands Point, N.Y.), "Arts of the West" (1932, Whitney Museum mural), and several prints, including *Comin' Round the Mountain* (1931) and *Waiting for the Revolution* (1934). The same drawings, made in Galena, also form the basis for the illustration entitled *Traveler's Rest* that appears in *An Artist in America*, facing p. 57.

5. Jerry Bailey, "Tom and Tex Worked Out New Hall of Fame Mural," *The Tennessean* (March 29, 1974): 63.

4. Homer Leverett, Galena, Missouri. 1931; ink, pencil, sepia;
10 x 8¼; inscribed, Benton.

5. Tex Ritter, Kansas City.
1974; pencil; 13 x 8¾;
inscribed, Harold Armstrong
Frankfurt Kansas 66427.

the figure of the shifty white trader selling whiskey to the Indians in the great Missouri Capitol mural Tom painted in 1936, after his brother Nat and State Senator Ed Barbour twisted every arm in Jefferson City. Poor Nat was gone now. And so was Jackson Pollock, the harmonica player, the one who plays Tom's own instrument in the picture and became his most famous and controversial student because, instead of drawing likenesses so real you'd swear Wilbur Leverett was going to leap off the page, he made the drips and blotches those damned fool critics called "Abstract Expressionism." In the fifties and sixties, the fancy-pants critics had been so gaga over this "action painting" of Jack's that people who drew pictures were all but forgotten for most of the twenty-odd years Tom's picture, with old Jack blowing away on the harmonica, hung at the head of the broad staircase on Belleview Avenue. Lately, of course, "the human figure [was] coming back into fashion . . . and what are all those poor sons of bitches going to do now? They never learned how to draw." As for Jack Pollock, "You talk about sons rejecting their fathers. Well, he was practically a son."[6]

It hurt to remember, sometimes. Most memories, though, like the violets of "The Lone Green Valley," bloomed and then faded away, with time. But some yesterdays—the ones that lived on in the sketchbooks, fresh and sharp as the tang of this morning's martini—never did pale and dim. Jackson played the harmonica. Glen sang the song. And the sad-eyed old fiddler who sat in between them came from a drawing Tom made in 1926, outside Jasper, Arkansas, during his very first summer on the road. He was "a genuine Ozark fiddler," and, almost half a century later, he fiddled still with the special vigor that comes from crisp black lines on white paper, incisive stabs of wash at the turning of a cocked elbow. Tom Benton remembered the Ozark fiddler from Jasper as he started work on the Nashville mural—the Jasper fiddler; and Homer Leverett, of course; and Howard Bruffet, who'd been such an inspiration to Homer in Galena; and Uncle Lawrence, who complained that in the Appalachian song festivals "it's always some carn-y-val fiddlers they lets play an' at gits the prizes"; and Dudley Vance, the Tennessee fiddler who taught Tom that those Tin Pan Alley tunes and hillbilly records "never wuz right."[7]

There were lots of old fiddlers in Tom Benton's memories and in his sketchbooks, ripe for the plucking, but somehow they weren't quite right for Tex Ritter's mural. It was all well and good to use the images stored up, one by one, over countless summers on the road; after the war, when he'd started feeling old for the first time, he'd kind of lost his nerve about talking to

6. Ray M. Lawless, "Thomas Hart Benton's *Jealous Lover* and Its Musical Background," *Register of Museum of Art* (University of Kansas) 2, no. 6 (1961): 37; Wernick, "Down the Wide Missouri," p. 97; and Robert S. Gallagher, "An Artist in America" (interview with Thomas Hart Benton), *American Heritage* 24, no. 4 (1973): 90. Although Benton told Lawless that he painted *The Jealous Lover of Lone Green Valley* in a matter of days in 1934 in his New York studio, there is ample evidence that he worked on it for several periods between 1931 and 1934, in New York and in Martha's Vineyard, and exhibited the work at several stages. The picture now hangs in the University of Kansas Museum of Art in Lawrence, and the surface shows the signs of several reworkings, including a transparent, golden glaze in which the musical score for the song appears.

7. Lawless, "Thomas Hart Benton's *Jealous Lover*," p. 37, and Benton, *An Artist in America*, pp. 112–13.

strangers, anyway, cajoling them into posing for a drawing. There was nothing quite like the bite of reality, though: sketches preserved that sense of the real, but drawing itself—the chatting, and the looking, and the pull of the pencil on the page—had a special kind of authenticity and, well, *life* about it that the years drained out of the best likenesses in the world. And so, last fall, at eighty-four years old, Thomas Hart Benton had gone on the road again, to Branson, Missouri, looking for fiddlers, for the kind of charge he used to get from stalking America down her dusty backroads, and for fresh material, just in case he decided to paint another "last" mural for a suburban banker who wanted one about the celebrated bank job the Dalton Gang pulled in 1892 in Coffeyville, Kansas. "I figure that with a little luck I've got five or six good years in me yet," he crowed, as he hunted down "Old Nick Nickens, the Left-Handed Fiddler," and Chick Allen, the jawbone-of-an-ass percussionist, in the wooded hollows of the Ozarks, just north of the Arkansas border.[8]

Along the way, Tom paused at a cabin near the School of the Ozarks, a stop he'd used for years as a base camp for floats on the Buffalo River; an old friend from these parts, it seems, had found the perfect model for the most awkward pose in the whole mural. The patient young woman, a student at the school, sat for her portrait with her mouth wide open, as though in song. No mean feat, that, since every little sketch, done oh, so deliberately with a softish pencil, took about fifteen minutes to finish, and one sketch was never enough, never quite right. In the mural, turned this way and that, her features inform the faces of the girls in the choir, the dulcimer player, and the barefoot singer with the big straw hat. There's something of her determined set of shoulder in the pert young things barn-dancing to the fiddler's tune. No single woman in the Nashville mural is a perfect copy of the Ozark singer, but all of them owe just a little—a curve of the cheek, a tilt of the head—to Tom's afternoon with his sketchbook and a pretty girl. There are hints, too, in those girls in the mural of other times, other ladies, other sketchbooks—the young couples square-dancing in the moonlight that Tom once drew from life at a University of Oklahoma student production of *Green Grow the Lilacs*, when he needed an idea for an illustration; the girls who serenaded him with "The Jealous Lover of Lone Green Valley" in the high-school gym in Neosho, during a gala "homecoming" for their favorite son, while in the town square, to the music of no fewer than four hillbilly bands, in a hoedown to end 'em all, cavorted more dancers than he'd "ever before seen."[9]

8. Robert Stanford, "Sketch of Benton in the Ozarks," *St. Louis Post-Dispatch* (January 24, 1975), pp. 1D and 3D, and Archie Green, "Commercial Music Graphics #37: Thomas Hart Benton's Folk Musicians," *JEMF Quarterly* 12, no. 4 (1976): esp. 87–90. See also Alan Buechner, "Thomas Hart Benton and American Folk Music," in *Thomas Hart Benton: Chronicler of America's Folk Heritage* (Annandale-on-Hudson: Bard College, 1984), pp. 69–77.

9. Vincent Alvin Keesee, "Regionalism: The Book Illustrations of Benton, Curry and Wood," Ph.D. diss., University of Georgia, 1972, pp. 126–27. *Green Grow the Lilacs*, a play based upon twenty-five traditional American folksongs, was first produced in 1931 and served as the basis for the popular Broadway musical *Oklahoma*. In 1954, Benton was commissioned to illustrate a special edition of Lynn Riggs's original text, published by the Limited Editions Club. During his preparatory work, he attended a revival of *Green Grow the Lilacs* at the University of Oklahoma. For an account of Tom Benton's Neosho, Missouri, "homecoming" celebration, see an untitled report in *Life* 52, no. 21 (1962): 2–3 and 38–39; *An Artist in America*, pp. 362–65; and the official publication, *Thomas Hart Benton, Artist of America* (Neosho: Citizens of Neosho, 1962).

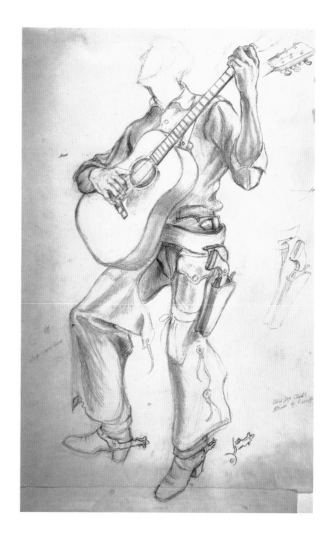

6. Cowboy singer, based on Tex Ritter, for the mural *The Sources of Country Music.* 1975; pencil; 22 x 14; inscribed, twenty divisions of frets, stop came loose, Old Joe Clark Street of Laredo.

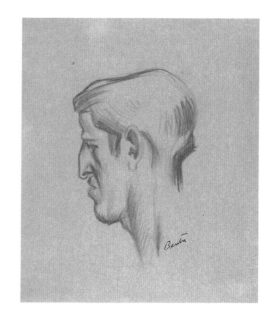

7. Sketch of a student at the Art Students League, New York. 1933–1934; pencil; 7½ x 6; inscribed, Benton.

Benton used this head for the title figure in his folksong painting *The Jealous Lover of Lone Green Valley* (Spencer Museum of Art, University of Kansas, Lawrence, Kansas) and for several figures in his Indiana mural of 1933.

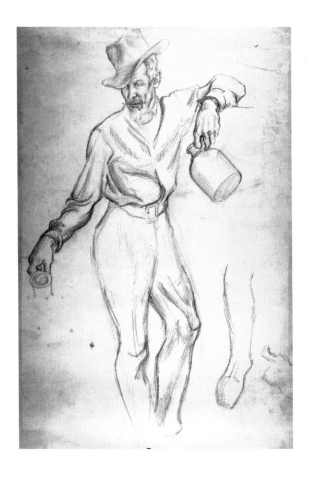

8. Frontier whiskey trader, study for the "Pioneer Days" segment on the north wall of the Missouri State Capitol mural (House Lounge, West Wing, Missouri State Capitol, Jefferson City, Missouri). 1935–1936; pencil; 25 x 19; inscribed verso, #4, Glen Rounds.

Glen Rounds, another Benton student, posed for this figure and for the singer of the ballad of *The Jealous Lover*. His fellow student, Jackson Pollock, was the harmonica player in the same painting.

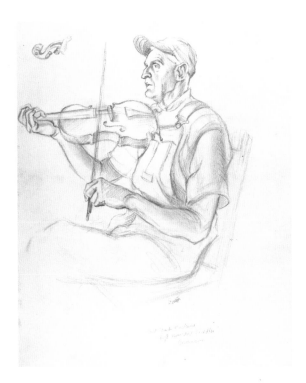

9. Old Nick Nickens, left-handed fiddler, Branson, Missouri. October 1974; pencil; 13 ¾ x 11; inscribed, Benton, Old Nick Nickens "left handed fiddler" Branson.

So the ladies in the Nashville mural were taken care of. The fiddlers were another story, though. Despite all the old drawings, and all the new ones, those two crucial characters still weren't right. On to Branson, with a reporter for a St. Louis paper in tow!

After two days of sketching at a leisurely pace, Benton needed . . . one more face, a fiddler. He wanted an older man. He got a name by going to a hillbilly music show and talking to musicians. They said that Raymond Bruffett once had played fiddle and very well. He lived in the woods over by Reed Springs, they said.

The search for Bruffett took the morning of the next day. A barber knew him. "Yes, those Bruffetts are real hill folks. I think he weaves baskets at Silver Dollar City, but it's closed today."

The secretary who answered the phone at Silver Dollar City said, "I'm sorry. We're not allowed to give out addresses or phone numbers of employees."

A policeman said to ask at a filling station six miles from town. The filling station operator said to ask at a general store eight miles farther. The woman at the store said to go back to a junction and ask at a house. . . . We were closing in on Bruffett. We found a man who pointed to a lane into the woods and said, "Go in there and bear left. The house is at the end."

I asked Benton whether he considered it to be important that the face of the fiddler in the mural be the face of a man who actually had played the fiddle. Or would just any face do?

"Aw, hell," he said, "I guess I could use the face of an actor. But sometimes what people do for a long time in their life—their occupation—shows in their faces. Or is suggested. That might be true in a musician. The emotions he has experienced might show. I don't know. I just have to see the face."

The sitting in the cabin at the end of the lane was accomplished with the help of a portrait of Chick Allen, made en route to Branson at his rundown highway tourist attraction *cum* "antique shoppe." Tom dangled it through a chink in the door, like a calling card. Raymond knew Chick, of course, and the name *Benton* meant something, once Tom reminded Bruffett of the old Fifteenth District and his dad, the congressman. Then there were the couple of bucks Tom offered in return for a good close look at Raymond's face: "Just my face? You're not getting much for your money!" But Tom was ecstatic. "A fine face," he said. "A sensitive face. And he certainly was a gentleman."[10]

Tom Benton had peeked at Raymond's hands, too, wonderful old hands that had held a fiddle for fifty-four years, fifteen of those years with a sore finger, split in a mill accident. Those old hands, caressing strings and bow with the graceful ease of habit, are about all that's left of Raymond Bruffett in the Nashville mural. The fiddler in the pink shirt, the one closest to Tex, has the head of Chick Allen, and his big Adam's apple. The other fiddler, in the red shirt, looks a lot like Sammie Feeback, an ex-wrestler and TV cameraman Tom met back in 1953, when both of them were covering the Bobby Greenlease kidnapping trial. Over the years, Sammie had become a great friend and a boon companion on Tom's legendary river trips, despite the fact that, with a torso like a whiskey barrel, he was "built all wrong for white water."[11] Feeback roped a pal of his, freckle-faced Melvin Deaver, into posing

10. Stanford, "Sketch of Benton," p. 3D.
11. Robert F. Jones, "The Old Man and the River," *Sports Illustrated* 33, no. 6 (1970): 30.

for the black banjo player, largely because Deaver owned such an instrument, bought by a relative before the turn of the century from the Sears Roebuck catalogue. Sammie himself posed for the figures of both fiddlers and further obliged by taking up the posture of the reformed drunk, singing in the choir in the left-hand corner, right behind one of the several incarnations of Tom's warbling Ozark girl.[12]

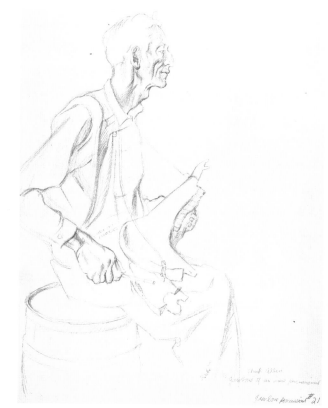

10. Chick Allen, jawbone-of-an-ass percussionist, Branson, Missouri. October 1974; pencil; 13¾ x 11; inscribed, Benton, Chick Allen Jawbone of an ass percussionist, Jawbone percussionist #21.

Since a major recreational feature of any Benton river float was the heroic consumption of jug bourbon and Gluek's beer, Sammie and Tom had a good laugh over his sobriety in the make-believe world of the mural. And a make-believe place it was. Tex Ritter was real enough, but—and Mel Welsh must have noticed it this morning—everybody else was kind of strange. Take the fiddler in the pink shirt. He was Chick Allen, all right, but, well, he looked a lot like Sammie, too, around the forehead. And his right hand was sort of mangled, like Sammie's hand after those years of rasslin'. But that old fiddler down in the Ozarks, that Raymond Bruffett, he'd had a bad hand too, and, my, could he fiddle, just like the fella in the picture. The fiddler with the pink shirt was Raymond and Chick and Sammie all rolled into one, and the other fiddler, why he was just the same, and the both of 'em looked more like old Tom Benton himself than not. The bodies of those fiddlers were just your average bodies, but the faces were older than the grave, spectral, with skin thin as parchment stretched tight over brittle old bones. Old men's faces, as though Tom, at eighty-five, wasn't just Tom any more, but was Raymond Bruffett and old Nick Nickens, Dudley Vance, and Wilbur and Homer, Jack and Glen, and Sammie Feeback, too, and the sad-eyed old geezer he'd met in Jasper in 1926. In his "last" mural, Tom's own self had merged, little by little, with his sketchbooks and his memories and his friends. He shrank away into them, as old men shrink with the years, until he became the spirit that touched their faces, an echo of a fiddle in the breeze, the faint call of a far-off train whistle on the night wind that sounded like "The Wabash Cannonball."[13]

The engine streaking through the background of the Nashville mural is the famous Cannonball, the train that was for the hobo and the vagabond and those who rambled down the backroads of the Ozarks what the Flying Dutchman was for the sailor. The melody sounded like the tune of "The Jealous Lover," and the lyric, too, spoke of death: "When my life is over, and the curtains 'round me fall / May they ship me off to heaven on the Wabash Cannonball."[14] When Tom trudged into the house from the studio that Sunday afternoon, wearing the old hat his friend John Callison wore as he turned the hoist in the Joplin mural, he looked like death, and the Cannonball was on his mind. The euphoria of the morning was gone, replaced by nagging wor-

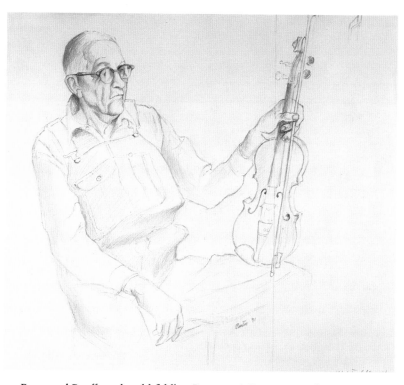

11. Raymond Bruffett, the old fiddler, Branson, Missouri. October 1974; pencil; 14½ x 15¾; inscribed, Benton '71, Old Fiddler 16.

12. Diana Stafford, "Benton Brushstrokes Immortalize Friend," *Kansas City Star* (September 17, 1975): 1A.

13. The train in the Nashville mural alludes, of course, to the mournful train songs prominent in country music, particularly "Casey Jones" and "The Wabash Cannonball." In most such songs, the train is an agent or a symbol of death. See Lynn Harvey, "His Mural, His Music," *The Tennessean* (February 23, 1975): 6–8.

14. Norm Cohen, *Long Steel Rail: The Railroad in American Folksong* (Urbana: University of Illinois Press, 1981), pp. 374 and 377. The lyric quoted here is the one I learned from Nashville on the radio in the forties.

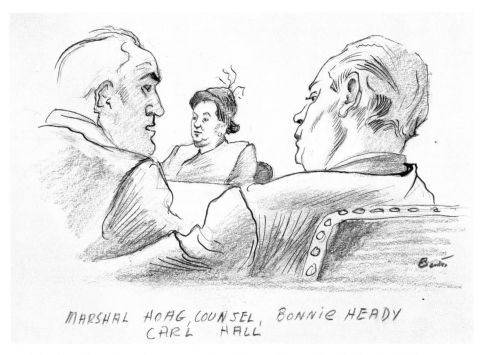

MARSHAL HOAG, COUNSEL, BONNIE HEADY
CARL HALL

12. Sketch made in the Jackson County Courthouse, Kansas City, during the Bobby Greenlease kidnapping and murder trial, showing Bonnie Heady and Carl Hall, the defendants, along with their lawyer. November 1953; ink, pencil; 7⅜ x 9⅞; inscribed, Benton, Marshal Hoag, Counsel, Bonnie Heady, Carl Hall; verso, Marshal Hoag Bonnie Heady Carl Hall Greenlease Case.

Benton met television cameraman Sammie Feeback during this sensational trial. In 1969–1970, Feeback coproduced *A Man and a River*, a film about Benton's love of nature, recording a trip down the Buffalo River in northwest Arkansas. They made many river floats together.

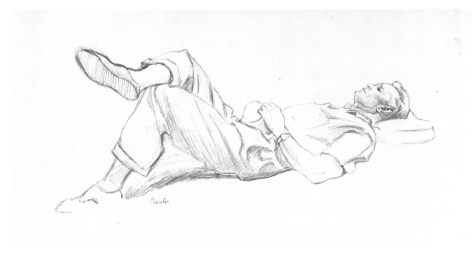

13. Lyman Field on a river float, Buffalo River, Arkansas(?). 1963; pencil; 13¾ x 16½; inscribed, Benton, Lyman Field.

This sketch was incorporated into a 1963 painting *Cave Spring* (Field Enterprises Educational Corporation), one of many works of the period depicting such trips. Among Benton's most faithful companions were Field, Callison, Feeback, Fred McCraw, Bernie Hoffman, and guide Harold Hedges.

ries. The mural was almost done, but what if it wasn't right? You could draw, and poke around, and draw some more; you could scramble around to find the perfect girl singer, the perfect old banjo. Hell, there was a limit, wasn't there? Faces and poses and fiddles and banjos. They were OK. But what about the damned train? At eighty-five, Tom Benton was having trouble with the same damned locomotive that had given him trouble seventy-eight years before, when a seven-year-old Tommy drew a freight train in charcoal right up the stairway, on Mama's brand-new cream-colored wallpaper. "It began with the caboose at the foot of the steps and ended at the top with the engine puffing long strings of black smoke—because of the heavy grade."[15]

When he came into the house late that afternoon, Tom looked bone-weary, so tired that John Callison declined his invitation to go back out to the studio and see the mural, with its hints of Sammie and springtime river floats long ago. Instead, they had a drink and talked a little, about the future mostly, about the next, great annual float trip, now in the planning stages, and about the banker's yen for a holdup mural. But, little by little, the conversation circled 'round again to the picture on the easel out in back. "How about driving me over to St. Louis, John?"[16] There was urgency in Tom's voice. "Sure," John replied. But why should Tom want to go to St. Louis now, with the mural just about done? The mural was as good as done, and ahead of schedule, Benton explained—but there was an old train in St. Louis, a train like the old Wabash Cannonball, and, just to be sure, before the mural went in its crate, well, you know, just to be sure that the train's absolutely *right*; not that anything needed changing at this stage, mind you, but, just to be sure. . . . It would be a comfort to see the train and make a few drawings. Then Rita said that dinner was ready, and John left, promising to call in the morning, to make plans for the trip to draw the train in St. Louis.

After supper, Tom usually went back to the studio, to look over that day's work and plan for the next. Tonight, there was nothing left to plan, and that was a letdown. At this stage, the most he could do was sit on the old, straight-backed chair before the easel and fret a little, as he'd worried the train half to death with John that afternoon. Dammit, the train was fine. He didn't need to drag John to St. Louis to draw any old engine. The mural was just right, the train and Tex and Sammie and the pretty girl from the Ozarks and Melvin Deaver's old banjo. Wait a minute, though! How many strings should that banjo have, anyway? It stands for old-time minstrel music, so it ought to have, what, five strings? Or is it four? Where are those drawings, the old ones from Tennessee, from '26 or '28, of old Dad McNamara picking his banjo, the ones from a couple of years later, from '34, up on the Blue Ridge, where it breaks into the Cumberlands, the ones of that little tinhorn minstrel show, "Five Famous Colored Artists and Entertainers"?[17] Where the hell are they?

When he didn't come in to bed that cold January evening, Rita put on a

15. *An Artist in America*, p. 13.
16. Wilma Yeo and Helen K. Cook, *Maverick with a Paintbrush: Thomas Hart Benton* (Garden City, N.Y.: Doubleday & Co., 1977), pp. 120–25.
17. *An Artist in America*, pp. 92 and 113.

robe and went looking for Tom, to scold him for painting half the night, and at his age. She found her husband on the floor, in front of his "last" mural.[18] Tom Benton was dead. Two days later, his great good friend Lyman Field spoke for all his other friends when he eulogized Tom's folksy profanity, his salty humor. But the really special thing about Tom was his darting brown eyes, "afire with interest in everything around him," his "intense interest in the configuration of a flower, a sea shell, the fretted intricacies . . . of moss growing on a stone wall, the shape of a Morel mushroom."[19] Looking was the key to the art of Thomas Hart Benton, looking and setting down in once-controversial murals, in big, roiling paintings, and in popular prints the American images that he had made peculiarly his own. The obituary in the *New York Times* characterized the painter with a litany of those familiar, Tom Benton images: "farmers scything hay, Jesse James executing a holdup, gaunt Ozark hillbillies and their mournful sweethearts, Negro sharecroppers picking cotton, soldiers in honkytonks, riverboats on the Mississippi, [and] roaring steam trains."[20]

Lyman Field and the rest of Tom's friends from Missouri would have added musical themes to the list. "It was one of his great loves," Field recalled, "particularly the music of the country."[21] They played the harmonica at Tom Benton's funeral, and his daughter, Jessie, sang "Amazing Grace," an old-time camp meetin' song. Just a few months later, in July 1975, they dedicated his last "last" mural, the one about his favorite music, at the Country Music Hall of Fame in Nashville. It was a pity Tom couldn't have been there, to spin a yarn, cuss a little, and play a country tune on his harmonica; he'd been practicing for months on the sly in the studio during his lunch breaks. It was a pity, too, that the picture lacked his distinctive signature—the *Benton* with the big, bold *B*— scrawled across the corner. But the picture was great, anyway. The choir and the fiddlers and the square dance and the likeness of Tex Ritter were fine. The train, the Cannonball, was just fine, too. Tom needn't have worried about a thing. And the night before the unveiling, or so folks say in Nashville, somebody pulled the curtain back and painted another string on the banjo, just as neat as you please, so it looked like the banjos in Tom's old drawings, the ones he was looking for that last evening, the banjos you picked real fast, with three fingers, when the train picked up speed, in the final chorus of "The Wabash Cannonball."[22]

The train and the banjo. Between last-minute reservations about the way

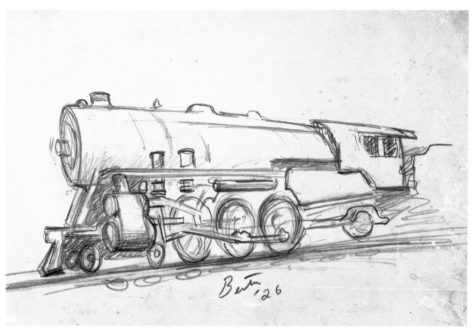

14. Steam engine. 1926; pencil; 6¾ x 9⅜; inscribed, Benton '26; verso, $50.

the Cannonball really looked and nagging worries over his rendition of Melvin Deaver's Sears Roebuck special, Tom Benton died with drawing on his mind. There is a certain, fine irony in that fact, for the railroad train on his Mama's new wallpaper was Benton's first major drawing—and a controversial one, at least in the Benton household—while that banjo string, by whatever mysterious agency it reached the surface of the Nashville mural, was demonstrably his last. Between them lay a lifetime of controversial art; of murals often called "tabloid caricatures" of American life; of paintings often adjudged "prosaic, . . . commonplace, . . . not of museum standard"; of debates over the political implications of art in which he was often accused of "vicious and windy chauvinism" verging on Fascism, or worse.[23] His politics, his pictures, and the huge, dynamic murals that made him famous seldom failed to offend somebody prone to saying why in the public press. But the informal drawings and sketches on which his much-acclaimed and much-maligned art was

18. Paul Watkins, Jr., "Thomas Hart Benton Remembered," *Missouri Life* 3, nos. 1–2 (1975): 55.

19. Lyman Field, *Eulogy to Tom Benton*, 2d ed. (Kansas City: privately printed, 1975), pp. 4–5; Field quotes the words of Robert M. White, a Missouri newspaper editor who wrote several perceptive profiles of the artist.

20. "Thomas Hart Benton Dies; Painter of the American Scene," *New York Times* (January 20, 1975), sec. 1, pp. 1 and 30, cols. 7–8, 1–3.

21. Field is quoted in Harvey, "His Mural, His Music," p. 6. For "Amazing Grace," see Albert E. Brumley, *Olde Time Camp Meetin' Songs* (Powell, Mo.: Albert E. Brumley and Sons, 1971), p. 3; the text on revival songbooks was contributed by Gene Gideon of Branson.

22. This story is part of the apocrypha of Nashville; it comes from many sources, but all those who tell it as gospel decline to be identified by name.

23. Henry McBride, critic for the *New York Sun*, quoted in "Abou Ben Benton," *Art Digest* 7, no. 8 (1933): 6; Emily Genauer of the *New York World-Telegram* quoted in "'Benton Is Getting Better,' Say New York Critics," *Art Digest* 15, no. 14 (1941): 6; and Stuart Davis, speaking of Benton, the Regionalists, and critic Thomas Craven, in "The New York American Scene in Art" (1935), reprinted from *Art Front*, the left-wing periodical, by Diane Kelder, ed., *Stuart Davis* (New York: Praeger Publishers, 1971), p. 153.

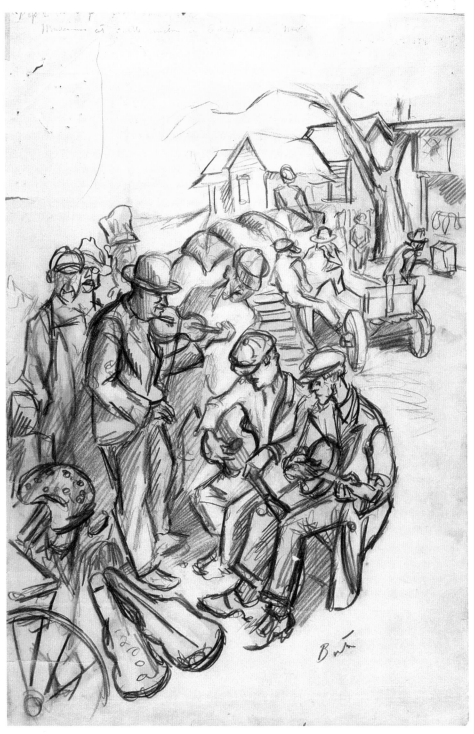

15. "Pop and the Boys," musicians at a cattle auction, Independence, Missouri. 1942; pencil; 18 x 12; inscribed, Pop. The Boys. Pencil drawing study. Musicians at cattle auction in Independence Mo., Benton; verso, $300.

This drawing was the basis for a painting of the same title, completed in 1963 (Dr. and Mrs. William Muland, Scarsdale, New York).

based escaped, by and large, the opprobrium heaped upon his more polished performances, the "great art" of a "Great Missouri Painter."[24]

Indeed, the drawings and watercolors done in the Ozarks in 1924, when the thirty-five-year-old artist returned home to Missouri to comfort his dying father after a long absence in the studios of New York and Paris, brought Benton his first unqualified critical success.[25] Those sketches from life, and the sketching trips that followed, fundamentally altered Benton's career. In a favorable review of an exhibition of "New Benton Drawings" held at the Delphic Galleries in New York in 1929, Lloyd Goodrich hinted at the reasons for Benton's abrupt, midlife shift of emphasis:

> As an artist, Mr. Benton is a strangely contradictory temperament. The theoretical side of his nature is so strongly developed that his paintings seem mere demonstrations of his theories about form. And yet in these drawings all this side of his character is submerged; he has gone direct to reality and created work that has the true breath of life.[26]

By his own admission, Thomas Hart Benton had wasted more than a decade in New York, wallowing in one "cockeyed 'ism'" after another, searching for some magic formula to reconcile the flatness of the picture plane with the self-evident rotundity of objects in the real world, some surefire method to resolve the tension between the modernists' obsession with the "forms" of art and old-fashioned "content"—the subject matter most people noticed first when they looked at pictures. Goodrich, for one, had always found Benton's paintings tedious because they bore such a heavy burden of theorizing. The odd segments, or "chapters," of the apparently interminable *American Historical Epic* mural cycle that Benton had been showing around town at every possible opportunity, in the absence of a wall on which to paint his pioneers and Indians, struck Goodrich as theorems rather than works of art. Benton, he argued, produced such paintings to illustrate the proposition that

24. This phrase appears in a headline in *Life* 6, no. 4 (1940): 30. Dan Longwell, Benton's good friend and one of the movers behind the Neosho "homecoming" celebration, was an editor at *Life*, a magazine that always gave Benton "star" treatment (and twice sent him on assignment), as did *Collier's*, the *Saturday Evening Post*, *Coronet*, *Scribner's*, and other popular periodicals. Benton's willingness to work for magazines, movie studios, and corporations no doubt contributed to his "good press"; by design, Benton avoided the appearance of exclusivity that sometimes made his modernist contemporaries seem foolish and precious to members of the fourth estate. Benton's celebrity status began with the use of his self-portrait for the cover of the issue of *Time* in which the so-called Regionalist movement in American art was defined for the first time; "U.S. Scene," *Time* 24, no. 26 (1934): 24–27. Along with Thomas Craven's hyperbolic and strident espousal of the work of his old friend, Benton's news value to the media was certainly one major source of the resentment of Benton endemic in the critical establishment from the midthirties onward.

25. For his successful exhibition of Missouri-made watercolors at the Daniel Gallery in 1924, see "In Missoura," *New York Times*, Late City Edition (November 30, 1924), sec. 9, p. 13, cols. 6–7, and Lloyd Goodrich, "In Missoura," *Arts* 6, no. 6 (1924): 338. The definitive monograph on Benton's art is Matthew Baigell, *Thomas Hart Benton* (New York: Harry N. Abrams, 1973); Baigell offers a comprehensive treatment of Benton's various exhibitions, many of which are also discussed in Thomas Hart Benton, *An American in Art: A Professional and Technical Autobiography* (Lawrence: University Press of Kansas, 1969).

26. Lloyd Goodrich, "New Benton Drawings," *New York Times*, Late City Edition (October 27, 1929), sec. 9, p. 13, col. 607.

modernism had wantonly neglected subject matter, to demonstrate the eternal validity of Renaissance solutions to the formal problems of pictorial organization. As paintings, therefore, they possessed all the charm and appeal of a legal brief.[27] But the new drawings were another matter:

> The present group of drawings seem to me to mark a great advance in reality and vitality. They were done this summer in the course of two months' wandering in a Ford through the Southern states. Being of this soil and these people—he was born and raised in Missouri—Mr. Benton has pictured them with understanding. . . . [His] chief interest . . . is the world of industry and labor—of factory, mine, railroad and steamboat—and his drawings on these subjects are powerful and living. His pictures of river traffic are particularly stirring, with some of the sweep of Mark Twain's *Life on the Mississippi*. . . .
>
> [The drawings] are comparatively free from the obvious forced rhythms of his earlier style; by a wise use of straight lines and of contrasts between static and dynamic elements he has obtained a new stability and firmness. In them he displays that rare quality, a genuine graphic sense—a sure grasp of form and a rich gusto in the realization of plastic values. . . . Their strength lies in their downright, matter-of-fact vigor. Everything in them can be touched and grasped, and what cannot be submitted to that test is apt to be ignored.[28]

By the spring of 1930, the once-obscure painter of historical murals nobody wanted and of arcane "Synchromist" color exercises loosely based on Michelangelo had finally made his name as a graphic chronicler of the forgotten America, out there beyond the Hudson River.[29] Tom Benton's America was a place without paved roads and flivvers. It was a place without radios, where an evening's entertainment was a pie supper and an amateur fiddler "named Cunningham, half Irish, half Cherokee" playing the "Chicken Reel" in a leaky tent.[30] It was a place where folks worked hard, when there was

27. Carl Zigrosser, *The Artist in America: Twenty-four Close-ups of Contemporary Printmakers* (New York: Knopf, 1942), p. 176, suggests that, because of Benton's "haphazard decision to become an artist" as an act of rebellion against his lawyer-father, there may not have been an organic relationship between his chosen profession and his innate capacities. Benton, Zigrosser notes, decribed his own painting ability as "never fluent under the best circumstances." In his tendentious early paintings, executed before years of discipline had given him some mastery of his craft, there is more of the lawyer than the born artist.

28. Lloyd Goodrich, "The Delphic Studios," *Arts* 16, no. 3 (1929): 183 and 185.

29. For Benton's Synchromist phase and his role in the Forum Exhibition of 1916, see Gail Levin, *Synchromism and American Color Abstraction, 1910–1925* (New York: George Braziller/Whitney Museum of American Art, 1978), esp. pp. 31–33, and Matthew Baigell, "Thomas Hart Benton in the 1920's," *Art Journal* 29, no. 4 (1970): 422–24. For his murals of the period, including a four-part "History of New York [City]" that he executed on panel in the hope of placing the murals in the third-floor rotunda of the New York Public Library, see "Thomas H. Benton Conceives a New Style of Mural Painting," *Art Digest* 1, no. 9 (1927): 7, and Phillip Dennis Cate, *Thomas Hart Benton: A Retrospective of His Early Years, 1907–1929* (New Brunswick, N.J.: Rutgers University Art Gallery, 1971), unpaginated. See also the review of Benton's second drawing show of the season, also held at the Delphic Studios, in *Art News* (October 19, 1929): 17.

30. Thomas Hart Benton, "Thirty-six Hours in a Boom Town," an illustrated travelogue about his trip to Disney, Oklahoma, in *Scribner's Magazine* 104, no. 4 (1938): 52. For an extended discussion of boomtowns, Benton's sketching trip in Texas in 1927, and the relationship between the documentary drawings of the twenties and the genesis of Regionalism, see Karal Ann Marling, "Thomas Hart Benton's *Boomtown*: Regionalism Redefined," in Jack Salzman, ed., *Prospects: The Annual of American Cultural Studies* (New York: Burt Franklin and Co., 1981), 6:73–137.

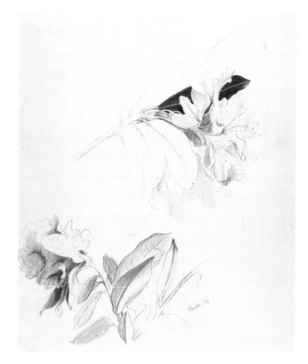

16. Plant study. 1974; pencil; 14 x 11½; inscribed, Benton '74.

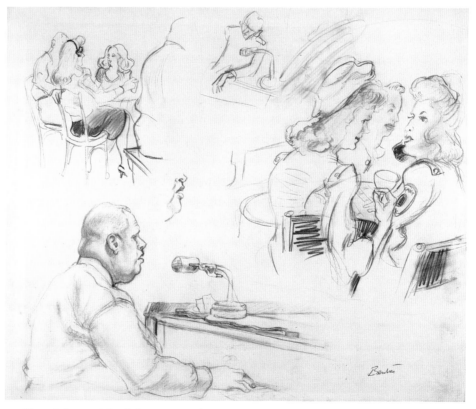

17. New Orleans night club, "Fats" Pichon singing. 1943; pencil; 13¾ x 16¾; inscribed, Benton; verso, New Orleans Night Club.

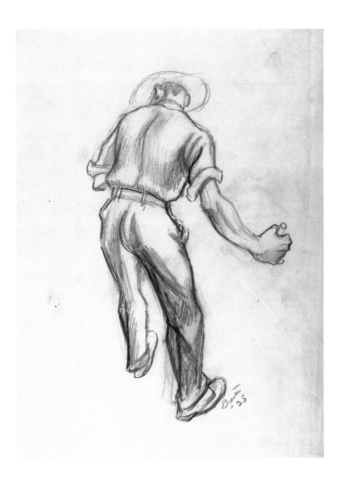

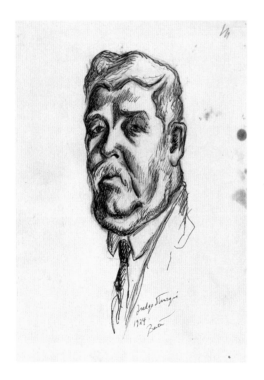

18. Study of a farmer cradling wheat, for the "Farming" segment of the east wall of the Missouri mural. 1935; pencil; 14⅝ x 11¼; inscribed, Benton '35.

This figure inspired the famous oil *July Hay*, of 1942 (Metropolitan Museum of Art, New York; George A. Hearn Fund).

19. Judge Sturgis, Missouri. 1924; ink, pencil; 8 x 5; inscribed, Judge Sturgis 1924 Benton.

work to be had, and knew what they were doing when they poured steel or chopped cotton. And when hard times came, Tom Benton's America sang hymns and shook in the throes of heavenly healing and prayed to the Lord.

Since that first, sad trip back to Missouri in '24, Benton and his sketchbook had found themselves in West Virginia, Tennessee, and Kentucky; in Arkansas, Oklahoma, and Louisiana; in Georgia and New Mexico; in Pennsylvania. He had drawn Ozark hillbillies and his father's old political cronies. He had drawn his summer neighbors on Martha's Vineyard, off the Massachusetts coast—Yankee farmers and their prim New England wives. He made whole suites of drawings, arranged in documentary series, called *King Cotton* and *Coal Mines*, *Lumber Camp* and *Holy Roller Camp Meeting*.[31] What's more, he sold those drawings to prominent collectors, although he had drawn them, in the first place, with the idea of "their possible use for painting." His pictorial notes on his travels, he recalled many years later, were "exploratory and reportorial and at no time intentionally 'aesthetic.' I was not trying to make exhibition drawings, only useful ones." But the novel technique that made his field reports useful for future reference—a critic once said his odd mixture of media "sounds a bit complicated, but the result is not"—also made them beautiful, and desirable:

> After the first few days of my 1926 walking trip through the Ozark hills, I noticed that the drawings in my sketch books, which were made with pencil, were beginning to smear. Due to the movements of my walking, the pages of these books were rubbing together, sometimes almost obliterating the lines. I began, then, a practice of covering the main lines of these with India ink and washing a thin tone of watercolor—sepia or umber—over the rest. The gum in the watercolor held the pencilled modellings. In this way I was able to preserve my material intact for later use.[32]

The chance for "later use" came soon enough. In 1930, Thomas Hart Benton, would-be muralist and heretofore thwarted aspirant to the mantle of LaFarge, Blashfield, and Kenyon Cox, was given his first wall to paint, in Room 510 of the new New School for Social Research on West 12th Street.[33]

31. For Benton's early New England paintings, see "Thomas H. Benton—American Modern," *Survey* 57, no. 1 (1926): 31–34. For his reportorial series and collectors' purchases, see "An Author and a Critic Acquire Bentons," *Art Digest* 4 (mid-November 1929): 8, and "Thomas H. Benton," *Art News* (October 19, 1929): 17.

32. Edward Alden Jewell, "One-Man Shows by Benton, Biddle and Joe Jones," *New York Times*, Late City Edition (October 31, 1937), sec. 10, p. 10, cols. 2–4, and Benton, *An American in Art*, pp. 59–60.

33. As a youngster, Benton had marveled at the academic murals in the Library of Congress. The influence of the art of the so-called American Renaissance on the mature Benton is discussed in J. Richard Gruber, "Populist Murals and the 'American Scene': Thomas Hart Benton's 'American Historical Epic,'" paper delivered at the 9th biennial meeting of the American Studies Association, Philadelphia, November 3–6, 1983, pp. 4–5. The New School murals occupied the space for which they were painted for some fifty-two years, during which time the artist inspected his work on several occasions and restored damaged portions of the surface. In 1982, however, the ten panels were removed and sold, for a reported $2 million, to Christophe P. Janet, a Manhattan dealer who promised to keep the works together. After months of rumor and uncertainty, the murals were acquired, for something over $3 million, by the Equitable Life Assurance Society, in the spring of 1984. The corporation plans to reinstall the murals in a specially designed space in its new headquarters on New York's 7th Avenue,

He got his wall—four walls and a bit of ceiling, actually—not on the strength of his cosmic theories or his big, overheated practice panels, but because his unpretentious, alfresco drawings of sawmills and sleepy country towns had disarmed the most virulent critics and intrigued the rest, by virtue of the charmingly unfamiliar people and places brought to life in vibrant line and spills of color. He titled his New School murals with one collective name: *America Today*. His theme was nothing less than the sum of all the drawings, a modern epic, a panorama of American life in ten segments, including the rivers and cotton fields of the Deep South, as he had sketched them in Georgia and Louisiana; the lumber industry and the cornfields he had drawn in Virginia, Tennessee, and Oklahoma; the western oil fields, set down in sketchbooks kept in Texas and New Mexico; the coal industry, recorded on stops in Alabama, West Virginia, and New York State; and the drama of the steel industry, captured in studies of Bethlehem's Sparrows Point plant.[34] There were new drawings to be made, too, of New York City—of skyscrapers rising, liners steaming into port, street-corner evangelists yowling, and ticker tapes ticking—but the bulk of *America Today* was already waiting in his stacks of drawings, in the "mass of factual material gathered" on the spot, on the road. "I had the material in my travel sketchbooks, all of it," Benton later confessed. "It was simply a question of organizing it."[35]

There were intermediate stages, to be sure, in the flow of images from sketchbook to wall, stages that called for other kinds of drawings. Benton's travelogue sketches from life, for instance, were mainly portraits or attitude studies. Additional studio work from the model was needed to give those distinctive heads equally distinctive bodies and to equip dramatically strained torsos with plausible heads. So urban scene painter Reginald Marsh agreed to pose for the figure of "the negro with the drill" in return for the recipe for the egg-tempera medium he (and Benton) would use for the next several decades. Jackson Pollock, who had barely enrolled in Benton's class at the Art Students League, was hustled off to model for most of the other major figures in the composition.[36] The head of Max Eastman, radical columnist and Benton's sometime neighbor on the Vineyard, turned up atop the body of a dapper chap ogling a chorine in the New York subway; Tom's wife, Rita, and their baby son, T. P., sat for the portrayal of mother and child that constituted the only oasis of serenity in an agitated disquisition on the diversions of

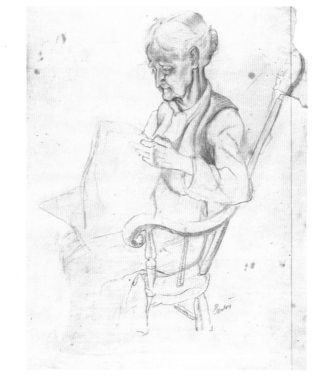

20. New England lady, educating herself by reading a magazine, Martha's Vineyard, Massachusetts. 1926; pencil; 11 x 8½; inscribed, Benton.
 Studies of his father's old cronies, gathered at his deathbed, and his summertime neighbors at Chilmark, were among Benton's earliest mature exercises in reportage.

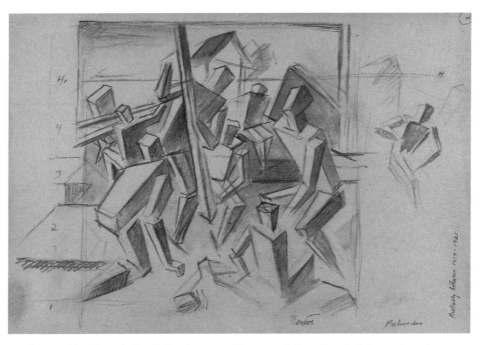

21. Compositional study for *Palisades*, one of five murals from Part I of the projected "American Historical Epic" mural cycle (on loan to Nelson Gallery-Atkins Museum, Kansas City). 1919–1921; sepia, pencil; 8¾ x 13; inscribed, Benton, Palisades, Probably between 1919–1921.

between 51st and 52d streets. See brief news reports on the sale and resale in the *New York Times*, January 17, 1983, and February 19, 1984.

34. "Benton in New Set of Murals Interprets the Life of His Age," *Art Digest* 5, no. 5 (1930): 36.

35. *An Artist in America*, appended "Chronology" for 1930–1931, p. 382. Benton wrote many versions of this document. See, for example, "A Chronology of My Life," in *Thomas Hart Benton: A Retrospective Exhibition* (Lawrence: University of Kansas Museum of Art, 1958), unpaginated, or *Thomas Hart Benton, Artist of America*, pp. 14–20. Benton discussed the derivation of the New School mural freely with Robert S. Gallagher, "An Artist in America," p. 85.

36. Reginald Marsh, "Thomas Benton," *Demcourier* 13, no. 2 (1943): 9, and Marilyn Cohen, *Reginald Marsh's New York* (New York: Dover Publications/Whitney Museum of American Art, 1983), p. 45. Illustrator Denys Wortman, another of Benton's Vineyard pals, was co-inventor of the egg-tempera medium; see "The Battle of Beetlebung Corners," *Collier's* 132, no. 10 (1953): 84–85. For Pollock's role, see Stephen Polcari, "Jackson Pollock and Thomas Hart Benton," *Arts* 53, no. 7 (1979): 120–21.

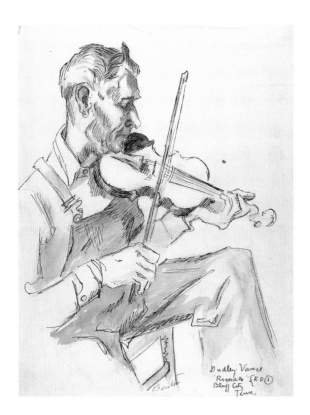

22. Dudley Vance, fiddler, R.D. 1, Bluff City, Tennessee. Circa 1930–1932; ink, sepia wash, pencil; 11¾ x 9; inscribed, Benton, Dudley Vance, "Riverside" R. D. 1. Bluff City Tenn.; verso, Tennessee fiddler $100.

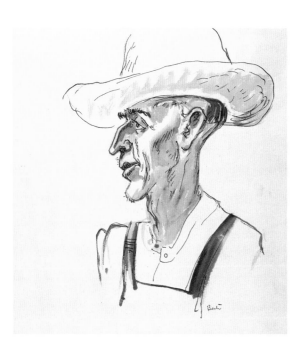

23. One of the "plain people of the hills," the Ozarks, Arkansas. Circa 1926; ink, sepia wash, pencil; 10 x 9; inscribed, Benton; verso, $50 $175.

Benton used this drawing to illustrate an article on the folkways of the hill country. It was published in *Travel* magazine in 1934.

Gotham; and the painter himself, rendered somewhat taller than life by the powers of foreshortening, lurked in a corner of the same panel clutching a shot of bourbon—neat—and toasting Dr. Alvin Johnson, director of the New School, for his good sense in hiring Tom Benton.

Commentators found flaws in *America Today*. Although Goodrich loyally attempted to put the best complexion possible on the most glaring defect when he waxed lyrical over feeling "a sensation like that of looking out the window of a train speeding through cities, past factories and mines, through farmland and woods, over prairies, across rivers," the New School decoration was episodic, one pungent incident set down next to another with little concern for integration and subordination of elements.[37] The translation from sheaves of isolated drawings to full-fledged mural cycle was, perhaps, too direct for real painterly coherence: the emphasis on the constituent parts slighted the design as a whole.[38] But, however much Goodrich and his cohorts might quibble with the use Benton made of the drawings that were the raw materials for *America Today*, the critics were unanimous in praising those firsthand, documentary records—"direct, real, and full of fresh observation"—and the zest they lent to the New School murals. Authenticity of experience, the truth of Benton's graphic annals of America, set the standard by which his accomplishments as a painter were calibrated. "Every detail of the mural," marveled one commentator, "was done from a thing the artist himself has seen and known."[39] "These murals," gushed another, "are the commentaries of one who lives with gusto, who revels in the full-bodied muscularity of action and . . . does not fear to record what he observes."[40]

As if to confirm the value of such observations of the native habitat, the prestigious Whitney Museum of American Art bought a dozen of the New School drawings and, in the spring of 1932, commissioned Benton to paint a second series of picaresque murals in its reading room, adjacent to the galleries. Again, he went straight to his sketchbooks. There he found Wilbur and Homer Leverett, ready to serve as symbols for the "Arts of the West." There he found the toothsome "Appalachian Oread" in the white dress with the stylish little hat, a girl he had seen in the mountains of western Virginia, quivering with orgiastic piety at a Holy Roller gathering deep in the woods.[41] She became the controlling muse of the "Arts of the South." One by one, the colorful characters Tom Benton had stopped to scrutinize on his travels found their places in *The Arts of Life in America*. And, when inspiration

37. Lloyd Goodrich, "The Murals of the New School," *Arts* 17, no. 6 (1931): 401.

38. The strips of molding applied on the surface of the New School murals—they were derived from the montage technique used in newspaper rotogravure sections and, earlier, in the vignettes of nineteenth-century illustration—are Benton's attempt to impose a composition as if by fiat on his inherently chaotic collection of sketches from life. Goodrich, "The Murals," p. 402, attributes compositional confusion to Benton's ongoing interest in abstract design; that is, Goodrich reasoned that a design that might work in a nonrepresentational context could well fail when merged with the figures and objects of real life. It seems plain, however, that the problem stems from Benton's desire to preserve intact the drawings for which he received his first sustained critical praise.

39. "The Murals by Thomas Hart Benton," *Pencil Points* 11, pt. 3 (1930): 987.

40. C. Adolph Glassgold, "Thomas Hart Benton Murals at New York School for Social Research," *Studio* 1 (April 1931): 287.

41. *An Artist in America*, pp. 97–99.

flagged, he hit the road again, although he didn't need to travel farther than Eighth Avenue to find the floozy with the lipstick, the bathing beauties, the jazz babies, or "Shake 'em Baby," with her chromium cocktail set, all dubious heroines of the "Arts of the City."[42] "*The Arts of Life in America* is only a tag hung on American doings which I have found interesting," wrote the proud creator in the program handed out at the unveiling. "I have seen in the flesh everything represented except the Indian sticking the buffalo."[43]

Success bred success: a commission for a twenty-six-hundred-square-foot mural history of Indiana, to be shown at the world's fair in Chicago in 1933, came on the heels of the Whitney job. Benton claimed three thousand miles of travel in Indiana, in search of indigenous characters, buildings, and implements. Columnists delighted in trying to pick out the portraits of prominent Hoosier worthies, cast in flattering, unlikely, or downright peculiar roles: of course, when Governor Paul McNutt appeared as a great statesman, scholarly college Dean Stanley Coulter as a planter of trees, and the director of the committee that hired the artist as a forestry expert, it was hard to be sure exactly what the joke was, and on whom. But the *Indianapolis Star* was able to assure taxpayers that, of the hundreds of figures in the mural, "all but a few were sketched from life right here in Indiana from our own people."[44] Benton's sketches from life continued to be prized, and much discussed, for as the yards and acres of murals multiplied, the artist increasingly came to defend his kaleidoscopic treatments of America on the basis of the integrity of his research. He called his studies "pages from the book of my

24. Cotton gin, from the "King Cotton" series of reportorial drawings shown in New York in 1929. 1928; sepia, ink, pencil; 11¾ x 8¾; inscribed, Benton.

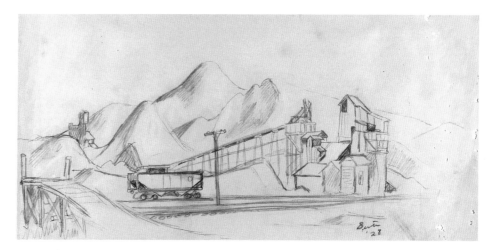

25. Coal mine, western Pennsylvania(?), from the "Coal Mine" series. 1928; pencil; 8½ x 16¾; inscribed, Benton '28, Coal Mine.

42. The artist's titles for the separate episodes of the "Arts of the City" panel are cited in "Benton Depicts America Aggressively for the Whitney Museum," *Art Digest* 7, no. 6 (1932): 5. Benton made no bones about his contention that Juliana Force had underpaid him for his work at the Whitney, although it is difficult to assess what influence the Whitney's 1954 decision to remove the murals from its library (they are now in the collection of the New Britain Museum of American Art, New Britain, Connecticut) had in his recollection of the affair. The Benton papers and the Whitney Museum papers touching on Benton, both in the collection of the Archives of American Art, Smithsonian Institution, do make it clear that Benton wanted to be reimbursed for a great deal of travel and was turned down flat. The evidence of the Benton drawings suggests that Mrs. Force was right to do so; except for the panel on the city, the Whitney murals seem to have been drawn mainly from sketches made before the commission was awarded. Nonetheless, in numerous statements to the press, Benton implied that he had wandered all over the country while working on the project. See, for example, "Benton and Lauren Ford Now in Metropolitan," *Art Digest* 8, no. 6 (1933): 10, discussing a trip to the South to gather material for the Whitney mural, and Richard Beer, "The Man from Missouri," *Art News* 32, no. 14 (1934): 11, based on an interview in which Benton claims no less than three trips to the West while working on the Whitney panels.

Benton did make numerous sketches for the "Arts of the City" in New York. For instance, in a news report filed while he was covering the Bruno Hauptmann kidnapping trial in Flemington, New Jersey, he discussed using drawings made on visits to the Friday night prizefight at the Eighth Avenue Burlesque as background material for both the New School and Whitney murals; see "Artist Likens Trial Scenes to Burlesque," *New York World-Telegram* (January 3, 1935): front page.

43. Thomas Hart Benton, statement in *The Arts of Life in America: A Series of Murals by Thomas Hart Benton* (New York: Whitney Museum of American Art, 1932), p. 4. The library was shown to the public for the first time from December 6 to 13, 1932.

44. "Benton Taps Heart of America in Monumental 'Indiana Mural,'" *Art Digest* 7, no. 18 (1933): 1, and Frederick Polley of the *Star* quoted in "Indiana's Mural," *Art Digest* 7, no. 16 (1933): 20.

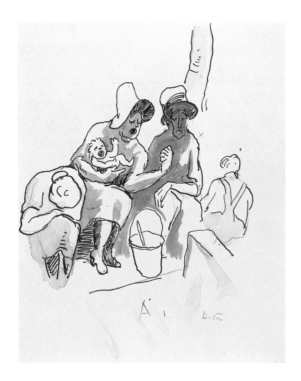

26. Camp meeting, West Virginia, from the "Holy Roller" series. 1926; ink wash; 8⅞ x 7¹/₁₆; inscribed, A 1, Benton; verso, Holy Rollers calling on the Lord, Virginia—Holy Rollers.

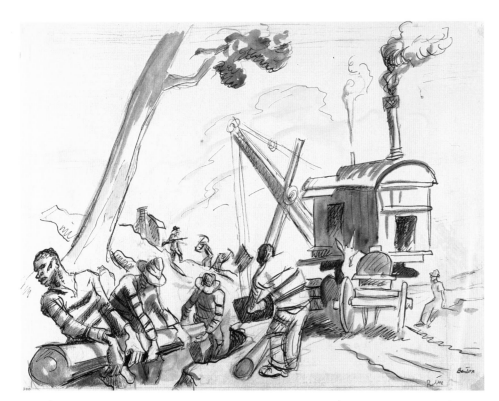

27. Chain gang, on a southern road. 1934; sepia wash, ink, pencil; 9 x 11⅞; inscribed, Benton, Benton; verso, $200, Chain gang.

The use of pencil, ink, and wash in the same drawing typifies the more carefully executed travel drawings of the twenties and thirties.

life."[45] His drawings, the miles he logged to make them, and the understanding of grass-roots Americana the sketchbooks seemed to guarantee: these factors, in his own mind, determined the aesthetic value of Benton's murals. As he remarked in the catalogue accompanying a show of his travel drawings, mounted in Indianapolis in 1933,

> The . . . drawings included . . . were made directly from people and places. The murals in the New School for Social Research and in the Whitney Museum in New York are dependent both for their subject and their form on such studies as are shown here.
>
> These drawings are not only objective records, but carry a full train of personal association which enables me to return in imagination to the places and people they represent and live over my experience. If my murals come to have an enduring life, it will be wholly because their form was directed by little drawings like these made in the heat of direct experience.[46]

Benton's emphasis upon the primacy of drawing set him apart from the New York modernists with whom he had associated during the teens and twenties. For instance, Stanton Macdonald-Wright and the Synchromists, whom Benton had joined in the Forum Exhibition of 1916, worked in brilliant contrasts of color, in a tradition of direct painting that reached back to French Impressionism. Yet, even in the statement written for the Forum catalogue, Benton had insisted on "the importance of drawing, of line, . . . because of its . . . control of the idea of form, and I believe that no loveliness of color can compensate for deficiency in this respect."[47] Three years later, when Alfred Stieglitz, the patron and protector of the fledgling New York avant-garde, saw a show of watercolors Benton had done during his wartime service in the Navy, he took him aside and showed him a Cubist watercolor by John Marin. "This is painting," Stieglitz said. "Your watercolors are only tinted drawings—colored outlines. Do you always have to guide your painting with a lot of hard rigid lines? Why don't you try to free yourself like Marin?"[48] But Benton remained unconvinced and committed to drawing—specifically, to drawings of the things of the world that were, he thought, rapidly vanishing from the realm of modern art.

Thus, in 1926, as his own drawings began to be noticed, he used a review of recent work by the abstract sculptor Constantin Brancusi to attack the notion that "all great art was a strictly plastic affair and that values of a social, religious, or particularly human character were extrinsic values and had better be wholly done away with as they simply stood in the way of what was essential." Brancusi, he declared, had achieved formal perfection—and

45. Quoted in J. S., "Thomas Benton," *Art News* 33, no. 21 (1934): 1.

46. "Benton in Indiana," *Art Digest* 7, no. 11 (1933): 20.

47. Thomas Hart Benton, statement in *The Forum Exhibition of Modern American Painters* (New York: Mitchell Kennedy, 1916), unpaginated. This, and other key statements by the artist, have been collected in Matthew Baigell, ed., *A Thomas Hart Benton Miscellany: Selections from His Published Opinions, 1916–1960* (Lawrence: University Press of Kansas, 1971), pp. 3–4.

48. From a conversation reconstructed by Benton in *An American in Art*, p. 45. His growing estrangement from the New York avant-garde begins with this encounter.

utter sterility, a kind of cold geometry meaningful only to a highbrow coterie of fellow artists, dealers, and collectors:

> It was the fashion, it afforded exclusiveness, it offered a plank of obvious superiority, and flatteringly separated the artist from the humdrum vulgarity of subways, tenement houses and rival practitioners of older schools.[49]

Benton's invocation of "subways, tenement houses and . . . older schools" pointedly alludes to the so-called Ash Can School, a group of former newspaper illustrators led by Robert Henri, who had startled the genteel establishment of their own era by painting the seamy underside of New York life as though tenement dwellers, Bowery bums, and other members of the lower orders were just as worthy of pictorial treatment as steel magnates, debutantes, or imaginary godlings.

Although, in his voluminous writings of later years, Benton mentioned his illustrious predecessor only in passing, Robert Henri was the most influential teacher in New York during Benton's formative years. In fact, for a brief period before the death of the older man, Benton and Henri served together on the faculty of the Art Students League.[50] Henri harbored serious reservations about the academic practice of training students by teaching them to draw casts after the masterpieces of ancient art, a practice Benton also deplored. Nonetheless, Henri respected fine draftsmanship and often brought Old Master drawings to class to demonstrate that "the beauty of the lines of the drawing rest[s] in the fact that you do not realize them as lines, but are only conscious of what they state of the living person." In his eyes, life and art were one: no true artist could produce "a line of 'sheer beauty,' i.e., a line disassociated from human feeling" and from the sights of daily life. The artist's breadth and depth of human experience counted for more than dexterity, technical expertise, or theoretical sophistication. Life validated art. "When a drawing is tiresome," Henri preached, "it may be because the motive is not worth the effort."[51]

Robert Henri's disciples and students maintained a strong graphic presence in the New York art world, even after the Armory Show of 1913 signaled the ascendancy of modernism. What's more, John Sloan, Everett Shinn, George Bellows, and the rest drew the teeming life of the city with warmth and sympathy and sent their drawings back into the real-life arena in the form of cartoons for *The Masses*, illustrations for magazine articles and books, lithographs, and other cheap prints with large editions.[52] Confronted

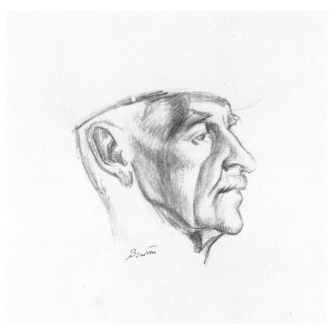

28. Billy Benson of Chilmark, Massachusetts. Circa 1922; pencil; 5¾ x 6⅞; inscribed, Benton; verso, Billy Benson of Chilmark, Mass.
 In his younger days, Billy had been a rascal, charged with stealing pigs and sheep and with the attempted murder of his own parents by a dose of Paris Green that poisoned the chickens instead. When Benton met him, he was around sixty and fond of boasting about his adventures with the law.

with stylistic refinements, minutely calibrated to the eye of the cognoscente, these artists responded with boldness, directness, and simplicity of line. Faced with a wholesale retreat from meaningful subject matter, they answered with reportage, a dispatch from the streets, a juicy slice of life in the raw. Benton countrified their city-slicker ways. He mussed their brilliantined hair as he eased into his knapsack and his old travelin' clothes. But, however much the accent changed, Thomas Hart Benton plainly spoke the language of the Ash Can School when he called his work "a conglomerate of things experienced in America":

> The subject is a pair of pants, a hand, a face, a gesture, some physical revelation of intention, a sound, even a song. The real subject is what an individual has known and felt about things encountered in a real world of real people and actual doings.[53]

The real world was the world of drawings from the heart, drawings that were honest and true because the good, honest dirt of the road still clung to the watercolor wash. As he prepared to shake the baser grime of Manhattan from his shoes and go home to Missouri for good, Tom Benton abjured for-

49. Thomas Hart Benton, "New York Exhibitions," *Arts* 10, no. 6 (1926): 343.

50. William Innes Homer, *Robert Henri and His Circle* (Ithaca, N.Y.: Cornell University Press, 1969), esp. pp. 158–64.

51. The flavor of Henri's evangelical teaching style is preserved in his notes, articles, letters, and talks to students compiled by one of those devoted pupils, Margery Ryerson. See Robert Henri, *The Art Spirit*, ed. M. Ryerson (Philadelphia: J. B. Lippincott Co., 1960), pp. 78–79, 110–11, and 106.

52. See, for example, Donald Drew Egbert, "Socialism in American Art," in Donald Drew Egbert and Stow Persons, *Socialism and American Life* (Princeton, N.J.: Princeton University Press, 1952), pp. 706–19, 729–31. Benton's Chilmark (Martha's Vineyard) friend and fellow muralist, Boardman "Mike" Robinson, who got him the teaching appointment at the League, was a member of this circle. Like Sloan, Robinson drew cartoons and other illustrations for *The Masses*.

53. Benton, *The Arts of Life in America*, p. 5.

29. "Very first" sketch for "Lumber, Corn, Wheat" and "The South" segments of the New School for Social Research murals (Equitable Life Assurance Society, New York). 1930; ink, watercolor; 4 x 10 (image size); inscribed, Benton.

30. Watercolor study for "City Building" segment of New School murals. 1930; tempera; 15 x 20; inscribed, Benton 1930.
Painter Reginald Marsh posed for the final rendering of the standing Negro with the drill, at the left side of this composition.

ever the self-generated shape, the cold and calculated art of the intellect:

> I never start any more with a preconception of the nature of the form. I start with faces, tree trunks, old shoes. I make thousands of drawings. I see something that interests me, and the formal relations follow.[54]

Benton's decision to leave New York after twenty-four years was influenced by many factors. A commission to decorate the Missouri State Capitol in Jefferson City was in the offing. Growing differences with former friends on the left wing of American politics had been aired in the press, with no little rancor on both sides. Once-sympathetic critics, motivated by ideological and aesthetic questions about the interpretation of the American epic set forth in his murals, suddenly littered their reviews with caveats and quibbles.[55] Benton's troubles began in earnest with his appearance in December 1934 on the cover of *Time*, Henry Luce's brash and very popular weekly. In *Time*'s own punchy patois, the cover story virtually created what would come to be known as Regionalism by identifying and applauding American painters—Grant Wood, John Steuart Curry, and Reginald Marsh were mentioned by name, and Tom Benton was called "the most virile" of the lot—whose themes were drawn exclusively from "the U.S. Scene." The not-so-tacit contrast, of course, was with the "unintelligible," Frenchified painting in vogue since the Armory Show, the kind of art that looked just as good when accidentally hung upside down. By way of contrast, the American Scene painters worked from good, old-fashioned drawings and, by gum, those drawings looked like something—something real and readily understandable:

> Thomas Benton has filled scores of notebooks with sketches of the U.S. scene which eventually find their way into his work. He boasts that all his burlesque queens, stevedores, Negroes, preachers, and college professors are actual persons. His vivid portraits of them are fast becoming collectors' items and the cost of Benton's [drawings] has been steadily rising.[56]

The *Time* profile finished Tom Benton in New York City.[57] Overnight, it seemed, he had become the enemy. Some of his colleagues were green with envy over those rising prices; some of the gallery crowd, as if by reflex, loathed whatever *Time* endorsed in its quotable journalese; some thoughtful observers of the political scene sensed peril in the attitude that led Luce's minions to espouse "direct representation in place of introspective abstractions" and held Benton somehow responsible for the marriage of art and "windy chauvinistic ballyhoo" effected by the article. Cubist Stuart Davis spoke for many liberals when, in a rejoinder to *Time* published in *Art Front*, he pointed out the dangers of the kind of knee-jerk isolationism implicit in strict adherence to the "U.S. Scene," whether in art or economics or global statesmanship. "The slight burp which this school of the U.S. scene in art has

54. Ruth Pickering, "Thomas Hart Benton on His Way Back to Missouri," *Arts and Decoration* 42, no. 4 (1935): 18. Ruth Pickering was one of Max Eastman's "loves" and thus another of Benton's Vineyard friends.

55. *An Artist in America*, pp. 261–69, recounts his reasons for making the move to Kansas City.

56. "U.S. Scene," *Time* 24, no. 26 (1934): 24–25.

57. See Baigell, ed., *Miscellany*, chap. 3, "The 1930's," pp. 38–87, for the escalating hostilities between Benton and the New York art world.

made, may not indicate the stomach ulcer of Fascism," Davis conceded. "I am not a political doctor but I have heard the burp and as a fellow artist I would advise those concerned to submit themselves to a qualified diagnostician." Benton's brand of "direct representation" posed its own political problems:

> Are the gross caricatures of Negroes by Benton to be passed off as "direct representation"? The only thing they directly represent is a third-rate vaudeville character cliché with the humor omitted. Had they a little more wit, they would automatically take their place in the body of propaganda which is constantly being utilized to disfranchise the Negro politically, socially and economically. The same can be said of all the people he paints including the portrait of himself which is reproduced on the cover of *Time*. We must at least give him credit for not making any exceptions in his general underestimation of the human race.[58]

For an artist whose chief claim to the indulgence of his fellow citizens rested upon his made-from-real-life drawings—upon the fidelity and authenticity of his graphic report on the state of the nation—such charges of inaccuracy and "gross" caricature were especially damning. But, while Davis's barbs stung more deeply than most, he was not the first to detect a cartoonish flavor in Benton's pictorial chronicle of America, a quality that seemed, at times, to owe more to tabloid journalism than to objective reportage. Lloyd Goodrich saw the fine hand of a satirist in Benton's earliest Missouri drawings. And even those who did not know the story of young Tom's stint as a newspaper cartoonist in Joplin routinely noticed that "he . . . has a natural flair for caricature, somewhat akin to that of the comic strip artist."[59] Throughout the twenties and the early thirties, Benton's comic flair and his lively "sense of the grotesque" were noted in laudatory terms; his drawings were judged especially "American," in fact, by virtue of their humor and exaggerations, hallmarks of the wild, flamboyant comedy of the Wild West, the prose of Mark Twain, the political cartoons of Thomas Nast.[60]

So long as Benton confined his comedic talents to the sketchpad, the critics waxed lyrical about the unfettered spirit of the West, and all was well. In the unspoken hierarchy of values, studies, sketches, and even polished exhibition drawings ranked well below paintings, which, in turn, took second place to murals, eternally bonded to works of architecture at the pinnacle of the aesthetic *paragone*. Benton's little drawings weren't taken too seriously. Murals, however, were a very serious business indeed. For that reason, Benton took pains to justify the apparent frivolity and vulgarity of his mural subjects—his hillbillies and rural blacks, his fiddlers, his floozies—with repeated testimonials to the authenticity of his sources and endless recitations of the miles he had covered: his drawings validated his murals and the sprawling, bawling America on display therein. "He took the life of a continent," wrote one bedazzled interviewer, "and filtered it through a lead-pencil."[61]

58. Davis, "New York American Scene," pp. 152 and 154.

59. Goodrich, "In Missoura," p. 338. Anonymous reviews in the *Times* and elsewhere reflected this view.

60. Goodrich, "New Benton Drawings," p. 13, and "Murals of the New School," p. 401. Again, Goodrich says best what many other critics imply. He changed his mind little over the years. See Lloyd Goodrich, "Thomas Hart Benton," in John I. H. Baur, ed., *New Art in America: Fifty Painters of the 20th Century* (Greenwich, Conn.: New York Graphic Society/Praeger, 1957), p. 130.

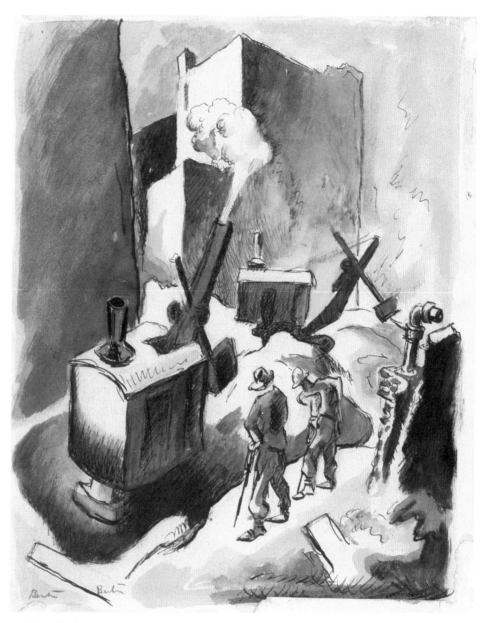

31. New York construction. 1926–1927; ink, pencil, watercolor; 9⅛ x 7; inscribed, Benton, Benton.

At first, Benton's sheer audacity forestalled adverse comment on his mural schemes, projected or executed. But by the time he had completed the Whitney library cycle, the excuse that his drawings from direct observation justified both his themes and their manner of presentation had worn a little thin. Or so hinted an exasperated Henry McBride, influential critic for the *New York Sun*, when asked to explain why it pained him to have voted for

61. Beer, "Man from Missouri," p. 11, writing about the New School, Whitney, and Indiana murals, after an interview with Benton.

32. Max Eastman on the subway, sketch for "City Activities" segment, New School murals. Circa 1931; pencil; 17⅜ x 13; inscribed, Benton, Max Eastman; verso, Max Eastman 1930 Not for sale.

giving Thomas Hart Benton an award in recognition of his achievement in the Whitney murals. McBride had voted "for" Benton, reluctantly:

> I hold it "against" Benton that there is too much hearsay about his painting and not enough direct experience. I have already called it "tabloid," but in addition, the caricaturish cowboys, Negro revivalists and Broadway dancers seem to derive from the vaudeville stage and comic strip rather than from real life.[62]

McBride deplored the coarseness of Benton's vision; his "yea" vote reflected a sad awareness that American music, drama, and literature, too, had been overtaken by a tide of vulgarity, emanating from "the lower orders." Despite his rhetoric, he did not really doubt that Benton had seen such sights—although maybe, just maybe, he had seen some of them in the movies, or the *Police Gazette*—but, like Arthur Millier of the *Los Angeles Times*, McBride wondered why the roving artist had seen "sweat, jazz and gin" and nothing else.[63]

Paul Rosenfeld, of the *New Republic*, also thought Benton's purported *Arts of Life* "crude, gross and ungracious" additions to the decor of the Whitney Museum of American Art. The room, he said, was now unusable, an "Ex-Reading Room," given over to a sorry exhibition of mobsters, burlesque queens, and "cornfed Negroes . . . drawn from the primitive fringe of American life . . . now humorously, now nastily, violently, hysterically expressing the national insensibility." Rosenfeld reluctantly conceded the rigor

of Benton's fieldwork. The artist had observed those "dancing, carousing, murdering types," but, "[if] he has seen some of them accurately, he has consistently depicted them with an accuracy barbed with hate or disgust or fear."[64]

What Benton chose to draw and whether those drawings reported the facts or editorialized about them were the issues most often raised in measured, critical reactions to his early murals. With the *Time* cover story and the rejoinder in *Art Front*, these caveats surfaced again, with a contemptuous vengeance, but the grounds of the debate widened to include a quasi-philosophic wrangle over the relationship among observed reality, drawing from life, and the re-presentation of American life in mural form. "I deny that he has ever perceived the American environment on the evidence of his own work and statements," sneered Stuart Davis, warming to the attack in an anti-Benton diatribe published by the *Art Digest* several weeks after Davis's first blast at the incipient Fascism of the "U.S. Scene" movement:

> No, Benton's environment is the *Puck* and *Judge* school of caricature, reproductions of muscle painting in the Italian Renaissance, Hearst politics, which can run an editorial against the brutality of the prize fight on the front page and promotes a milk fund bout on the sports page, and a dime novel version of American history.
>
> Compilation of sketches from life does not constitute understanding of environment. Benton's sketches may be from life, but their coordination in mural form is conditioned by sketchy ideas as to their political, social and economic significance.[65]

It is true that America cannot be described by her visual characteristics alone—that no mere drawing or set of drawings can express the complexity of sociopolitical reality. It is quite true, too, that the Whitney murals, more obviously than the "composed" and contrived New School cycle, present a pastiche of raw data, drawings wafted from sketchbook to wall with little effort to establish the formal relationships between one episode and another that might have suggested larger ideas. But it is not true that Benton's murals lack coherent meaning, or possess only what scraps of sense can be deduced from a bogus draftsmanship, from the amusing (or are they mean-spirited?) twists of line his critics called "caricature." Since critics as diverse in viewpoint, and political affiliation, as McBride, Rosenfeld, and Davis all found fault with his interpretation of *The Arts of Life in America*, then Benton's decision to seek out and draw ordinary people—ordinary people with a gusto, an intensity, a creative spark missing from the average, placid Rotarian—*did* say something to observers who deplored his rudeness and his disinclination to promote worthy causes in pictorial sermons. And caricature, on behalf of good causes or suspect ideology, is frequently in the eye of the beholder. In fact, of those who thought the artist made cartoons instead of drawings out there on the streets and backroads of America, no two agreed about whether

62. McBride is quoted in regard to a service award presented by *The Nation* in "Abou Ben Benton," p. 6. Thomas Craven's intemperate praise of Benton's murals in *American Mercury* is also mentioned.

63. Quoted in "Abou Ben Benton," p. 6.

64. Paul Rosenfeld, "Ex-Reading Room," *New Republic* 74, no. 958 (1933), pp. 245–46.

65. "Davis' Rejoinder," *Art Digest* 9, no. 13 (1935): 26. For Benton's answers to a series of questions put to him by *Art Front*—answers that constitute his reply to the Davis accusations—see Baigell, ed., *Miscellany*, pp. 58–65.

Tom Benton liked or hated dime-a-dance dollies; whether he saw in the blacks encountered on his southern tours grotesque confirmations of the old racial stereotypes or simply an unknown, fascinating, alien subculture; whether he was poking fun at hillbilly ways or just bringing rural folklore to the attention of a hell-bent-for-leather, industrialized, and increasingly standardized society, where there was no room left for Ozark fiddlers, revivalists, and broken-down cowboys.

First, last, and always, there were the drawings, though, drawings as likable in their aesthetic complexity as the murals, cobbled together from them, were controversial in their apparent multiplexity of theme. Lewis Mumford's understanding of what Benton really meant had fluctuated over the years. In 1929, for example, he noted the direct linkage between the sketchbooks, the drawings, and the ambitious decorative programs. "The same architectural statement, the same mordant and restless eye, the same vitality of design," Mumford crooned, were evident "in the small landscape as in the largest mural":

> The Missouri village, with its shambling Main Street; the Arkansas hill-billy, the Texas oil well, the Tammany politician, the New England fisherman, the Mississippi negro; the power plant, the street excavation; the robust, the venerable, the seedy, ancient pride and equally ancient down-at-the-heelness—all these are part of Mr. Benton's great canvas, as one by one the details unroll.[66]

By 1935—in the meantime, he had championed Benton's ongoing exhibition of segments from the *American Epic* at the Architectural League and agitated on behalf of his proposed murals for the New York Public Library—Mumford had undergone a remarkable change of heart. In the pages of the *New Yorker*, quoting himself out of context, Mumford ridiculed Benton for having "elevated a seedy, down-at-the-heels, half-baked, half-ruined America into a national symbol." What had once been "robust" detail in Benton's pageant of America was now "half-baked" sentimentality, in the wake of *Time*'s christening of a new school of midwestern art, with "the Rip-tailed Roarer from Pike County, Missouri," at its head.[67]

Lewis Mumford was disgusted by the nationalistic ballyhoo in which Tom Benton had been draped by his apologists, until the artist of talent was barely visible underneath the yards of Stars and Stripes. Benton was, he thought, an artist of real talent, albeit of a highly specialized sort. His sketches were marvels of "quickness and directness." But, when he played at being "the Great National Painter" of vast walls and mighty canvases, or so Mumford argued, his work foundered on the very penchant for the small and the particular that made his sketchbooks so intriguing. "Benton is like a newspaper reporter who spends a week polishing a news story that should have gone into the first edition": fresh observation hardened and staled when on-the-spot drawings were redrawn, restudied, and squared up, to be scissored-

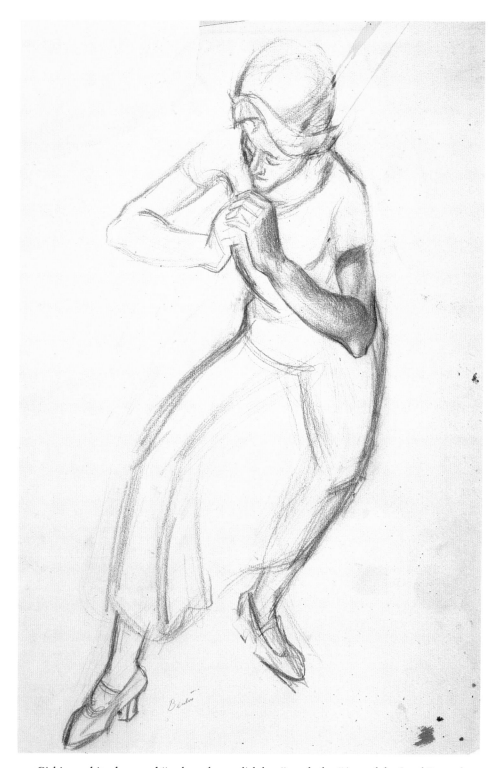

33. Girl in a white dress and "a cheap but stylish hat," study for "Arts of the South" panel, Whitney Museum of American Art Library mural cycle (New Britain Museum of American Art, New Britain, Connecticut; Harriet Russell Stanley Fund). 1932; pencil; 18⅛ x 12⅛; inscribed, Benton.
Benton first saw this "Appalachian Oread" in West Virginia, on one of the exploratory trips of the late twenties and early thirties described in his 1937 autobiography, *An Artist in America*. He reworked his sketchbook notations, using live models, to produce this image.

66. Lewis Mumford, "Thomas Benton," *Creative Art* 3, no. 6 (1928): xxxviii. This brief article appears as a kind of appendix to Benton's lengthy "My American Epic in Paint," pp. xxxi-xxxvi. Mumford's words are quoted with approval in "An Author and a Critic Acquire Bentons," p. 8.
67. Lewis Mumford, "The Three Bentons," *New Yorker* 6, no. 10 (1935): 48.

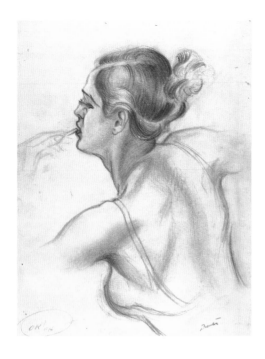

34. Taxi dancer, putting on her lipstick, sketch for "Arts of the City" segment, Whitney Museum murals. 1932; pencil; 11¾ x 9; inscribed, OK? CH Benton; verso, Cities 9 Make-up.

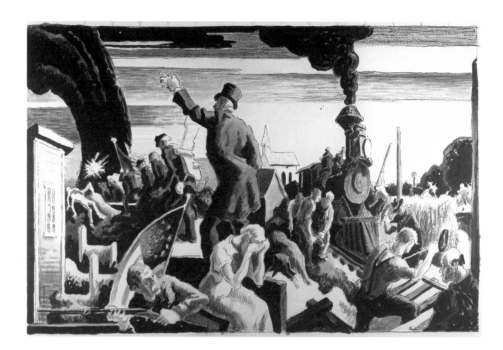

35. Illustration, based on the "Civil War" and "Expansion" segments of *A Hoosier History*, mural for the Indiana Pavilion, Century of Progress Exposition, Chicago, Illinois (Indiana University, Bloomington, Indiana). Circa 1933; ink wash, crayon; 19 x 28⅜; inscribed, Benton '33.

and-pasted into "important" artistic statements. Those direct sketches from life, in ink and wash, disclosed an artist more likable and far more profound than "the Great National Painter" of blockbusters and barnburners:

> Here is a man with a great appetite for facts who has evolved an effective short-hand for putting them down. His studies of places and characters, particularly in the remoter parts of the Mississippi Valley and in Texas, have a unique value. To find Benton's equal in this department we must go back to Winslow Homer in his best days after the Civil War. A portfolio of Benton's sketches before they are irretrievably scattered would make an important document both graphically and historically.[68]

From the opposite end of the political spectrum, Thomas Craven, Benton's onetime roommate and most vociferous champion, also looked upon the drawings and found them splendid and real. "They represent not hearsay," Craven thundered, "but life." As for the prevailing opinion that the sketches were distorted versions of life and, in any case, too narrow in their

compass to serve as the basis for an art of cogent social commentary or reform, he begged to differ. Benton's disinclination to paint what he had not seen and drawn in person—his "appetite for facts"—was the surest mark of his gritty American character: "he has, to the full, the American's distrust of ideas divorced from facts, a healthy realism which, whether our social sooth-sayers like it or not, may carry us safely into a better society."[69] Tom Benton was, after all, from Missouri.

And Tom Benton went home to Missouri in 1935, to begin his most celebrated mural cycle in the Capitol of his native state and to take up his appointment as head of the painting department at the Kansas City Art Institute. Thomas Hart Benton, the teacher, often had occasion to look back on his own training and wonder whether he wasn't doing his students more harm than good: most anything worthwhile he'd had to find out for himself, despite the combined efforts of the Chicago Art Institute and the leading academicians of Paris, France, to ruin his ability to draw. Long before little Tommy Benton wrecked the new wallpaper with his spirited rendition of Engine No. 11, he had been drawing wild Indians, romantic figures culled from the lore of a Western boyhood. When the family followed Congressman Benton to Washington, young Tom continued to make pen-and-ink drawings after heroic tales—Beowulf and Hercules took their places alongside "Custer's Last Stand"—in the style of "the cartoonist Berryman, of the Washington *Post*," his first artistic idol.[70] But when the budding illustrator was sent off to Saturday morning classes at the Corcoran Gallery, he bridled at a course of

68. Ibid., pp. 48 and 50. After this review—Benton later attributed the rift to his own review of one of Mumford's books—Mumford and Benton did not speak for many years. In the sixties, politics again set them at odds; Benton walked out on a dinner at which Mumford, who was supposed to be speaking on the arts, denounced American military intervention in Vietnam. See Wernick, "Down the Wide Missouri," p. 96. The points that Stuart Davis and Lewis Mumford made in 1935 about the caricature in Benton's drawing style and the insufficiency of a mural art premised upon "small," discrete observations that failed to add up to a coherent (politically acceptable) social statement were echoed by liberal critics for years. See, for example, Meyer Shapiro's review of *An Artist in America*, "Populist Realism," *Partisan Review* 4, no. 2 (1938): 57, in which he discusses the "intimate, trivial" scenes that make up the segment of the Missouri Capitol mural illustrated on the cover, or, in regard to the influence of sketches on the same murals, Malcolm Vaughan, "Up from Missouri," *North American Review* 245, no. 1 (1938): esp. 88–90.

69. Thomas Craven, *Modern Art* (New York: Simon and Schuster, 1935), pp. 35–36.
70. Thomas Craven, *Thomas Hart Benton* (New York: Associated American Artists, 1939), pp. 9–10. See also Gallagher, "An Artist in America," p. 42.

instruction that consisted of representing wooden cubes and other geometric figures of equally "forbidding" and uninteresting appearance. Art, he thought, should tell a story, spin a yarn, and he was good enough at it, without benefit of further training in the depiction of cubes, to hold down a real job as a cartoonist for the *Joplin American*, at age seventeen.

He took his cartoonist's bag of tricks with him to Chicago in 1907; after all, the seasoned veteran had enrolled in art school only as a practical matter, to advance himself in his journalistic career, to get a job on a bigger paper. Classes with Frederick Oswald were fun: he improved his pen-and-ink technique by copying the drawings of popular illustrators considered more stylish than old Berryman of the *Post*. The childish crosshatching gradually disappeared. The Institute was not a trade school, however, and students—even bona fide, wage-earning journalists from Joplin—were expected to follow a standard, academic curriculum. That meant drawing in charcoal from casts of Greek and Roman sculptures, and, no matter how boring or tough that "niggling" exercise, the course was a prerequisite for promotion to life classes. Young Tom Benton liked drawing from life very much. Until he left for Paris and the Académie Julian in 1908, he spent half of every day in the life class, drawing the human figure and, little by little, deciding to become a real painter, despite his difficulties with the oil medium. Oils were too slippery, too buttery: they played hob with his ability to maintain any decent kind of drawing.[71] His paintings didn't look like much of anything.

Neither did his drawings, when judged against the standards maintained in French schools. For the first two weeks, in fact, he was consigned again to the hated cast class, and his pride was badly wounded. Elevated at last to the figure class, he discovered a caste of "master draughtsmen" who huddled closest to the model, where the view of poses held for weeks on end was best but where the foreshortening was at its most extreme. These were professional students, who enrolled year after year for the arid pleasure of solving such problems of acute foreshortening with their plumb lines, their measuring sticks, their erasers, and their sticks of erasable charcoal. At the time, Benton was, by turns, bored stiff, frustrated by his inability to develop a knack for this nonlinear kind of drawing, and fearful that he was not, after all, cut out to be a great artist in the mold of the "master draughtsmen." He sulked, made pen drawings pretty much as he had always made them, in the streets and cafés, and only years later did he find the courage to lash out at the theory of "the innocent eye," universally promulgated in the teaching institutions of the turn of the century. According to that doctrine, or so Benton scornfully contended, the artist was being trained in willful ignorance, trained to see only with the eye and to represent only the distorted optical puzzles that could be perceived through foreshortened vision: "What came out were those bum imitations of photography we know as 'academy drawings.'"[72]

71. Benton, *An American in Art*, pp. 11–13. "Chicago Views Benton, Midwest Dickens," *Art Digest* 20, no. 11 (1946): 14, reports Benton's recollection that he had "arrived in Chicago from south-western Missouri to study cartooning" but gave up the ambition, much to the consternation of his parents (who thought cartooning was low enough), "and became a painting addict."

72. Thomas Hart Benton, "The Nature of Form," *The University of Kansas City Review* 17, no. 1 (1950): 16.

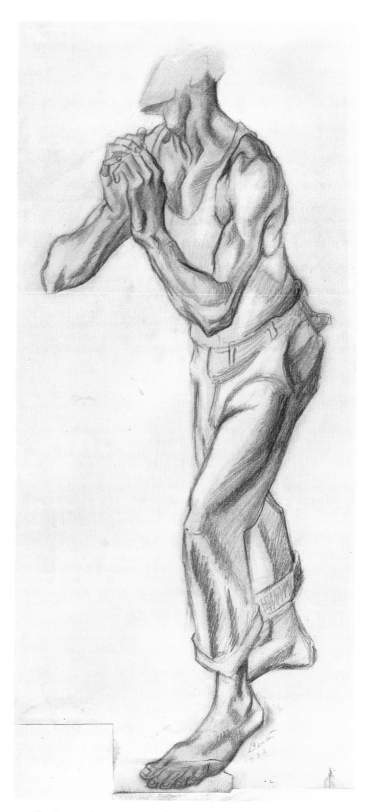

36. Black gospel singer, study for "Arts of the South" segment, Whitney Museum murals. 1932; pencil; 23⅞ x 11¼; inscribed, Benton 1932.

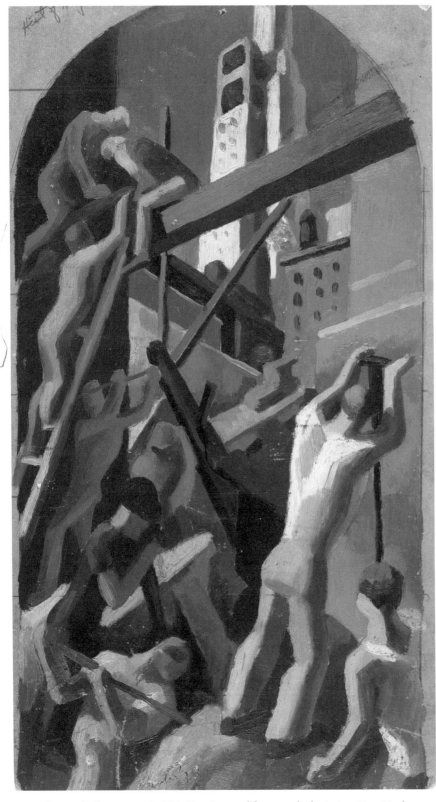

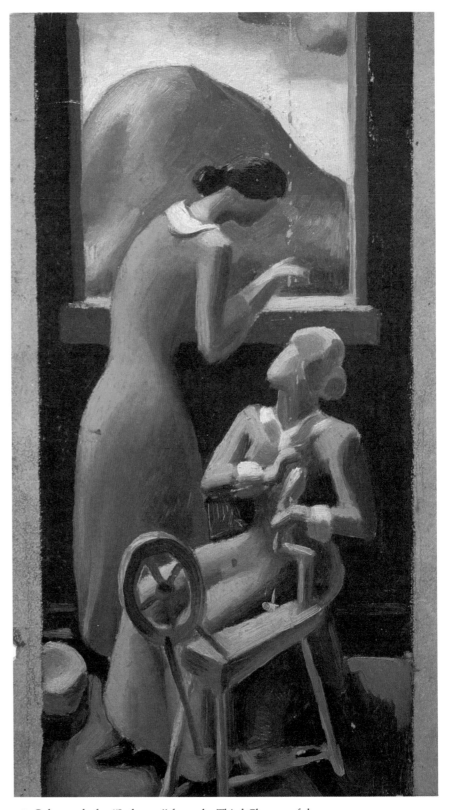

37. Value study for "New York To-Day," one of five murals depicting *New York History* planned for the New York Public Library. 1927; oil; 13¾ x 7¾; inscribed, Hist. of N.Y., Benton '28; verso, segment of larger oil study.

38. Color study for "Industry," from the Third Chapter of the projected *American Historical Epic* mural cycle. Circa 1928; oil; 15⅞ x 9; verso, segment of still life in oil.

Knowing *what* he was seeing was irrelevant to the "master draughtsman" of the tortured, two-week pose; but, for the rest of his long life, the "whats"—the romance of the Indian, the roar of the train, the music of the fiddle, the urge to hold fast in line and color these fleeting, evanescent moments in American time—were Tom Benton's special joys and his torments, the goads that drove him to draw ceaselessly, compulsively, haunted somehow by the specter of his long-ago failure to draw like the nineteenth-century academicians who taught at the Académie Julian. "They introduced me," he said of those "master draughtsmen," remembering their scorn vividly, some sixty-five years later. "They taught me skills of doing that kind of thing. I was never very good at it."[73] In frustration, he fled to the Atelier Collarossi, in Montparnasse, where novices could sketch from models as they pleased, without famous authorities hanging over their sketchbooks, tendering gratuitous, stinging criticism. Mainly, though, he went to the Louvre, on the say-so of an American friend—a nephew of Elbert Hubbard, the cracker-barrel Sage of East Aurora—who thought that from the canvases of the Old Masters "more knowledge of drawing could be obtained . . . than in the classes of the academies," all rolled into one.[74] He didn't exactly copy masterpieces in the Louvre, not quite:

> I never copied anything. I made sketches. Rough figures. The first thing I did was Titian's *Entombment*. You'd just hold the pad in your hand and make copies, rough copies, trying to see what you could find out.[75]

When he returned from France and set up shop in the Lincoln Square Arcade, in New York City, he kept up the practice, working from reproductions in books and magazines. One of his roommates remembered "thousands" of drawings after the masterpieces of the past—Michelangelo, Rubens, El Greco—stacked up in the studio where Benton worked "night after night, month after month," unlocking the secrets of the classics by translating their intricate patterns of line and color into blocky geometric figures, a kind of "sixteenth century cubism" modeled after the work of the Genoese painter Luca Cambiaso.[76]

The point of these exercises was not improved draftsmanship, although the discipline had that effect. Instead, these drawings were a means of learning how to move from drawing to complex painterly composition; the canvases he sent to the 1916 Forum Exhibition, his first major New York exposure, were free adaptations of Michelangelo's *Dying Slave* and *Battle of the Centaurs*, tricked out in bright modernist color. But it was the pen-and-ink sketches of Paris, quickly done, crosshatched in the old, cartoonist's method and composed only by the rhythm of heavy, curving lines, that paid

73. Benton, quoted in an interview conducted at Martha's Vineyard in the summer of 1973 by Paul Cummings, *Artists in Their Own Words* (New York: St. Martin's Press, 1979), p. 27.
74. Benton, *An American in Art*, p. 16.
75. Benton, in Cummings, *Artists in Their Own Words*, p. 29.
76. Craven, *Modern Art*, p. 334, and Ralph T. Coe, unpaginated introduction to *Thomas Hart Benton: An Artist's Selection, 1908–1974* (Kansas City: The Nelson Gallery and Atkins Museum, 1974). Craven was the roommate who watched Benton draw those studies; in numerous published writings, Benton acknowledged the lasting influence of John Carlock's advice to copy the Old Masters.

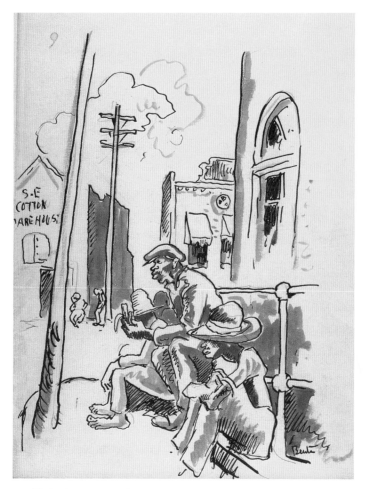

39. "S. E. Cotton Warehouse," Georgia(?). Circa 1934; ink, sepia wash, pencil; 11¾ x 8¾; inscribed, Benton; verso, $100.

40. Sharecropper's cabin, Georgia(?). 1928; sepia, ink wash, pencil; 9 x 12; inscribed, Benton.

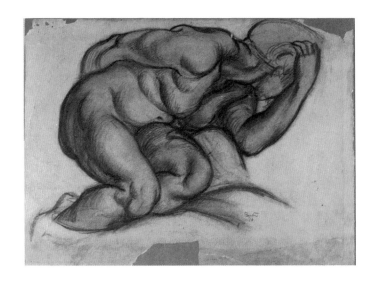

41. Michelangelesque drawing. Circa 1915–1916; pencil; 8¼ x 11; inscribed, Benton '16.

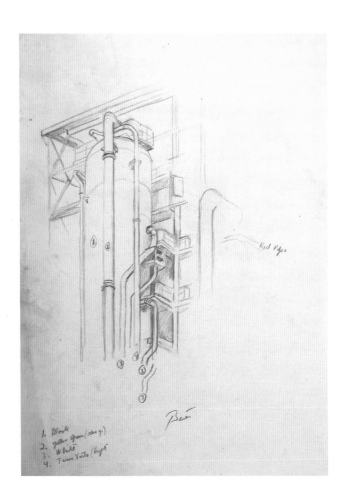

42. Sketch with color notes, catalytic converter or "'cracker,'" near Baton Rouge, Louisiana. 1943; pencil; 17 x 11; inscribed, Red pipe, Benton, 1. Black, 2. Yellow green (ochre g.), 3. White, 4. Terre Verte (light).

As part of his war work, Benton filed visual reports on the industrial plants and oil fields of the homefront. He came down the Ohio and Mississippi rivers to the gulf as a passenger on an L.S.T.

the bills during his early days in New York. In 1914, those sketches became illustrations for *Europe After 8:15*, a collection of brittle, sophisticated travelogues by satirist H. L. Mencken, George Jean Nathan of *The Smart Set*, and Willard Huntington Wright (brother of Benton's Paris companion, Stanton Macdonald-Wright), an aspiring art critic also on the staff of *The Smart Set*, who was one of the organizers of the Forum show.[77]

Although he mined his on-the-spot impressions of Paris for illustrative material, Benton did not draw from life any more. Drawing had become a source of imagery for hack jobs, a tool, a preparation for the all-important act of painting. And, to a certain extent, this attitude persisted throughout Benton's life: with signal exceptions, his drawings are studies for painted figures and scenes—cubified compositional notations; pungent, life drawings of heads, ready to be attached to bodies posed in the studio; drawings squared up for transfer to canvas; pictorial notes on details of costume or machinery, made to plug a specific iconographic gap; exquisite exhibition drawings, penciled duplicates of painted figures, far too "finished" to have been the casual working studies they purport to be. Drawing is the measure of Benton's never-to-be-resolved anxiety about his decision to become a painter, over the objections of his father, and about his questionable competence as a true "master draughtsman": fifty or more assorted studies in pen or pencil, grisaille or wash, routinely stand behind each painted work. And, for murals and major canvases, there are also his compositional models, sketches of a sort, sculpted in clay and colored.[78]

The exception to the rule of drawing for the sake of painting is the remarkable series of graphic reports from the backroads that Benton issued, on an almost annual basis, from 1924 until his last trip to Branson, Missouri, in 1974, with significant detours, especially in the sixties, down the whitewater rivers of the West and Middle West. These direct studies from real life represent a spiritual break with the arcanum of the painting business and with the whole academic tradition. Whether in Paris or in Norfolk, Virginia, the process of working on the spot, with his trusty cartoonist's pen, carried Benton back, back beyond the frustrating years of formal study, back to Joplin and to his roots, back to Neosho and the boy Benton bedazzled by railroad trains and Buffalo Bill. It was in Norfolk, in the summer of 1918, that Tom Benton took the first, faltering steps toward the backroads and home. World War I was raging. Tom had joined the Navy, as an architectural draftsman:

> The head of my department, seeing I had no training for such work, put me to making freehand studies of installations and activities about the base. This was my first reportorial work, except for some drawing in the cafés of Paris, since my reporter days in Joplin, Missouri, in 1906. . . . It was not so much *what* I

77. H. L. Mencken, George Jean Nathan, and Willard Huntington Wright, *Europe at 8:15* (New York: John Lane Co., 1914), with "decorations" by Thomas Benton.

78. For commentary on the mass of studies that stands behind the least of Benton's paintings, see "Battle of Beetlebung Corners," p. 84, and Gibson Danes, "The Creation of Thomas Benton's *Persephone*," *American Artist* 4, no. 3 (1940): 4–10. Benton began using sculptural models for his paintings in the fall of 1919, after reading an article about Tintoretto's use of such models for the famous *Last Supper* in Santa Maria della Salute in Venice. During those early years, he also prized a set of photographs showing Ghiberti's pictorial reliefs for the doors of the Florentine Baptistry. In the fifties, during a visit to Spain, he searched for sculptures said to have been used by El Greco in preparing his paintings.

painted but *how* I did so that [had been] the prime concern of these ten years. Now the situation was reversed. My architectural bosses of the Navy did not care *how* I did things but how accurately I *described* them. The subject became, rather suddenly, a very important factor. Airplanes, blimps, particular kinds of ships, coal loaders, dredges could not be merely "expressed," they had to be accurately defined, their characteristics distinctly shown.[79]

This was the most important event in my development as an artist. I was forced to observe the character of things— . . . things so interesting in themselves that I forgot my esthetic drivelings and morbid self-concerns. I left once and for all my little world of art for art's sake.[80]

The Navy studies—the ones Stieglitz hadn't liked—were a howling success when they were shown at the Daniel Gallery after the war, and Benton's career as a reporter-artist, the master of the wry observation, was launched at last, on the basis of drawings. Not bad, for a kid from Missouri, who couldn't keep up with the "master draughtsmen" of Paree!

His drawings became murals for the New School and the Whitney, for Indiana and Missouri, and even the critics who liked the sketches he toted home in his knapsack began to wonder if Benton's studies from life really belonged on the walls of schools, museums, and statehouses for all time to come. Shouldn't adornments for important public buildings exude a certain timeless dignity? Weren't Benton's murals too up-to-the-minute, too flip, too crass, too much like comic strips—like cartoons in the *Joplin American*? And weren't the much-ballyhooed drawings for those murals, at bottom, nothing more than Sunday-supplement caricatures of Boss Pendergast, William Kemper, and J. C. Nichols, of Judge Kirby and Sheriff Curtis, of Senator Ed Barbour, Governor Guy Park, Mayor Means Ray and Postmaster Carroll Wisdom, of the late Congressman Maecenas E. Benton of Neosho?[81] Reporters for the *Kansas City Star* and the *Journal-Post* had found all those Missouri luminaries, and more, tucked away in the State Capitol murals, often in ludicrous or compromising roles, or, worse yet, cunningly juxtaposed with scenes Tom Benton sure as hell hadn't seen with his own two eyes anywhere in the Great State of Missouri. Frankie gunning down Johnny in a St. Louis honky-tonk, 'cause "he done her wrong." Jesse James, that sorry specimen of a native son, holding up the Danville train. Huck Finn and Nigger Jim lazing on the banks of the Mississippi, chewing the fat with an evil-looking trader who's fixin' to give whiskey to the Indians. A baby, with its bare behind primed for diapering, detracting from the solemnity of stump speeches for old Champ Clark back in '93.

Malcolm Cowley, for one, lauded the baby's bottom in the Jefferson City mural as a symbol of Benton's impatience with stuffy respectability. "He has the Middle Westerner's deep respect for facts," Cowley wrote, and diapers,

79. Benton, *An American in Art*, pp. 43–44.
80. Benton is so quoted in "Thomas Hart Benton in Omaha," *Newsweek* 38, no. 23 (1951): 56.
81. For identification of many of the figures in the Missouri murals—a local sport at the time—see Walter G. Herren, clipping from *Kansas City Journal-Post* (December 25, 1936), and clipping by M. K. P., *Kansas City Star* (December 27, 1936). Newspaper articles cited herein without titles come from the extensive Thomas Hart Benton clippings file in the Mississippi Room of the Kansas City Public Library.

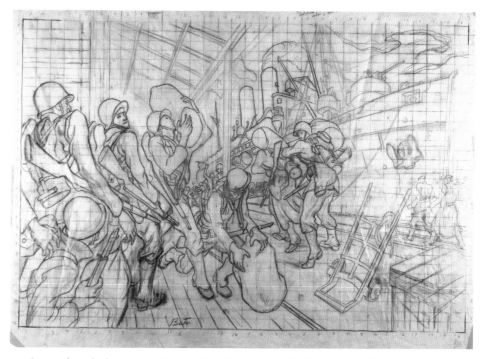

43. Squared study for 1942 painting, *Prelude to Death (Embarkation)* (The State Historical Society of Missouri, Columbia, Missouri). 1942; pencil, ink; 17 x 23¾; inscribed, Inside Soldiers [illegible], Letters go above it, Benton.

Benton was roundly criticized for his portrayal of the young soldier peering back over his shoulder in the left foreground of the picture. Some felt he did not look sufficiently eager to leave for war and, indeed, seemed reluctant to go.

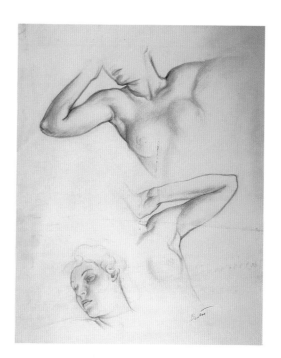

44. Study for or after the oil painting *Persephone* (Nelson Gallery-Atkins Museum, Kansas City, Missouri). 1938–1939; pencil; 17¾ x 13½; inscribed, Benton.

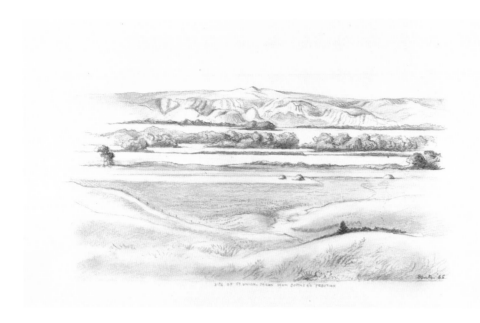

45. Site of Ft. Union, drawn from Karl Bodmer's position, on the Upper Missouri River, Montana. 1965; pencil; 11½ x 14⅝; inscribed, Benton '65, site of Ft. Union, drawn from Bodmer's position, #7, site of Ft. Union, #22; verso, $175.

In the summer of 1965, Benton made a river trip from Omaha, Nebraska, to Three Forks, Montana, following the route of the Lewis and Clark expedition of 1805. The Army Corps of Engineers took him along to gain his approval for a water-control scheme that would raise the level of the river significantly. Thus Benton took special care to record sites of historical interest along the route, including places drawn by Karl Bodmer in 1835 when he accompanied Prince Maximilian von Wied-Neuwied on his scientific exploration of the Great Plains.

46. Squared study for south wall, "St. Louis," "Frankie and Johnny," and "Kansas City" segments, Missouri Capitol mural. 1935; ink, pencil; 14¼ x 24¾ (image size).

Tom Pendergast sits in the lower right corner of the completed "Kansas City" segment, smoking and listening to a speech by R. Bryson Jones, a local insurance man. J. C. Nichols, on the left, and W. T. Kemper, on the right, are among the local celebrities attending the address. The drawing suggests that Benton went "head-hunting" for celebrities to vivify his mural rather late in the game.

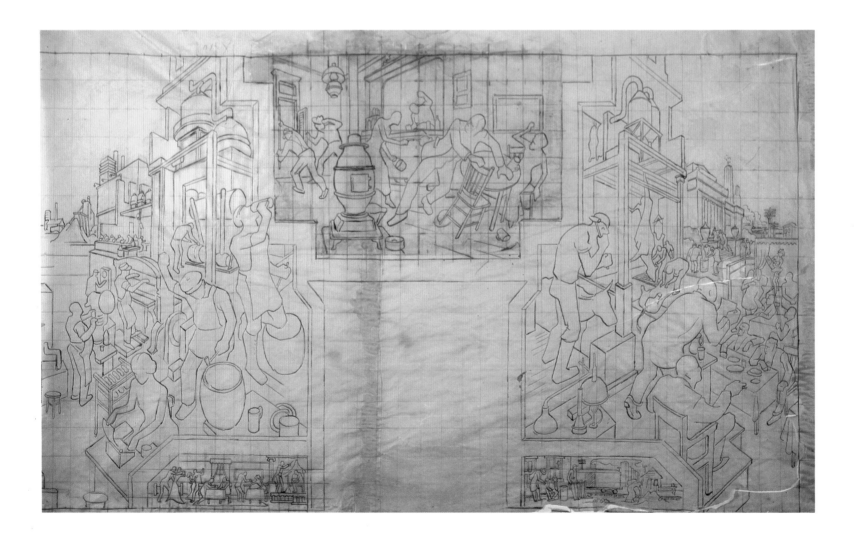

rogues, famous fictional characters, folk songs about less than ideal couples, and the shortcomings of America's frontier forebears were surely among them, although upstanding Middle Westerners might wish it otherwise.[82] But Cowley and his cronies at the *New Republic* were not Missouri legislators, or their constituents. Writers who did not hail from small towns might well find something appealing about drawings, and murals, that smacked of "a comic-strip" and brimmed over with "the same earthy, small-town humor."[83] Missourians, who saw nothing particularly funny about their lives, their small towns, or their cities, for that matter, suspected the worse. Was Benton poking fun at Missouri? Were the murals really "caricatures," as the New York papers said all along? Or did the lack of a suitable refinement in his handling of the story of Missouri betray a coarseness, a crudity, a defect of judgment all the more troubling in one recently entrusted with a position of public responsibility as chairman of the department of painting at the Kansas City Art Institute?[84]

Forced to defend his work at gatherings held in church basements, Legion halls, businessmen's clubs, and the Art Institute, Benton fell back on the hundreds of drawings, the months of research, on what he had seen among the gentry and the rest of the folks, too, when they were doing what they usually did, without their "fish and soup manners":

> I traveled all over the state. I met all kinds of people. I played the harmonica and wore a pink shirt to country dances. I went on hunting and fishing parties. I attended an uproarious three-day, old settler's drunk, in the depths of the Ozarks. I went to political barbecues and church picnics. I took in the . . . night clubs of Kansas City and St. Louis. I went to businessmen's parties and to meetings of art lovers' associations. . . . I chased Missouri society up and down from the shacks of the Ozark hillbillies to the country club firesides of the ultimately respectable.[85]

And when, in a particularly repugnant segment of the State Capitol mural, he had shown a dancer wearing high heels, a smile, and not much else entertaining the cream of the Kansas City business community, there was nothing phony or cute about it. Tom Benton had the drawings to prove his point. "I've been to many businessmen's parties here and in St. Louis," he told an assembly of concerned citizens in Kansas City, "and I want to tell you I put considerable clothes on her!"[86]

82. Malcolm Cowley, "Benton of Missouri," *New Republic* 92, no. 1196 (1937): p. 375.

83. Goodrich, "Delphic Studios," p. 185.

84. On the 1937 legislative uproar over the murals, see Nancy Edelman, *The Thomas Hart Benton Murals in the Missouri State Capitol* (Kansas City: Missouri State Council on the Arts, 1975), pp. 1–4; Elizabeth Ourusoff de Fernandez-Giminez, "Thomas Hart Benton," in *Controversial Public Art from Rodin to di Suvero* (Milwaukee: Milwaukee Art Center, 1983), pp. 25–27, and Louis La Coss, "Missouri Murals Split Home Critics," *New York Times*, Late City Edition (January 17, 1937), sec. 4, p. 10, cols. 6–7.

85. Benton, *An Artist in America*, p. 273.

86. For a detailed report on one such open meeting and Benton's spirited defense of the accuracy of his drawings, see clipping, *Kansas City Star* (January 15, 1937).

47. Coffee urn, soda spigot, and clamshell crane, New York. 1927–1929; pencil; 8 x 5; clamshell crane drawn on verso of coffee urn and soda spigot.

Benton began to do sketches like these, made from everyday sights, during his stint in the Navy. He used his sketchbooks as sources of motifs. The spigot, for instance, appears in the "City Activities" segment of the New School murals and in the "Water Story" mural, unearthed in 1975 from the basement of a Washington, D.C., drugstore and apparently painted in 1929 for the soda fountain (sold at auction on December 6, 1984, by Sotheby's).

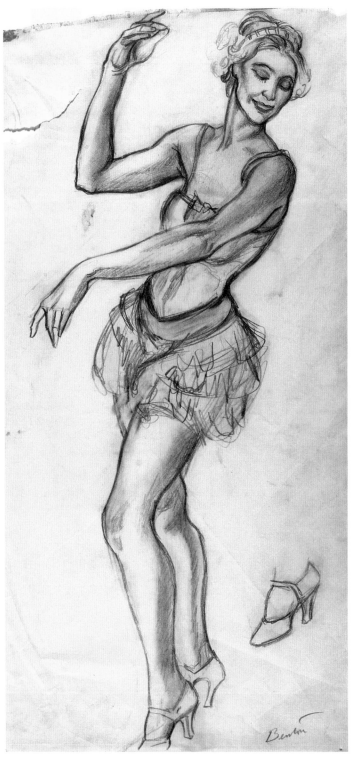

48. Striptease dancer, study for south wall, "Kansas City" segment, Missouri Capitol mural. 1935–1936; pencil; 16½ x 9; inscribed, Benton.

In the finished version, she wears high pink boots and a full, transparent skirt: as Benton claimed, then, reality was ofttimes more scandalous than his art.

Although Benton came to discover, during his long campaign of persuasion, that realism was not necessarily "a shared Missouri virtue," his appeal to middle western fact carried the day with most church circles and business leaders.[87] With most, but not all. Stubbornly unconvinced was one Howard E. Huselton, a real estate man who had heckled Benton at one of his fence-mending sessions, asking if the artist wasn't "proud of" his state and, if so, then why was there "neither beauty nor refinement" in the Capitol murals? After Benton mentioned the incident disparagingly in his 1937 autobiography, *An Artist in America*, Mr. Huselton red-penciled all the juicy bits, phrases indicative, he thought, of a "sensuality" and "grossness" that rendered the artist unfit to instruct the young by virtue of moral turpitude, and he passed the book around at a meeting of the Institute's board of governors called to approve teaching contracts for the upcoming year.

What really bothered Huselton was not Tom Benton's printed "profanities," by which the board, in any case, was not unduly alarmed. What bothered him was the scene in the State Capitol murals, the scene with the floozy at the Rotary luncheon, a slur on the Kansas City business fraternity that continued to rankle one of its charter members almost two years after Benton had airily cited his sketchbooks to silence the hecklers. Huselton had studied the image carefully enough to recognize his own friends and associates in the dancer's lair. J. C. Nichols, the real estate tycoon, was listening to the luncheon speaker, who was Bryson Jones, the insurance magnate. "Ever did you see a man with such a back as this artist gave Bryson Jones in that mural?" sputtered Huselton, at the conclusion of his vain effort to convince the Institute to fire the muralist. "Mr. Huselton insists," the *Kansas City Star* reported as the dust cleared the next morning, "that Thomas Hart Benton paints hunched shoulders and fat legs and fears that all the students in this section will be drawing as Benton draws."[88]

Benton held on to his job that time, but in 1941 he was finally forced to resign. Bourbon and Tom Benton had given a joint interview to the New York press in which the sexual proclivities of museum directors were discussed at length and the artist was quoted as saying he'd sooner hang his work in privies—even in "saloons, bawdy houses, [and] Kiwanis clubs"—than in your average fancy museum. The directors of the Kansas City Art Institute, a fine museum as well as a school of art, understandably took umbrage at his remarks. Benton was quietly informed that his contract would not be renewed. Although he feigned ignorance of the reasons for the ouster, telling reporters only that the same "Art Gang" he had left behind when he quit first Paris and then New York was "after his scalp" again in Kansas City, Benton's teaching career was over.[89]

By all reports, he had been a kindly, unorthodox teacher whose attitudes toward the fundamentals of his craft were profoundly influenced by the shortcomings of his own training in the academies. Unlike Jean Paul Laurens,

87. Clipping from *Kansas City Star* (October 23, 1937).
88. Clippings from *Kansas City Star* (January 15, 1937, and June 16, 1938).
89. Clipping from *Kansas City Journal* (May 3, 1941), and "Benton, Critic of Museums, Says Ouster Is Sought by Kansas City Art Institute," *New York Times*, Late City Edition (April 29, 1941), sec. 1, p. 21, col. 5.

the chilly eminence who conducted the drawing class at the Académie Julian, Tom Benton "sedulously refrain[ed] from discouraging his pupils."[90] On the contrary, he hung a little sales gallery of their work in his home and even insisted that their pictures be shown and reviewed alongside his own in 1937, when Associated American Artists mounted a retrospective of Benton drawings.[91] Jack Pollock saw his name in print for the first time as a result of that generous act, as did Fred Shane, in whose honor Benton later wrote his only sustained essay on the subject of "Drawing." That 1964 essay was a diatribe against the "Art Gang" and its Jackson Pollock-style "Modernism," an antisocial, nonrepresentational faddishness, Benton fumed, unworthy of the name of art. Art was drawing, above all; it was "*of something*," something people cared about.[92] And the drawings Benton's pupils made under his guidance in the late thirties were chock-full of somethings:

> I taught my students to say good-by to goofy "modern art" schools that have no connection with people and living. They went out to their homes, down in the Ozarks, back at the forks of the creeks. And they painted pictures and sold them, and at the same time learned something about Art and a little about life.[93]

Although he paid lip service to a doctrine of rigorous training in the art of drawing well and correctly, Benton hated to risk discouraging a novice with a stern word; the kids learned most of what they would learn by themselves, imitating their restless mentor at the forks of Missouri creeks.[94] An avowed stickler on anatomy, Benton prowled around the model stand in his life class, inviting the uncertain to go up and *feel* the muscles if they couldn't see just how things fit together, but he never popped up behind an easel to "blast and wither with scorn." Instead, he would do the studies he needed for murals and paintings right in class, alongside the beginners at the League or the Institute, "making mistakes, rubbing out, and destroying" drawings, just like they did, "with complete indifference to suspicions of ineptness that might be aroused among the students." In retrospect, Benton worried that his casual approach might even have fostered the institutionalized ineptness of Abstract Expressionism, the nondrawing of the action painters and their guru, Jack Pollock:

> His chief difficulty was with the basic art of drawing. It is possible that my concepts of drawing, which depended less on the appearance of what was in front of you and more on what you *knew* to be there, were confusing. In my figure classes I stressed a search for anatomical sequences of form rather than the usual study of the model's appearance in terms of light and shade. I believed that if it were carried out long enough such a search would acquaint my students with

90. Henry Van Brunt, clipping from *Kansas City Star* (October 16, 1938).

91. "Benton Drawings Shown," *New York Times*, Late City Edition (October 23, 1937), sec. 1, p. 12, col. 8.

92. Thomas Hart Benton, "Drawing," unpaginated introduction to *Fred Shane Drawings* (Columbia: University of Missouri Press, 1964).

93. Clipping from *Kansas City Journal* (May 3, 1941).

94. Thomas Hart Benton, quoted in "Thomas Hart Benton on Art," *Midwest Journal* 6, no. 3 (1954): 120–21.

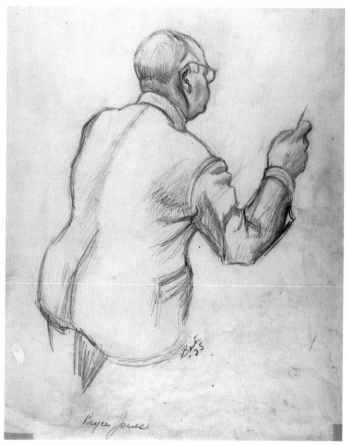

49. Bryson Jones, study for south wall, "Kansas City" segment, Missouri Capitol mural. 1935; pencil; 16¾ x 12½; inscribed, Benton '35, Bryson Jones.

Howard E. Huselton, the most vocal Missouri critic of the mural, objected to Benton's drawing of the "humped back" of Jones.

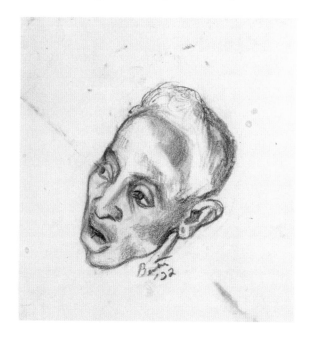

50. Frankie, study for "Frankie and Johnny" vignette above south wall doorway of the Missouri mural. 1936; pencil; 7 x 8½; inscribed, Benton '32.

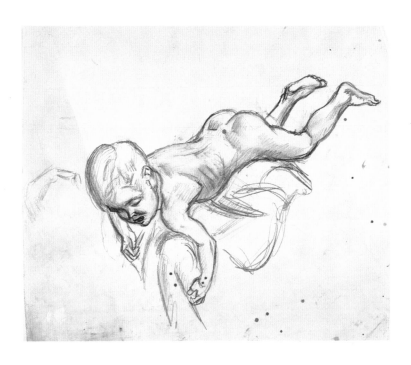

51. Baby (Harold W. Brown, Jr.), study for east wall, "Farming" segment, Missouri Capitol mural. 1935; pencil; 10¾ x 12.

The baby's father, Adjutant General Harold Brown, posed for the figure of the jury foreman in the "Law in Missouri" segment of the same wall. Nat Benton, the artist's brother and Greene County prosecutor at the time, played the role of prosecuting attorney in that scene.

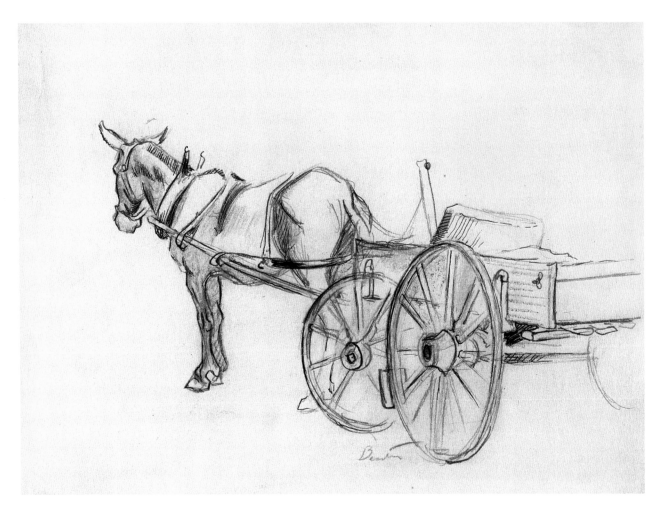

52. Missouri mule, in an Ozark town. Circa 1939–1941; sepia, ink, pencil; 9 x 11¾; inscribed, Benton.

Similar to the wagon of Hades visible in the upper right corner of *Persephone*, this drawing represents a growing interest in nature, and in animals and plant life in particular. Previously, Benton's art had been anecdotal and figural.

the "logic" of human anatomy and movement and generate the ability to project these elements imaginatively, an ability very necessary for the planning of murals and other pictures of a conceptual nature. Further, it would help with the rapid summations necessary for reportorial drawing in the field of American life which, with my Regionalist convictions, I strongly urged my students to practice.[95]

When they took his pupils away, Tom Benton piled into the car with Jake, his German shepherd, and took a run around Jackson County, stopping here and there to stretch, and sketch—a dried-up "holler," three mules gnawing on a fence rail, a clump of weeds. "The country is still there," he growled, a big, sprawling, fast-paced country that learned about itself on the run, from Tom Benton's pictures of America, from the drawings he made for *Life* and *Collier's* and *Coronet*, from the drawings he made for the lobbies of movie theaters, or for ads along the sides of a thousand dusty roads.

The fifteen-odd years between Pearl Harbor and the commission to decorate the River Club in Kansas City were lean and difficult ones for an essentially populist painter, whose preferred milieu was a scaffold in a public place: the war killed off the nascent mural movement created under federal relief patronage during the Depression, and, for a long time afterward, murals bore the onus of hard times and high social idealism gone wrong. At first, Tom Benton's style, especially the style of his drawings, began to change toward a meticulous, even niggling use of a hard pencil; there was something obsessive yet tentative about the new realism of the war years, when he would work for hours on a study of Jackson County weeds. At first, he had been eager to get involved in war work. The *Year of Peril* paintings he dashed off in a white heat of emotion after hearing the news of the Japanese attack were bought by Abbott Laboratories, presented to the government, and circulated as propaganda posters to drive home the consequences of unpreparedness. Twenty-six million reproductions, or so they said, appeared in newspapers alone. But when he began to draw the lives of young sailors in New England and of army recruits at camps in the South for use in the war effort, their girls called him "Fat Pop" or, worse, "Old Pop" and laughed at him when he wanted to dance. One night in New Orleans, doing the town with some Navy boys barely out of diapers, he was taken—like some green sucker—by a trio of fancy ladies disguised as WAVES.[96] All of a sudden, he felt old, an alien in this brash, young world of the young warrior. No wonder he drew weeds and flowers, old tin cans, and the trees beside Menemsha Pond, in faint and hesitant lines: the weeds and flowers couldn't talk back and hurt "Old Pop" Benton with their careless words.

The firing hurt. So did the taunts of the pretty young girls in the honky-tonks. But the failure of confidence that changed Tom Benton's work so markedly in the forties had other causes too. As mural commissions began to dry

95. Benton, *An Artist in America*, pp. 332–33.

96. See ibid., pp. 298–310; and Abbott Laboratories, *The Year of Peril: A Series of War Paintings by Thomas Benton* (North Chicago: Abbott Laboratories, 1942), with a foreword by Archibald MacLeish, Librarian of Congress and Chairman of the Committee on War Information. For additional war illustration by Benton, see captions and illustrations in Quentin Reynolds, "Take 'er Down," *Collier's* 114, no. 19 (1944): esp. 16 and 17. Not everyone found his almost surreal war art effective; see, for example, Manny Farber, "Thomas Benton's War," *New Republic* 106, no. 16 (1942), 542–43.

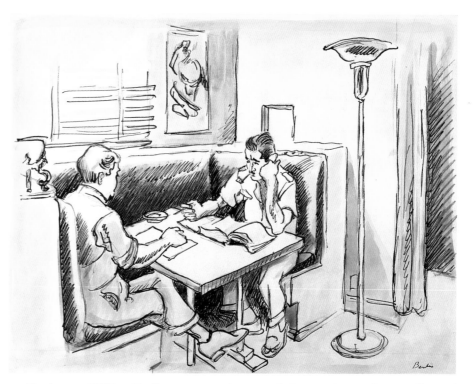

53. Conference (William Faulkner, screenwriter, at 20th Century-Fox studios), Hollywood. August 1937; sepia, ink, pencil; 10¾ x 13¾; inscribed, Benton; verso, Conference Series A-67.

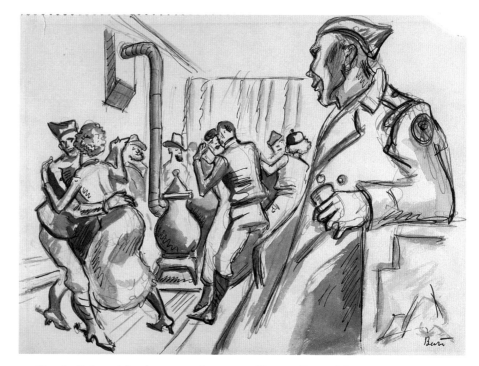

54. Flood relief at night, done on assignment to Kansas City and St. Louis newspapers in southern Missouri. Spring 1937; sepia, ink, pencil; 8¾ x 12; inscribed, Benton; verso, Flood relief at night, $50.

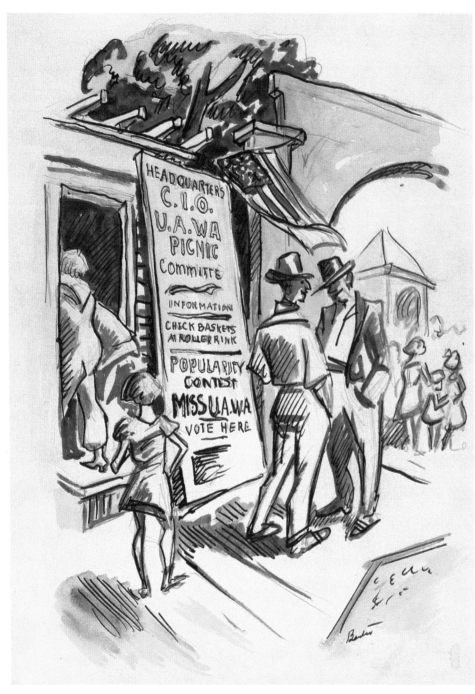

55. "Workers! You've Nothing to Lose but Your Change!," unused sketch made on assignment for *Life* at the United Auto Workers' Fourth of July picnic, Flint Park, Flint, Michigan. July 1937; ink, sepia, pencil; 12 x 8½; inscribed, Benton; verso, $250, Miss U.A.W.A., U.A.W.A. picnic, July '37.

up in the wake of the Missouri Capitol controversy, Benton had sought new outlets for his public ambitions. He had never quite abandoned his journalistic aspirations, despite "Shorty" Benton's dramatic decision to leave the *Joplin American* for the studios of bohemian Chicago. So, in 1934, in the spirit of his reportorial drawings from the backroads, he wrote and illustrated an account of the vanishing folk culture of rural Arkansas for *Travel* magazine; a year later, he "covered" the New Jersey trial of the accused kidnapper of the Lindbergh baby for a New York paper.[97] In the spring of 1937, when he might well have been in the same part of the state on his annual sketching trip, Benton sent back pictorial reports on the spring flooding in southeast Missouri to the *Kansas City Star* and *St. Louis Post-Dispatch*. In the summer, on the strength of his success, *Life* sent him to Michigan to take a satirical look at the Fourth of July picnics of the purported Communists of the U.A.W. and the purported Fascists of the German-American social clubs.[98] A month later, he was in California, on assignment for *Life* again, doing a painting and "a forty drawing commentary on Hollywood and the movie industry."[99]

Things went sour in Hollywood. *Life* rejected the painting as too risqué for a family magazine. Although the canvas took a prize in the prestigious Carnegie Annual and so wound up in *Life* anyway, in a full-color centerfold report, it was a loud, confused, and, in the end, a pointless picture, a collection of observed snippets by turns trite and kind of nasty, reflecting the tenor of the forty-plus sketches *Life* also declined to print as a picture-essay. Benton took the setback hard: to be scorned by the critics or the "museum boys" was one thing, but to be rejected by the people, insofar as *Life* and the popular media could claim to represent the public taste, was something else again. Angrily, he set out to prove *Life* wrong by writing a best-seller based on his Hollywood observations. The surviving text suggests that the flamboyant and sometimes seedy workings of the movie industry were to serve as a kind of extended metaphor for American business as a whole, but he gave up after a page or two, made a lithograph after the least tinsely of his sketches, and sold a few of the rest to *Coronet* in 1940.[100]

Benton's growing litany of failures and disappointments rankled in direct proportion to the hopes he had invested in a variety of projects to liberate art from the clutches of the museums and to restore it to a position of primacy in the popular arena. After 1938, and a prose-and-picture study of the boomtown business mentality for *Scribner's*, he pretty well gave up on magazines as the vehicles of aesthetic revolution and turned instead to the

97. See Thomas Hart Benton, "America's Yesterdays," *Travel* 63, no. 3 (1934): 6–11, 45–46, with thirteen illustrations. Benton later claimed that doing this article inspired him to write and illustrate his autobiography.

98. See "Artist Thomas Hart Benton Hunts Communists and Fascists in Michigan," *Life* 3, no. 4 (1937): 22–25.

99. For the *Life* project, see Erika Doss, "Regionalists in Hollywood: Painting, Film, and Patronage, 1925–1945," Ph.D. diss., University of Minnesota, 1983, pp. 122 ff. For the painting, see *Life* 5, no. 24 (1938): 74–75.

100. See undated MS in Benton papers, Archives of American Art, Reel 2327, cited with the permission of the Thomas Hart and Rita P. Benton Trusts, and "A Tour of Hollywood, Drawings by Thomas Benton," *Coronet* 7, no. 4 (1940): 34 ff.

56. Cubist study for *The Kentuckian* (largest version in Los Angeles County Museum; gift of Burt Lancaster), a painting done to promote the movie of the same title (1955, United Artists), starring Burt Lancaster in the title role. 1954; ink, pencil; 10⅞ x 8⅜; inscribed, Benton; verso, see below.

 This sketch was made on the back of a letter to Benton from the Stitzel-Weller Distillery, offering to supply personalized bourbon labels with the purchase of each case. There is a certain irony in that fact, because the painting eventually did adorn labels for "Beam's Choice."

57. Child-actor Donald MacDonald, study for *The Kentuckian*. 1954; pencil; 16¼ x 13⅞; inscribed, Benton.

58. Life sketch for head of Seneca Indian in left foreground of the mural *Father Hennepin at Niagara Falls, 1678* (Power Authority of the State of New York, Niagara, New York), eastern Oklahoma. 1959; pencil; 7⅝ x 8⅜; inscribed, Study for Niagara Mural, Benton.

movies, with a vengeance. Even after the *Life* assignment fizzled, Benton went doggedly back to Hollywood, first to work on the 1940 publicity campaigns for John Ford's *The Grapes of Wrath* and his *Long Voyage Home* and, later, just after the war, to collaborate with Walt Disney (and Salvador Dali) on a feature cartoon *cum* folk operetta about Davy Crockett.[101] The musical end of things interested him most particularly: his own record, *Saturday Night at Tom Benton's*, made in 1941 and released in 1942, had mingled folksong with classical instrumentation in a pop format. His foray into the entertainment business had been a flop, but Disney, after all, was a master at the genre. Thus the speedy cancellation of the film project dashed with special cruelty his dreams of success in Hollywood and, with them, his last hopes for the kind of merger between the entertainment industry and the arts—between the popular and the oh-so-fine arts—that Disney had attempted in *Fantasia*, a mixture of classical music and Mickey Mouse that most highbrows found both repellent and pretentious. The publicity work in Hollywood did lead to jobs as a book illustrator, however, jobs that kept him in the public eye in the fifties, when his kind of art was going out of fashion in the galleries. And it led to a spectacularly unprofitable stint as a painter of ads

for Lucky Strike cigarettes that culminated in Benton being allowed, by the crafty George Washington Hill, president of American Tobacco, to buy back his own picture, at a three-thousand-dollar loss.[102] By 1947, Benton had become a genuine authority on the question of why business and art made bad bedfellows. While conceding that the artist suffered from his "present isolation," that "any work which helps to bridge the present gap between the artist and the practical forces of society is worth cultivation," Benton nonetheless drew the line at further hackwork for the likes of George Washington Hill. "Advertising," he baldly stated, "is not a field for fine art."[103]

He never quite gave up wishing, though. From time to time, he could still hang a picture in Billy Rose's posh saloon to make his point about the sterility of museums. He could still base a serious oil on an old Anheuser-Busch calendar, a chromo of the worst kind, and brag about it to *Time* magazine.[104] He could still crank out a picture of Burt Lancaster in buckskins to promote a horse opera called *The Kentuckian*, and then sell the rights to Jim Beam for an all-American bourbon label. He could still give Mike Wallace or Dave Garroway a hard time on TV and mug shamelessly for the cameras of *Sports Illustrated*, the *Saturday Evening Post*, or his old nemesis, *Life*. Stunts like these had made Tom Benton's name a household word, and they allowed him to survive, a cantankerous, dissident presence on the dim margins of the American consciousness, during the postwar years when realism was anathema to the art establishment. Among real folks, and folks who counted in the real world—the executives of Harzfeld's department store, the clubmen of Kansas City, Commissioner Robert Moses of the New York State Power Authority, and former President Harry Truman of Missouri—Benton was still "the best damned painter in America," and his appeal, in an age of splotches and drips, was all the greater when his drawings, as though to assert the primacy of realism all the more forcibly, became less mannered, tighter, harder, nitpicking, hair-splitting renditions of the real-est of real things.

His new drawings for the Power Authority murals at Massena and Niagara Falls, New York, and for the Truman Library in Independence, Missouri, were exercises in painstaking research on Indian dress and the technology of the frontier. The brash kid-reporter had become the grave historian-muralist, preparing to paint the arrival of Jacques Cartier in Quebec by reading the explorer's *Relation* in sixteenth-century French; by rummaging through the archaeological museums of Albany, Buffalo, and New York City in search of pikes and muskets; by turning up the only known accurate scale model of Cartier's flagship; and by tracing the peregrinations of the Canadian Iroquois of 1535 to the Seneca reservation in Oklahoma, where they still lived in

101. See news report in *Life* 6, no. 4 (1940): 29–31; "Art Comes to Hollywood," *Esquire* 14, no. 3 (1940): 64–65 and 173–74; and Marling, "Thomas Hart Benton's *Boomtown*," pp. 126–27.

102. His one successful tobacco ad ran in *Time* on July 20, 1942; his account of his tussle with Hill appears in Benton, *An Artist in America*, pp. 294–96.

103. Thomas Hart Benton, "Business and Art from the Artist's Angle," *Art Digest* 20, no. 8 (1946): 7–8, and Thomas Hart Benton, "Business and Art," in Elizabeth McCausland, ed., *Work for Artists: What? Where? How?* (New York: American Artists Group, 1947), p. 25.

104. See, for example, "Benton v. Adams," *Time* 47, no. 9 (1946): 49, with a reproduction of the calendar illustration after Cassily Adams's *Custer's Last Stand* used by Anheuser-Busch. *Time* called it "pool-hall" art.

1956. A fellow artist, Charlie Wilson, took Tom out to the bluffs above Wyandotte to draw a "perfect" Indian brave, as his seven wide-eyed children looked on; back in town, Benton took on the pupils at the Indian school, sketching them one by one, assembly-line fashion, while an honest-to-gosh Seneca elder, Chief Peter Buck, was induced to pose for the figure of the chieftain in the mural. "Drawing real Senecas was psychologically important to Benton," Charlie thought. And Tom admitted as much: "There's a security in knowing the models are the genuine article."[105]

The very act of painting the past provided its own kind of security, some measure of protection from the mercurial passions of the moment. Tom learned that in 1957, when he met Harry S Truman face-to-face. Truman, it developed, had given Tom the cold shoulder for years in the mistaken belief that the portrait in the Missouri mural was a calculated insult to his one-time mentor, Boss Pendergast. Worse still, "after Pendergast got to the penitentiary, some wag went up and painted his prison number on his back in the mural" and blamed Tom Benton for it.[106] The two elder statesmen could chew over the fine points of Missouri history by the hour and have a high old time at it: time had, after all, cooled the urgency of most disputes, and solved the rest. Nobody stood to be hurt by a good, clean historical fight. But the quarrels and the realities of the present day were fraught with the kinds of dangers Tom Benton had once faced in the church basements of Missouri, back in the thirties, when Mr. Huselton and his ilk had wagged their fingers and clicked their tongues and spread the word that he had painted a prison number on Pendergast's poor humped back. When the old president finally decided to entrust his library to Tom Benton's tender mercies, he did so on one ironclad condition: "Don't put any pictures of Harry S Truman in your plan," he directed. "I don't want to be there. I mean it."[107]

He drew Harry Truman, though, just the same, and fooled with the drawings for ten years, until he got the painted likeness just right. As the sixties wore on, in fact, Tom spent more and more time with his old drawings and with Rita, trying to remember just when and where he had sketched this sharecropper, that fiddler. He wrote to one collector, who wanted to buy a sketch, telling him that Benton drawings weren't really a scarce commodity: they just didn't "often come up in the New York sales centers. I myself own some thousands of my drawings. They are the 'research' material out of which my paintings, murals and other works are constructed. I do not part with them unless I am sure they will no longer be needed."[108]

But did he really still *need* all the New School drawings that weren't in the Whitney collection? Every last sketch of the flapper or the burlesque queen, ladies he had drawn incessantly in the early years, but types now ex-

59. Smithy tools, study for the mural *Independence and the Opening of the West* (Museum of the Harry S Truman Library, Independence, Missouri). 1958–1959; pencil; 17¼ x 11⅜; inscribed, close to fire box.

105. Benton, *An Artist in America*, pp. 344–47, and Charles Banks Wilson, "On the Trail with Tom Benton," in *Thomas Hart Benton, Artist of America*, pp. 25–26.

106. Quoted in Gallagher, "An Artist in America," p. 87.

107. Benton, *An Artist in America*, p. 351.

108. Undated letter to Gerald Dickler, attorney for Mrs. Jackson Pollock, in the Benton papers, Archives of American Art, Reel 2325. The letter should be dated circa 1965.

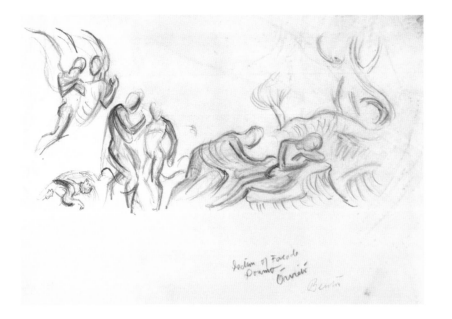

tinct, as antiquated as dodoes and dinosaurs? Did he really need sheaves of graphic notes on obscure altarpieces in Orvieto; piles of views of sleepy country streets back in the thirties, or the twenties, or was it the forties; heaps of life studies, made in classes—which classes? where? when? Brisk young art historians were asking the same questions: when had Mr. Benton first broken with modern art? Where had he gone on all those trips of his? Who was that fiddler in the lithograph, the mural, the painting?

In 1965, when he was forced to tell a researcher that he couldn't, "to save me, remember the titles" of some of his best-known works, he began a formal inventory of Benton's own Bentons, working from the evidence supplied by the drawings. With a contract for a new, technical version of his autobiography in the offing, the information was vital. It was difficult work, however. "When you have done as much work as I have it is hard to remember exact dates. Up to a few years ago," he confessed, "I did not date my

60. Free sketch of a portion of the fourteenth-century facade sculpture of the Duomo, Orvieto, Italy, by Lorenzo Maitani, showing the creation of man and woman. 1965; pencil; 8⅛ x 11¾; inscribed, Section of Facade, Duomo Orvieto, Benton.

61. "Midway Dance," Main Street, Borger, Texas. February 1927; sepia, ink, pencil; 7 x 10⅞; inscribed, B.; verso, $100.

paintings or drawings—sometimes did not even sign them—figuring the style was the signature."[109] Now he and Rita sat there by the hour, picking through the little pocket notebooks, the sketchpads, and the piles of crumbling paper, trying to remember when he had drawn a shoe factory, an Enfield rifle, a soda spigot, and why. As they went along, Tom dated the ones that needed dating (sometimes with a cruddy old blue ballpoint!). He made notes on some, in his spidery, old man's hand, about such things as where the image fit within a bigger mural scheme or whether it was the first or the second or even the third try at a decent composition. And in a big, gutsy scrawl, no longer quite his own, he put a *B* on drawings that never had been signed, because, once upon a time, the style had been signature enough. The inventory was a way of putting his estate in order, for Rita and the kids. It was a way of putting his life in order, too, of looking back through the eventful years, day by day, mile by weary mile, memory by memory, sketch by sketch, fiddler after fiddler, and floozy, and old friend.

Sometimes, after dinner, after sipping a little hundred-proof Muehlebach bourbon with a friend, it seemed as though he could finally tell it all, just like it was, if he could only just explain "The Art of Drawing." He started to do it once, too, on a scrap of old letter paper, after a pull or two on the bourbon, but he didn't get much further than the boozy dedication to Rita:

62. Life class at the Art Students League, New York. Circa 1927–1931; ink, sepia; 14½ x 10¼; inscribed, Benton.

The Art of Drawing

One night my wife Rita and me were eating an old tough wild goose which one of our friends brought to us after he shot it.

Rita said—You sure have to draw on your fork a lot to get the meat out of this bird.

I said—That's right. I've spent the most of my life trying to draw meat out of carcasses like this.

She said—Whatta you mean[? S]o this book came up.

Life is tough like the meat of that poor old goose that was shot down by our friend['s] shotgun. You never quite get it in its living, going state but only when it is brought to a halt.[110]

Drawing *was* life, Tom Benton's life, at any rate; and sometimes, when the banjos were still and the mighty trains stood silent on their rusty tracks, it was as tough to draw honestly and passionately as it was to live on, fierce and brave to the end, plagued with doubts and memories of other engines, other songs. It was tough, but the drawings are better than nothing, now that Tom Benton's gone. Once, they brought that "living, going" Benton to a halt for a long, hard moment, his pencil poised above the page. Now, they bring that moment, that man, that American original, Tom Benton, back to life, in all his cussin', cussed glory. "No airs," said his best friend and his eulogist, "no phoney baloney."[111] Just Tom and a lifetime of drawings.

63. Rita in the garden of the Benton home, 3616 Belleview Avenue, Kansas City, Missouri. Circa 1968–1975; pencil; 11 x 14½; inscribed verso, $50, rough sketch of house.

Benton's studio, where he died, stands in this garden behind the house.

109. Creekmore Fath, ed., *The Lithographs of Thomas Hart Benton*, new ed. (Austin: University of Texas Press, 1979), pp. 6 and 20.

110. Undated manuscript, Benton papers, Archives of American Art, Reel 2327.

111. Field, *Eulogy*, p. 4.

I Going Home

It was in Martha's Vineyard that I first really began my intimate study of the American environment and its people. . . . The city, though it had been for me a well of personal stimulation, had left my art barren and aloof from reality. Although I later dealt extensively in my painting with New York life, I did not learn to approach it pictorially until after the little Massachusetts island had freed me from its illusions and opened my mind to receive the great American world beyond it.

In 1924 my Dad came to the end of his rope. I went out to Missouri to be with him. . . . I cannot honestly say what happened to me while I watched my father die and listened to the voices of his friends, but I know that when . . . I went back East I was moved by a great desire to know more of the America which I glimpsed in the suggestive words of his old cronies. . . . To my itch for going places there was injected a thread of purpose which, however slight as a far-reaching philosophy, was to make the next ten years of my life a rich texture of varied experience.[1]

Thomas Hart Benton

1. Thomas Hart Benton, *An Artist in America*, 4th rev. ed. (Columbia: University of Missouri Press, 1983), pp. 63–64 and 75–77.

THOMAS Hart Benton claimed that when his Dad, the Congressman, tried to get him to read the collected speeches of his great-uncle, the great Missouri senator, the first Thomas Hart Benton, he would sneak out to the corncrib instead and pant over lurid dime novels. But a little of the biblical rhetoric of his illustrious forebear stuck all the same: in the many retellings of his life story, Tom Benton never failed to couch the beginnings of his career as a realist and a Regionalist in dramatic terms, with himself as the leading actor, knocked from his high horse, like Saul of Tarsus, by a blinding revelation.

Sometimes, it was his hitch in the Navy, as a draftsman of real, honest-to-gosh *things*, that made the difference. Sometimes, it was the plainspoken Yankees he met and began to draw on the Vineyard. Sometimes, it was his Dad's dying and his return to Missouri and the American heartland. But, between World War I and 1924, something did change a not-very-original, not-very-well-known young modernist of a strongly theoretical bent into the premier muralist of his generation, the people's artist, a populist whose pictorial reports from the byways and the backroads helped to define America for his generation and to put the Midwest back on the American roadmap.

A 1917 fire destroyed the Benton family home in Neosho, Missouri, and with it most of Tom's juvenilia—his work as a kid cartoonist; his art-school exercises; the sketches he brought back from Paris; the hack jobs for the Pathé and the old Fox movie studios in Fort Lee, New Jersey; the colorful, quasi abstractions left over from his flirtation with Synchromism. But the drawings done after 1917, the drawings Tom saved and, for the most part, used as raw material for his painted images, show him looking around in wide-eyed wonder at things outside the four walls of his New York studio. His nephew, come for the summer; the family cat: the most inartistic of subjects become the stuff of art. And the stuff that was to sustain his career forever after was Missouri stuff—mules and hillbillies and things he saw back home.

1–1. Brooklyn Bridge, New York. Circa 1923–1924; pencil; 8 × 5.

Benton began to carry a pocket sketchbook with him after his discharge from the Navy, to jot down his observations on the streets of the city, along the waterfront, and at the construction sights that, perhaps as a result of his wartime drawings of machinery, were the predominant theme of this little portfolio. Orthodox modernists were also obsessed with the ceaseless building and rebuilding of New York and the new skyscrapers of Manhattan, symbolizing the dawn of a "modern" era.

1–2. Cats, Martha's Vineyard. 1925–1930; ink, sepia wash, pencil; 11¾ × 8¾; inscribed, Benton.

Fresh attention to the minutiae of everyday life—including domestic life—and a free, fluid use of the pen typify drawings of this phase of Benton's gradual conversion to painterly realism. The areas of crosshatching and the quick generalization of such details as the paws recall his beginnings as a cartoonist. This bold manner was well suited to illustrating, and Benton fell back on it for journalistic purposes until the midthirties.

1–3. Nat Briggs(?), Martha's Vineyard. 1920–1925; sepia wash, ink, pencil; 11 × 8½; inscribed, Benton 1920; verso, $25.

The young boy in this sensitive study closely resembles Benton's nephew, who summered on Martha's Vineyard with "Nana," Benton's formidable mother. The date was added to the drawing by the artist after 1968, in one of his periodic bouts of trying to clarify his development for posterity, and is not necessarily accurate. The sketch is, however, consistent with the New England work of the period in the three-quarter-length format and the preference for the quiet, thoughtful portrait. The idiosyncratic combination of media suggests that Benton had already begun his annual sketching trips, since he claims to have evolved the technique to keep his drawings from being erased by friction in his knapsack.

1–4. Mountain Mother, southern Missouri or Arkansas. Circa 1924–1925; ink, sepia wash, pencil; 10⅝ × 7¼; inscribed, Benton '24.

Certainly captured on one of his early rambles, this woman bears a strong resemblance to Sabrina West, the deaf-mute Vineyard neighbor who sat for *The Lord Is My Shepherd* of 1926 (Whitney Museum of American Art, New York), one of the first of Benton's paintings to hint at his mature Regionalist style. Benton inserted her into the "Arts of the South" segment of his Whitney Museum mural in 1932; used to top a tense, dynamic body, drawn from a model as he was about to complete the mural, she is the onlooker in the brown dress, the skeptical "mountain mother" who, when a nubile young thing rolls about in the ecstasy of the saved, calls her a "stinkin' slut" under her breath.[2]

1–5. On the Cape, New England. Circa 1930; ink, pencil; 12 × 9; inscribed, Benton; verso, New England St. on the Cape.

Reportorial views like this one, more often showing the broad, dusty Main Streets of the West or the shantytowns of the Deep South, became Benton's stock-in-trade after 1924. His is always, at this date, a humanized landscape, alive with autos and signboards. The growing assurance of his line is evident in the masterful handling of the foliage.

1–6. Missouri mules. 1930–1935; pencil; 9¼ × 13½.

Benton first made the lop-eared mule a kind of personal symbol of a vanishing, rural America when he featured a team prominently in his depiction of "The South" in the New School for Social Research mural of 1930–1931. Mules became the ornery, funny-looking, long-suffering trademarks of Missouri's best-known artist of the twentieth century, a man who took some pride in his own mulishness.

1–7. Aunt Nina Lewis(?), Ava, Route 4, Missouri. 1936; sepia, ink, pencil; 16⅝ × 13¼; inscribed, Benton '36, Aunt Nina Lewis, Ava, Route 4, MO; verso, 19 Aunt Nina S. Mountains.

A hillbilly lady of enormous dignity, she was set down by Benton—chair and all—in a wagonbed in the Missouri Capitol mural, where she listens to a political speech by the artist's father, back around 1889 (the date inscribed on the cornice of a nearby building), the only woman present. While there is no doubt as to the date of the work, or its Missouri origins, Benton published it in 1936 under the title *Aunt Angie* and added the descriptive caption after 1968.[3]

2. Ibid., p. 99.
3. See reproduction in *University of Kansas City Review* 2, no. 4 (1936): 202.

1–1. Brooklyn Bridge, New York. Circa 1923–1924.

1–2. Cats, Martha's Vineyard.
1925–1930.

1–3. Nat Briggs(?), Martha's Vineyard. 1920–1925.

44

1–4. Mountain mother, southern Missouri or Arkansas. Circa 1924–1925.

1–5. On the Cape, New England. Circa 1930.

1–6. Missouri mules. 1930–1935.

1–7. Aunt Nina Lewis(?), Ava, Route 4, Missouri. 1936.

2 Chain Gangs and Cotton Fields

To make an original form, it seemed necessary to me to have references beyond art. I had to find something which would be a soil for growth. I found it when I became interested in the background of American life—things, places, and faces. If we are ever going to have a national art, with universal value, we'll have to yield to the pressure of the locality. Otherwise, I'm afraid, there will be only imitation of other forms, of Greek, of Negro sculpture, or a Cézanne landscape.[4]

<div align="right">Thomas Hart Benton</div>

Benton has produced a series of works which stand on their own merits; they have no need of titles or romantic associations. It is not necessary to know the South or to be interested in its laborers to appreciate the value of his work. His drawings have the universal quality which distinguishes all art that approaches greatness.[5]

<div align="right">Exhibition review, 1929</div>

BENTON'S first really long trip, after his exploratory travels on foot through southern Missouri, came in 1928. In the late spring of that year, he left New York in a battered Ford station wagon that was equipped for camping and driven by Bill Hayden, one of his students and a regular member of the Benton expeditionary force for several years to come. The two were gone all summer and most of the fall. Their travels took them to the cotton, rice, and sugar country of the Deep South; from there, they skittered west into cattle country. But it was the South that captured the imagination of the critics when Benton showed his sketches, fresh from the road, at the Delphic Gallery in December.

However much reviewers exclaimed over Benton's increasingly supple line, over the intricate, sometimes lovely contrasts of wash with faint traces of a hard pencil and coils of ink, his theme was at least as novel and intriguing as its handling. In the thirties, America would discover the South with a vengeance. George Gershwin and Marc Connelly would make the sweet, sad gospel songs of southern blacks a part of the nation's cultural heritage. *Tobacco Road*, with its dramatic caricature of "poor white trash," would seem fated to play on Broadway forever. New Deal agencies would photograph "croppers'" shacks, and union organizers would proselytize on their tumbledown front stoops. The "southern problem" would become a staple of political speechifying. In the twenties, though, Benton was the first outlander of any stature to suggest that the South and its traditions might warrant respectful attention. Indeed, his graphic statement of the case for Dixie managed to anticipate by several years the publication of *I'll Take My Stand*, the

famous literary manifesto of southern regional identity issued by the Vanderbilt Agrarians in 1930.

His own mother's folks had migrated west from Kentucky to Missouri and Texas in the last century, and Benton's first long trip was, in a sense, an effort to retrace their pioneer footsteps in the red clay, and to find himself in the process. When he came back, again and again, in the years that followed, however, he was seeking not his own roots but a vanishing way of life, a slower, simpler, older America, rural by and large, an America yielding to the changes brought by paved roads, the fast pace of modern life, and wheezing little Fords like his. While Benton deplored much of what he saw in the South—poverty, superstition, suspicion, casual violence, and prejudice are all described and deplored in his southern memoirs, and he was appalled by the chain gangs he saw along the expanding spiderweb of southern roads— he found much more to cherish. The grave courtesy and wondering curiosity of the Negroes he met charmed him, and he met more than his share of poor blacks and equally poor whites as he hiked or hitched rides or stopped his car to draw.

From that time forward, Tom Benton never painted an America that was the domain of the rich and famous, or even the exclusive playground of the comfortable and the polite. His history of *America Today* on the walls of the New School for Social Research was a people's history, shaped as decisively

4. Thomas Hart Benton, quoted in Ruth Pickering, "Thomas Hart Benton on His Way Back to Missouri," *Arts and Decoration* 42, no. 4 (1935): 19–20.
5. "Thomas Hart Benton, Delphic Studios," *Art News* (October 19, 1929): 17.

by black slaves and chain gangs and fieldhands as by white overseers and mechanics, a history forged as truly by the South as by the East or West. The "Arts of the South" merited a wall of their own in the Whitney mural cycle, exactly one-half of which was given over to black gospel music, crapshooting, and a young black mother, tenderly weaning her baby, all ordinary people's doings Benton had seen with his own eyes in Georgia, Tennessee, Arkansas, and the Carolinas.

2–1. Rice threshing, Louisiana. 1926; ink, pencil; 4⅞ × 6⅝; inscribed, Benton '26; verso, $50.

The earliest drawings made on the road are portraits, but Benton's interest in people led directly to his fascination with their "arts"—what they did and how they made a living. Just as he was aware of the forces of social change represented by his own station wagon, so he understood and sometimes deplored the technological changes that were reshaping both rural and industrial America. This study was incorporated into the portrayal of the South in the New School murals, a panel that pointedly contrasts the old ways of doing things—the mule team, stoop labor, the paddle wheeler on the river—with a whole range of new, almost prehensile tools, including a seed drill and the threshing apparatus detailed in this tiny, on-the-spot note.

2–2. Cotton Picking, Georgia. 1928; watercolor, ink, pencil; 10¼ × 14⅝; inscribed, Benton.

Benton described the pink color of the middle Georgia ground under the September sun and the purple of the shadows in *An Artist in America*. He drew the workers in the fields unawares, but, in order to do portraits during the noontime rest period, he had to pass out cigars and nickels.[6] This scene was also the theme for *Cotton Pickers (Georgia)* of 1928–1929 (Metropolitan Museum of Art, New York), purchase of which by the Metropolitan in 1933 helped to solidify Benton's growing critical reputation.

Benton's murals are full of pungent portraits, but his easel paintings of the thirties, especially those dealing with the subject of work, avert the faces of the laborers, as this sketch does. Ben Shahn and many of the so-called Social Realist or Social Protest painters of the Depression did the same thing, in an effort to arouse universal sympathy for the anonymous worker, the "forgotten man," the American Everyman. Paradoxically, by particularizing the features of all the figures in his murals Benton may have come closer to the mark: with the passage of years, it is the realism of the faces that invites the viewer to believe these are people just like him- or herself.

2–3. Chain Gang. 1928; watercolor, pencil, ink; 16¼ × 20; inscribed, Benton '28.

Benton added the date to this drawing long after the fact, but it is plausible enough. "Nothing is sadder than a gang of men under forced labor exhibiting their punishment to the world," he wrote. "They seem doubly sad in the ludicrous striped suits of the southern chain gangs."[7] He used this drawing as the basis for a chain-gang scene in the New School murals.

2–4. Black tent meeting, the Church of the Sanctified, Beauford, South Carolina(?). 1930; ink, sepia wash; 9 × 11⅞; inscribed, Benton; verso, $150, 30 Campmeeting audience.

Benton was an eyewitness to a Negro version of a Holy Roller service—"The audience began to jump. In two seconds the whole tent was a mad house"—and described it in some detail in order to show that black customs and beliefs were no stranger than those of the white people he observed.[8]

2–5. Beale Street, Memphis, Tennessee(?). Circa 1930–1934; sepia wash, ink, pencil; 9¼ × 7; inscribed, Benton; verso, $50, $175.00.

The artist took an eighteen-day towboat trip down the Mississippi in the early thirties and, of course, had to stop in Memphis to visit Beale Street, "home of the blues," exclusively Negro music then. His taste in folk music was remarkably catholic for the period.

2–6. Fightin' chickens, Arkansas(?). Circa 1937–1940; pencil; 8½ × 11⅞.

Benton was mesmerized by illicit cockfights in the South, although in two separate incidents, one, perhaps, in the Carolinas and the other in Arkansas, he witnessed the aftermath and the prelude to the main event but missed the action. In the first instance, he arrived just in time to see the chickens, "their hard eyes, yellow in the sunlight," arrested along with their owners. In the second case, he spotted bundles of straw tied to trees one Sunday afternoon as signals of a cockfight to be commenced. And he even found three abandoned pits. But the sheriff was about, and the principals had melted away into the woods.[9]

This sketchbook page contains an unpremeditated life drawing, done with some speed and without the usual formal embellishments Benton added when he reworked such quick notations.

2–7. Waiting. Circa 1940; ink, sepia wash, tempera, pencil; 9⅞ × 17; inscribed, Benton, Benton '28.

This drawing is the source for a painting of 1944, *Plantation Road* (Carnegie Institute, Pittsburgh), and was dated to 1940 by Matthew Baigell, a leading Benton scholar, in a monograph written with the artist's cooperation.[10] Baigell's date is almost certainly close to the mark: Benton reconnoitered large hunks of the South again just before and after the outbreak of World War II and returned to southern genre themes, such as cotton picking, in oils of the war and postwar years. The small reproduction of the work in the Baigell volume is innocent of any date. Thus Benton added "1928" to the face of the drawing some time after 1972–1973.

6. *An Artist in America*, p. 164.
7. Ibid., p. 185.

8. Ibid., pp. 169–70.
9. Ibid., pp. 172–73.
10. Matthew Baigell, *Thomas Hart Benton* (New York: Harry N. Abrams, 1973), plate 137.

2–1. Rice threshing, Louisiana. 1926.

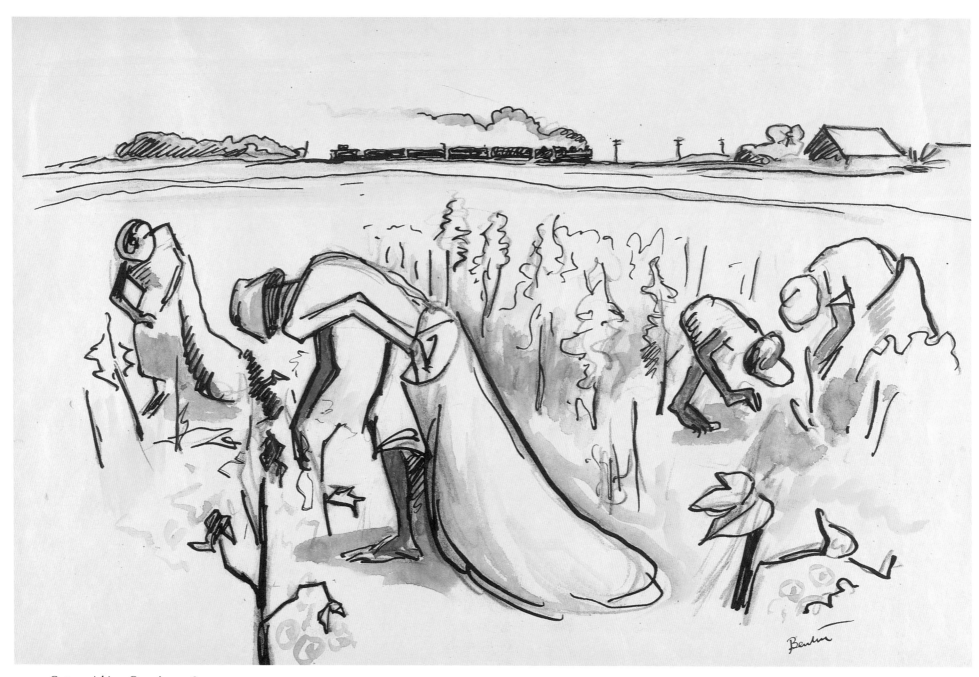

2–2. Cotton picking, Georgia. 1928.

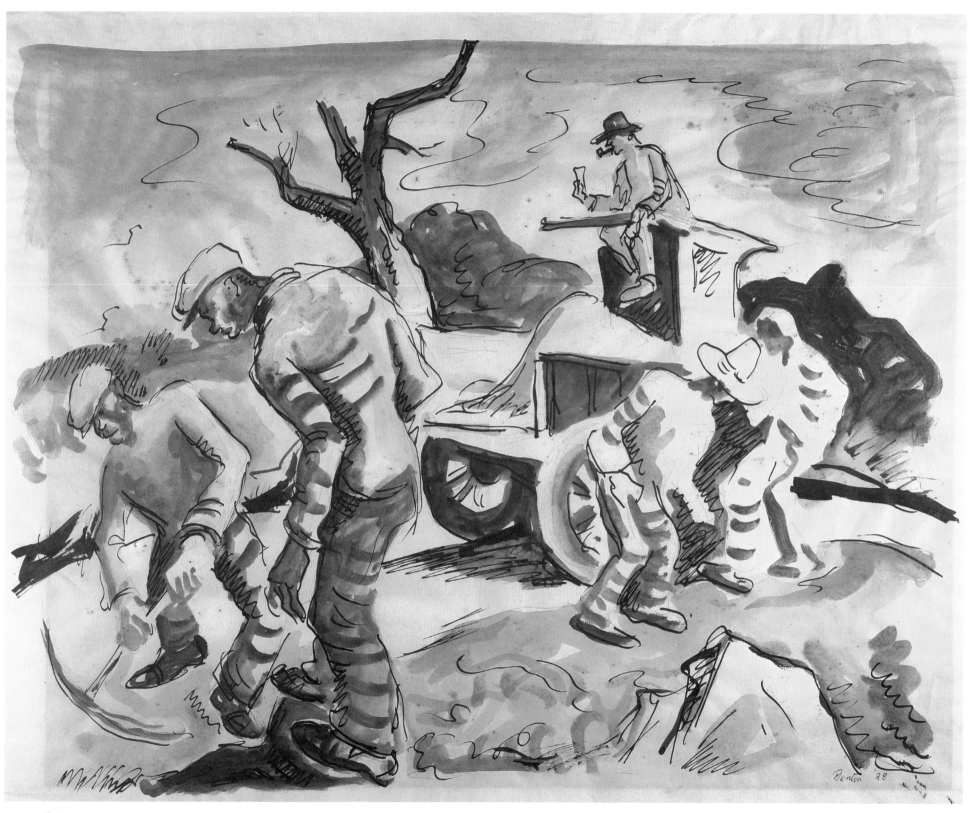

2-3. Chain gang. 1928.

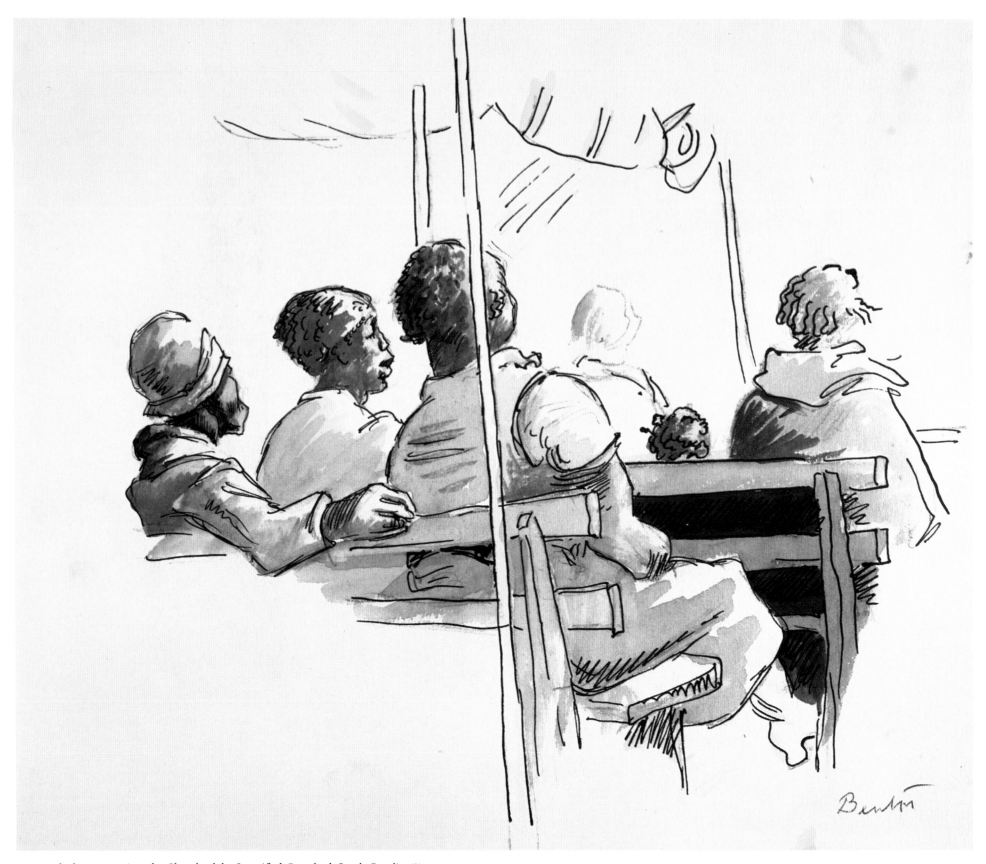

2–4. Black tent meeting, the Church of the Sanctified, Beauford, South Carolina(?). 1930.

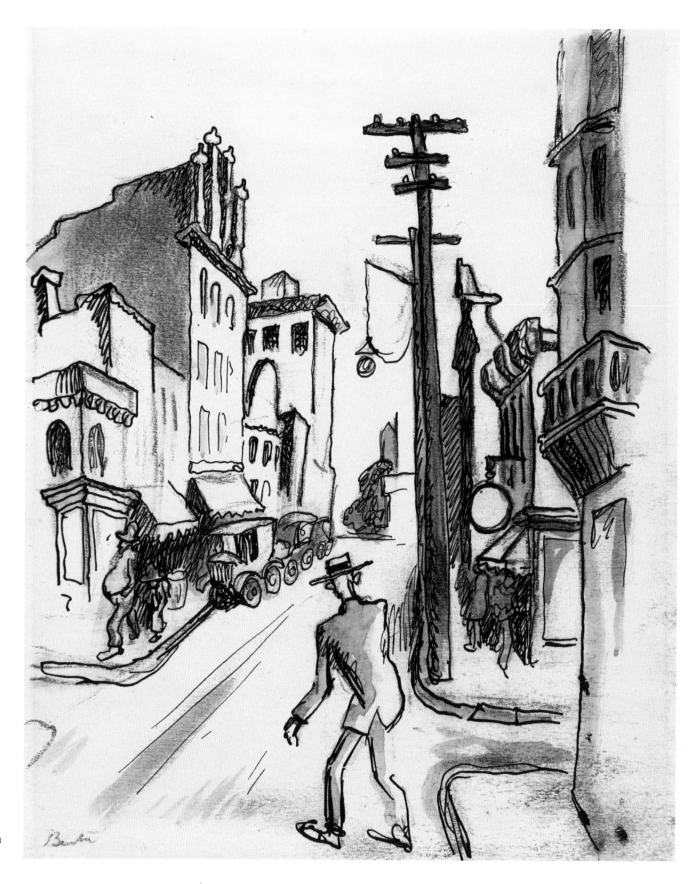

2–5. Beale Street, Memphis, Tennessee(?). Circa
1930–1934.

2–6. Fightin' chickens, Arkansas(?). Circa 1937–1940.

2–7. Waiting. Circa 1940.

3 That Old-Time Religion

The religious furies of the southern poor are blinding. The rich believe on Sundays and with a proper respect for the "things that are Caesar's" and for the physical things that are the devil's, though they take the latter with a snicker, but the poor believe all the time. They know nothing about Caesar's things and they easily confuse the devil's urges with the "will of the Lord," or, when they are too flagrantly not of "His will," as objects for gorgeous and exciting testimonial penance: "And I seen that woman a-washin' herself in the brush, brother, with her paps a-stickin' up, and the devil bein' in me—"[11]

Thomas Hart Benton

WHEN Benton took to the backroads in search of the real America, the mainstream Protestantism of the cities was epitomized by Bruce Barton's *The Man Nobody Knows*, the nonfiction bestseller of both 1925 and 1926 that portrayed Jesus as a smooth, successful business executive. But darker, wilder forces were stirring beneath the placid surface of conventional piety. The Scopes trial—the "monkey" trial—had just concluded in Dayton, Tennessee, with a stubborn reaffirmation of fundamentalism. In Los Angeles, the flamboyant "Sister Aimee," evangelist Aimee Semple McPherson, had disappeared into the sea, only to turn up again, miraculously rescued from a "kidnap" plot: even more miraculously, she regained control of her flock and her gaudy Angelus Temple despite convincing evidence she'd been just fine the whole time, albeit dallying in a "love nest" in Arizona with a married man. *Elmer Gantry*, Sinclair Lewis's 1927 parody on tent evangelism, bogus holiness, and Sister Aimee's sisters of the cloth both delighted and scandalized a nation increasingly aware of this fresh tide of revivalism, welling up from God-knows-where into the screaming headlines of the Hearst papers.

Not since the tense days of World War I, when John Reed and artist George Bellows together had covered Billy Sunday's hog-stomping, gospel-shouting rallies for *Metropolitan* magazine, had there been such a mania for the more extravagant forms of religious expression and such widespread public interest in the hysteria unleashed by the yowling divines. It was in the spirit of Bellows's reports from Philadelphia in 1916 that Benton chose the "Holy Roller Camp Meeting" as one of four themes for the much-admired documentary drawings he exhibited at the Delphic Gallery late in 1929. His published accounts of sojourns among the Holiness people, the brethren of the Church of God, and assorted Baptists and Methodists sermonizing in tumbledown little board churches up and down the ridges of the southern mountains make it clear that Benton was intensely interested in the phenomenon, as a kind of regional folkway, like banjo music, although he was as skeptical about the orgiastic goings-on he witnessed as were the hard-bitten mountain ladies he somehow always contrived to find in the seat next to him. But it is just as evident that Benton was not above courting popular attention by selecting topical and controversial themes for particular scrutiny. That old-time religion—and the baroque excesses thereof prevalent in places far off the path beaten by the big-buck reverends—was one such "hot" story in the very modern twenties.

3–1. Holy Roller camp meeting, western Virginia. 1926; watercolor, ink, pencil; 9 × 7; inscribed, Benton; verso, Holy Rollers Calling the light from Zion.

The preacher whose "missionaryin'" brought him to this remote spot in the Cumberlands was himself a Tennessean and a follower of a black man whom the Lord had visited in Los Angeles and told to spread the gospel of Holiness. He was also a banjo player (his three "brethren" played guitar). Benton stayed for the day, in a gully deep in the woods, watching a young woman roll about in the ecstasy of conversion, listening to a fire-breathing sermon likening the power of the Lord to a Norfolk and Western engine in the morning, eating a fried-chicken lunch at noon, and witnessing a total-immersion baptism in a creek in the afternoon.

The neck of the silent banjo pokes up from the crowd, like the neck of another skinny deacon, in this masterful sketch of the beginning of the sermon. Benton has a keen eye for humorous incongruities. Here he takes special delight in the contrast between the flapper in her flimsy little frock and cloche hat languishing against the sapling at the left and the traditional mountain woman in her bonnet leaning against

11. *An Artist in America*, p. 97.

the tree at the right. Like other drawings made on the road, this one uses several media: a first, quick impression from life, done in pencil; a reinforcement and refinement of linear detail in ink, perhaps added an hour or two later; and the wash, applied last, at the end of day, when the sketchbook was about to go back in the artist's kit. The green tone of the wash is especially appropriate in capturing the mood of the secluded, woodsy place where the worshipers met.

3–2. Holy Roller camp meeting, western Virginia. 1926; ink wash, pencil; 9 × 7; inscribed, Reds in trees Buckets hanging, Benton; verso, Holy Rollers God takes hold.

This drawing is a view of the same incident, although the tempo of the sermon has picked up considerably. The notes in the upper left corner of the sketch indicate that Benton hoped to use this research material at a later date. And he did just that in 1932. This camp meeting, down to such details as the sap buckets on the trees, the style of the rustic pulpit, and the coloring of the leaves on the trees, is recapitulated in the "Arts of the South" panel of the Whitney Museum mural of 1932.

3–3. Little girl at Holiness service, Tennessee(?). Cira 1928–1930; pencil; 19⅞ × 24⅝.

In 1963, Benton told the *Kansas City Star* that he had made the sketches for *Lord, Heal the Child* (Mr. and Mrs. John W. Callison, Kansas City, Missouri), his major 1934 canvas on southern evangelism, in Tennessee.[12] Wherever he met "Red," the banjoist, and the powerful lady preacher for whom Red played, the incident haunted him. In the painting, there is no hint of the problems that beset the service the night Benton watched the preacher try to heal a little girl held in her father's arms (in the painting, the child sits on a low stool for pictorial effect). That evening, a boy was knifed outside by a rival after making eyes at a girl in the back of the church, and most of the congregation trickled away to watch.

This drawing is one of several of this same little girl in a hat; it is a good example of how Benton redrew figures after his life sketches for use in paintings, sharpening detail and texture. Not all the sketches used to assemble the cast of pungent characters in the painting came from that particular service with the lady preacher, however. The women seated on the bench just in front of this little girl were drawn in 1926 at another Holy Roller meeting, west of Greenville, South Carolina.

3–4. The Holiness band, Tennessee. 1930–1934; pencil; 19⅞ × 25.

Benton's ink-and-pencil sketch of Red, the banjo player, was used as an illustration to the text of his 1937 autobiography, *An Artist in America*. But when it came time to turn his usual bust-length sketches into full-length figures in his murals and paintings, Benton not only redrew features and clothing in a more precise manner but also used models to study the anatomical complexities of poses. In the end, he blended one sketch with another to produce powerful composites, such as the little girl or Red the banjo player, or the guitarist, or the harmonica player in *Lord, Heal the Child*.

The guitarist in this life study from the model anticipates Benton's treatment of the cowboy singer in the Nashville mural by some forty years, just as the choir in *Lord, Heal the Child* seems to have been the prototype for the choir in that late mu-

12. Clipping, *Kansas City Star* (June 23, 1963).

ral. Benton's contention that he held on to his drawings because he needed them finds strong support in such details.

3–5. The Preacher, New York. 1930; pencil; 15 × 10¾; inscribed, The Preacher, Benton.

Surrounded by the buxom strippers of Minsky's matinee—"50 Girls 50," blares the billboard on the marquee—the street-corner evangelist, whose own, hand-lettered sign proclaims the love of God, is almost lost in the cacophony of "City Activities" that trumpets from the New School murals. As a Salvation Army band adds to the racket, a tall women falls to her knees on the sidewalk and flings her long arms up toward heaven: with her heavy features and brunette sensuosity, she is a flippant reference to Sister Aimee. And, as Benton presents it, religion in the city is something like burlesque—noisy, sexy, and most entertaining.

3–6. Study for the "Appalachian Oread." 1932; pencil; 11 × 8½; inscribed, Benton.

Benton first drew this girl in western Virginia at the camp meeting beneath the trees. She had risen from her place, twitched, and fallen to the ground in a perfect demonstration of what the name *Holy Roller* meant. He was particularly interested in her up-to-date clothes—the "simple white dress" and "little cheap but stylish hat" he took pains to mention—as though the rolling and the moaning might have been more in character had the female on the ground been one of the ignorant, back-country women in old-fashioned poke bonnets who also attended the meeting but were, in fact, dubious of just such carryings-on.

Consistent in style with the preparatory drawings done in New York rather than with the quick attitude or character studies done on the road, this seems to be a purposeful sketch for the Whitney Museum "Arts of the South" panel, made from the model, and incorporating the famous hat drawn earlier in the mountains of Virginia.

3–7. Hat, shoes, dress. 1938; pencil; 18 × 11⅝; inscribed, Benton.

These are the garments discarded by Susannah on the bank of a Missouri "crick" where she is bathing, observed by a sneaky pair of church elders, in the notorious canvas *Susannah and the Elders* (California Palace of the Legion of Honor, San Francisco). This story from the Apocrypha, translated to the Ozarks, shocked Missouri when the painting, with its implied comparison between good, upright Missouri elders and those biblical sinners, was exhibited in St. Louis in February 1939. Evangelist Mary H. Ellis took particular exception to the "very nude" nude and vowed to have it removed from the state: the incident triggered renewed calls for Benton's dismissal from the staff of the Kansas City Art Institute.

Of course, such Old Masters as Veronese, Tintoretto, and the great Rembrandt had used the theme before, and Benton's interest in the great art of the past was well known. But the precedents and Benton's learning paled before the obvious intent to tweak the Bible Belt for a certain preferred disparity between real-life actions and Sunday School platitudes.

The inspiration behind the painting was not a momentary whim, however, as this drawing makes clear. In fact, the idea had been simmering for a decade, brought to a boil perhaps by the memories Benton set in order in 1936 for *An Artist in America*. The text cited above—the introduction to Benton's long description of the Holy Roller camp meeting in western Virginia in 1926—clearly anticipates the theme later used in *Susannah and the Elders*. And Susannah has just discarded on the grassy bank the "little cheap but stylish hat" of the "Appalachian Oread."

3–1. Holy Roller camp meeting, western Virginia. 1926.

3-2. Holy Roller camp meeting, western Virginia. 1926.

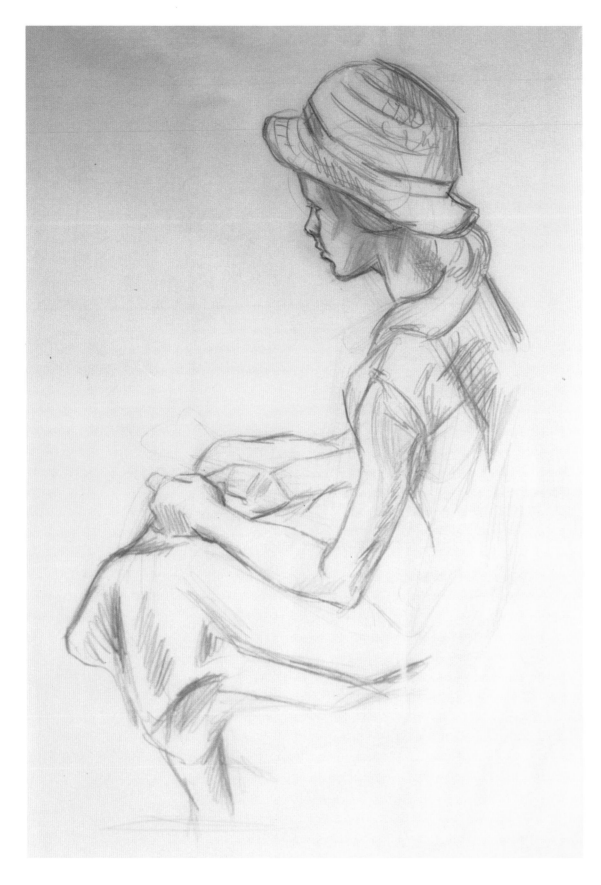

3–3. Little girl at Holiness service, Tennessee(?). Circa 1928–1930.

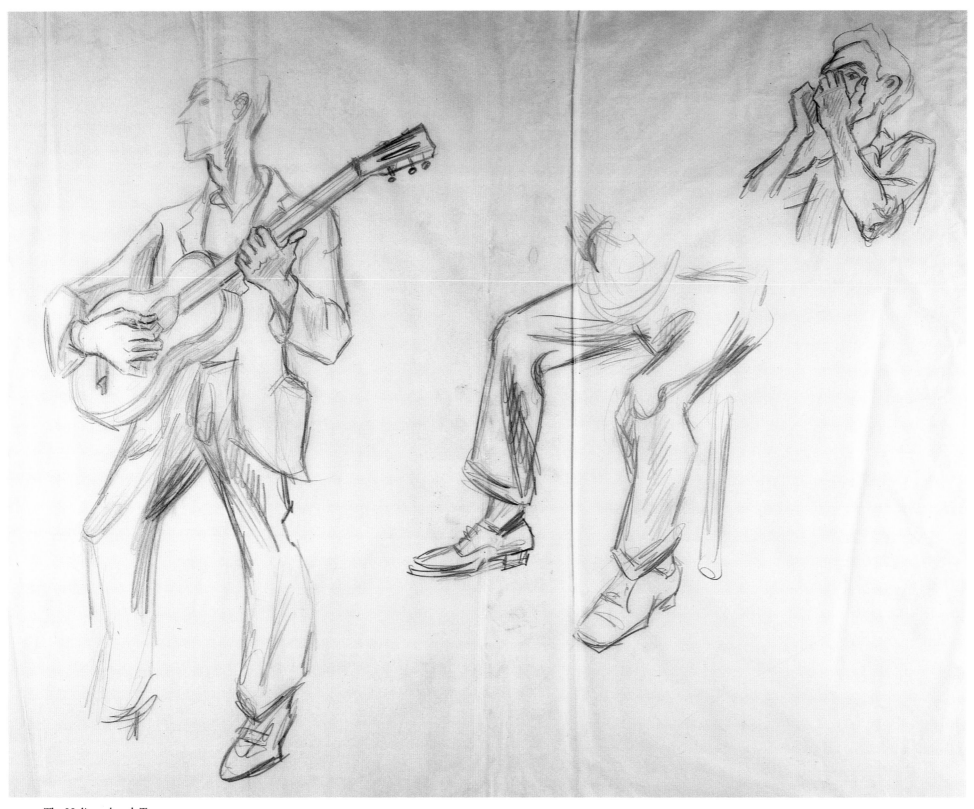

3–4. The Holiness band, Tennessee. 1930–1934.

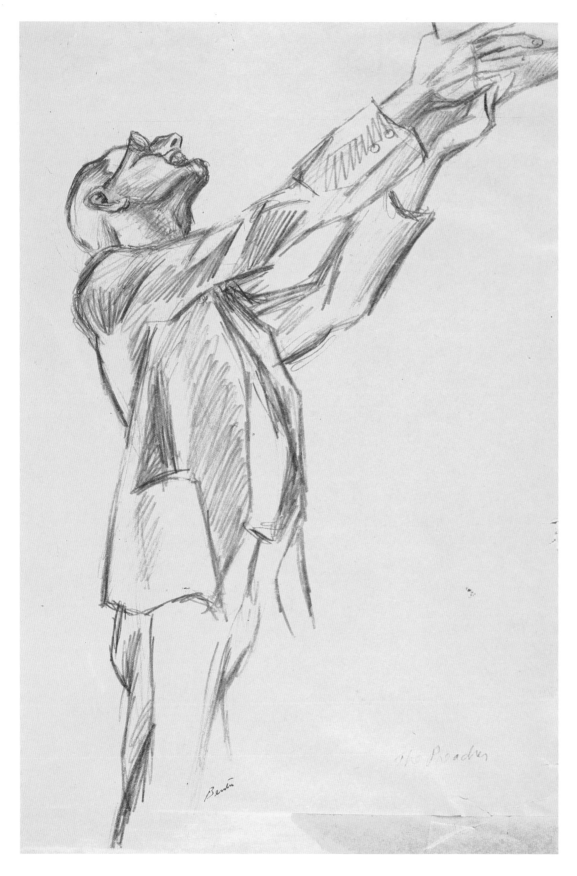

3–5. The preacher, New York. 1930.

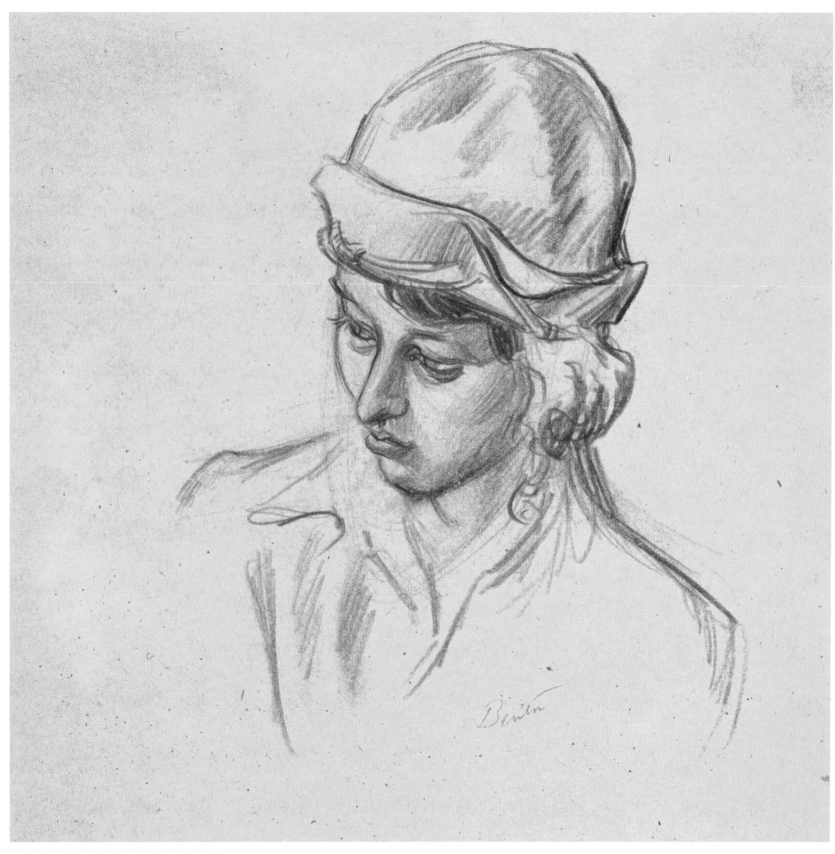

3–6. Study for the "Appalachian Oread." 1932.

3-7. Hat, shoes, dress. 1938.

4 Way Out West

FROM the days of his childhood, Tom Benton was obsessed with the West, with the larger-than-life, heroic West of the cowboy and the Indian, and the just as mythical West of Frederick Jackson Turner's famous frontier theory of American history. What he liked about drawing things when he was a little fella, he always said, were the wonderful stories from which he made his first schoolboy illustrations. The stirring exploits of Prairie Sam, Apache Charlie, and Buffalo Bill filled his dreams, and, in distant retrospect, the epochal events of his growing-up years were seeing Buffalo Bill Cody's Wild West Show in person at the 1904 St. Louis world's fair (he even got to shake hands with Geronimo!) and sneaking a peek at the garish chromolithograph of *Custer's Last Stand* just visible in grown-ups' territory, beyond the swinging doors of a Neosho saloon.

He never lost his relish for the James Fenimore Cooper cum cowboy-and-Indian stuff that found its way into the largely documentary murals of the thirties and, finally, in a chastened, almost archaeological form, came to dominate the murals of the fifties and early sixties.

Benton called his Wild West images at the Whitney a "romantic indulgence" and treated his own affinity for dime novels as a species of folklore, a remnant of a nineteenth-century, Tom Sawyer boyhood.[14] The late murals at the Truman Library, the River Club, and Robert Moses's power plants are folkloric in a different way, asserting by their very presence that the frontier events commemorated and exalted in paintings of enormous, almost frontier scale somehow shaped the modern-day descendants of those heroes of old. Their progeny, who come to see Tom Benton's murals, become direct partici-

pants in a pageant of mythic Turnerism no less powerful for its obvious romanticism.

Benton had Turner and the cowboys on his mind when he went out West in 1926 and 1927, looking for the last American frontier. Throughout history, the frontier had been the place to start anew, to find the pot of gold: it was a shifting spot on the map, chased westward by the restless ones, who always dreamed of something more, something better, just over the next rise of land. Turner declared the frontier closed in 1893, but Benton found it alive and well in Borger, Texas, in 1927. Borger was a gas and oil "boomtown," sprung up overnight. There was money to be made. The trucks rolled day and night, the drills hammered the plains, and, along the dusty Main Street with its flimsy false-front dancehalls and its painted dancehall girls, the Wild West of old Buffalo Bill and William S. Hart and the silver screen seemed to have come to wild and woolly life again.

4–1. Oil field, Texas Panhandle. 1926–1927; sepia, ink, pencil; 7 × 8¾; inscribed, Benton; verso, Oil fields Texas Panhandle 1926.

One of Benton's major fears was that the "exploitative" business practices that went hand-in-hand with new industrial technologies would ravage the land and destroy the culture he was trying so hard to record and preserve from the onslaught of Babbittical modernism. At the same time, however, there was a certain, unique romance in places like the oil fields of Texas and Oklahoma, where the work never stopped, where roustabouts prowled the streets by day and night, where the best and worst in the American character seemed to coexist in one, mad orgy of doing. The energy, the sheer spectacle of the "boom" attracted him, despite himself.

Some of Benton's best drawings of the twenties were done in the oil fields. Whereas the Southern drawings stress rich human incident and character studies, and

13. "Benton v. Adams," *Time* 47, no. 9 (1946): 49.
14. Thomas Hart Benton, statement in *The Arts of Life in America: A Series of Murals by Thomas Hart Benton* (New York: Whitney Museum of American Art, 1932), p. 4.

the industrial drawings of the "Lumber Camp" and "Coal Mines" series emphasize machinery, the western work strikes a balance between man and nature. The flatness of the prairie landscape, with its sparse clumps of vegetation, prevails despite the litter of derricks and tanks that represent the advent of modern technology. And the brutal machines themselves are softened and humanized by touches like the washline, the billowing tent, and the truck that shows there's someone home.

4–2. Main Street, Borger, Texas. February 1927; ink, pencil; 7 × 8¾.

Benton drew Main Street first from the second-floor window of Carol Dilley's American Beauty Bakery; from that vantage point, he could see "Midway Dance," visible here just below the oil rig, and several of the hotels that had sprung up like mushrooms after rain to accommodate the workers and the "insinuating whores" who followed them to Texas. This particular view was drawn at street level, however, from the front stoop of one of Borger's several Prohibition-era "drug stores," and incorporates many of the details used in the 1928 painting *Boomtown* (Memorial Art Gallery of the University of Rochester, Rochester, New York) that became, Benton said, "one of my best-known 'Regionalist' pictures." [15]

Boomtown, in fact, is also the first painting by Benton to exhibit the full range of stylistic and iconographic traits associated with the Regionalist movement. Among these characteristics is a deliberate double vision, an interpenetration of the modern present, with its ubiquitous cars and advertising signs, and the romantic past of the cowboy movie, with its broad streets, false facades, and white Stetsons. Benton's critics of the thirties often charged him with being no realist at all: instead, they said, he painted dime-novel yarns. Benton's sketches show that America was not as modern as the critics thought and that his paintings are reasonably faithful to the special, resonant sorts of reality he looked for on the road.

4–3. Will Ream, Wyoming citizen, Tullis, Wyoming. 1928–1930; ink, sepia wash, pencil; 11¾ × 9; inscribed, Benton, Will Ream Tullis Wy.; verso, Wyoming citizen.

This portrait drawing is similar to the southern sketches in the quality of Benton's trenchant observation. But there is a new austerity in the line and in the handling of wash that is particularly well suited to the spare vistas of Wyoming.

4–4. Rodeo at the fairgrounds, central Wyoming. Fourth of July, 1930; crayon; 10 × 13; inscribed, Benton.

In 1930, Benton spent the summer driving around the back country of the West with Glen Rounds, one of his students who hailed from the Dakotas and knew a thing or two about Wyoming. The night of July 3 found them holed up in a 25¢ cabin near the fairgrounds, waiting for the rodeo to start.

They posed as reporters for the *Denver Post* in order to have the run of the grandstand. Benton liked the intimacy of the rodeo—the fact that the broncobusters and the calf-ropers were local celebrities. He noticed, too, the telling juxtaposition of

the arena, with its display of cowboy skills, and the dirt just beyond the infield, where hundreds of cars and farm trucks were parked. And he picked out successive layers of frontier culture, all present at the rodeo together: the old cowhands, the sheep ranchers, and the guests, "half-lit," from a dude ranch down the road. [16]

4–5. Western landscape. Circa 1930; ink, pencil; 7 × 8¾; inscribed, Benton.

The suggestive asperity of this drawing finds its counterpoint in several lean, laconic paintings of the period: *New Mexico* of 1926 (Denver Art Museum) and *Cattle Loading, West Texas* of 1930 (Phillips Academy, Andover, Massachusetts). The same landscape forms the background for the "Changing West" panel in the New School murals.

4–6. Montana cowtown facade. Circa 1965; ink, sepia wash, pencil; 11½ × 14⅝; inscribed, Benton '65, Montana cowtown facade; verso, $150.

In 1948, Benton began an intensive study of the West, culminating in a group of paintings, drawings, and prints sometimes called the "Far West" series. His first fieldwork was done in New Mexico, Utah, and Wyoming, and his best-known works of the fifties are stupendous landscapes—such as *The Sheepherder* of circa 1958 (Mr. and Mrs. Fred McCraw, Prairie Village, Kansas)—depicting the Grand Tetons.

This drawing, an old man's reprise of the Borger sketches of 1927, was probably done on the long, exploratory trip Benton made up the Missouri River from Omaha to Three Forks, Montana, and from there into the "Rendezvous" area of the Wind River Mountains, following the route of Lewis and Clark. The romantic of the twenties had become the western explorer and historian of the sixties.

4–7. Costume notes for the figure of a Seneca warrior, Oklahoma. May 1956; pencil; 16¾ × 7½; inscribed, Benton.

The Truman Library mural of 1959–1962 is entitled *Independence and the Opening of the West*. It is, in other words, a full-blown illustration of the Turner thesis, with the mountain men, the voyageurs, and the plainsmen surging westward from the right side of the panel and meeting, at the central doorway that interrupts the wall, the vanishing Indian tribes of the West. Like Harry Truman, Benton had always prided himself on the accuracy of his vision, his clear-eyed realism. But it was one thing to make a rendition of a real, live cotton picker or rodeo star seem real, and quite another to depict historical times with the same wealth of authentic detail.

Benton found the descendants of the Pawnee and Cheyenne Indians of old Independence in Oklahoma. Charlie Wilson introduced him to Brummett Echohawk, a Pawnee artist from Tulsa, who rounded up "the right Indians, the right implements, and the right costumes." [17] Benton sat down and drew them as he found 'em. The old West *was* almost gone, and Tom Benton was determined to hold it fast, on the wall of the Truman Library. Three years earlier, he had made this sketch in Oklahoma, after learning from Wilson that the remnant of the Seneca nation from New York State lived there. Thus, the details in his murals for the New York State Power Authority at Messena were historically accurate.

15. Karal Ann Marling, "Thomas Hart Benton's *Boomtown*: Regionalism Redefined," in Jack Salzman, ed., *Prospects: The Annual of American Cultural Studies* (New York: Burt Franklin and Co., 1981), 6: 73.

16. *An Artist in America*, pp. 213–22.
17. Ibid., pp. 355–56.

4-1. Oil field, Texas Panhandle. 1926–1927.

4–2. Main Street, Borger, Texas. February 1927.

Will Ream
Tullis, Wy.

4–3. Will Ream, Wyoming citizen, Tullis,
Wyoming. 1928–1930.

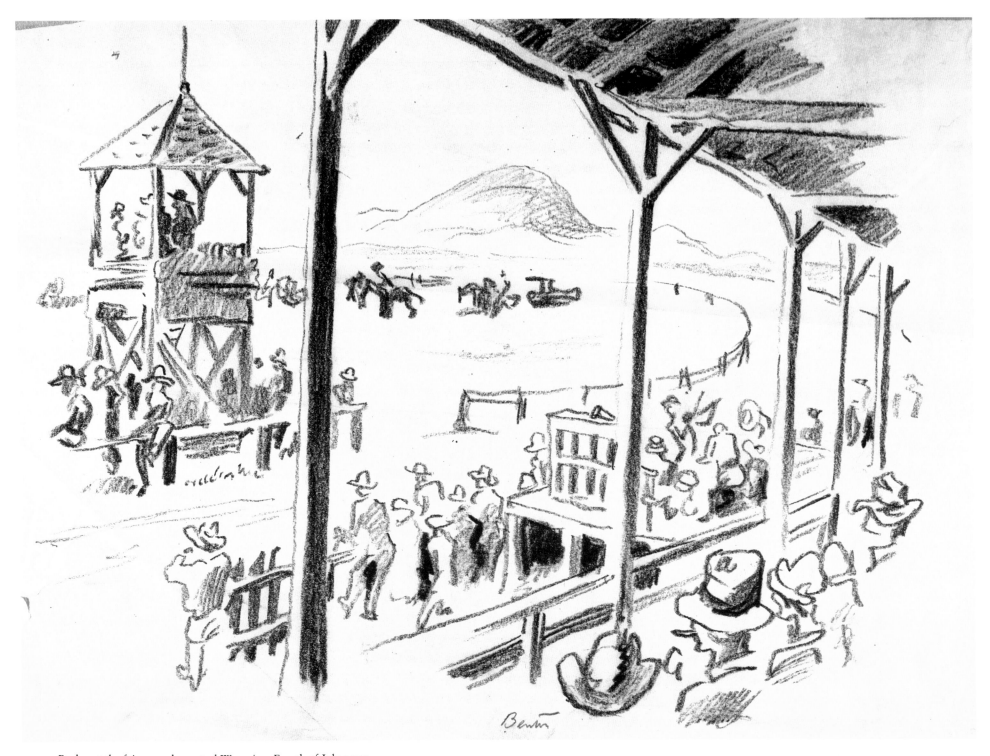

4–4. Rodeo at the fairgrounds, central Wyoming. Fourth of July 1930.

4–5. Western landscape. Circa 1930.

4–6. Montana cowtown facade. Circa 1965.

4–7. Costume notes for the figure of a Seneca warrior, Oklahoma. May 1956.

5 Mill, Mine, Factory: America Works

THE energy of Borger, Texas, on the boom—the ferocious gusto of the whores, the preachers, the patent-medicine pitchmen, the truckers, and the drillers who prowled Main Street—was the quality Benton thought characteristic of America as a whole during the go-go twenties, when his exploratory trips also took him to the lumber camps and coal mines of the South and to the steel mills of Pennsylvania. In the "great democratic dance" of capital and labor that kept the factories running night and day and celebrated the chicken in every pot, the nation itself was booming with a reckless, restless dynamism Benton struggled to convey in line and color.[19]

He made his steelworkers and factory hands look maniacally active by the knobby, lumpy mannerism of his drawing: Benton's workers have more joints, it seems, than nature ever intended, all the better to bend and stoop and twitch with muscular effort. In Benton's sketches, one critic wrote, "a tractor is an aggressive animal"; his factories and machines, too, have lives of their own, and they chug and wheeze and belch in rhythmic counterpoint to the exertions of their human masters.[20] The factory is humanized. And the work done there, in Benton's series of industrial studies and in the murals based upon them, is the kind of work ordinary people do.

Sometimes, carried away by admiration for the nearly seven years of graphic research that stood behind the New School and the Whitney murals,

commentators exaggerated Benton's catholicity of vision just a mite. In their litanies of Benton's people, millionaires sometimes turn up, cheek by jowl with waiters and stevedores. But, until the midthirties, Benton's America was a blue-collar democracy with little enough room for the comfy middle class and none at all for the bloated plutocrats at the top of the economic ladder. His people, his real American types, work with their hands. Those who don't, like the worried stockbroker, fussing with his ticker tape in the New School mural, are faintly sinister characters.

5–1. Steam shovel, New York. 1924; watercolor, tempera, ink, pencil; $7\frac{3}{8} \times 5$; inscribed, Benton '24, Steam shovel #4.

The term *Regionalism*, associated as it often is with the rural scene, obscures the fact that Thomas Hart Benton was a major figure in the artistic exploration of industrial America and the advent of the skyscraper age, both themes associated with the modernistic end of the aesthetic spectrum in the twenties. Energy and motion are conveyed in this study by the wiggle of the heavy lines and by the skittery, cartoon-like "force lines" made with a more delicate point.

5–2. Pulp, paper, and sawmill town, West Virginia(?). 1928–1929; ink wash, pencil; 9×12; inscribed, Benton '28; verso, Lumber camp series no. 15, Pulp paper and sawmill town.

Number 15 in the "Lumber Camp" series exhibited in 1929, this dramatic ink drawing served as the basis for a full-page illustration entitled "Factory Workers" in

18. Lloyd Goodrich, "The Delphic Studios," *Arts* 16, no. 3 (1929): 185.

19. *An Artist in America*, p. 203.

20. Lloyd Goodrich, "Thomas Hart Benton," in *New Art in America: Fifty Painters of the 20th Century*, ed. John I. H. Baur (Greenwich, Conn.: New York Graphic Society/Praeger, 1957), p. 130.

Leo Huberman's 1932 historical text for younger readers, *We, the People, The Drama of America*.[21] In the illustration—one of fifty-odd plates—Benton added a stooped procession of workmen, filing out a factory gate positioned in the right foreground. Huberman's book, which was nominated for the Pulitzer Prize and highly praised in reviews in the liberal press, aimed, said the *Baltimore Sun*, to show readers "that it is the toilers and not the fighters who have done the most for progress." The *New Republic* called it a history "in the true sense, with the mass as hero and victim, too."

The fact that Benton undertook this commission and was able to draw all the illustrations from the pages of his sketchbooks and the studies for his recent murals, speaks volumes about his ideological position as the New Deal began and further suggests how ill-used he was by his critics on the far left.

5–3. Sawmill, Tennessee(?). 1928–1929; sepia, ink, pencil; 9 × 11¾; inscribed, Benton; verso, $300, Ozark Saw-mill.

A crisp, clean, and wonderfully animated drawing, this sketch personifies the jerry-built apparatus of the mill with the jaunty angle of the stack and the prehensile reach of the drive belts. The men and their machine are both drawn in the same way, with an emphasis on points of articulation and potential movement. In the jobless thirties, exaggerating the size of a worker's hands, as Benton does here, became a widespread convention, an oblique reference to the troubled world of work: these were the empty hands that longed to grasp the tools of production once more.

5–4. Steel plant, Pennsylvania. Circa 1928–1930; pencil; 10¼ × 12⅛; inscribed, Benton; '28.

Although Benton added "1928" to this drawing many years after the fact, the scene suggests that it could also be associated with his trip to Pittsburgh and the Sparrows Point plant of Bethlehem Steel in 1930. With some changes in headgear, this particular sketch seems to have served as the point of departure for the immediate left foreground of the "Steel" segment of the New School murals.

The toothed paper used for the drawing is a rarity. Benton preferred a smooth ground, often used in conjunction with a very hard pencil. Since flashy effects are not easily produced in such austere media, the most casual Benton sketch is, in fact, a highly disciplined performance.

5–5. Crucible at the Bessemer Converter, Bethlehem Steel, Pittsburgh. 1930; ink, watercolor; 11½ × 9; inscribed, Benton; verso, $200.

This drawing, too, was used as the source for the crucible scene in the New School panel. Benton was particularly struck by the expressive postures of the tiny figures of the steelworkers, pushing on rods held at acute angles. The strain and the muscular exertion of the pose led Benton to repeat it over and over again in the "Steel" segment of the New School murals; the miners, by way of contrast, are stooped over from their hours in the shafts.

5–6. Shoe factory, the Assembly Line, St. Louis. 1935–1936; pencil; 8⅜ × 11⅞.

In this drawing made from life in preparation for the depiction of St. Louis on the south wall of the Missouri Capitol, Benton brought women into the industrial workforce. Toiling away below the tower of Union Station and a poster on a warehouse wall advertising the appearance of "The Veiled Prophet," these factory girls are a relatively minor note in the overall mural composition. Yet the wealth of detail, taken directly from this on-the-spot study, is remarkable.

The notice posted on the column at the right, the tiny electric fan, and the odd design of the workbench all find their way into the finished mural and contribute to the sense of hyperauthenticity—a surfeit of reality—that grows in Benton's work between his departure from New York and his dismissal from the Kansas City Art Institute. Although a kind of superrealism verging on the surreal is associated with the war years and the big nudes done just prior to that time of crisis, this drawing and other exploratory studies for the Missouri cycle suggest that a major stylistic reorientation began earlier than is generally thought.

5–7. Brewer, St. Louis. 1935–1936; pencil; 6¼ × 6⅜; inscribed, Benton.

Brewing is the other industry used to characterize St. Louis in the Missouri Capitol; on the opposite half of the same wall, Kansas City is represented by a meat-packing plant, as well as by the Rotary-style luncheon presided over by Boss Pendergast.

In the midst of the mechanization of American life, Benton saw the human elements first; the men sealing the beer kegs stop for a moment to sample their own product. The pretty secretary, typing away just in front of them—it is not entirely clear whether her "office" serves the brewery or the shoe factory—keeps a fizzy cherry soda, with a straw, at her elbow.

21. Leo Huberman, *We, the People*, rev. ed. (New York: Monthly Review Press, 1960), p. 230.

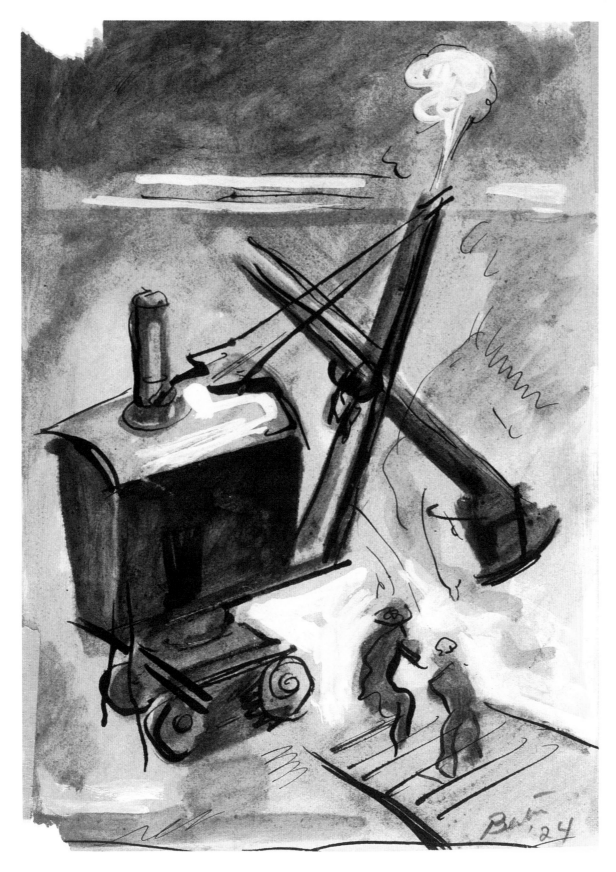

5–1. Steam shovel, New York. 1924.

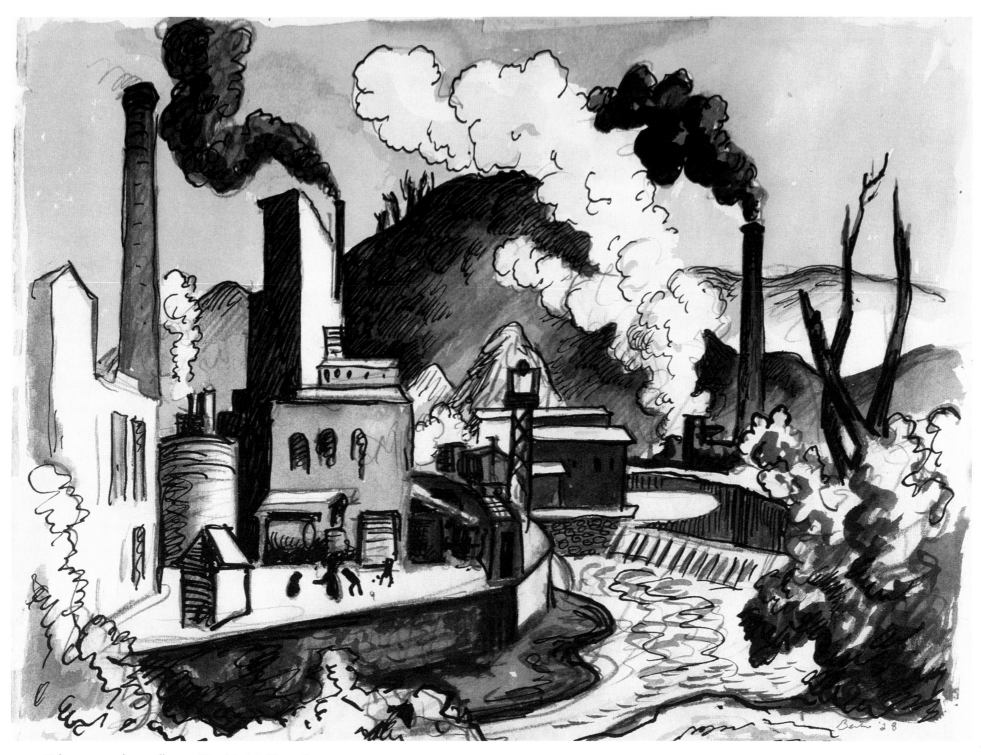

5–2. Pulp, paper, and sawmill town, West Virginia(?). 1928–1929.

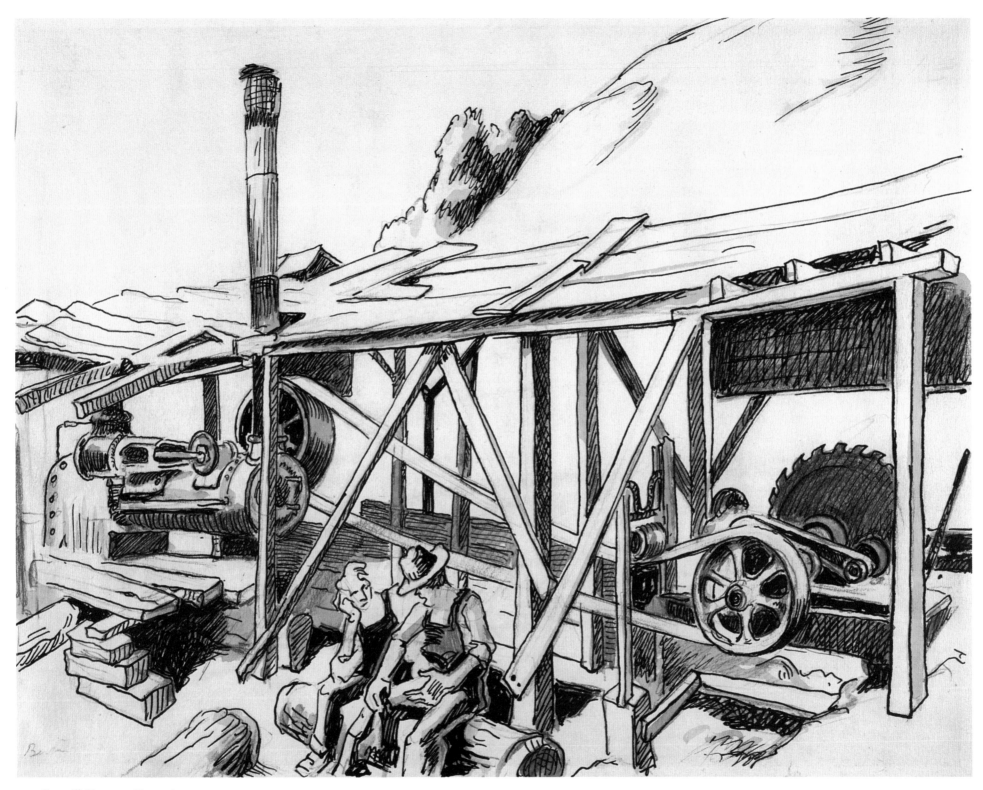

5–3. Sawmill, Tennessee(?). 1928–1929.

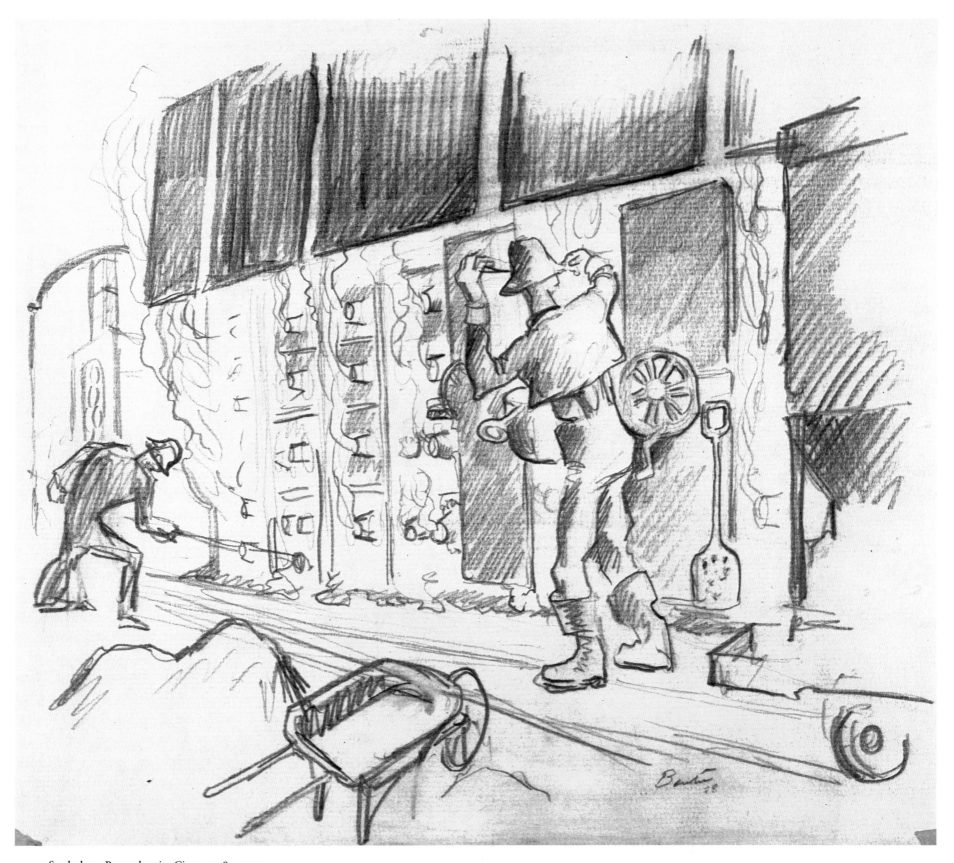

5–4. Steel plant, Pennsylvania. Circa 1928–1930.

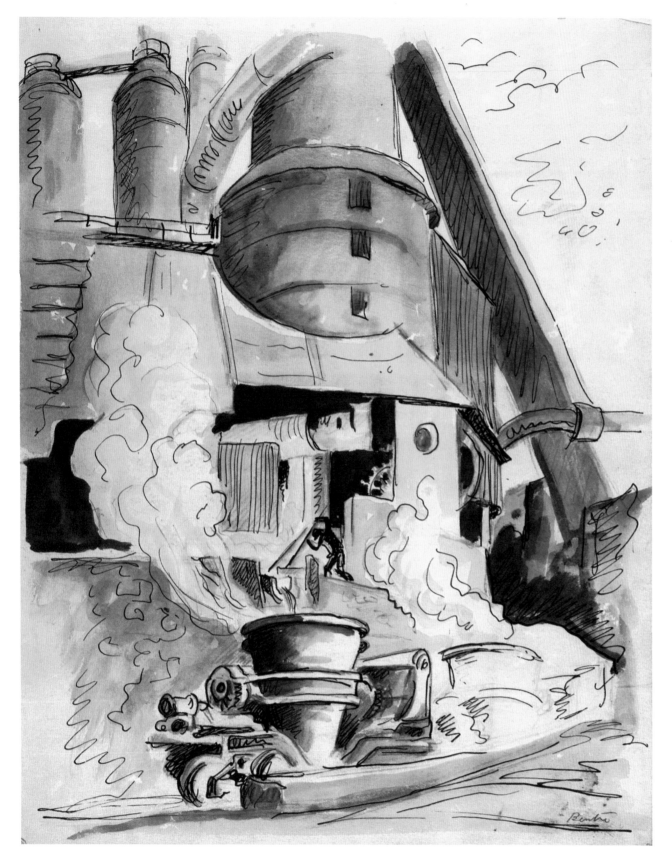

5–5. Crucible at the Bessemer Converter, Bethlehem Steel, Pittsburgh. 1930.

5–6. Shoe factory, the Assembly Line, St. Louis. 1935–1936.

5–7. Brewer, St. Louis.
1935–1936.

6 On the Road

His expeditions are not those of the traveler or sightseer, the social reformer or the statistician; they are in the nature of the return of the native to the country of his youth.[22]

The net result of these expeditions was a veritable mountain of Americana, volume upon volume of notes, sketches, and finished drawings.[23]

Thomas Craven

DURING the thirties, Benton was, perhaps, the most famous artist in America, best known for the travels chronicled in his illustrated articles and popular autobiography as well as in his drawings and the controversial murals based upon them. But quite apart from the actual content of any given work, that penchant for going places struck a responsive chord in the American psyche.

In the twenties, when cross-country tourism and automobiling began in earnest, "gypsying" along the open road embodied the new freedom of the modern, machine age; such travel also symbolized the new wealth and leisure time that were the by-products of corporate prosperity. In the thirties, mobility took on a different meaning, one that Benton would explore in his two sets of illustrations for the movie and the Limited Editons Club versions of John Steinbeck's *The Grapes of Wrath*.[24] In 1939, he made sketches for his depiction of the Joads out on the road, in eastern Oklahoma and northwestern Arkansas. And somehow, drawings made on the running board of an old Ford by the most peripatetic of artists uniquely suited both the Steinbeck story and the tenor of those troubled times. The novel traced the flight of the Joad family west, down Highway 66, in a beat-up truck. Tractored off their land, the Okies took to the roads to join a refugee army of the dispossessed for whom mobility in the Great Depression spelled not freedom but shame and despair.

The Joads were on the road in the thirties. So, suddenly, were carloads of FSA photographers from Washington, along with legions of socially committed writers, like Steinbeck, all there to "document" the plight of the migrants and, by showing America the sorry truth, to change it, to stop the anguished wanderings of the poor. Thomas Hart Benton had already been there for a decade, in good times and bad, using his documentary reports from the field as a spiritual bulwark against the forces of heedless change, the modern, monster machines that would push Ma Joad and Tom and "Roşasharn" off their land. But he also looked squarely at new ways and the new machines in his several industrial series of the period, as well as at a dizzying array of other things chosen seemingly at random, because they were there, or topical, or just plain interesting to look at. And that passion for collecting and savoring American stuff of a wildly polyglot character became a hallmark of Depression culture, too. In an imperiled society, marks of the bumptious, sprawling diversity of America demonstrated the vitality and the value of the enterprise. Throughout the shattering nightmare of the Great Depression, Benton's reports from the road were the self-administered pinches that proved America was really alive and well.

6–1. Pittsburgh. 1930; ink; 9⅛ × 6; inscribed, B.,30; verso, William Penn Hotel letterhead.

Drawn in the white heat of excitement on a sheet of stationery from the William Penn Hotel, this view out his hotel window records Benton's very first glimpse of the American industrial machine, going full tilt. The radical angle of vision and the vertical format add drama to the thrust of the tall stack in the center. He liked the effect well enough to reuse it in a plate for Huberman's *We, the People*.

6–2. The Century of Progress Exposition, Chicago. 1933; watercolor, ink; 10 × 14; inscribed, Benton; verso, $100.

Benton was in Chicago, at the fairgrounds, for the installation of his massive "Hoosier History" murals in the Indiana pavilion. The pylons, the towers, the aerial circus, and the rolling chair were all among the well-advertised attractions of the Chicago fair, along with Sally Rand, the new "Little Egypt," whose steamy act Benton also sketched.

The figure in the straw boater in the right-hand corner of the drawing acts as the viewer's surrogate in the composition, turning his back on the world outside the scene and plunging straight into the hurly-burly the artist conveys with a scratchy, darting line and festive strokes of color.

22. Thomas Craven, *Modern Art* (New York: Simon and Schuster, 1935), p. 335.
23. Thomas Craven, *Thomas Hart Benton* (New York: Associated American Artists, 1939), p. 15.
24. Creekmore Fath, ed., *The Lithographs of Thomas Hart Benton*, new ed. (Austin: University of Texas Press, 1979), pp. 90 ff., and Vincent Alvin Keesee, "Regionalism: The Book Illustrations of Benton, Curry and Wood," Ph.D. diss., University of Georgia, 1972, pp. 89–100.

6–3. Lobby, the Union Hotel, Flemington, New Jersey(?). 1935; ink wash; 10¼ × 9⅜; inscribed, Benton.

In January 1935, Benton went to Flemington to observe the sensational trial of Bruno Hauptmann, accused kidnapper of the Lindbergh baby. He spent a great deal of his time lurking and sketching in the lobby of the Union Hotel, where most of the principals were lodged. Whether Benton had a formal assignment to "cover" the trial is not entirely clear, but he was interviewed at length (in the lobby of the Stockton Hotel, local headquarters of the fourth estate) about his impressions of the proceedings by the *New York World-Telegram*. Along with the text of the often irrelevant interview—Benton seems more interested in recounting tall tales about his sketching expeditions to burlesque houses than he is in talking about the trial—that newspaper did publish several sketches from the series, including one depicting the examination of "Tentative Jurors."

6–4. In the pit, the Stock Market, New York or Chicago(?). Circa 1931–1935; pencil; 8¾ × 11⅝; inscribed, Benton; verso, Stock market.

Unlike most of Benton's drawings, this sketch of the trading floor cannot be firmly associated with any given mural, painting, or other project, although the "Big Board" and the upraised hands bear a strong resemblance to details in the stock-market tableau surrounding the broker in the New School mural of 1930–1931. There are some internal suggestions—a nightclub scene in the same group of drawings—that this is Gotham before the departure of Benton for the West and of burlesque for New Jersey.

The setting could also be the Commodities Market in Chicago, a city Benton visited often between his preparations for the fair and a major exhibition of his work at the Lakeside Press Galleries that opened in 1937. Finally, it is possible that Benton went to the local exchange in the course of his research for the Missouri Capitol murals: the style is close to that used in the small, quick sketches for the meat-packing episode in the Kansas City panel.

Although trading on the exchange is not the kind of hard, physical work Benton's art generally celebrates, the antic pace of the scene has the same kind of appeal and makes for a dynamic composition. Benton did not have to travel great distances to visit Wall Street (or the Loop), but the drawing is still an informative report on an aspect of American life usually known only to the few. This "insider's" perspective on the workplace becomes a major element in Benton's painting after 1935. The Missouri Capitol murals are full of the hows and whys of cradling wheat, butchering a calf, diapering a baby, and sealing a cask. Like a visitor, a traveler who is always welcome, the viewer thus gains access to the lives and crafts and customs of a wide variety of other Americans.

6–5. G.O.P. Parade, Cleveland(?). 1936; sepia wash, ink, pencil; 13⅛ × 16⅞; inscribed, Benton.

The handling of this drawing and the treatment of such details as the hats in the left foreground (used in his Hollywood drawings of 1937) support a date coincident with the Republican Convention of 1936, the Cleveland convention that nominated Alf Landon. A companion drawing (private collection) clearly shows a political gathering of major proportions, rife with elephant banners. If it is not the Landon convention, then it is a local election-year rally that rivaled the party's national conclave in hoopla and spectacle.

Election parades were not the localized objects of the traveler's dreams; rather they were colorful rituals of democracy, a part of the American pageant that helped to define the collective identity of an uncertain, shaken nation during hard times.

6–6. Battle surface, "Load!," New London, Connecticut. 1943; watercolor, ink, pencil; 13⅞ × 16⅜; inscribed, 'Battle Surface,' Detail #1, Benton, A; verso, $50.

Like that other indefatigable tourist of the period, Eleanor Roosevelt, Tom Benton turned up in the damnedest places—in this case, on the deck of a U.S. Navy submarine on its training run in the waters of the Atlantic, off New London. During World War II, Abbott Pharmaceuticals of Chicago undertook, in the public interest, to commission works of art and then lend them to the government for propaganda use. Some were by combat artists, in the field. Others were home-front pictures, by artists unfit for service overseas.

Benton toured war industries and training camps under that arrangement; his visit to the submarine base at New London yielded this drawing and the illustrations for a Quentin Reynolds article published in *Collier's* in 1944. His friend Georges Schreiber also contributed illustrations to the piece. But the focal feature was a side-by-side comparison between Benton's sketch of a scene entitled "Up Periscope" and a finished painting based on the drawing. For reasons by no means clear, the process of chronicling the war was deemed significant for the wartime reader, even though Benton, as was his practice, made no real, perceptible changes as the work progressed from observation to polished illustration. The caption suggested otherwise: "The sketch above is a preliminary drawing for the painting . . . demonstrating how the artist first caught action aboard the submarine and how his ideas were transformed into the finished version." [25]

6–7. A free copy after Goya, and scenes in Spain. 1954; pencil; 11⅝ × 8¾; inscribed, Goya, Saturn devouring his children, where we ate lunch, B.

After the war, America's foremost vagabond artist extended the scope of his travels to Europe. In 1949, on his first return since his student days, he encountered Reginald Marsh. From Venice, Marsh wrote to a friend back home, describing the meeting: "Yesterday we ran into Tom and Rita Benton and today Tom and I went to the Scuola [di] San Rocco. I never realized till now how much Tintoretto owed to Tom Benton!" [26]

On his trips to Europe, Benton revived his student practice of copying works by the Old Masters, albeit with distinct uses in mind to which he would now put those exercises. In 1954, for example, he went to Spain largely to see at firsthand the works of El Greco he had begun to study in Paris in 1909 and had cherished ever since in reproduction. Specifically, as he prepared to embark on a new round of postwar mural painting, Benton wanted to see the sculptural models El Greco was supposed to have made for his compositions. Benton had made such models himself, and he would elaborate upon the process in the years to come. But he could not make himself understood sufficiently well at El Greco's house in Toledo to find the master's studies and contented himself instead with looking at other famous works, such as Goya's horrific *Saturn Devouring His Children* (Prado, Madrid).

The choice of this work by Goya to copy is, perhaps, not too surprising in light of the strong surrealistic tendencies of Benton's wartime "Year of Peril" series. But Benton, the tireless observer of local manners and mores, cannot resist filling the sheet with a view of the place "where we ate lunch" and a peasant's donkey that is kin to a backroads Missouri mule.

25. Quentin Reynolds, "Take 'er Down," *Collier's* 114, no. 19 (1944): 17.
26. Edward Laning, "Reginald Marsh," *American Heritage* 23, no. 6 (1972): 34.

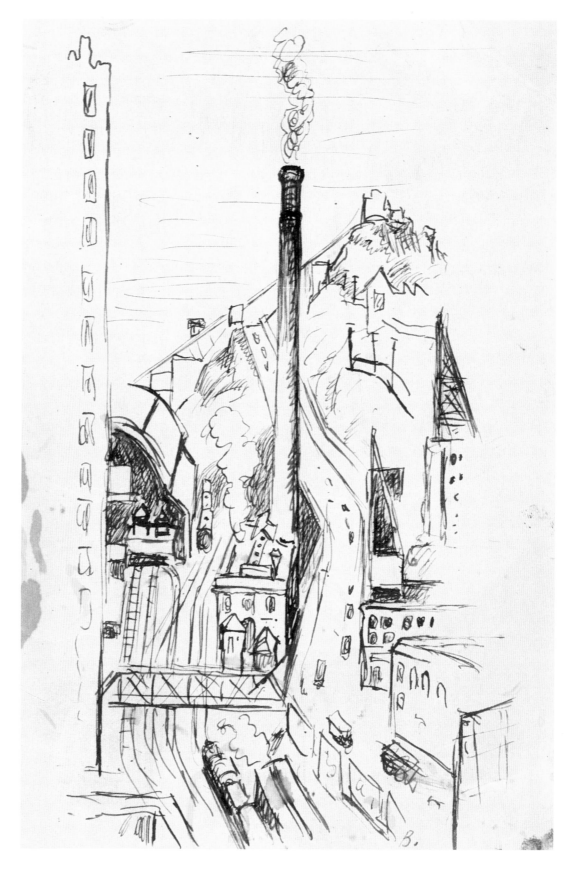

6–1. Pittsburgh. 1930.

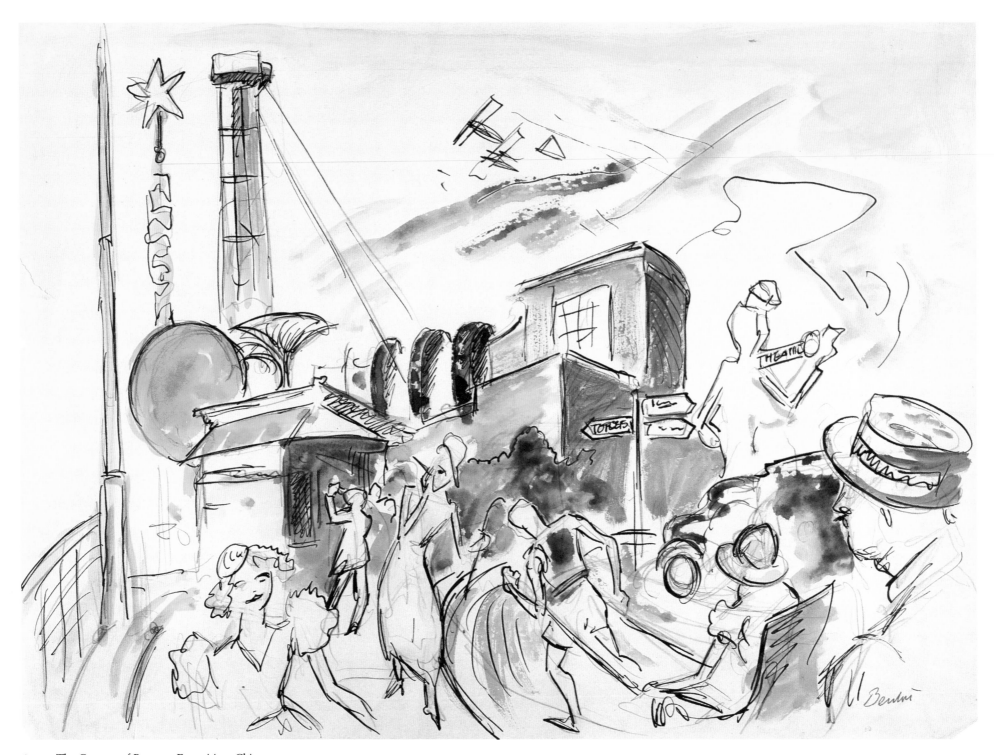

6–2. The Century of Progress Exposition, Chicago. 1933.

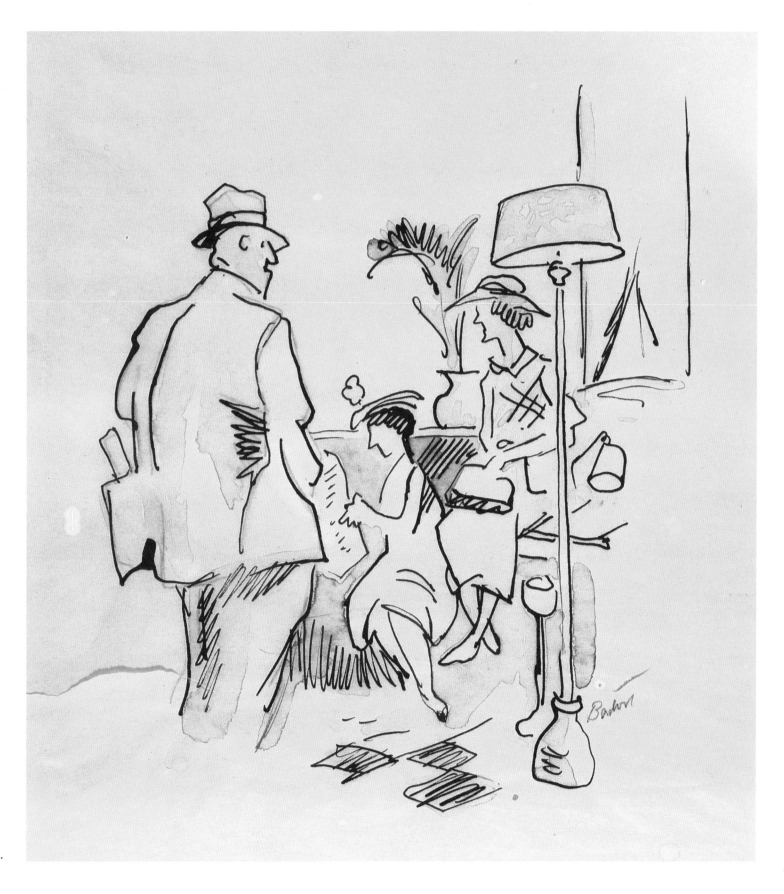

6–3. Lobby, the Union Hotel,
Flemington, New Jersey(?). 1935.

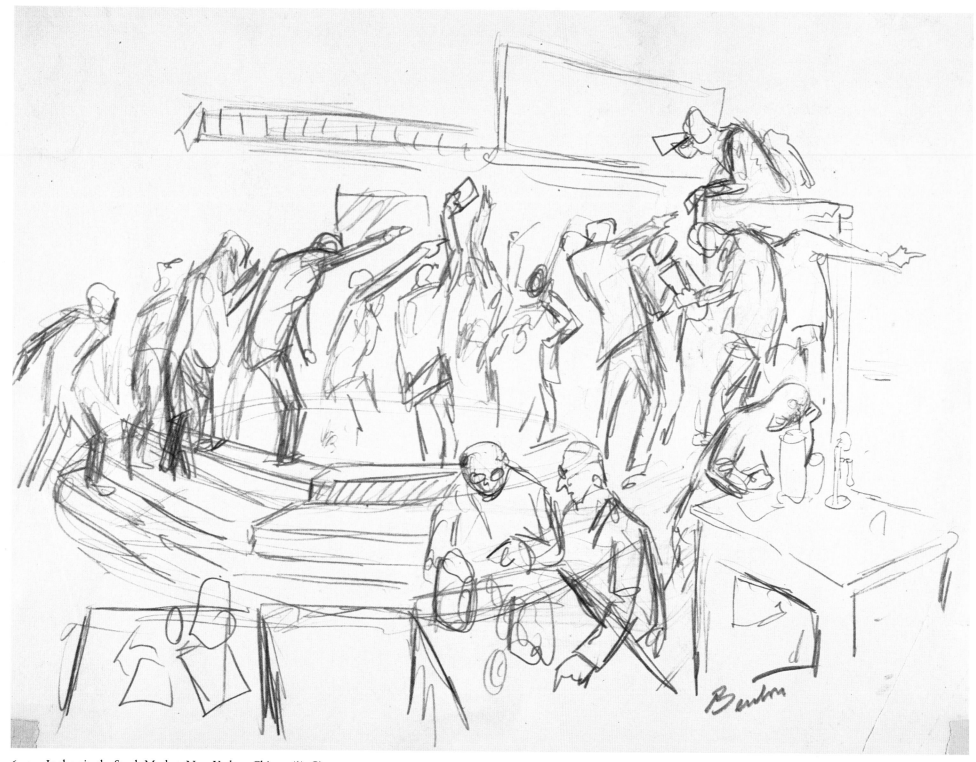

6–4. In the pit, the Stock Market, New York or Chicago(?). Circa 1931–1935.

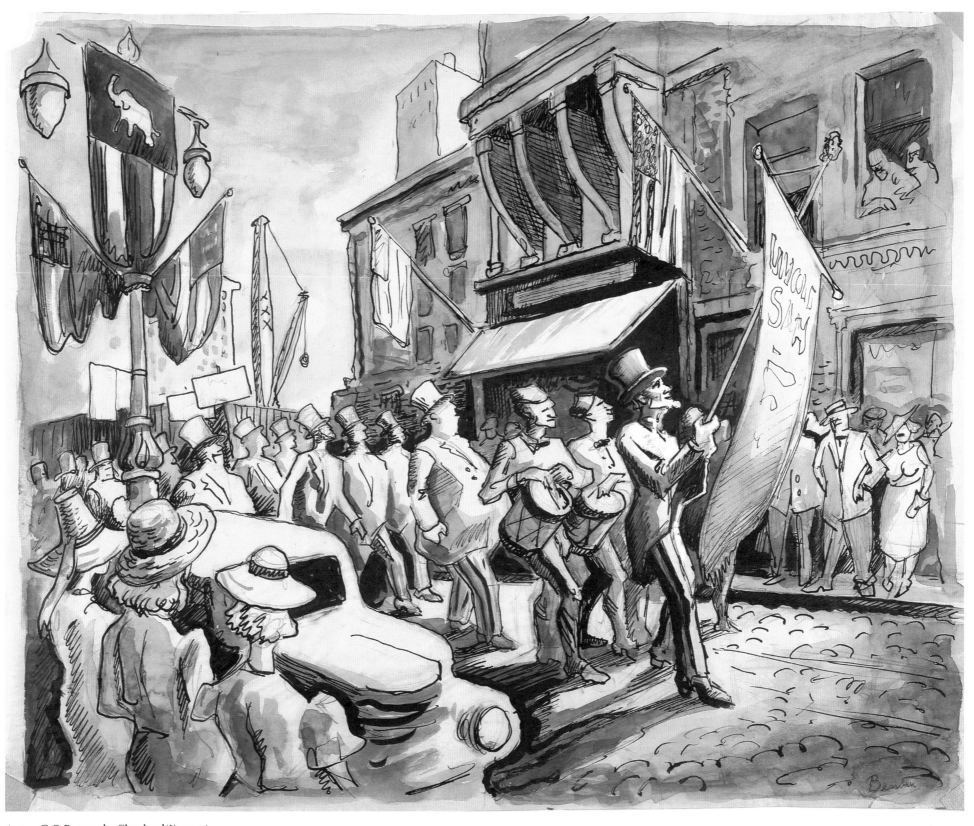

6–5. G.O.P. parade, Cleveland(?). 1936.

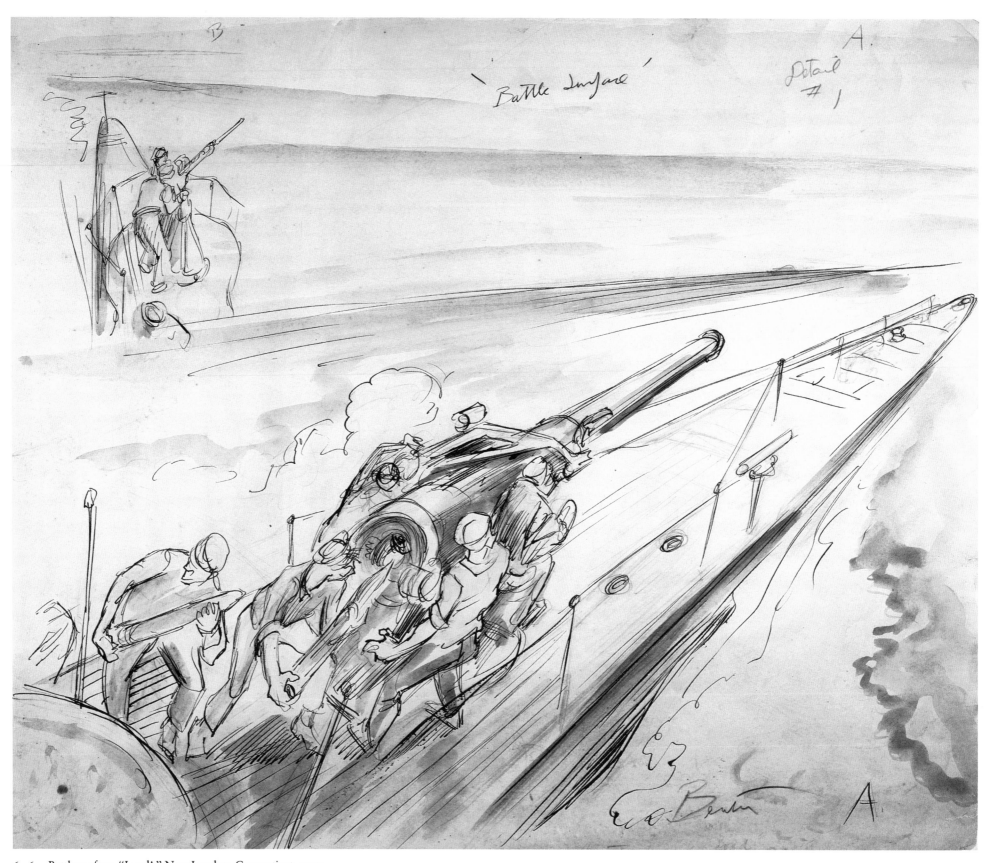

6–6. Battle surface, "Load!," New London, Connecticut. 1943.

6–7. A free copy after Goya, and scenes in Spain. 1954.

7 Your Roving Reporter

I have just returned from a flood-stricken area in southeast Missouri and up-per Arkansas. . . . Description can give no sense of the dread realities of flood misery—the cold mud, the lost goods, the homeless animals, the dreary stand-ing around of destitute people.[27]

Like movie stars, baseball players and loquacious senators, I was soon a figure recognizable in Pullman cars, hotel lobbies and night clubs. I became a regular public character. I signed my name for armies of autograph hunters. I posed with beauty queens and was entertained by overwhelming ladies like Hilde-garde and Joan Bennett.[28]

Thomas Hart Benton

ART, said Benton, ought to be "arguable in the language of the streets." The reportorial content of the New School and Whitney murals gave those works a broad, popular appeal: it did not take a degree in so-ciology or a chapter-and-verse familiarity with the aesthetic theories of Roger Fry to make perfect sense out of scenes showing silver-screen cow-boys—the kind you saw in a Tom Mix oater—or stockbrokers, or the gospel-thumping evangelists Sinclair Lewis exposed in *Elmer Gantry* a couple of years back. Benton's characters were all newsworthy types, who routinely found their way into the Hollywood gossip columns or into banner headlines screaming charges of fraud and chicanery. The squiggles of molding that di-vided one "story" from another on the walls of the New School came straight from the rotogravure pages of the Sunday supplement. It didn't take some fancy-Dan art critic to notice the similarity between Tom Benton's murals and the format of the newspapers; even when he left out the serpentine lines around the vignettes, as in the Whitney ensemble, the way one episode kind of jostled another still put you in mind of the tabloids, where news of a tax bill, a love-nest murder, and the Lindbergh case were liable to appear, willy-nilly, on the same sheet of newsprint.

In a very real way, Benton had risen to a position of notoriety as a muralist by injecting both the format and the man-in-the-street content of American journalism into the la-di-da domain of "high" art. A kind of closet reporter in any case, one who stalked his stories from Wall Street to west Texas and back again to Flemington, New Jersey, Tom Benton (former ace-journalist of the *Joplin American*) made the transition back to the press corps eagerly and easily in 1937, covering spring floods for a couple of Missouri papers. Although he had earlier done some "atmosphere" sketches of the Hauptmann jury and a nostalgic piece on the Ozarks for a travel magazine, this was his first, legitimate "hard-news" assignment as an artist-reporter.

Based on that experience, his recent skirmishes with the Missouri legislature over the propriety of his Jefferson City mural, and his kinship with Missouri's first senator, *Life* thought him the ideal combination of political observer and pictorial satirist. "The ablest living painter of the American scene" was dis-patched first to Michigan, to cover a series of controversial Fourth of July rallies, and later to Hollywood, to do a forty-drawing investigative report on the movie industry.[29]

To his enormous disappointment, *Life* scrapped the Hollywood feature. Perhaps the painting that was to have been the centerpiece of the article *was* a little too sexy for a family magazine, or maybe it was, unlike Benton's usual fare, just plain incomprehensible. "I know it doesn't make sense," he told a *Life* staffer. "Nothing in Hollywood does."[30] Or maybe the satirical point of the drawings was even more obscure. The titles sounded probing and prickly, but the sketches themselves were straight backlot-tour stuff, nice enough, but not really hot. It took Benton several years of pain and frustration to hit upon the truth that, however much they might aspire to make their work "argua-ble" and accessible to a mass audience, their work was still art, and great artists weren't necessarily great journalists or movie moguls or ad men or nightclub comics with pencils.

7–1. "Emperor of his domain," southern Missouri. February 1937; sepia, ink, pen-cil; 8¾ × 12; inscribed, Benton; verso, Emperor of his domain, K C Star, Feb. 14, p. 1, #41.

27. *An Artist in America*, p. 146.
28. Ibid., p. 278.
29. "Artist Thomas Hart Benton Hunts Communists and Fascists in Michigan," *Life* 3, no. 4 (1937): 22.
30. "Movie of the Week: *The Grapes of Wrath*," *Life* 5, no. 24 (1938): 74–75.

This drawing was published in the *Kansas City Star* on February 14, 1937. The misery of the flood affected Benton deeply; in addition to their appearance in reports filed with the *Star* and the *St. Louis Post-Dispatch*, the artist used his sketches as the basis for lithographs and for illustrations in the chapter of his autobiography entitled "The Rivers." The importance of travel and reportage to his art through 1937, the year of publication, can be deduced from the format of *An Artist in America*, which is organized geographically, like a travelogue or a series of dispatches from the field.

There is also a hint of the biting, not quite appropriate, and not always sharply focused satire of the later *Life* pieces in this juxtaposition of straightforward pictorial observation with a smart tag line that strains after humor. Albeit his heart was firmly affixed to his sleeve, Benton belonged, or wanted to belong, to the hard-boiled school of journalism, the Ernest Hemingway tough-guy fraternity.

7–2. Flood relief at night, southeastern Missouri. Early spring 1937; sepia, ink, pencil; 12 × 8¾; inscribed, Benton; verso, Flood relief at night, $100.

Soldiers, in distinctive AEF uniforms, were the rescue workers who sandbagged the river and pitched the tents for refugees. When darkness fell, these heroes gave themselves over to all manner of "Night-time whoopee," at least according to a note Benton scribbled on the back of one of the many drawings showing swaggering young soldiers on the loose in the honky-tonks of flood country.

Judging from the space devoted to the subject in his autobiography, Benton had himself quite a time in those beer joints. In fact, the suggestion that he enjoyed a lot of attention as a celebrity and big-time reporter (in 1930, he had posed as a reporter for the *Denver Post* and learned the value of the ploy) gains support from the invidious contrast Benton, the author, set up in *An Artist in America* between this episode and his barroom tour of the wartime South. In 1943, he was devastated by the rebuffs of young women who thought him old and who preferred the young soldiers. In 1937, it would seem, the girls had been a lot more friendly.

This kind of lively, anecdotal theme was obviously easier for Benton to handle than the flood itself, the pictorial possibilities of which were limited to views of toilers on the levees and survivors standing about in abject misery. A good story did not always make for a good reportorial drawing.

7–3. Flood on the Kaw River, outside Kansas City. October 1951; sepia, ink, pencil; 9⅛ × 13¼; inscribed, Benton '51; verso, $125.

Although Benton had given up on reporting long before, the summer flood of 1951 that devastated Kansas City and environs brought him back from his eastern holiday to tour the area. Norman Rockwell (with John Atherton) had recently completed a poster to aid in the relief effort. Benton was eager to help too and, remembering that George Caleb Bingham, the great Missouri artist-politician of the last century, had sent out lithographs when more orthodox methods of persuasion failed, resolved to lobby Congress for flood-control programs in the same way.

This drawing is the on-the-spot study after which the flood lithograph *Homecoming, Kaw Valley—1951* was made, with the addition of a devastated family, a ruined car, and the family washing machine, filled with mud and washed away by flood waters. These details emphasized the human cost of the disaster and added emotional force to the otherwise dry issue of additional funding for the Corps of Engineers. Benton sent copies to each senator and each representative; the *New Republic* put the image on the cover in November and gave the artist space to argue his case. But most of the prints, he thought, wound up in congressional wastebaskets, and "those that didn't had . . . no effect."

Benton also did a painted version of the theme, called *Flood Disaster* (Mr. and Mrs. Louis Sosland, Shawnee Mission, Kansas), in 1951. The flood series of 1951 marked his last, discouraging hurrah as a reporter.

7–4. "The Revolution in Pengelly Hall, Flint's Smolny Institute," Flint, Michigan. July 3, 1937; ink, sepia, pencil; 8¾ × 12; inscribed, Benton; verso, Delany Cafe, Pengelly Hall, Flint July '37.

Benton was sent to Michigan, in the care of "a seasoned Detroit reporter," to file a picture story on the rumored rise of communism and fascism in the industrial midland of America. But simple, direct reportage was not exactly what *Life*, or Benton's old friend, editor Dan Longwell, had in mind. Instead, *Life* was hoping to use Benton's cheeky irreverence to deflate the pretensions of the usually imperturbable *New York Times*. The *Times*, it seems, had published alarming reports by one F. Raymond Daniell maintaining that Michigan was on the brink of civil war: "Both armies," he wrote, "are highly mobile."

Life thought the prospects of a Nazi-Red takeover slim, however, and turned Benton loose as much to satirize the *Times* reports as to investigate the actual political situation. The format of the finished story, which presents the drawings not as images but as eyewitness sketches, with sketchbook perforations and the edges of the sheets visible, is itself a parody of a hot-off-the-wire news dispatch.

And Benton did not disappoint his employers. Although the drawings are somewhat more spontaneous and emphatic than the usual Benton product and are full of harsh, aggressive angles, they are, at bottom, pleasant genre scenes. The editorializing comes in Benton's captions. Like the line beneath the fourteenth drawing in the series, comparing a placid, beery afternoon in a union hall to the great days in the headquarters of Lenin's Bolsheviks, the captions used ham-handed irony to emphasize just how normal things were in Flint.

7–5. "Additional Evidence of the Nazi Upheaval in Michigan," Schwaben Park, near Detroit. July 5, 1937; ink, sepia, pencil; 8¾ × 12; inscribed, 12, Benton; verso, Series A #40, "Additional evidence of Nazi upheaval in Michigan," $250, "The Band."

The high point of Benton's weekend in Michigan was the United Auto Workers' big Fourth of July picnic in Flint Park, at which he failed to detect anything much more sinister than a beauty contest and an alfresco wedding in progress. But the all-American holiday picnics he visited, one after another, from July 3 through 5, provided ample scope for ridiculing predictions of imminent revolt. The so-called vigilantes of the American Legion, a portly and sociable bunch, were discovered parading "lustily" at the annual Rose Festival in the suburbs. And German-American subversion, in the main, consisted of passing out beer and pretzels, listening to a brass band play its oompah-pah "Lorelei" songs, and watching blonde-haired kiddies ride ponies.

7–6. "Hollywood Note: Thursday Night at the Cock-and-Bull, It's the Maid's Night Out," Hollywood. Summer 1937; ink, sepia, tempera; 16⅛ × 20; inscribed, Benton.

The series of forty drawings rejected by *Life* seems to consist of several distinct, chapterlike sections. "Hollywood Notes," also called "Candid Camera," is a kind of illustrated gossip column, depicting the private lives of the movie colonists in tourist-eye view, with an emphasis on places where the famous are said to gather, or where an authentic map of the stars' homes may be found.

"My Favorite Stars" is just that—portrait heads of W. C. Fields, Eddie Cantor, and other luminaries of the day; it is a throwback to Benton's job in the Fort Lee studios, when he first arrived in New York, roomed with budding director Rex Ingram, and made a living by painting sets and portraits of Theda Bara, Violet Mercereau, and other queens of the silent screen. Benton was thoroughly star-struck anyway: press reports have him getting Edward G. Robinson's autograph, ostensibly for his son, T. P.

The third group of drawings examines the technical steps involved in making a movie at 20th Century–Fox, from "Set Designing" and trips to the "Costume Room" and the "Prop Department" to a premier at the glittering Carthay Circle on San Vicente Boulevard. Screenwriter and novelist William Faulkner appears in a depiction of a story conference from this suite, although Benton apparently failed to recognize that his sitter was almost as famous as Eddie Cantor or Edward G. Robinson.

Life sent a photographer named Zerbie to Hollywood with Benton; while the painter inspected the set for the Tyrone Power epic *In Old Chicago* and hobnobbed with the executives, his cameraman was supposed to shoot the intimate details of Hollywood's glamorous interiors.

7–7. "Conference Table," or "Directors' Meeting," 20th Century–Fox Studio, Hollywood. Summer 1937; ink wash; 14½ × 18; inscribed, Benton.

The fourth and final part of the Hollywood series consists of behind-the-scenes glimpses of the complex mixture of financing, management, and creative art that made up the movie business. For that purpose, Benton's base of operations was a couch in the plush studio office of Raymond Griffith, a top producer at Fox. He sat in on conferences, took notes, drew sketches furiously, and, between trips to the projection room or the dubbing department, dozed on that office couch.

When the Hollywood project fell through, Benton made a lithograph after a drawing called "Writer assigned by head producer looks for inspiration in the solitude of his cell" (the 1938 lithograph was titled *The Poet*; Benton professed not to recall who the writer was) that is a detailed study of the young man with glasses in the center of this piece; he also sold the most typical and cliché-ridden subjects of the series to *Coronet* in 1940. They were, in every sense, "the notations of a tourist who could draw."[31]

The drawings from the executive suite stayed with him, however, and seem to have been the inspiration for an abortive book called "Hollywood Journey" that Benton started around 1938 in an effort to salvage something from the Hollywood adventure. The few tortuous pages he completed concerned the tense relationship between business and "the moving picture Art."[32] After the war, and his publicity work for such movies as *Long Voyage Home*, *The Grapes of Wrath*, and Jean Renoir's *Swamp Water*, Benton would regretfully conclude that business and art did not mix readily.

31. Harry Salpeter, "Art Comes to Hollywood," *Esquire* 14, no. 3 (1940): 173–74.
32. Thomas Hart Benton, "Hollywood Journey," manuscript in Benton papers, the Archives of American Art, Smithsonian Institution, Reel 2327.

7–1.　"Emperor of his domain," southern Missouri. February 1937.

7–2. Flood relief at night, southeastern Missouri. Early spring 1937.

7–3. Flood on the Kaw River, outside Kansas City. October 1951.

7–4. "The Revolution in Pengelly Hall, Flint's Smolny Institute," Flint, Michigan. July 3, 1937.

7–5. "Additional Evidence of the Nazi Upheaval in Michigan," Schwaben Park, near Detroit. July 5, 1937.

7–6. "Hollywood Note: Thursday Night at the Cock-and-Bull, It's the Maid's Night Out," Hollywood. Summer 1937.

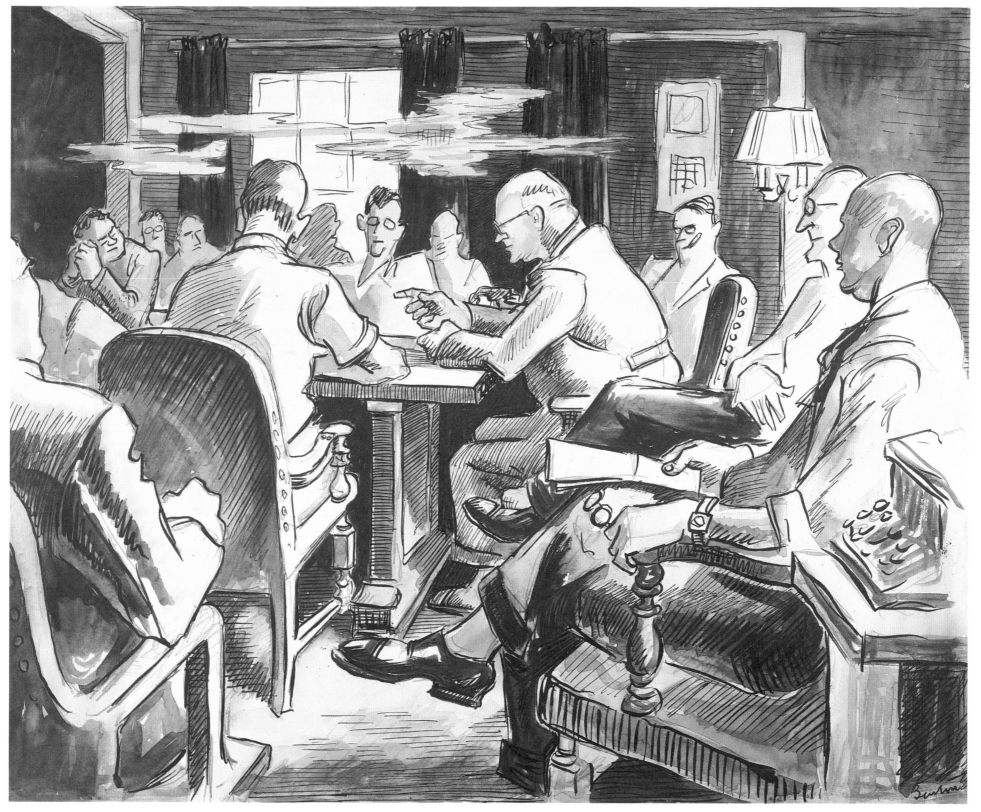

7–7. "Conference Table," or "Directors' Meeting," 20th Century–Fox Studio, Hollywood. Summer 1937.

8 *America Today*: The New School for Social Research

I had by then done so much sketching in the field that I was ready and anxious for an opportunity to put some of this new stuff into a form. I had already done one modern thing, called the *Bootleggers*, and I was more and more fascinated with modern subjects. So when the New School thing came up, Alvin Johnson and I decided to concentrate on contemporary America, and I had the material in my travel sketchbooks, all of it. It was simply a question of organizing it.[33]

Thomas Hart Benton

IN 1930, after years of designing grandiose mural cycles nobody wanted, Tom Benton finally got his wall at the New School for Social Research in New York. Architect Joseph Urban approved the decoration of his new building by Benton and the Mexican painter José Clemente Orozco; both of them, insofar as proven performance in places accessible to the New York critics was concerned, were prominent muralists manqué. It is not surprising, then, that Benton should have accepted the peculiar deal offered by Dr. Johnson, director of the school, with almost indecent alacrity. Benton wouldn't be paid for his work, not exactly. Instead, he was to get a modest lecturing contract and might, if he could, peddle the drawings for the mural panels to supplement his nonexistent fee. Most of the preliminary studies, in fact, went to the Whitney on generous terms. But profit paled in comparison to the staggering fact that Tom Benton was finally ready—and able—to proclaim on the walls of an important public building just what his sketchbooks had taught him about America, *America Today*.

These very first murals were also to be the only ones Benton would ever paint without a strong historical component. Taken directly from drawings already heaped about his studio—"All that was necessary was that I organize what I had on hand," he later recalled—the New School ensemble, with its fierce contemporaneity, alienated more viewers than it charmed.[34] Although Benton had indeed provided "as complete a picture of the kaleidoscopic vertigo of the American temper as the news-reel or the illustrated tabloid," the transitory details and passing fancies of the present seemed most unsuitable for permanent enshrinement in the mural medium.[35] There were those, of course, who wondered if detailed renderings of modern biplanes and 1929-vintage farm machinery wouldn't look quaint and silly to the eyes of 1989.

But the question of decorum did not arise quite so forcefully in the case of panels dealing with the technology of "Mining" or "Steel" or the oil industry of "The Changing West" as it did in regard to the two largest segments of *America Today*, two colorful, sprawling, and consummately vulgar disquisitions on "City Activities."

The city is unmistakably Gotham. Lest Benton's collection of burlesque queens, neckers-in-the-park, and dime-a-dance dollies be palmed off on St. Louis, and lest his anthology of greedy brokers, sleazy politicians, and love-starved soda jerks pass for Kansas City, the artist himself appears in one corner, being toasted for his powers of acute, on-the-spot social observation by Dr. Alvin Johnson of the New School for Social Research, in New York City. The rest of America works, in the fields, the mines, the mills: New York plays or panders to an insatiable appetite for entertainment. New York goes to the movies, the circus, the fights, a girlie show. Tough as nails, New York even stops to snicker at the antics of a Salvation Army band. New York makes bootleg hooch and ogles chorus girls on the subway. And Thomas Hart Benton, giddy with the sheer, titanic energy of the streetwise spectacle, celebrates an uncouth vigor he has seen before, on a thousand dusty backroads. The real dynamism of *America Today* comes not from modern machinery but from people, and people are pretty much the same, whether you find them hymn-singing in a gully in Virginia or dancing the hootchy-kootchy on Friday night at the old Eighth Avenue Burlesque, in Manhattan.

33. Quoted in Robert S. Gallagher, "An Artist in America," *American Heritage* 24, no. 4 (1973): 85.
34. *An Artist in America*, p. 248.
35. C. Adolph Glassgold, "Thomas Hart Benton Murals at the New York School for Social Research," *Studio* 1 (April 1931): 286.

8–1. J. B. Newman lecturing at the New School for Social Research, New York City. 1930–1931; sepia wash, ink, pencil; 11¾ × 11½; inscribed, Benton; verso, $300, J. B. Newman lecturing at the New School of Social Research NYC.

Under the terms of the deal he struck with the New School, Benton painted *America Today* in return for an appointment as a lecturer. Although he started the assignment with high hopes of initiating a dialogue with his peers, he soon learned that the other profs had a low opinion of lectures and never attended them, except under duress. His audience consisted of "timid art lovers" and schoolteachers.

Although Benton must have been lurking in the classroom when he made this drawing—perhaps he was looking for pointers—the audience for Joseph Newman's spirited lecture on the ancient architectural orders seems to have been made up in the main of art lovers. It is interesting that, for whatever reasons, Benton attended lectures on the art of antiquity while planning the New School murals, for he later cited the interlocking formal units of Hellenistic, Etruscan, and Roman sculpture as precedents for his own treatment of separate, anecdotal vignettes fitted together by a nonnarrative, purely formal pattern of curved moldings. The profile of the detail that Newman points out here is similar to the shape of the moldings employed in the New School designs.

8–2. Rejected study for "Steel" segment, New School for Social Research murals, New York. 1930; pencil; 11¾ × 8¾; inscribed, Benton.

The formal pattern of ornament dividing one pictorial incident from another is visible at the right of this study. The details of the machinery, including the dangling hook and the angular postures of the workers, can all be found among Benton's steel-mill sketches of 1928, 1929, and 1930. And most of them, realigned and rearranged, appear in the final, mural version of "Steel."

The principal difference between the rejected sketch and the mural Benton painted is the relative prominence of the human figure. In the sketch, the workers are insignificant, almost robotlike tenders of the giant crucibles and converters. In the mural, the workers in the "Steel" panel—and in the depictions of "Mining," "City Building," and all the other industries—have grown much larger in relationship to the machinery they operate; in fact, human vitality completely overshadows the mechanical energy of modern machinery.

This shift of emphasis apparently took place when the work was well along, for the finished ensemble still includes the "Instruments of Power" panel—a montage of a plane, a train, high-tension wires, and an engine with a piston and wheel similar to those shown at the left and the center of this drawing. But the meaning of "Instruments of Power" is blunted and obscured by the revised, humane orientation of *America Today*. Benton's growing sense of a people-centered America reached its climax in the densely packed masses of humanity that crowd the two "City Activities" panels.

8–3. Stockbroker, study for "City Activities," New School for Social Research, New York. Circa 1930; pencil; 11⅜ × 8¼; inscribed, Benton, Stock broker.

This is not a casual sketch later borrowed for use in the New School murals. The angle of vision, up from below, the rough indication of the dimensions of the ticker-tape machine, and the faint notation of the position of the clock over the broker's left shoulder all show that Benton made this drawing to fit an assigned place in the upper tier of his design.

But the distinctive, slightly sinister face was a real one, probably first drawn on the floor of the Wall Street stock exchange. Benton often took a set of features from his sketchbooks and mentally viewed them from a different angle with the help of a live model; by the time he came to paint the Missouri murals in 1935 and 1936, he was so proficient at making such composites that he could combine the features of two sketchbook faces with a posed figure. He also altered the expressions on faces first drawn and seen years before, leaving the features untouched. The painted version of the broker is an angry man, with a hidden gaze, whereas the man in the study is glancing down past the ticker, at the viewer, with a superior, albeit somewhat harassed expression.

At first blush, it might be assumed that there is a political message in Benton's decision to surmount his panel with the fateful apparatus of capitalism discredited by the market crash of 1929. But, in the context of the relentless round of popular entertainment that makes up the broker's half of the "City Activities" pair, the statement seems funnier and less straightforward. With investors gazing at the Big Board as if transfixed, against a frieze of upraised hands grasping at liquor bottles—to drown their sorrows?—the market is presented as another urban spectacle to watch, on a par with adjacent scenes of a dance in a speakeasy, moviegoing, the circus, the bright lights of Broadway, a political poster. In a typical example of Benton's working methods, the face of old Judge Sturgis, drawn in Missouri in 1924, turns up on that poster.

8–4. The Eighth Avenue Burlesque, New York City. 1922–1930; pencil; 11⅞ × 8½.

Of the ten panels that make up *America Today*, two—both originally hung on the north wall—deal with "City Activities." The broker looms over one of them. The other is filled with billboards advertising "50 Girls" at a matinee: awash in sexy dames, flaunting knees, behinds, or shapely bosoms, this panel is, appropriately enough, topped off by a glimpse of a burlesque house, at the upper left, where the presiding goddesses bump and grind away, and a prizefight, at the upper right, that Benton observed from the gallery of the old Eighth Avenue Burlesque.

This is a perforated page from a small sketchbook Benton carried with him on his forays into the world of the ecdysiast, a world he considered more vital than the desiccated realm of the fine arts. "The mural painter is a student of the burlesque house," a New York paper reported in obvious astonishment. "He thinks that what this country needs is a lot of fat girls in the burlesque houses and a lot of loud comedians to hit the fat girls with barrel staves."[36]

Burlesque, and the prizefights that were often held in burlesque houses, constituted a kind of link between his academic training in drawing from the nude model, the great art of the past with its semi- or underdraped deities, and *America Today*, a society whose genteel veneer could not quite subdue its own attraction to the earthy sensuality of a Rubens or a Rembrandt. When Benton sat in the gallery at the Eighth Avenue Burlesque, yelling and hooting and drawing almost-nude figures from life, the distance between the tinny, modern world and the rich traditions of the artistic past vanished.

In years to come, Benton would make that act of temporal erasure explicit in his mythological paintings, such as *Persephone*, the *Achelous and Hercules* mural of 1947 (commissioned by Harzfeld's department store in Kansas City and now in the collection of the National Museum of American Art, Smithsonian Institution, Washington, D.C.), or the countless versions of *Potiphar's Wife*, done around 1971. Reginald Marsh, who posed for one of the figures in the New School murals, shared Ben-

36. *New York World-Telegram* (January 3, 1935), front page.

ton's affinity for burlesque and made it one of the major subjects of his oeuvre. The background of the Bowery preacher vignette adjacent to the burlesque scene in "City Activities" also looks like vintage Marsh, with its tracery of columns, holding up the "El," and its forest of signs, including the huge glasses of a cheap oculist. Marsh was just finding his subject matter in the years between 1930 and 1932, and it seems likely that Benton's handling of this aspect of the urban scene, culled from his own sketchbooks, inspired Marsh. Marsh acknowledged that he learned from Thomas Hart Benton, who had used it for the first time in the New School murals, the formula for the tempera medium he would use in delineating his chorines and bums.

8–5. Burlesque clown, preparatory study for "City Activities," New School for Social Research, New York. 1930–1931; pencil; 7 × 8 (image size); inscribed, Clown, Benton.

Tucked away at the far left edge of the "City Activities" panel with the burlesque theme, this clown face helps to link the composition with the second New York panel, the broker's mural, in which the circus appears at the far right margin of the picture. The comic with his tiny derby is also a reprise of the subway rider in the foreground of the burlesque panel, a beefy Tammany hack in a huge derby who reads a tabloid headlining a "Banker's Love Nest": the sweet young thing pictured on the front page is a reversed image of the burlesque queen closest to the clown. In this way, Benton suggests that life and art—the popular arts of the city, the soon-to-be theme of his Whitney Museum murals—are mirror images of one another.

The clown is one of the "loud comedians" who whacked the "fat girls" with an assortment of phallic weapons in the standard burlesque routine of the day.

8–6. Shorty McAllister, the Irving Place Theater, New York. Circa 1928–1930; pencil; 8 × 5; inscribed, Benton, Shorty McAllister Irving Place Theater.

The typical, squared-off pencil strokes and the light crosshatching identify the drawing of the burlesque comic as a study done after a sketchbook drawing, in preparation for use in the New School murals. It was probably not the last study of the figure, either, since the position of the bite mark on the brim of the derby has been shifted, for humorous effect, to the front.

This life drawing of Shorty McAllister is one large step closer to the street. A rapid sketch, probably made backstage at the Irving Place Theater between acts, this likeness of Shorty is reversed in the painted version, in which the sad-faced entertainer stands in the wings of the burlesque show with the jolly comedian in the derby. As a pair, they are Benton's streetwise answer to the "Comedy" and "Tragedy" of the legitimate theater.

8–7. Miss Peggy Reynolds, of the burlesque stage, New York. 1929; pencil; 8¾ × 5⅝; inscribed, Benton '29; verso, Sketch for New School mural chorus girl.

Miss Peggy Reynolds, her pose altered to let her dangle fetchingly from a strap in the New York subway (and to let her serve as the naughty double for the virtuous woman who falls to her knees during the preacher's sermon, in the adjoining scene), is given the eye—but not his seat—by columnist Max Eastman in the same "City Activities" panel. The irony of Benton's juxtapositions was not lost on all his critics. Suzanne LaFollette, for instance, made special note of the "gorgeous, abandoned hussy of a burlesque dancer" who "toes it perilously near a wickedly caricatured soap-box revivalist." [37]

A luminary of the burlesque stage, Peggy is right at home in a picture that chronicles the myriad delights of one such establishment and portrays several of the genre's best-known headliners. But, for the artist in need of a pretty head, meeting the likes of Miss Reynolds was not an unmixed pleasure. "In my paintings," Benton boasted, "I use real people as models. When I represent a farmer I get a farmer, when I represent a night club girl I get one of them too. The farmer doesn't cost more than a ten-cent cigar generally, but the girl is likely to be more expensive. She has to find it entertaining to pose or she won't do it." [38]

37. Suzanne LaFollette, "America in Murals," *The New Freeman* 2, no. 23 (1931): 543.
38. *An Artist in America*, p. 255.

8–1. J. B. Newman lecturing at the New School for Social Research, New York City. 1930–1931.

8–2. Rejected study for "Steel" segment, New School for Social
Research murals, New York. 1930.

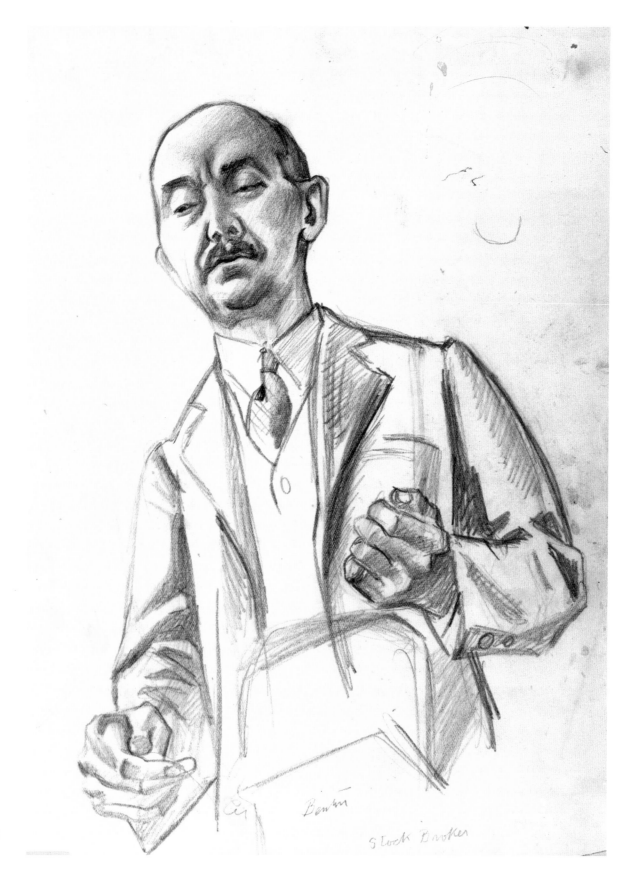

8−3. Stockbroker, study for "City Activities," New School for Social Research, New York. Circa 1930.

8–4. The Eighth Avenue Burlesque, New York City. 1922–1930.

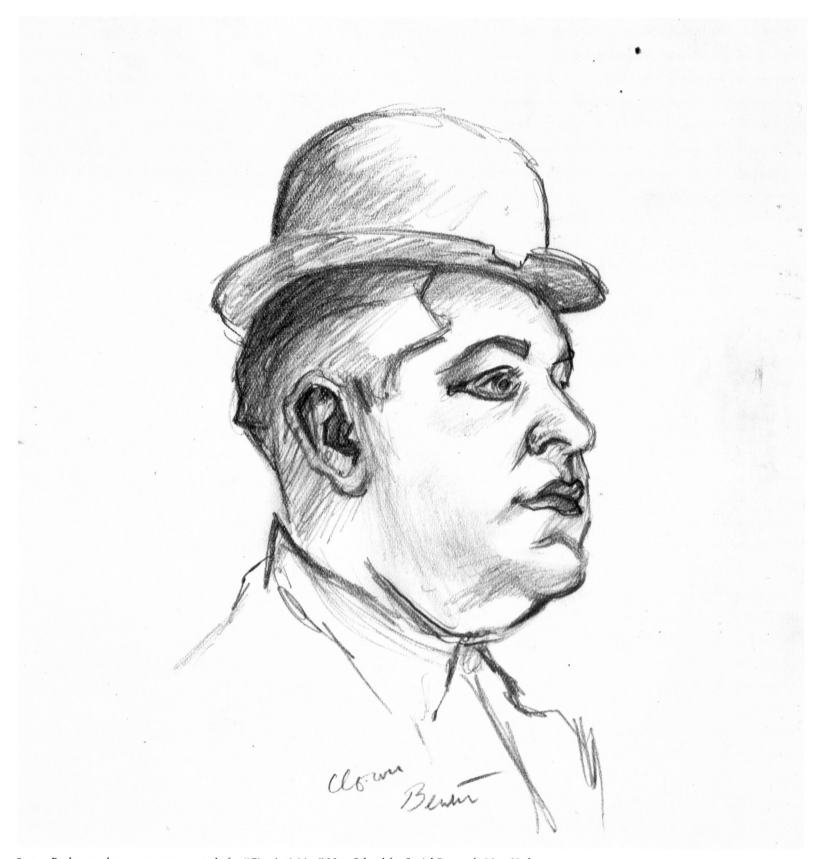

8–5. Burlesque clown, preparatory study for "City Activities," New School for Social Research, New York. 1930–1931.

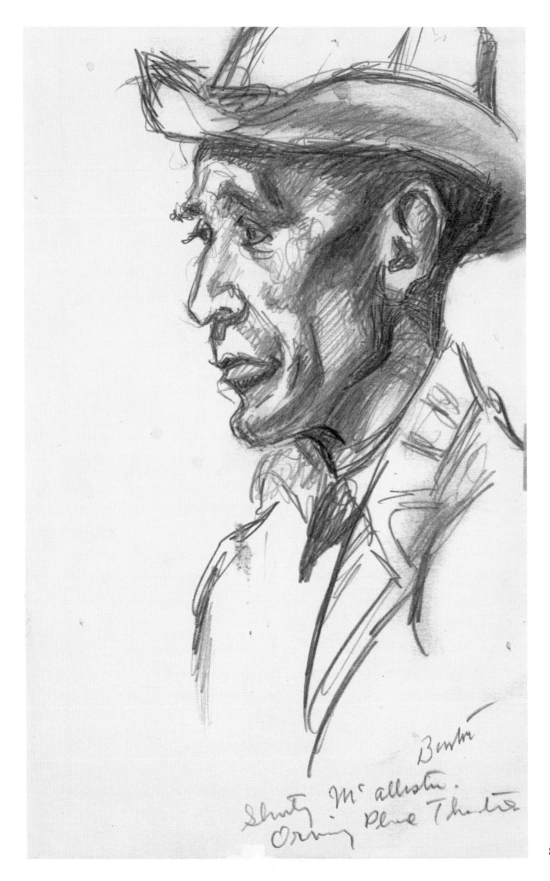

8–6. Shorty McAllister, the Irving Place Theater, New York. Circa 1928–1930.

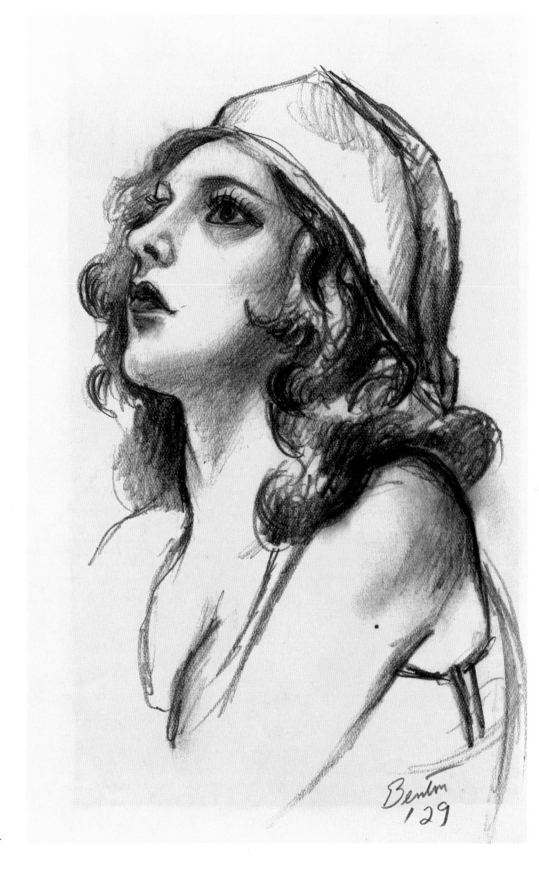

8–7. Miss Peggy Reynolds, of the burlesque stage, New York. 1929.

9 The People's History

When the War was over . . . I proclaimed heresies around New York, talked on the importance of subject matter, then under rigid taboos among the aesthetic elite, and ridiculed the painters of jumping cubes, of cockeyed tables, blue bowls, and bananas, who read cosmic meanings into their effusions. In a little while, I set out painting American histories in defiance of all the conventions of our art world.[39]

Thomas Hart Benton

THE up-to-the-minute theme of the New School murals must have seemed anomalous to gallery-goers who followed Benton's career closely, since his main claim to fame had been the *American Historical Epic*, a series of big costume pieces designed as murals for an as yet undesignated site. Merely finding a place to exhibit his wares to potential patrons was difficult enough when each constituent unit of the *Epic* needed some twenty-five running feet of wall space. It was only after several years of unheralded work on the project that, through the good offices of Reginald Marsh's painter-father and the architect Ely Kahn, Benton was, in 1924, able to display the first, five-part "chapter" of his projected sixty-four-panel mural history at the Architectural League.

Benton's unfashionable interest in historical subject matter had several points of origin. His father had been interested in American history, particularly as that chronicle touched upon the career of the illustrious Senator Thomas Hart Benton of Missouri; in the years just before the death of Maecenas E. Benton, his rebellious son, the painter, was struggling toward a reconciliation with his Dad and his Missouri past, a heritage that included a glimpse of the legendary Buffalo Bill and a handshake from Geronimo. And during the hitch in the Navy to which Tom Benton often attributed his return to painting meaningful subject matter, he spent his evenings confined to the parlor of his Norfolk boardinghouse, poring over an old-fashioned, four-volume illustrated history of the United States, fascinated by the steel engravings of great men and stirring deeds.

Yet Benton's *American Historical Epic*, when he came to paint it, was bereft alike of heroes and of moments of high drama. Instead, he presented a people's history, enacted by bands of anonymous pioneers and minutemen, a story noteworthy for the injustices visited upon red men and blacks, a tale punctuated by unremarkable, unglamorous actions, like spinning wool, "Clearing Woods," and "Chopping Trees." Benton's populist view of historical realities was conditioned by his friendship with Dr. John Weischel, founder of the People's Art Guild, whom he met in 1914. Under the influence of Weischel and the socialist-Marxist discussion groups he led, Benton rethought the romantic "great man" history of his youth and the elitist view of the artist's superiority to the vulgar horde, much in vogue in the studios of modern-day New York. He even served for a term as the director of a "people's gallery" on the West Side and taught art classes (where he met his future wife, Rita Piacenza) for the hoi polloi under the auspices of the Chelsea Neighborhood Public Schools.

Benton's new understanding of history had a profound effect on his attitude toward the present day. If he believed that ordinary people's actions on the land had truly shaped America, he also believed the plain folks on the backroads and the painted ladies on the city streets were more worthy of his attention than any Rockefeller. Thus the documentary drawings Benton used to create *America Today* for the New School were, in fact, a part—the contemporary part, the final chapters—of his ongoing people's history, his *American Historical Epic*. After the New School decorations were finished in 1931, Benton's fortunes as a muralist rose immediately. In short order, he accepted commissions for his Whitney murals, his 250-foot Indiana panorama, and his great Missouri Capitol cycle. After World War II, the list continued to grow, with additions at Lincoln University in Jefferson City, Missouri, the hydroelectric plants of upstate New York, the Truman Library, and the Joplin

39. Ibid., p. 45.

Municipal Building. So it went, each mural full of historical detail, sometimes set down side by side with its present-day consequences, and each mural dominated by the humble and the forgotten.

When Jacques Cartier "discovers" the Indians, the viewer witnesses the event from the heart of an Indian village and, in the next panel, watches the Seneca "discover" the French right back, that event having somehow been omitted from the history books. When the history of nineteenth-century Missouri needs summing up, the viewer gets the scruffy likes of Huck Finn, sitting by the side of his great friend, Nigger Jim. When Maecenas E. Benton gives a stump speech for Champ Clark, the audience includes a black man, some hillbillies, poor farmers, and even a woman or two. For more than forty years, Tom Benton painted history like that. He painted it in New York and in Chicago. He painted it in Kansas City, in Jefferson City, and down in Nashville. But he never did find a home for the *American Historical Epic*, the people's history that started it all.

9–1. Sketch for "Struggle for the Wilderness," in Chapter 2, *American Historical Epic*. 1924; pencil; 9½ × 14⅛.

The second chapter or series of the *Epic* consisted of the following subjects: "Pathfinder," "Over the Mountains," "Jesuit Missioners," "Struggle for the Wilderness," and "Lost Hunting Ground." As the titles suggest, Benton's series would show the white man's conquest of the wilderness in realistic terms. Instead of depicting heroism and glory, he concentrated on the subjugation and destruction of the Indian and, as in the first panel of Chapter 1, the divine "Retribution" that must surely follow.

The projected chapters followed a rough chronological order, with some notable deviations. The first, begun in 1919, dealt with the earliest days of "Discovery" and "Aggression," when "Palisades" were erected and "Prayer" was offered. The second, started in 1924, followed frontiersmen into the West, for the next great confrontation with the natives. A third, started in 1925 and continued until the New School commission came up, introduced "Slavery" in the South, jumped back to the now subdued frontier to show "Clearing Woods" and "Chopping Trees," and wound up in New England, with depictions of distaff "Industry" and the zealous excesses of "Religion."

At times, however, while keeping the same subject groupings intact, Benton shuffled the order of the chapters. In 1927, for example, on the occasion of the exhibition—at the New Gallery in New York—of most of what is now generally identified as Chapter 2, Benton said it was the third, unfinished, part of the *Epic* and listed the themes of a revised Chapter 2 as "Axes," "Planters," and "Slaves," with another panel still to come.[40] And there are studies for other parts of the cycle, with titles like "Pocahontas," "King Phillip," and "Aboriginal Days," that fit comfortably within neither schema but are clearly part of the ensemble.

This figure did not turn up in the *Epic*, at least in the precise form shown in the drawing, although many similar Continental soldiers with tricornes, muskets, and ammunition cases did. There were soldiers, but no generals on white horses, and the soldiers were more alike than different, anonymous, indistinguishable one from the other.

40. Clipping, *Boston Transcript* (March 5, 1927).

9–2. Study for "Slavery" mural, the *American Historical Epic*. Circa 1925; pencil; 12½ × 15½ (image size); inscribed, Benton, Study for "Slaves" early '20s.

Although the figures throughout the *Epic* are generalized and somewhat abstracted, in keeping with his interests in anonymity and the rhythmic organization of form, the later parts of the cycle evince a slightly greater interest in facial features and the minutiae of mustaches and eyebrows. But, as this drawing from the model illustrates, careful life studies still stood behind the least specific of Benton's American everymen and everywomen.

The *Epic* did not shrink from indicting white America for the persecution of the Indian and the enslavement of the Negro. Indeed, that revisionist approach to history was the raison d'être of the project, a point of view that links Benton with Charles Beard and other prominent Marxist thinkers of the period.

In light of the intellectual parentage of the *Epic* and its ideological content, attacks on Benton from the left for his presumably demeaning "caricatures" of racial minorities seem badly misdirected. His stormy reception in a 1934 appearance before the Communist-led John Reed Club of New York also suggests that his work was little known by those who blamed him for Thomas Craven's xenophobic and chauvinistic excesses.

9–3. Sketch for "The Pathfinder," Chapter 2, *American Historical Epic*. 1926; pencil; 10 × 7¾; inscribed, Benton '28, Benton; verso, $25.

By most counts, the sixth component of the *Epic*, and the first segment of Chapter 2 ("Colonial Expansion"), this scene shows a lanky figure in buckskins—not Davy Crockett or Daniel Boone—coming upon an Indian tribe at the end of his trail. "I wanted to show that the people's behaviors, their *action* on the opening land, was the primary reality of American life," Benton wrote.[41] Hence, the pioneer is nobody in particular, the volumetric handling of his form lending him a kinship with his Indian foes and with the rocks and trees around him.

In this early (and misdated) pencil sketch, Benton has already settled the narrative content of his mural. The basic ingredients of the story would not change as he developed the formal structure of the work, but details were revised.

9–4. Value study for "The Pathfinder." 1926; oil; 12 × 8⅞; inscribed, Benton 26; verso, Epic of Amer. 2nd Series.

Additions to the pencil sketch visible for the first time in this painted study include the clouds in the sky and the obtrusive cubistic rock in the right foreground. Benton moved from rough sketch to finished panel in minutely calibrated increments, each separate study adjusting one or two seemingly minor details with enormous care. Only at the end of the process did the most appealing touches in the finished mural appear—the droopy mustache of the plainsman, his powderhorn, the blasted, leafless branch above his head, and the fingerlike clouds, pointing at the hidden conqueror.

The cubist rock serves as a reminder of Benton's unease, the difficulty of moving beyond the familiar conventions of easel painting and twenties modernism into the uncharted terrain of history painting on enormous walls. The multiple studies that trace the slow, dogged process of design anticipate the equally cautious working

41. Thomas Hart Benton, "American Regionalism: A Personal History of the Movement," in *An American in Art: A Professional and Technical Autobiography* (Lawrence: University Press of Kansas, 1969), p. 315.

methods of Benton's mature career, when every mural would demand life sketches, compositional studies, posture sketches, finished drawings of heads, value studies, squared drawings, clay models, and more.

9–5. Huck Finn, study for north wall, Missouri Capitol mural. 1936; pencil; 21 ¼ × 18 ¼; inscribed verso, #6 Frank Brent.

By using Mark Twain's fictional "bad boy" as the genius loci of nineteenth-century Missouri—the episode also dates the historical progression shown on that part of the wall to 1840–1850—Benton reveals mixed feelings toward the American Dream and the promise of the frontier. Huck and Jim are shown trolling for catfish on the river, blissfully free. But Jim is still a slave, while Huck, and his friend Tom Sawyer, are hard-pressed by the conventions of American society.

Between 1939 and 1944, Benton illustrated three of Sam Clemens's books for the Limited Editions Club: *The Adventures of Tom Sawyer*, *Adventures of Huckleberry Finn*, and *Life on the Mississippi*. He donated the 203 original drawings to the Missouri State Historical Society toward the end of his life. By then, Missouri had learned to be proud of Benton and tolerant of the Missouri-related fiction of Mark Twain.

The episode from Mark Twain pictured in the Missouri mural was all the more shocking to Benton's audience because of the prominence given to Huck's companion, who, like most of the characters in the work, was studied from life. Jim was Rotha Williams, a.k.a. "Popeye," the man who mopped up after the painter's mess in the Capitol, and Benton was careful to tell him the name of the character he would portray before he made his sketches. Missouri was not entirely ready for people's history, however, especially if the people included Negro janitors as well as Anglo-Saxon businessmen. It was fine for Charles La Pierre, the local insurance agent, to make an appearance as the "Pathfinder" figure in buckskins with the two dogs who introduces the later nineteenth century in the mural cycle, but it was a serious breach of decorum to give "Popeye" Williams the same degree of attention.

9–6. "Colonial Post," study for unexecuted mural in the U.S. Post Office, Federal Triangle, Washington, D.C. 1935; pencil; 23 ⅜ × 13 ⅝; inscribed, Benton.

In this pencil study, Benton depicted the sundry activities of historical mail handlers with the same undistinguished, anonymous features he had used in the *Epic*, a departure from the sharper characterizations of the New School and Whitney murals. Otherwise, the use of a continuous scene, shaded almost imperceptibly into distinct episodes, recalls the compositional method recently perfected in the Whitney murals.

Benton's kind of readable, unheroic history was ideally suited for use in a New Deal mural program that aimed at bringing fine art back to the American people and liberating it from the hothouse atmosphere of the New York galleries. That program,

called the Section of Painting and Sculpture, might almost have been founded with Benton's populist yearnings and his accessible people's histories in mind.

The Section wanted Benton to participate, too. Although the agency's usual practice was to award commissions on the basis of anonymous competitions, an exception was made for the eminent Mr. Benton. But he quit the project after completing pencil and preliminary color studies for two panels contrasting the "Colonial Post" with "Contemporary Postal Activities." In a letter to an official of the Section written from Jefferson City, where he was painting the Capitol murals, Benton said, "The subject matter of the Post Office was just a bore to me. I only undertook it because I wanted to be in on something which I believe has genuinely significant cultural prospects for the country."[42]

Later, he gave other, different reasons, at one time citing an excess of bureaucratic pettifogging and, on another occasion, in a display of real bitterness, charging that the New Deal programs were Communist plots. The truth is that, although Benton was prepared to put up with all manner of criticism from the people who came to see his work, he was acutely sensitive to criticism from his peers, or from those who would be his equals—art critics, fellow painters, administrators, museum curators. Especially after the round of vitriolic criticism that drove him from New York in 1935, just as he was beginning his Section sketches, Benton resented anything but praise for his work. But the Section *always* had suggestions to offer, however highly a drawing was valued in the upper echelons of the bureaucracy.

9–7. A student-teacher in the nursery school at Lincoln University, study for the mural in Page Library, Lincoln University, Jefferson City. 1954; pencil; 14 ¼ × 11 ¼; inscribed, Benton, Lincoln Mural.

Benton donated this portable mural panel to the black college in his home state in 1955, after a subscription drive to raise his $20,000 fee failed. He was later honored with a doctorate in humane letters for his contribution to Negro education.

He found this young woman, an undergraduate at Lincoln, working in the day school, where he also drew the two little boys she teaches in the finished mural. Abraham Lincoln, the most homely of all America's heroic personages, is the only "important" figure in the scene, and he appears as if in a vision, freeing a young man, between two far more mundane scenes of black literacy. In the distant background, enlisted men of the Sixty-second Colored Infantry pause, as the Civil War ends, to learn how to read and write. In the foreground, a black teacher of the present time helps her charges to learn. It is interesting that the title of the book on the table at her elbow could read *The History of America*. It could also be *The History of Africa*.

42. Karal Ann Marling, *Wall-to-Wall America: A Social History of Post-Office Murals in the Great Depression* (Minneapolis: University of Minnesota Press, 1982), p. 141.

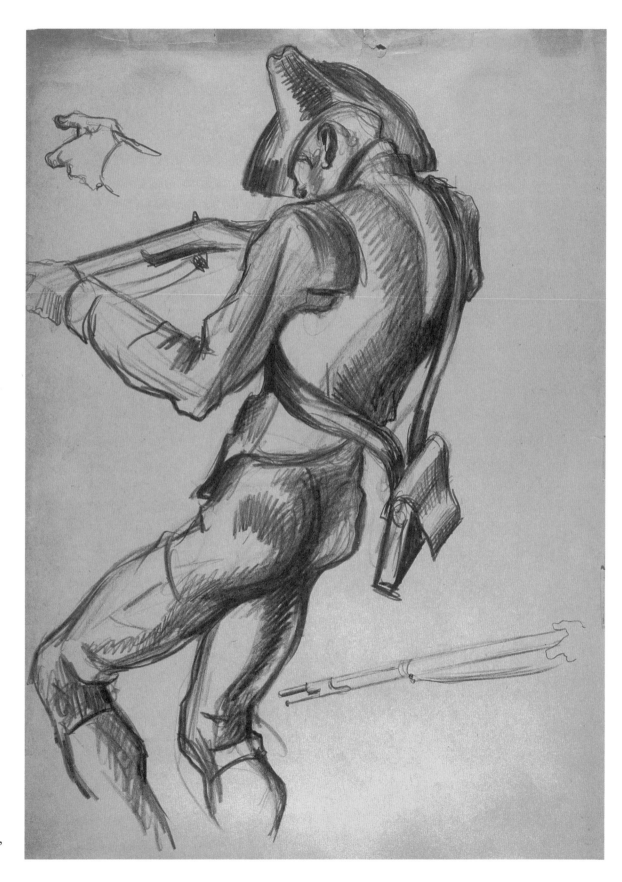

9–1. Sketch for "Struggle for the Wilderness," in Chapter 2, *American Historical Epic*. 1924.

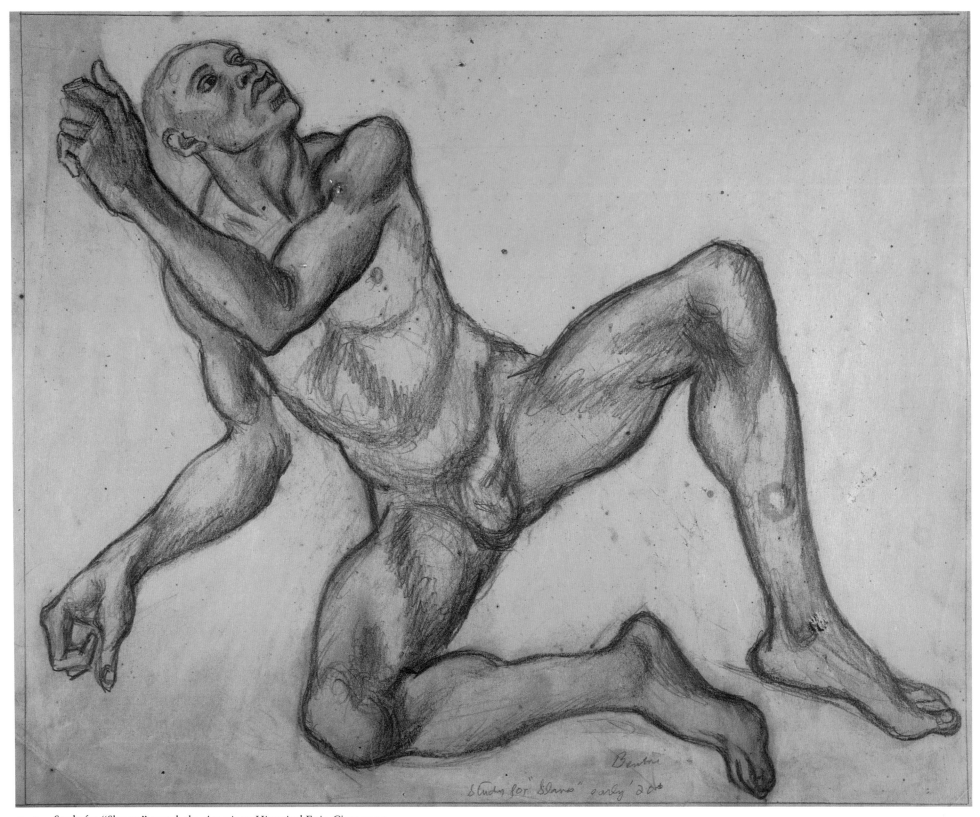

9–2. Study for "Slavery" mural, the *American Historical Epic*. Circa 1925.

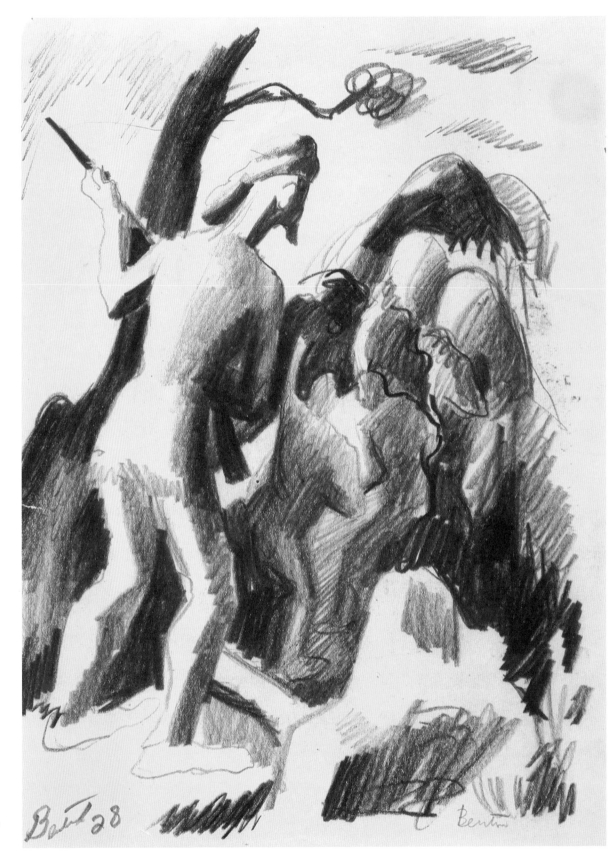

9–3. Sketch for "The Pathfinder," Chapter 2, *American Historical Epic*. 1926.

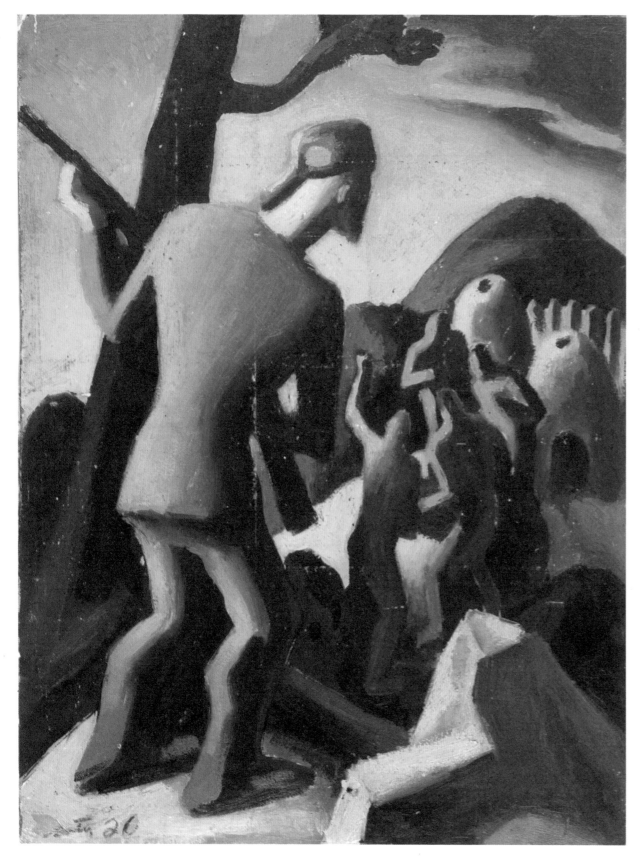

9–4. Value study for "The Pathfinder." 1926.

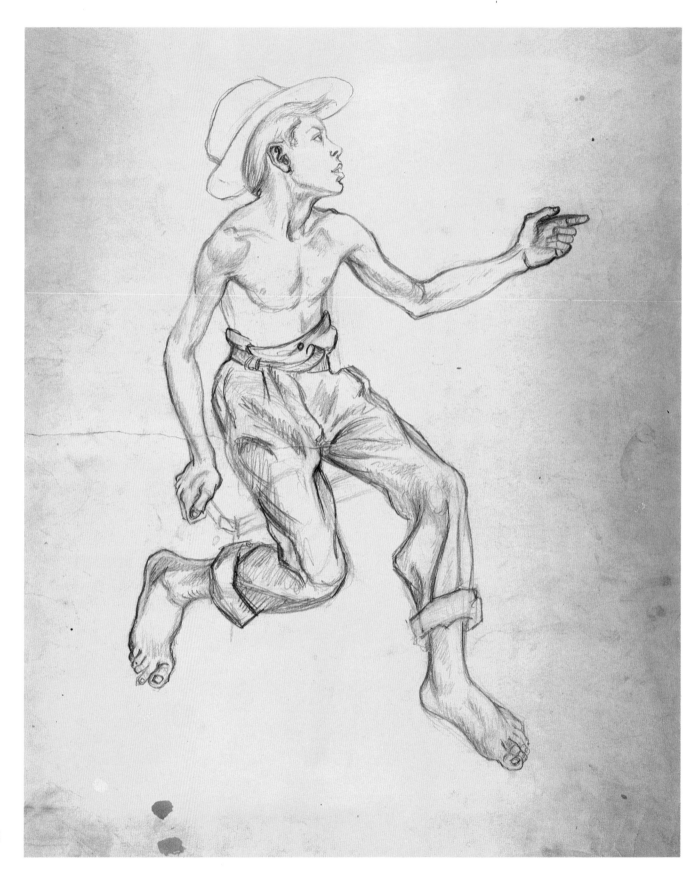

9–5. Huck Finn, study for north wall, Missouri Capitol mural. 1936.

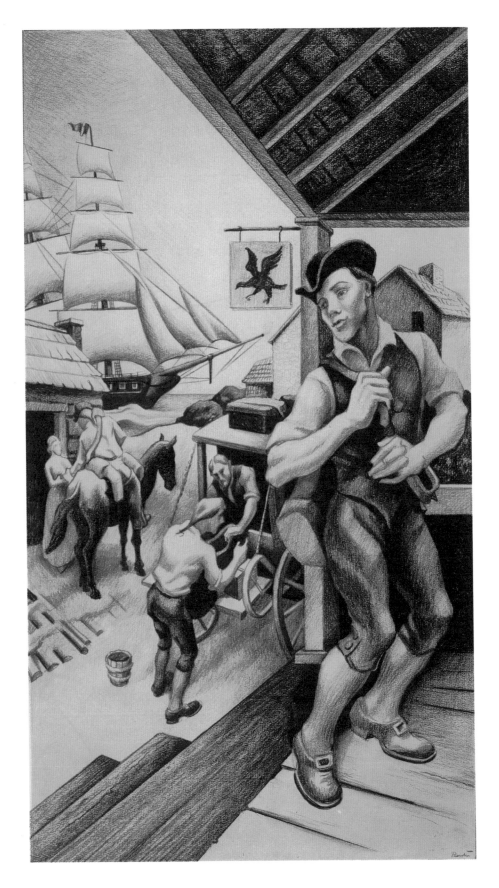

9–6. "Colonial Post," study for unexecuted mural in the U.S. Post Office, Federal Triangle, Washington, D.C. 1935.

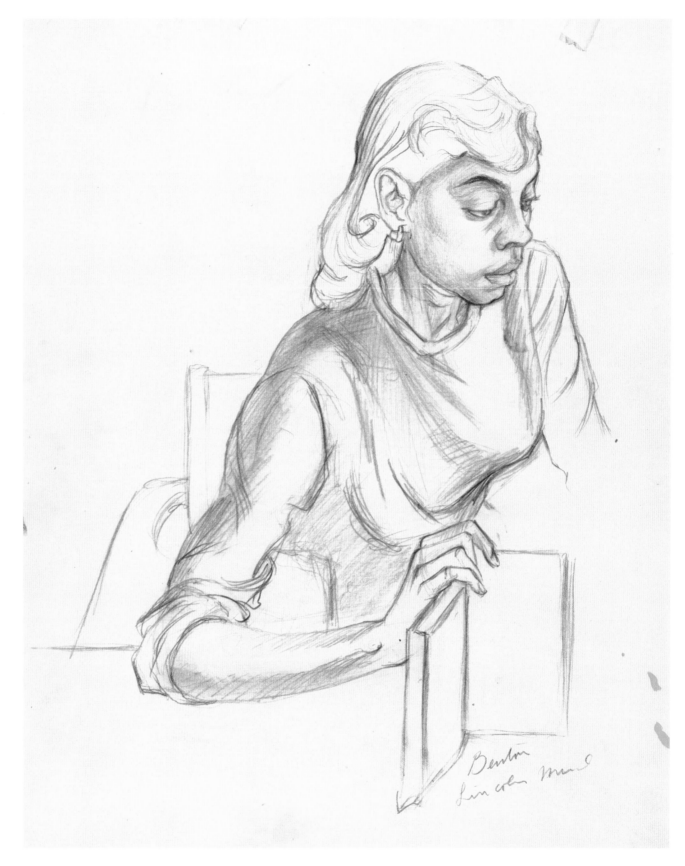

9–7. A student-teacher in the nursery school at Lincoln University, study for the mural in Page Library, Jefferson City. 1954.

10 *The Arts of Life in America*: The Whitney Museum

The real subject of this work is, in the final analysis, a conglomerate of things experienced in America: the subject is a pair of pants, a hand, a face, a gesture, some physical revelation of intention, a sound, even a song. The real subject is what an individual has known and felt about things encountered in a real world of real people and actual doings.[43]

Thomas Hart Benton

JULIANA Force, director of the Whitney Museum of American Art, felt sorry for Tom Benton. His New School murals, if not exactly a critical triumph, had been noticed by the press; the panels were a tribute to his lonely persistence. Yet, except for the money the Whitney had spent on the drawings for *America Today*, the artist had gained little but recognition for his efforts. That much was obvious in the autumn of 1931, when Rita Benton called on Mrs. Force to try to sell her a set of four six-foot murals—and the two little panels that went with them—tracing the history of New York City. Benton had painted them in 1927, to the exact measurements of the empty niches in the New York Public Library, and had exhibited the pictures at the New Gallery in the vain hope that a benefactor would come forward to acquire them for the city. Now the Bentons, with a little boy still in short pants and with overdue bills to pay, needed hard, cold cash. Would the Whitney *please* consider buying the murals and giving them a good home in New York, where they belonged?

If the Whitney Museum of American Art was going to acquire a mural ensemble, Mrs. Force shot back, it was going to be one specially painted for the Whitney Museum of American Art! And so Tom Benton found himself with his second legitimate commission in as many years. It is hardly surprising, then, that the Whitney Library murals should deviate only slightly from his recent and apparently satisfactory work at the New School. The theme—*The Arts of Life in America*—was tailored, with a studied irony, to the museum setting in which the panels would hang, but Benton's treatment of that subject in terms of the deliciously "low" arts of poker-playing, faith-healing, and warbling pop hits on the radio derives from *America Today* and its goggle-eyed obsession with such popular, urban "arts" as moviegoing, soda-fountain-sitting, and burlesque-hoofing. Like the New School murals, the Whitney suite attempts a panoramic picture of the nation as a whole, with segments devoted to the West, the South, and the "Arts of the City": again, Benton's selection of pictorial material depended heavily on the content of his sketchbooks, where drawings of Texas boomtowns, revival meetings, and a brace of urban floozies left over from *America Today* awaited his pleasure.

The faces in his sketchbooks meant that *The Arts of Life in America* would be those of the people, and, for the first time in a bought-and-paid-for

setting, Benton also poured in a healthy dose of his *Epic*, his people's history. The "Arts of the West," for instance, hover in time somewhere between the local color Benton soaked up on the plains and a Hollywood horse-opera rendition of the Wild West, circa 1870. "Indian Arts" in the days before the coming of the white man are given their own panel, one that reverts stylistically to the *American Historical Epic* segments of the early twenties.

But the mural cycle as a whole represents a striking advance over the compositional awkwardness of Benton's earlier offerings. By the time he came to paint the New School Board Room, his prewar format was fixed: his murals were mosaiclike in chararacter, moving the eye across the wall by the rhythmic beat of figures clustered into discontinuous narrative groupings. That formula, evolved as much in response to his manner of working from his sketchbooks as from any particular aesthetic conviction, played hob with the sense of his stories, however. What was the viewer to make of the spectacle of a huge fieldhand, about to be run over by a huge farmer on a disc-harrow, as the last, working riverboat in America prepares to steam between them? That is what happens in the segment of the New School ensemble describing the South, and Benton tried to solve the problem by applying gilded wooden moldings to the surface of the panels, linear forms that reassert the flatness of the picture plane in the face of the illusory depth of the scenes and also divide one narrative incident from another. In the "Arts of the City" panel for the Whitney—an awkward shape to begin with, broken by a dado and two big openings—he experimented with a less obtrusive manner of doing the same thing. Instead of using pieces of wood tacked to the wall, Benton separated a dance hall from a radio studio with a painted swag of drapery and the studio from a "blind pig" with a chest-high section of painted wall, an odd but effective device widely used in the Missouri Capitol murals. In the remainder of the Whitney panels, all much smaller than the long wall describing the city, Benton avoided the issue altogether by treating the murals as oversize easel paintings, in which the Leveretts and their band, or a clump of black crapshooters Benton first saw outside a big, red cotton warehouse in Alabama, are encased in bubbles of their own space, unique to their particu-

43. Benton, *The Arts of Life in America*, p. 5.

lar activities, and differentiated from the rest by their position in a gridwork of old-fashioned, linear perspective.

When he was done, though, the critics had little to say about Benton's fresh solutions to the formal problems of wall painting. Instead, they harped on a portrait of "the national insensibility" so gross and crude as to give viewers with a modicum of good taste a case of the vapors.[44] Despite its gorgeous dames and colorful crooks, New York, as Tom Benton was rapidly discovering, was almost *too* tasteful for a country boy from Missouri to bear.

10–1. Study for "Arts of the City," the Whitney Museum of American Art. 1932; oil; 12 × 25; inscribed, Whitney Mus.

Judging by the compositional and iconographic similarities between this panel and the New School "City Activities" segments, it seems likely this was the first of the Whitney panels done. The others were, in any case, much less demanding. "Indian Arts" closely resembles preexisting compositions in the unsold *Epic* and *New York History* series. The scenes of the South and West are relatively unadventurous in design and consist, in the main, of vignettes transferred directly from sketchbooks, with little, if any, restudy.

In *An Artist in America*, Benton admits to some difficulties over the fee he was to receive for his work at the Whitney and to disappointment at the amount finally tendered. What he does not say is that bills he submitted for trips to the South in connection with the work went unpaid, although the validity of some of the claims may be demonstrated by the reappearance in the Whitney panels of figures drawn in Tennessee and Virginia.

10–2. Dinner at a lunch counter, study for "Arts of the City." 1932; pencil; 13⅝ × 11¼; inscribed, Benton.

A significant difference between Benton's treatment of the city in 1930–1931 and his handling of the theme in 1932 is revealed in this drawing. Benton's usual, wisecracking optimism has deserted him. Suddenly, sinister forces are at work beneath the glittering veneer of New York. There is crime. There is despair. And people are jobless, poor, hungry.

The far left corner of the "Arts of the City" is given over to a pictorial admission that the Depression is a new urban reality. The rituals of a beauty pageant are undisturbed by the bleak scenes that unfold around it: one man scavenges in a garbage can; another queues up for a handout at a mission; the third gulps his meal for the day, a thin sandwich and a cup of weak coffee. Benton called that segment of the mural "None Shall Go Hungry."

10–3. Girl at a soda fountain, sketch for the "Water Story Mural," Washington, D.C. Circa 1930–1931; pencil; 18⅝ × 14½; inscribed, Benton.

At the time Rita Benton went to make her appeal to Mrs. Force, the financial picture must have been grim indeed, since Benton was apparently commuting to Washington to paint a mural above a drugstore soda fountain. In the great mass of autobiographical reminiscence he left behind, however, Benton never discussed the

44. Paul Rosenfeld, "Ex-Reading Room," *New Republic* 74, no. 958 (1933): 248.

commission; this drawing is the most convincing proof of the authenticity and proper dating of a work that turned up suddenly in 1975, after thirty-five years in a basement.

Appropriately enough, a soda fountain—a more elaborate version of the fountain in "City Activities"—stretches across the top of the mural. The water bubbles up to that height, to be charged and flavored, from the jar of an Indian river god in the lower right corner: in its lumpy handling, that figure resembles Benton's Whitney Indians. But the subdivision of the secondary scenes—in addition to the lunch counter and the Indian, there is a waterfall, a river, a farm boy priming a pump, and so on—is accomplished by a fretwork of segmental lines, similar to the moldings in the New School murals.

One such curving line follows the bend of the right knee and calf of the girl in this sketch, forcing Benton to push back the right leg, lightly indicated here as if in anticipation of the problem. And the face finally added to the figure of the young woman eating an ice-cream confection at a table for one is Peggy Reynolds's face, neatly reversed from its position in Benton's sketchbook and in the New School subway scene.

There is a nice sense of urban intimacy in the New School soda-fountain scene. The girls on the stools—waiting to be "discovered," perhaps—wear lively expressions, and the soda jerk likes them. In the quick-lunch vignette in the Whitney murals, the tenor is one of desperation; the city has grown colder, grimmer, far less accommodating. This sketch stands between those extremes. The pose is active, yet tense. The facial features are far from giggly. The girl is all alone, like most of the isolated people stranded in the "Water Story Mural." Benton's seemingly boundless affection for the petty vices (and virtues) of the city is wearing thin.

10–4. Radio soprano, study for "Arts of the City." 1932; pencil; 18⅛ × 11; inscribed, Benton.

In contrast to the people-centered "arts" on display in the New School "City Activities" panels, this singer is a tiny cog in a huge entertainment "industry," the factorylike character of which is emphasized by the lights, towers, high-tension lines, and dynamo that overpower the performers.

High above the confusing welter of equipment and chorus boys floats a bloated cupid, hanging from a wire, an obscene deus ex machina, a grotesque parody of Peter Pan. The density of the image, its lack of clarity, and the persistent suggestions of unwholesomeness anticipate the painting called *Hollywood* that Benton did in 1937 after a firsthand look at the California dream factory.

The artless arts of the people delighted Benton, but he was less sanguine about those arts merely directed at the people. What emerges in the Whitney cycle is the first intimation of a conflict between the claims of folk and popular art, a distinction Benton tried hard not to draw too firmly, but one that bothered him throughout his later flings at being an ad man and a movie studio functionary. When Benton worked at the Disney studios in 1946, on a popular adaptation of folk music to the cartoon medium, he was angered and disappointed by the artistic restrictions mandated by the financial realities of the entertainment industry.

10–5. Hoodlum (bootlegger), study for "Arts of the City." 1932; pencil; 13½ × 12½; inscribed, Benton.

Entertainment is the creature of industry; crime, too, is controlled, quite literally in "Arts of the City," by a sinister machine, an affair of dials and levers that flanks an

ascending social hierarchy of corruption. He called the vignette "Prohibition-Booze-Politics-Business." At the bottom of the heap, with his still nearby, stands this desperado with a revolver, guided and manipulated from behind by a politician who, in turn, is controlled by a caricature of a millionaire in a silk hat. Via this ladder of wrongdoing, the booze moves from the still to the top of the panel, where the cocktails are being shaken.

Like Charlie Chaplin in *Modern Times* (1936), Benton seems to conclude that the times are out of joint, the machines have run amok, and the city corrupts those it does not swallow alive.

Between the time he executed this drawing and the time he painted the mural panel, Benton made a series of facial alterations to the hoodlum, particularly around the eyes and nose. The effect is to make the crook Italian, or at least markedly ethnic, which he is not in the pencil study. The hoodlum also becomes less convincing in the process, a gangster movie stereotype.

In fact, with the possible exception of the piano player accompanying the soprano, none of the personages in this mural panel is the sort of pungent individual seen earlier, in the New School cycle, and later, in the Missouri Capitol. They are generic personages, with poses sometimes drawn from models but more usually borrowed from older drawings. And the faces, in many instances, verge on caricatures made up as Benton painted in a white heat.

Speed was a factor. When Benton had the time, he took great pains to make each figure in a mural a real portrait or a composite portrait. When he was rushed, as in the case of the Whitney and Indiana commissions, he sometimes fell victim to his own facility for invention. But critics who detected that quality in the Whitney murals dismissed the entire cycle—and the artist's corpus to date—on the basis of a momentary failing; they also read deep political meaning into a simple consequence of overwork.

10–6. "Shake 'em Baby," sketch for "Arts of the City." 1932; pencil; 11⅞ × 9; inscribed, Benton.

Standing at the apex of the bootlegger's pyramid of crime, this girl is the pivot, moving the eye toward the left and the final narrative sequence: "Love and Gin," a wild party scene enacted beneath a poster for Minsky's Burlesque, gives way to "Beauty and the Prize" and, finally, to the breadline.

Benton probably drew this strong-featured girl in a place similar to Minsky's. Her daring décolletage and the inflated bubble(?) beneath her right arm suggest the chorus line; both of these details have been altered in the painting, and the arms have been rather awkwardly adjusted to hold a cocktail shaker. The title, of course, is a bit of smutty double entendre.

10–7. Bathing beauty, study for "Arts of the City." 1932; pencil; 20⅜ × 13⅜; inscribed, Benton.

The face concerned Benton very little in making this study; in the mural proper, both beauty contestants have essentially the same bottle-blonde head, a stereotype of the all-American glamor girl.

The burlesque queens in the New School were vital, earthy creatures who made their sensual appeal directly to the viewer. Here, the bathing beauties are being inspected by a judge, a coarse-featured oaf who stares directly at their obvious endowments. For his purposes, their faces—their identities as people—are profoundly beside the point. Benton's view of the kind of girlie show he once savored has grown bleak and sour. Even the title—"Beauty and the Prize"—seems to allude to the salivating intensity of the judge ("Beauty and the Beast") and to the yawning gulf between the great American beauty pageant and the golden prize offered to whomsoever was the fairest, in the judgment of Paris.

10–1. Study for "Arts of the City," the Whitney Museum of American Art. 1932.

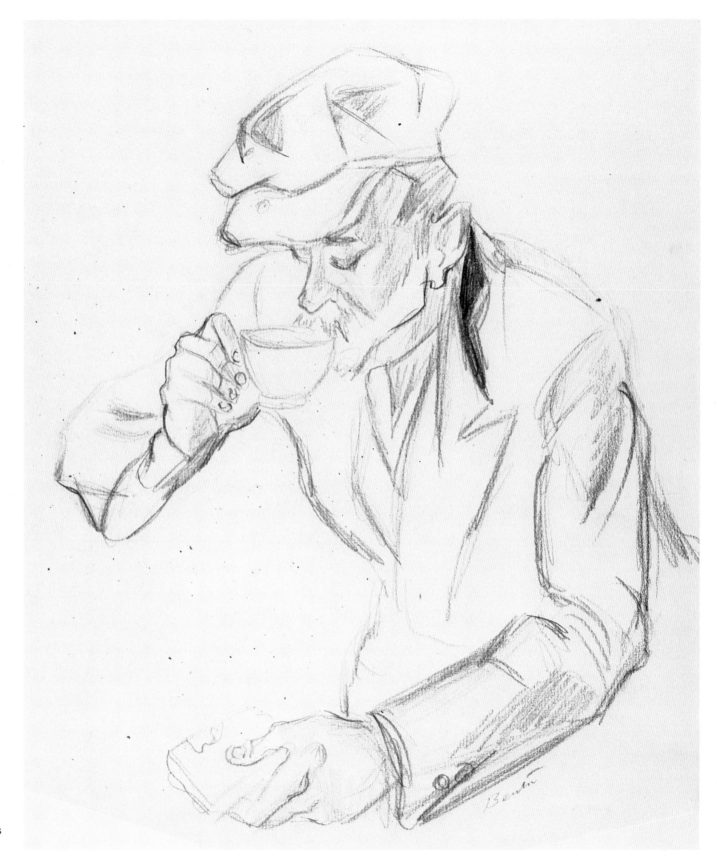

10–2. Dinner at a lunch counter, study for "Arts of the City." 1932.

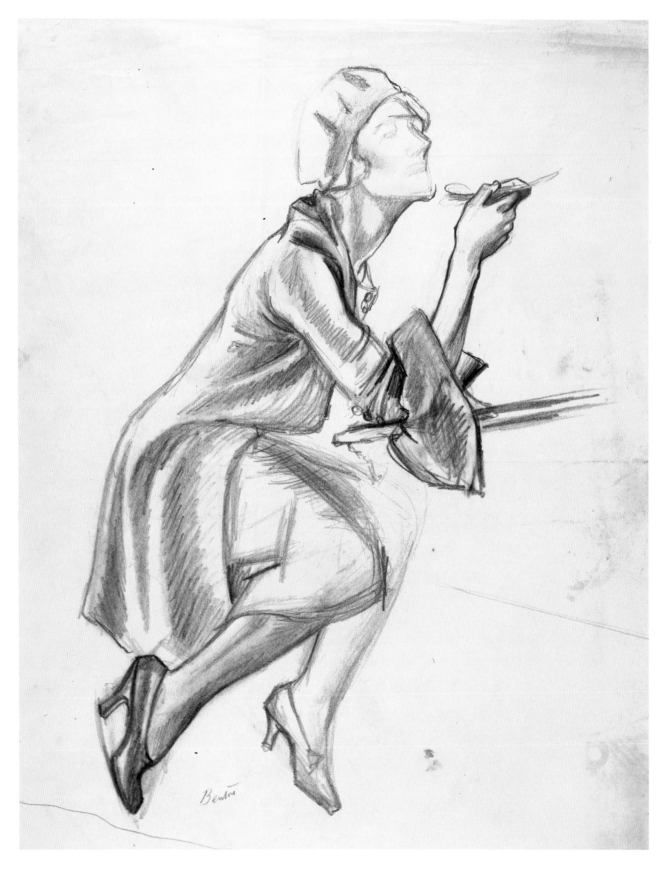

10–3. Girl at a soda fountain, sketch for the "Water Story Mural," Washington, D.C. Circa 1930–1931.

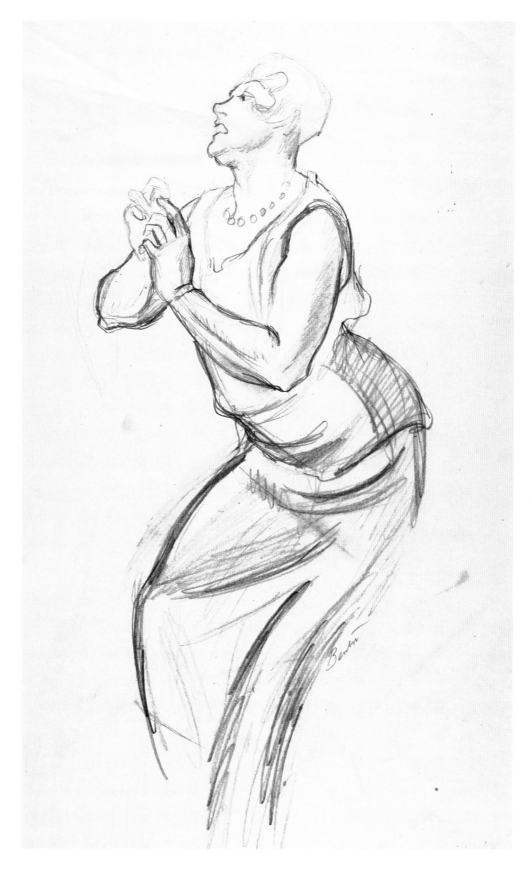

10–4. Radio soprano, study for "Arts of the City." 1932.

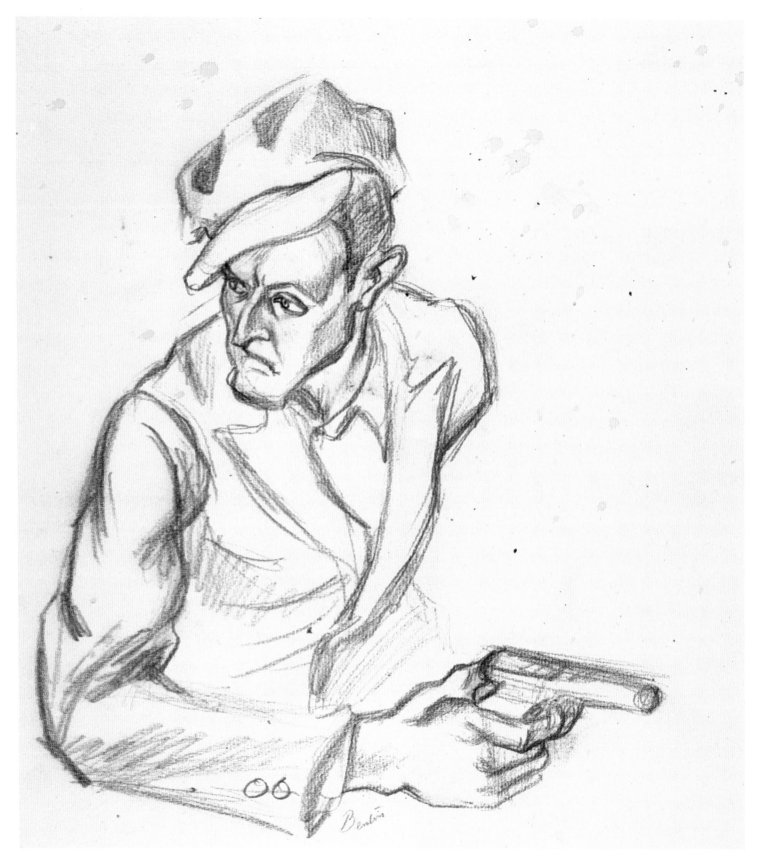

10–5. Hoodlum (bootlegger), study for "Arts of the City." 1932.

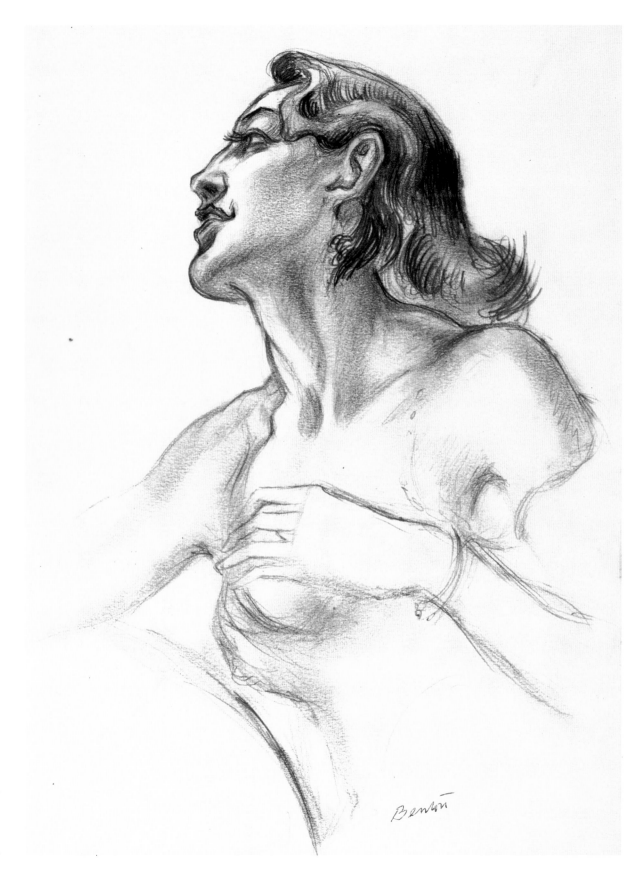

10–6. "Shake 'em Baby," sketch for "Arts of the City." 1932.

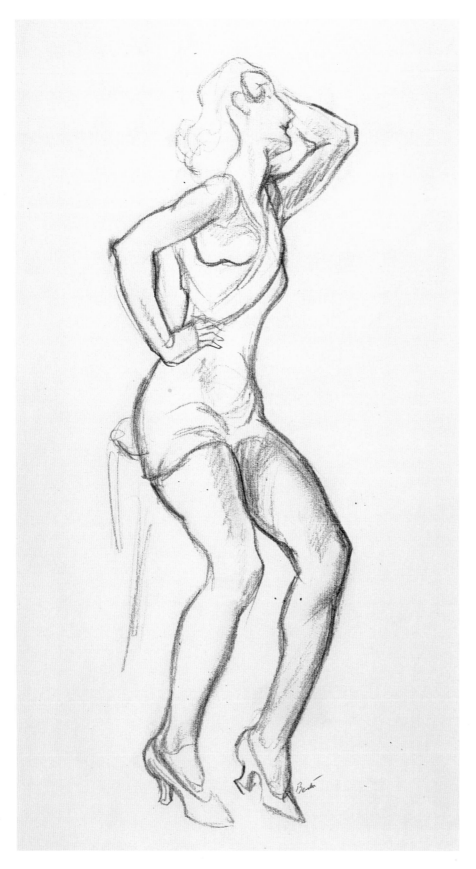

10–7. Bathing beauty, study for "Arts of the City." 1932.

I I My Missouri

That Benton has by hook or by crook managed to catch down galore the people he wanted to picture is attested by the multitude of drawings from life he has brought back from his travels. The faces, figures and most of the incidents in his [murals]—lanky plowboys turning up a corn patch, Holy Rollers cavorting for their Lord, Negro roustabouts shooting craps, chorus ladies strutting their torsos, hot mammas on a whoopee holiday and stacktown of a Sunday in the cool country—all are built up from notes and sketches originally made at first hand.[45]

Commentary on the Missouri murals, 1938

IN the autumn of 1935, Missouri's prodigal son began work on the mural cycle that would be the crowning achievement of his career. Home at last, he had returned to trace out the *Social History of the State of Missouri* on the walls of the Capitol in Jefferson City. Home at last, he had returned to make sense of the history of the place his own people came from, a history that might reconcile the wandering exile—the erstwhile Paris bohemian with the black cape and walking stick, the suave city sophisticate who frequented Minsky's and the Eighth Avenue Burlesque, the political brawler who had recently survived a hail of folding chairs at a "cell" meeting of the notorious John Reed Club—to his own sturdy roots in the soil of southwestern Missouri.

As he had done before, Benton populated his make-believe Missouri with real, down-home people. Some of them, Benton found close at hand; Rotha Williams, the Capitol janitor, became his "Nigger Jim," and a whole bevy of perky Capitol stenos contributed a feature apiece to his likeness of a St. Louis secretary. Some, like the figure of Horace Roark, his father's old law partner (and the only Republican in the scene showing the political rally, with the Honorable Maecenas Benton at the podium), sent him back down the twilight pathways of memory. Others, like the hillbilly grandma seated in a chair in the bed of a wagon, put the artist back on the road, searching, poking through the little towns strung out along old Route 4. He logged a thousand miles in Missouri and then detoured into Kansas, to Haskell University, to draw a real Osage Indian, who, in the finished mural, is shown being wheedled out of Missouri by Glen Rounds, Benton's friend and student, who posed for the wily trader with the jug of corn likker. He looked at farmland, tractors, and mules, but he looked at the cities, too, even though Regionalism was supposed to be a hick affair of heroic farmers and cornstalks rampant: he sketched his brewers and meat packers and shoemakers in their factories and

hung around businessmen's luncheons in Kansas City long enough to notice the odd exotic dancer, tip-tapping her way through the exclusive world of the Kempers and the Nicholses.

His previous murals had been sprawling, cosmic panoramas of the whole of America—the country, the city, the factory, the farm, the South, the West, a little of the past. Now he proposed to treat Missouri in just the same way. In the process, Thomas Hart Benton, late of New York and Paris, France, would become Tom Benton of Missouri, Missouri's historian, analyst, social conscience, critic, reporter extraordinaire, court jester, and, of course, Missouri's premier mural painter. By painting its walls, he would also make the State Capitol his own, a rich pictorial testament to Tom Benton's new and highly personal understanding of his own place in the people's history of the state that his father, the congressman, once represented in Washington.

The two short walls in the House Lounge that Benton painted formed the prelude and the postscript to his real story. The north wall, with Glen and the Indian boy from Kansas and Rotha Williams doing a turn out of Mark Twain, opens his history in the mid-nineteenth century. It is a not a picture of unsullied glory. Settlers work diligently at clearing the forest, and craftsmen sweat at their anvils, but the Indian is being cheated, slaves are being sold at auction and beaten, and Mormons are being persecuted. The idyllic freedom of Huck on his raft, hovering over the scene, is a fictional gloss on a period Benton approaches with clear-eyed candor. On the south wall opposite, what the pioneers wrought is shown in terms of their modern-day descendants and counterparts in Missouri's cities. Like the blacksmith of old, modern Mis-

45. Malcolm Vaughan, "Up from Missouri," *North American Review* 245, no. 1 (1938): 89.

sourians work hard in their sundry industries. But the landscape has disappeared altogether under a layer of factories, towers, and public buildings; the poor must gather lumps of coal along the railroad tracks; the pace is, at best, frenetic; and the tricksters, turned soft and flabby by years of office work, are still on the scene, now making speeches and slapping one another on their rounded shoulders over lunchtime drinks. That Frankie should be shooting Johnny, up above it all—in front of a barroom print of *Custer's Last Stand*—seems only too logical in this hard, cold world of violent action and noise.

The west wall consists of four narrow strips between the windows. Two of them contain the powerlines of Missouri industry and two the cornstalks of Missouri agriculture. They are decorative flourishes, enlargements of details scattered lavishly across Benton's earlier murals. The north wall is the kind of history Benton invented for his *Epic* long ago: it is unheroic and unedited. Less bitter, perhaps, but also less dynamic, less vital, the south wall is the kind of urban commentary Benton perfected in *America Today* and *The Arts of Life in America*. Only the long east wall that dominates the room is truly new, and only there is the secret heart of Thomas Hart Benton revealed.

The years chronicled on the east wall roll by in a kind of special, familial time, beginning in the "Politics" segment at the left (or north) end, meandering through two "Farming" scenes, and coming to a close in the "Law" vignette at the far right. In the "Politics" episode, enacted in front of the old Pike County Court House in Bowling Green, the date is sometime in that "corner of the century" after the Civil War, which rages in the distant background. It is the political heyday of Tom Benton's father, his era, a golden age full of all the silvery tales he told his son when he took him out stump speakin' in Missouri, long ago. Preserved in the memory of his wayward child, the congressman comes to life again on the Capitol wall. In the "Law" episode, mounted before the old Neosho Court House in Tom Benton's boyhood hometown, his brother Nat, the prosecuting attorney of Greene County, pleads a case. The moment verges on the present and the adjacent scenes of present-day St. Louis. Yet, with the old courthouse and Nat and all, the scene suggests the thirty years of home and family Tom Benton missed, when he strayed far from Missouri.

The whole, colorful cavalcade of local history—it begins with his father's memories, passed down through Tom, and winds up with a family-picnic summary of what the other Bentons did while he was gone—is alive with he-Bentons. His dad. His brother, Nat. His son, T. P., munching on a piece of jelly-bread in a cozy farm kitchen. Two of his nephews, debating the ownership of a watermelon in most inelegant terms while their grandpa makes his speech (Senator Ed Barbour from Springfield, Nat's friend, and the man who got Tom the mural job, plays peacemaker). The only Benton missing is the artist himself, and some folks say the big tom turkey stands for Tom, who liked to paint while humming "Turkey in the Straw" and sometimes, during breaks in long days in the Capitol, would play the tune on his harmonica for passersby who came to watch the painter-fella work. That big Tom turkey in the farmyard in the middle of the picture, with feathers spread so proud, stands for a country boy come home, home to his own folks, home to his own snug place in the very center of the history of Missouri.

11–1. Steve Hunter, sketch for figure in "Politics" segment, east wall, Missouri State Capitol mural. 1935; pencil; 12 × 8¾; inscribed, Steve Hunter, Benton.

The east wall is Benton's tribute to the same historical period covered in *An Artist in America*, namely, the earliest years of his direct knowledge of Missouri history, via his father's stories, through 1934, and his own decision to return to Missouri, where his brother had some influence in state politics. His father's world of politics appears on the left side of the wall; his brother's career in law is on the right. Benton had rejected both callings in favor of art, thus alienating himself from his family and the prevailing parental values. In the mural, however, Tom Benton—the cock-of-the-walk turkey, the poet-to-be of the farmstead—is nestled between "Politics" and "Law," a part of the Benton clan once more, finally reconciled to the virtues of the kind of life he chose not to choose.

The character of this wall makes it logical that Benton should have chosen to search out well-known political figures, former associates of his father, and his brother's friends for inclusion in the courtroom and stump-speech scenes. Stephen B. Hunter, chairman of the Missouri Penal Board, was one such person. Benton put him, cane in hand, in the audience at Congressman Benton's address, in the middle of the second row, right next to Senator Ed Barbour and the scuffle over the watermelon.

Many other Benton associates appear in this area of the mural, including Mrs. Joseph Lillard, a childhood friend (she's the lady in the sunbonnet, fixing the picnic lunch for the politicians); Judge C. A. Leedy, Jr., of the Missouri Supreme Court; W. F. ("Doc") Simpson, manager of a local hotel; and Sid Hamilton, commissioner of the Permanent Seat of Government.

11–2. Harvest scene, study for "Farming" segment, east wall, Missouri Capitol mural. 1935–1936; pencil; 13⅞ × 16¾.

Benton placed his own tom-turkey image in the big farming tableau that surrounds the doorway. To the left of the door, near the "Politics" of the last century, are scenes from Missouri agriculture of that period—a log-cabin farm in the Ozarks, with a mule-driven sorghum mill; a mid-Missouri wheat field being cradled by hand; a steel plow guided by hand and pulled by the ubiquitous mule. To the right of the doorway, near the present-day courtroom scene, are the farms of today, studied by a documentarist in a Ford. There is hand labor still (as in the pitching of hay), and horses and mules are still in evidence, but steel silos, tractors, harvesters, and steam threshers are all at work, too, among the hog raisers, the dairy farmers, and the wheat producers, and new concrete grain elevators loom in the distance.

Benton's obvious delight in this subject matter presages the gradual shift that took place in his work after 1936, when the portrait study was displaced by the nature study, and rural or agricultural themes, for several years, took precedence over historical subjects and social commentaries. The genesis of the lovely river-float and western landscape compositions of his later years can be traced back to this decisive, Missouri-inspired change in emphasis.

11–3. Cookstove, with apple pie, study for "Farming" segment. 1935; pencil; 13¾ × 10½; inscribed, Benton.

The centerpiece of the right-hand half of the "Farming" scene that deals with the slow introduction of more modern methods is a cutaway view of the interior of a one-room family farmhouse in which four generations of Missouri yeomanry interact. Great-grandpa beams down from a portrait on the wall upon grandpa (reading his paper by the stove), grandma (rolling out crust for the next pie), and their son

(washing up in a tin basin after chores). Meanwhile, their grandson perches on a box near grandma, not quite oblivious to the prospect of pie for supper. The familial emphasis restates the autobiographical thrust of the whole east wall.

Some of the wealth of detail in this delightful drawing of the familiar cast-iron cookstove was omitted from the mural because the old man's foot hid the front oven ledge from view. But, in the painted version, the biscuit pan (filled up in the meantime) still teeters on the back of the stovetop, under the pipe, where it will stay warm.

11–4. Preliminary study for the figure of the old farmer, "Farming" segment. 1935; pencil; 10½ × 16¼; inscribed, Benton.

This drawing suggests that Benton may not have begun the farmhouse scene with the notion of recapitulating the generational thrust of the mural as a whole in the farmhouse detail. This model is much younger than the old farmer whose head Benton eventually set upon his shoulders (and he wears low, citified shoes, instead of the big boots the country grandpa toasts on the stove).

The head in this drawing does resemble the generic, nonportrait heads Benton assigned to the many younger men in this part of the mural cycle, men whose primary function was to work, with a great show of muscular energy. A pair of sawyers and a plowboy to the left of the door and the young man pitching hay on its right side are such figures, as is the "son" washing up in the farmhouse detail. In a sense, they are the people from Benton's previous people's histories, the anonymous mass of people whose labor built America, and Missouri. But they are also closely related to the formulaic men Benton invented in 1932–1933 to people the massive Indiana mural when detailed studies for all the requisite figures became a physical impossibility.

11–5. Head of the old farmer, study for "Farming" segment. 1935–1936; pencil; 9¾ × 5½; inscribed, Benton.

Eventually, Benton found his old farmer and put his head on the body posed with the crossed legs and the newspaper. But the merger was more subtle than a simple graft of a head studied from life, in a real-life situation, onto the body of a studio model. The body has been adjusted to receive that head, the chest sunken and curved, the arms and legs thinned out, the hands elongated and gnarled.

11–6. T. P. Benton, study for "Farming" segment. 1935; pencil; 12 × 8¾; inscribed, Benton; verso, Capital mural.

Born in 1926, Thomas Piacenza Benton, Tom and Rita's eldest child (a daughter, Jessie, would be born in 1939) was about nine years old when he posed for the figure of the little boy keeping his grandmother company in the old farmhouse. In the mural, a family resemblance between Tom Benton's towheaded son and the dark-haired man washing up for supper is established by giving T. P. thick, black locks.

From the time he was a baby, T. P. was one of his father's favorite models. In addition to many easel paintings, he appears prominently in several of Benton's early murals. Rita and the infant T. P. form a madonna-and-child grouping that is itself an indictment of the racy "City Activities" in the New School murals. In the Whitney cycle—the "Arts of the City" panel—T. P. is a newsboy, a tough little city kid who sneaks a peep at the comics in a dance hall filled with insinuating ladies.

In his New School apparition, T. P. was joined by his father, shown in self-portrait, toasting the success of *America Today* in a nearby vignette. The Benton family emphasis is far stronger in the Missouri mural, where T. P.'s grandfather, uncle, and cousins also surround him. And his father, again, appears in the picture, quite nearby.

11–7. "Tom" turkey, a comic self-portrait of the artist, study for "Farming" segment. 1936; pencil; 13¾ × 16¾.

With this clever allusion to his name and his music, Tom Benton also declared his commitment to the kind of midwestern subject matter he had painted only fitfully before his return to Missouri, and home.

135

11–1. Steve Hunter, sketch for figure in "Politics" segment, east wall, Missouri State Capitol mural. 1935.

11−2. Harvest scene, study for "Farming" segment, east wall, Missouri Capitol mural. 1935−1936.

11-3. Cookstove, with apple pie, study for "Farming" segment. 1935.

11–4. Preliminary study for the figure of the old farmer, "Farming" segment. 1935.

11–5. Head of the old farmer, study for "Farming" segment. 1935–1936.

11–6. T. P. Benton, study for "Farming" segment. 1935.

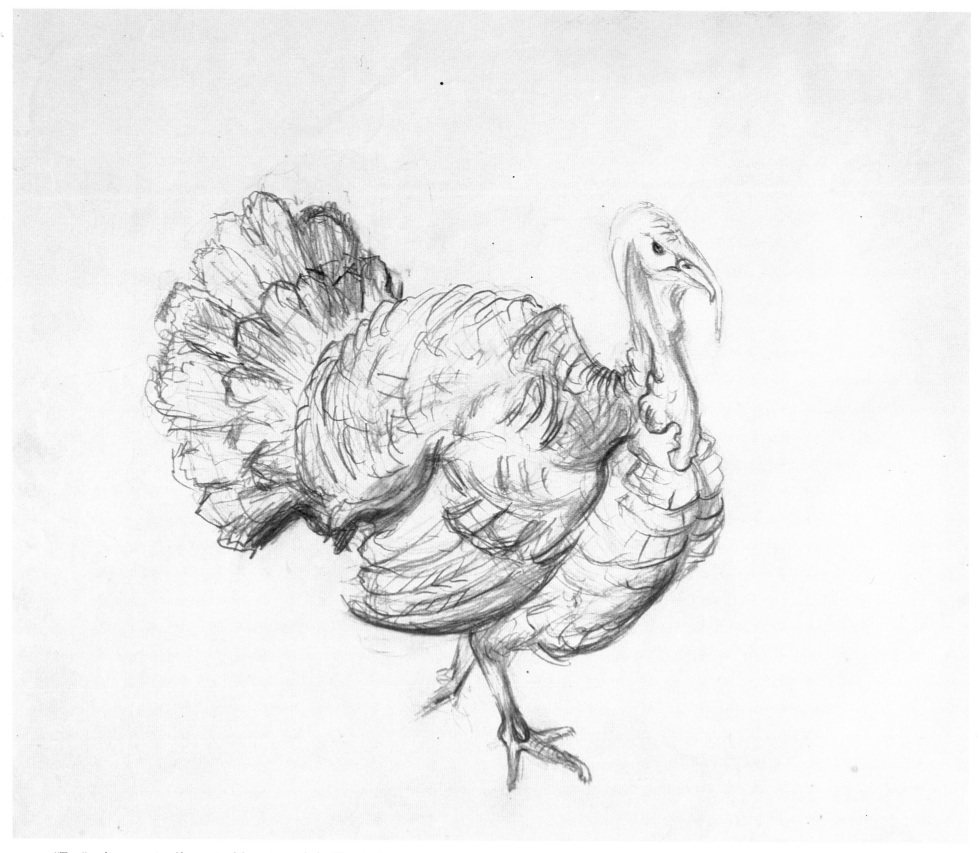

11–7. "Tom" turkey, a comic self-portrait of the artist, study for "Farming" segment. 1936.

12 Roads, Rivers, and Rails

I often had to keep a strong hold on myself to restrain welling tears of excitement. To this day I cannot face an oncoming steam train without having itchy thrills run up and down my backbone.

Its whistle is the most nostalgic of sounds to my ear. I never hear a train whistle blow without profound impulsions to change, without wanting to pack up my things, to tell all my acquaintances to be damned, to be done with them, and go somewhere.[46]

Thomas Hart Benton

ALTHOUGH he came home to Missouri in 1935, Tom Benton never really lost his wanderlust; from first to last, from the train mural on his mother's wallpaper to the steam train in his Nashville mural, he always responded to the siren's call of turning wheels. As a young man, Benton hitchhiked and, when his luck failed him, took the trains he loved to draw. He made his name with the drawings he toted home in his knapsack from the Arkansas hills and the Oklahoma plains; he even found time for an eighteen-day towboat trip down the Mississippi, from Cincinnati to Cairo and on toward the Gulf, in search of the old river towns and the last of the great sternwheelers. After he settled down in Kansas City, he still poked around the countryside when the weather was nice. Less often and with less relish for the hunt, he lit out for the territories in an old car, with an art student to keep him company, looking for those shrinking pockets of unspoiled Americana. And high summer always found him in residence on Martha's Vineyard, off the Massachusetts coast, where a Yankee remnant stubbornly resisted the tides of change.

Caught up in the colorful story of his travels, it is easy to overlook the sundry means by which Tom Benton got to those mountain "hollers" of his, to those sunbaked little false-front burgs on the prairie. But Benton never did forget. Better than any other observer of this century, Benton understood the meaning of power, acceleration, speed, and rapid pace—the hallmarks of modern life—in terms of the technology of locomotion, symbolized by his vivid renderings of belching engines, soaring planes, chugging cars and threshers. The most famous print he ever made was a 1934 lithograph called *Going West* that showed an express train roaring past, stretched out and straining like an iron racehorse with the urgency of its flight toward the sunset.[47] Based on an image created for the "Instruments of Power" panel at the New School, the print is even more dramatic and dynamic thanks to the stark black-and-white punch of the medium. And Benton saw the opening of the West and the saga of American progress on the land in highly dramatic terms, as a ceaseless, unbroken cavalcade of wheels rolling across a continent, bringing change and the benefits of civilization but bringing, too, destruction of the old ways he cherished. Wagon wheels, paddlewheels, the flanged wheels

of the mighty locomotives, the studded rims of the harvester, the rubber tires of the zipping auto: wheels punctuate his murals and adorn his paintings like so many pictographs for the name of Thomas Hart Benton. Indeed, the charging train in *Going West* may stand for his own impending flight west to Missouri, for the force of his longing for home.

In his major works, these vehicular harbingers of change always serve important functions. The old sidewheeler behind Huck Finn in the Missouri mural, for instance, helps to date that segment of the saga, and Benton named the riverboat the *Sam Clemens* in big, bold letters, just in case the significance of the vignette still eluded the viewer. Time passes from early-nineteenth-century Missouri to the present as much by the progression from horse-barge to steamboat to Tom Thumb engine to steam thresher to modern truck as by any sequence of arcane historical events. Yet Benton's boats and the rest of his menagerie of mechanical beasts of burden are more than vivid markers on the time line of history. Lloyd Goodrich once remarked that, when it emerges from Benton's pencil, "a tractor is an aggressive animal."[48] By the same token, a car is a restive one, pawing the earth with its rubber hooves, snorting with impatience to be off. A steamboat is a lordly creature, wafting along with scarcely a ripple on the waters to mark its wake, stacks held proudly against the sky. And a train, why a train is always brave and true and simply wonderful, part Missouri mule with a backbone of steel, part mythical Pegasus.

Benton's vehicles are pets, who share certain quirks of personality with their human masters. Or they are such common elements in the modern-day American landscape that, like birds and squirrels and fire hydrants and telephone poles, they are all but invisible: alone among the painters of his generation, Benton does not deem the quaint beauty of a wayside carnival ruined because he sees it over the tailfin of a '61 station wagon or the quiet beauty of

46. Benton, quoted in Carl Zigrosser, *The Artist in America: Twenty-four Close-ups of Contemporary Printmakers* (New York: Knopf, 1942), pp. 178–79.
47. Fath, *Lithographs of Thomas Hart Benton*, p. 32.
48. Goodrich, "Thomas Hart Benton," p. 130.

a Vineyard pond wrecked by the presence of a rusty pickup. Within the world of Benton's art—as in the restless land he saw and captured in his restless wanderings—the faithful car, the friendly truck, the boat, the train *belong.* The lonesome call of locomotive whistle on the night wind is as evocative as the song of any nightingale.

12–1. The railroad station, Enid, Oklahoma. 1926; ink, pencil; 4¾ × 6½; inscribed, Benton.

Benton remembered making this drawing during "a trip in a Model T Ford from Springfield, Mo. to Taos, N.M."[49] It has special importance because the sketch was the basis for Benton's first lithograph, a print variously called *The Station, Oklahoma, Edge of the Plains,* and *Train in the Station.* Printed by George C. Miller, who was also responsible for the seventy-seven other prints Benton made before the death of his technician, his lithographs were the means by which Benton finally reached "the people." Benton's principal contribution to American art was his insistence that the art object not only reflect the mass culture of the day but also find its way into the daily lives of those it pictured. Hence, his emphasis on reportage, on murals for accessible public places, on stunts like his Hollywood work and his ads: hence, too, the prints that, especially after he became affiliated with Associated American Artists in 1943, were retailed through department stores and mail-order catalogues on a truly populist basis, at $5 apiece.

The subject matter underscores Benton's association between the train and the romance of the West. The engine is always the bearer of civilization, a mechanical pioneer whose ministrations are sometimes subverted, as in the Jesse James train robbery vignette in the Missouri mural cycle, also the subject of a 1936 print. A 1942 print, *Homeward Bound* or *The Race,* depicts a contest between a steam locomotive—an iron horse—and a stallion on a twilight prairie and carries with it the bittersweet intimation that the old West is passing away with the roar of the engine.

12–2. Touring car. Circa 1926–1927; pencil, ink; 4¾ × 6½; inscribed, Benton; verso, $25.

The scene vaguely indicated here could be Martha's Vineyard, or southern Missouri, or the Southwest; Benton was clearly less interested in nature than in the big car parked in the foreground. Cars like this one are among the principal actors in *Boomtown,* the 1928 oil painting that was his first, mature Regionalist canvas. In that work, the Model-T touring cars and Durants wait at the hitching posts of a western town like so many gasoline-powered horses; as they are central to the field of vision in the painting, so, Benton says, are they crucial to the transformation of American culture in the booming twenties.

Benton saved this drawing for years and finally used it as the model for the car parked in front of the Ozark church in the distant background of his controversial nude, *Susannah and the Elders* (1938). Because it was out of date by then, the car helped to suggest the narrowness, frugality, conservatism, and repression of the churchgoing "elders" who peek at the naked bather from the bushes. The car also made it abundantly clear that Benton meant the painting to be read as an American parable, a modern-day parallel to biblical events.

12–3. The steamboat *Cincinnati,* a sidewheeler, on the Mississippi River. Circa

1930–1935; sepia, ink, pencil; 9 × 11¾; inscribed, Benton; verso, $200.

Among the most beautiful and the liveliest of all Benton's drawings is the series of incisive pen-and-ink renderings of Mississippi packet boats and paddleboats, to which this example belongs. When Benton went down the river in the early thirties, and when he camped for days along its banks in Louisiana waiting for the *Tennessee Belle,* the last of the great old riverboats, to put in for cargo, he was acutely aware that he was recording a vanishing moment in American history. Indeed, the *Belle* ran aground and went down below Vicksburg shortly after Benton drew the landing scene that he incorporated into his view of "The South" at the New School.

The sense of nostalgia—heightened by the stalwart puff of smoke—is palpable in Benton's treatment of the *Cincinnati* as a kind of humanoid entity, a doughty old dowager of the waters whose decks have warped with age into tired, pliant curves. Cleaned up and trimmed for service, the *Cincinnati* set sail again in the praedella to the right of the doorway on the east wall of the Missouri Capitol mural, a scene that deliberately invokes the romance of steamboat and plantation days in gracious, antebellum Missouri.

12–4. The steamboat *City of Memphis,* on the Mississippi River. Circa 1930– 1935; sepia, ink, pencil; 9 × 11¾; inscribed, Benton; verso, $250.

With the float of logs in the foreground, this drawing already suggests the composition of the Huckleberry Finn vignette in the Missouri Capitol. In the mural, Tom Benton renamed her the *Sam Clemens.*

He returned to the river in 1939, when he was commissioned to illustrate *Tom Sawyer,* and promptly exhibited another group of riverboat drawings at the New York galleries of Associated American Artists in that year. In his illustrator's foreword to *Huckleberry Finn,* issued in 1942, Benton revealed a deep affection for the Mississippi and the historical spectacle represented by the passing traffic on its waters: "I know the river, and its backwaters and tributaries, not only as geographic facts but as waters over which the sun rises and sets and casts reflections, pink and blue and jet-black. I was raised among people who talked the language of Huck Finn's people, who thought like them, and acted like them. I am in that book just as the book, after all these years of reading it, is in me. The difference between Huck's time and my time as a boy was a matter of fifty years or so."[50]

12–5. Refinery engine, Louisiana. 1943; pencil; 12¾ × 11¾; inscribed, Benton.

In keeping with his assignment, most of the studies Benton made on behalf of the war effort at the oil refineries outside Baton Rouge and New Orleans are exciting, dramatic views of the soaring and futuristic shapes of the catalytic converters, bedecked with coiled tubing and a steel exoskeleton. But he could never resist a train. This yard engine takes on a real personality from the cocky set of the valves above the boilers, and Benton was careful to display its "name" along the side. The handling of the pencil, particularly around the stack and the valves, is not only sensitive to the slightest nuance of contour but also extremely sensual.

The war somehow turned Benton's attention back to the train, as a folkloric entity and a symbol of catastrophe. In 1943, for instance, Benton did both a painting (Marilyn Goodman, Great Neck, New York) and a lithograph on the theme, *The Wreck of the Ol' 97.* Based on a "cowboy" or "hillbilly" ballad popularized by the country singer Vernon Dalhart in the twenties, the picture described the moment

49. Fath, *Lithographs of Thomas Hart Benton,* p. 22.

50. Thomas Hart Benton, foreword to Mark Twain, *Adventures of Huckleberry Finn* (New York: The Limited Editions Club, 1942), p. lxxiii.

when the steam train hit the downgrade at ninety miles an hour and busted loose. Benton made drawings for the composition in the winter of 1926–1927 but waited almost twenty years to develop the idea. The pessimism and retrospection of the scene are also exhibited in other works of the period, such as the painting (Robert Strauss, Houston, Texas) and print entitled *Fire in the Barnyard*, based on a childhood memory of a nighttime fire at his grandfather's cotton farm near Waxahachie, Texas.

12–6. The family Ford, Martha's Vineyard. Circa 1950–1953; ink; 8 ⅛ × 7 ⅛; inscribed, Benton.

There is a still, summertime feeling about this casual glance at one of the first of the new postwar automobiles sunning itself lazily on the lawn, with the front porch and the screen door of the cottage in the background. The set of the tires and Benton's subtle attention to the facelike configuration of radiator grille, bumper, and headlights hint at the Ford's weary gratitude for a snooze.

After the war and his disillusionment with human contact, Benton traveled less regularly and relied more heavily on the domestic scene for his subjects. The early

fifties, when Benton added a new chapter to his autobiography, was a time of sad reappraisal of his career in the light of Jackson Pollock's success; that process, too, turned his pen toward humble and mute subjects, closer to home.

12–7. Jeep, southern Missouri or northern Arkansas. Circa 1968; pencil; 10¾ × 13¾; verso, landscape with canoe in stream.

This drawing is a souvenir of the annual river floats that brought Benton back into the vital fellowship with humankind that had inspired his best work. While some of the drawings he made on his river trips—most notably, those done on his 1965 trek along the route of Lewis and Clark—are done in a spidery hand, weak with fatigue, the recreational trips of the period generally elicited robust studies of rock formations, clouds, and the detritus of the camper. Picnic coolers, tents, folding chairs, and outboard motors are set down with a participant's relish at inspecting the gear of the outdoorsman. The chubby, rounded shapes into which Benton most often resolves the mass of such objects render them benign and comforting in their solidity, like so many teddy bears in a children's book. This jeep has that kind of chunky presence and monumentality.

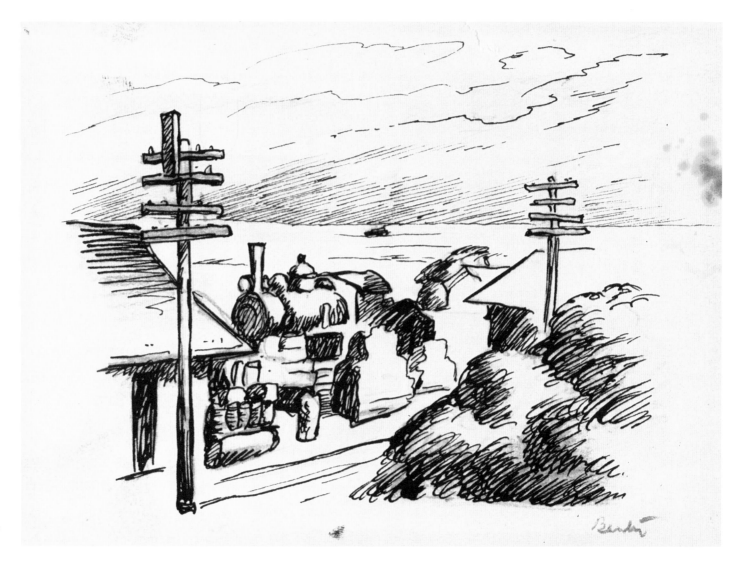

12–1. The railroad station, Enid, Oklahoma. 1926.

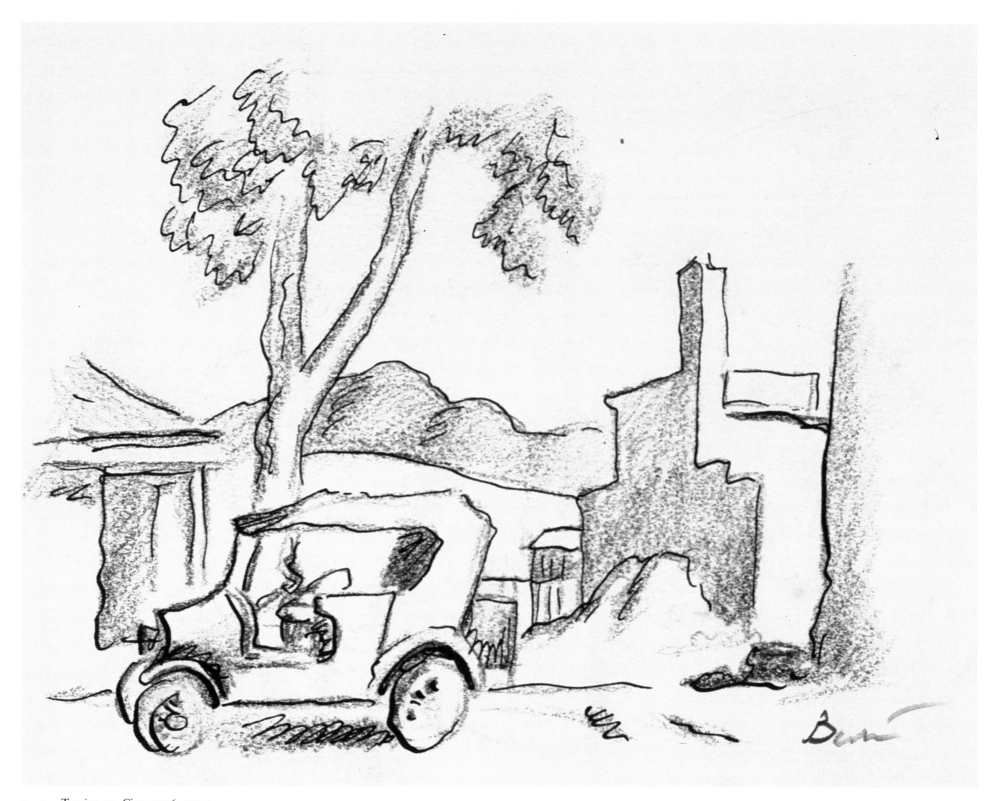

12–2. Touring car. Circa 1926–1927.

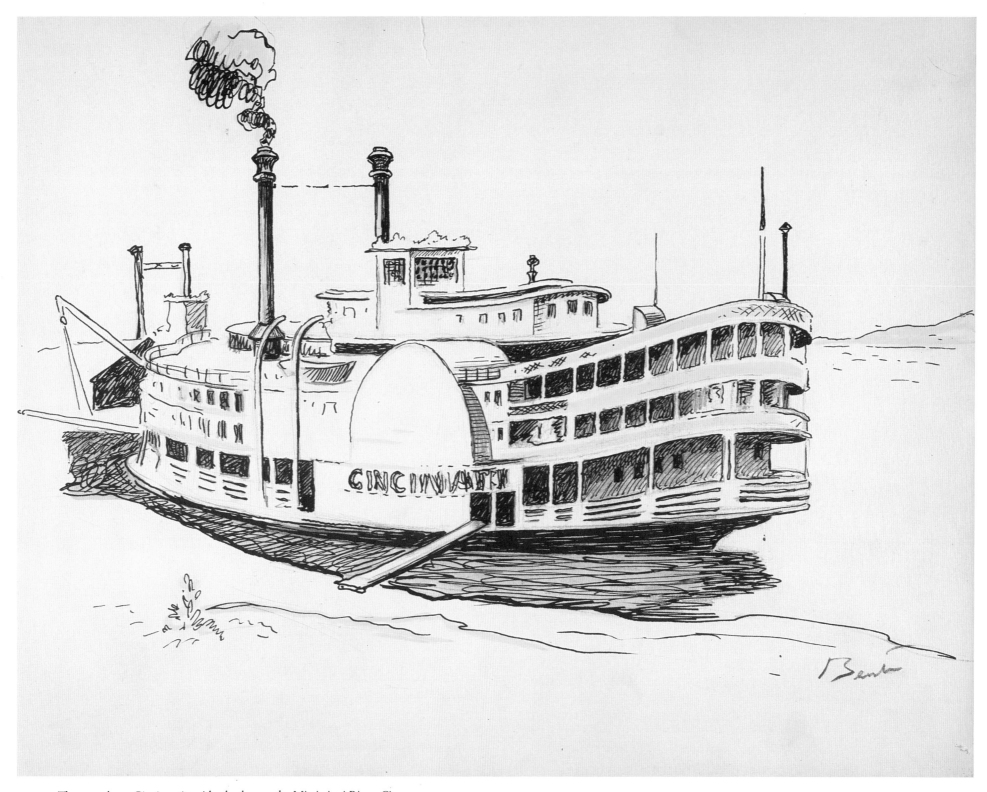

12–3. The steamboat *Cincinnati*, a sidewheeler, on the Mississippi River. Circa 1930–1935.

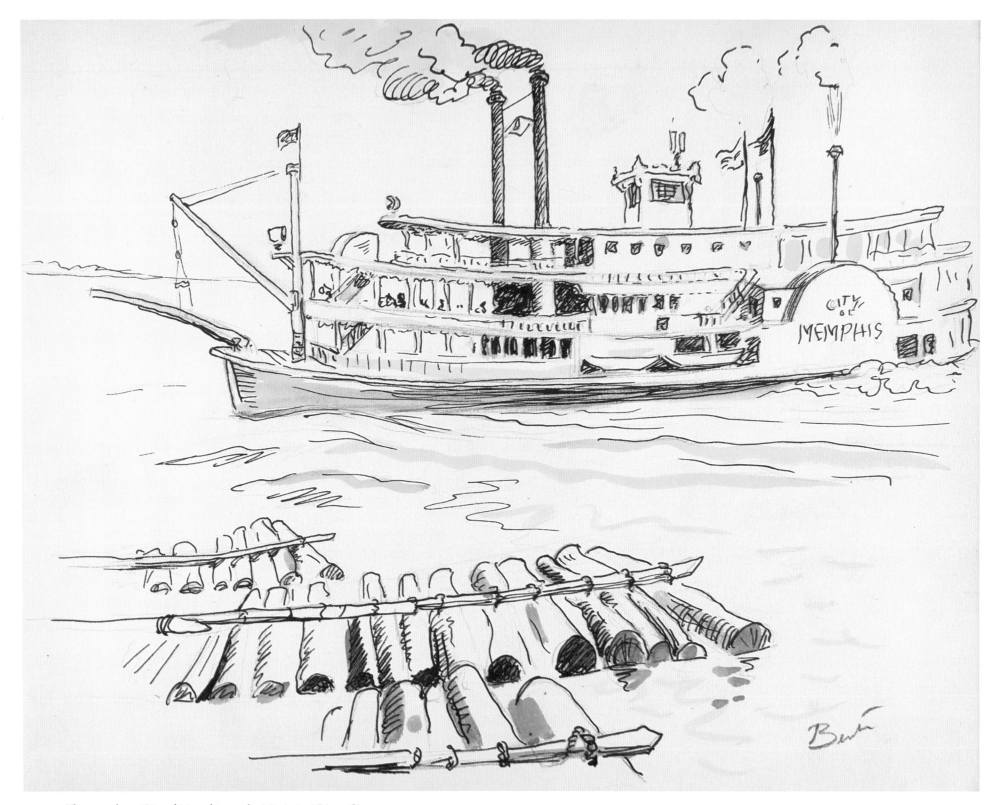

12–4. The steamboat *City of Memphis*, on the Mississippi River. Circa 1930–1935.

12–5. Refinery engine, Louisiana. 1943.

12–6. The family Ford, Martha's Vineyard.
Circa 1950–1953.

12–7. Jeep, southern Missouri or northern Arkansas. Circa 1968.

13 The Bentons of Chilmark (and Kansas City)

Overwhelmed by the turmoil of events and feeling the inadequacy of his plastic means to give expression to them, Benton began turning his attention to the ordinary, intimate aspects of the everyday world, the play of tone and texture, the rhythm of line and foliage, flowers, land formations, figures—a renewal of nature in terms of plastic form.[51]

Critical appraisal of Benton's postwar work

FROM the late twenties, and the notice attracted by his sketches from the backroads, through the late thirties, and the cumulative notoriety engendered by his murals, Thomas Hart Benton had lived and worked in the public arena, under the basilisk gaze of the public eye. By painting great historical themes or "arguable" interpretations of modern-day social history, he had seemed to court the role of the public man of affairs. The war changed all that: his art was powerless to affect the inexorable course of events, and his self-confidence crumbled under the merciless scrutiny of the young GIs and their girls who saw an old man, all washed up, over the hill. But even those drawings done before Pearl Harbor show the tentative beginnings of a shift away from grand, public themes and toward more personal ones. The move back to Missouri turned Benton's pencil back toward home as well, toward the smaller, sweeter world of family, friends, and blessed peace.

Benton's quest for stability and serenity did not, at first, lead him to depict the family's new house in Kansas City: what with the needling of Mr. Huselton and the pressures of a new job at the Art Institute, Missouri was a madhouse. Instead, he turned his attention to the summer place on Martha's Vineyard. On the advice of Rita Piacenza, Tom Benton had summered on the island for the first time in 1920. He had used the proceeds of his first teaching job, at Bryn Mawr, to buy a house there in 1927, and, thanks to the business acumen of his wife, Rita, he had paid off the debt on the property by the summer of 1928. It wasn't much—a three-room cottage on a hill, with a chicken coop and a barn that could be used as a studio—but the view of Menemsha Pond and the Sound beyond was magnificent, and it was Tom Benton's first permanent home since he had left Neosho, the first home of a new family composed of Tom and Rita and little T. P.

Off the Massachusetts coast, nothing much seemed to change from one summer to the next. Billy Benson and Sabrina West and the Brugs and the Look clan who lived between the Chilmark town hall and the Benton place all went along, pretty much the same, from one year to the next. Vineyard Yankees were, if not exactly hidebound conservatives, strong traditionalists who held a low opinion of change for the sake of change. In the twenties, when Benton was beginning to think about painting American history and was finding the hidden nodes of folk culture still thriving in a money-mad, machine-mad world, the islanders were his first subjects. They stood for tra-

ditional values and the American past; they also came to represent, in the mind of their restless seasonal neighbor, a continuity and a rootedness missing from his own life. In the forties, when the machines of war spat death and his untidy life was in shambles once again, Tom Benton did a whole series of drawings, paintings, and prints based on the unchanging routines of his Chilmark neighbors, tasks like milking the cow by hand or reaping island hay with long scythes and strong arms. Their steady resistance to progress and the tides of time became Tom Benton's bulwark against both modernism and mortality.

13–1. The beach at Martha's Vineyard. Circa 1920; pencil; 6⅝ × 8¼; verso, sketch of flowers and pots.

Benton jotted this drawing down in a school exercise book that also contains a draft of a letter dealing with his enlistment in the Navy; it is among the earliest of his new, object-oriented studies done under the influence of his work as a naval draftsman.

The contemporary, slice-of-life subject is a departure. The treatment of the scene in terms of masses balanced on either side of a central axis and a carefully calibrated sequence of forms moving into depth is not anecdotal, however. Instead, it reflects Benton's continuing commitment to abstract pictorial organization. In 1919, Benton read an article about Tintoretto that attributed the control and plasticity of his multifigure compositions to the use of clay models for his works. Benton adopted the procedure, for which he had a natural affinity. Even in this fairly spontaneous study, the artist handles details of beach umbrellas, reclining bathers, and women drying their hair as compositional building blocks. These units allude to or parallel the real world of the beach but do not describe it.

After the Synchromist pictures derived from the great art of the past and the Navy sketches, with their heavy emphasis on machinery, this drawing fairly sparkles with life and points toward the Chilmark portrait drawings and the earliest of the Missouri travel sketchbooks. Benton would soon forget the antics of the summer people on the beaches in order to concentrate on the natives; the marriage portrait of Tom and Rita on South Beach, painted in 1922 (National Portrait Gallery, the Smithsonian Institution, Washington, D.C.) is the last example of this "tourist" genre.

13–2. Henry Look and the white calf, Chilmark. 1941–1945; pencil; 12⅜ × 16⅞; inscribed, 50″ 4′2″ high, N.V.

51. Henry La Farge, *Thomas Hart Benton: A Comprehensive Exhibition of Drawings,*

Henry Look, one of Benton's Vineyard neighbors, owned two cows. He did a pretty good business selling milk until a snoopy summer person came upon him straining it through his used pocket handkerchief. Or so Benton told the story about his friend, a story that made him into a colorful character, fit for a Benton painting.

In the early forties, Benton painted Henry Look at least four times, unhitching his horse, taking his two cows off to pasture, and simply posing stoically for a portrait called *New England Farmer* (New Britain Museum of American Art, New Britain, Connecticut) executed in 1941 for the second annual All-Island Cavalcade and County Fair at West Tisbury, where it was sold for the benefit of the local hospital.

The central motif of this squared study for a painting on the same theme was used as the inspiration for *White Calf*, a 1945 lithograph depicting Look milking a cow, with the calf tethered nearby. The emphasis on a simple, old-fashioned way of doing things and the use of an old friend as a model are typical of Benton's work during this troubled period.

Benton claimed that several of the motifs used in his Chilmark works of the forties—the hay mower with his hand scythe, for example—had been drawn in the midtwenties. While this contention serves to emphasize the nostalgic cast of the wartime pictures on Vineyard themes, it is not supported by surviving drawings, which were clearly done in the forties, not the twenties.

13–3. Study for the foreground of *Picnic*, a scene on Menemsha Pond, Martha's Vineyard. 1943; pencil; 5½ × 4¾; inscribed, Benton; verso, The tin can.

Benton began painting independent still life in earnest around 1940–1941. Rather than painting studio arrangements of objects—he did paint vasefuls of flowers from Rita's garden occasionally in the forties but most often in his last years—Benton looked close-up at the fields and roadside foliage that figured in his Regionalist works. His earliest studies in this vein were done on Martha's Vineyard and rely heavily on the twisted scrub oak of the area for their expressionistic overtones. The tree in this drawing appears many times in Benton's oeuvre, from *Woodland Chilmark* of Circa 1941, to *Picnic* of 1943, to *Silver Stump* of 1943, to *Still Life* of 1952 (Mrs. Joseph Frisch, Vineyard Haven, Massachusetts).

The strangest painting in the nature series is *After Many Springs* of Circa 1940 (Mr. and Mrs. Harris J. Klein, New York). In the background, set against a split-rail fence, a farmer plows a field behind a mule. But the scene is not really the Midwest, or so the foliage suggests. The dominant foreground, placed very close to the eye, contains a still life made up of scrub oak, mid-August trumpet vine, and wild grape, all Vineyard plants, and, in among them, a skull surmounting a rusted pistol. The work is a disturbing one on many levels, a merger of the Missouri and Massachusetts halves of a turbulent life, with hints of suicidal despair.

In *Picnic*, the mood has lightened, although the composition is remarkably similar. The vines, the tree, and the leaves shown in the drawing (they are reversed in the painting) constitute the foreground for a distant view of a late summer picnic on the beach. Whereas the gun and skull gave voice to the still life in *After Many Springs*, the tin can performs that function here. This is a place, it says, where many a picnic has been held, a place where man and nature have contrived to live together for a long, long time. Benton is never a pure painter, for all his struggles with abstract form; even the most personal, the least rhetorical of his subjects manage to speak to social issues.

13–4. A corner of "our living room" in Chilmark. 1950s(?); tempera; 12¼ × 10¼; inscribed, Benton; verso, Corner of our living room in Chilmark, along with a landscape sketch.

As an art student in Chicago, Benton complained that oil painting was hard for him because the fatty pigment ruined his drawing. Benton harbored a mistrust of direct painting and of color for the rest of his career. In his murals, local color was the last detail to be added to his clay models, after an elaborate series of drawings and studies had been completed. In his drawings of the twenties and thirties, watercolor is, at best, an afterthought, added to preserve the integrity of pencil lines.

This is one of a handful of Benton brush sketches, the vast majority of which were painted during summers on the Vineyard and depict the domestic clutter of the interior or the view from the front porch. These infrequent drawings in pure watercolor, without the support of pencil underpinnings, show Benton in his most relaxed, his least anxious, and his least self-conscious mood.

13–5. Menemsha Bight, Martha's Vineyard. 1970; ink; 7¼ × 10½; inscribed, Benton '70; verso, $25.

Done with a ballpoint pen on a piece of Rita's imprinted stationery ("Mrs. Thomas Hart Benton, Chilmark, Massachusetts, Island of Martha's Vineyard"), this most informal of sketches was, in fact, the inspiration for a large canvas called *The Race (On Menemsha Pond, Martha's Vineyard)* of the same year. The distinctive rock and spit of land near the sailboat figure in many of his other works of the forties and fifties.

This was the Vineyard of the semi-native, the almost-local Benton. During his early trips to the island, Benton invariably sketched South Beach and the Wes'-quobsque Cliffs, places where summer people frolicked.

13–6. Tom Benton's house, the Roanoke district, Kansas City. Circa 1966–1970; pencil; 13 × 8⅞; inscribed verso, $25.

In his later years, Benton could be equally relaxed about the Kansas City house he often sketched from the doorway of the studio in the old carriage house. Rita's flower garden provided him with subject matter when inspiration flagged. He started painting flowers, he said, when the bunch T. P. picked for his mother's birthday began to wilt; old Dad quickly painted a picture of them, guaranteed to be ever-fresh.

The Benton house had been built in 1903–1904 by George A. Matthews, who also laid out the wealthy and once-private enclave called Janssen Place, some two miles to the east.

13–7. Tom's grandson, Anthony Benton Gude. 1965; pencil; 11 × 8¼; inscribed, Benton.

This sketch was incorporated into the double portrait *Jessie and Anthony*, depicting Benton's daughter and her son playing with a kitten on the sofa in the living room of the Kansas City house where Jessie had once decorated the little windows on either side of the front door. Jessie, her son Anthony, and her daughter Daria were among the delights of Benton's final years.

Born in 1939, at the beginning of Benton's midlife crisis, Jessie first appeared in the remarkable *Jessie, One Year Old* of 1940, in which the baby is surrounded by Vineyard plants and vines of such hallucinatory clarity and vitality that they become menacing and surreal. Although Benton painted several actual portraits of his daughter in the fifties and sixties, her features can also be detected in the faces of several young women prominent in the postwar murals. There is something of Jessie in the Indian maiden in the River Club mural, for instance, and more than a hint of her in the pioneer mother in the Truman Library mural.

13–1. The beach at Martha's Vineyard. Circa 1920.

13–2. Henry Look and the white calf, Chilmark. 1941–1945.

13–3. Study for the foreground of *Picnic*, a scene on Menemsha Pond, Martha's Vineyard. 1943.

13–4. A corner of "our living room" in Chilmark.
1950s(?).

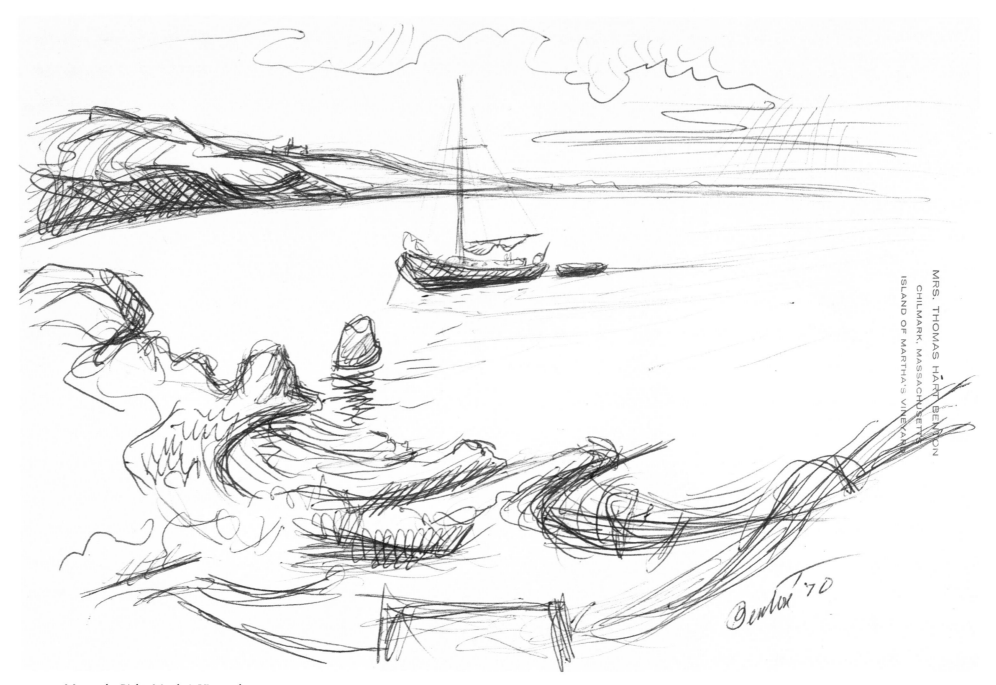

13–5. Menemsha Bight, Martha's Vineyard. 1970.

13–6. Tom Benton's house, the Roanoke district, Kansas City. Circa 1966–1970.

13-7. Tom's grandson, Anthony Benton Gude. 1965.

I4 The Real Thing

I never start any more with a preconception of the nature of form; I start with faces, tree trunks, old shoes.[52]

Thomas Hart Benton

BENTON'S newfound interest in still life and the minutiae of his physical environment was anticipated by the density of anecdotal detail in the Missouri Capitol mural. Taken as a whole, the decorations of the House Lounge disorient and, finally, overwhelm, but the separate parts, in their attention to the poignant set piece and the telling particular, more often charm. A cuspidor imparts an earthy touch to the proceedings in Nat Benton's courtroom, and somebody has even missed the mark and sprayed the floor instead; the clock and calendar behind the head of the bored judge show how slowly time is dragging by. When the strapping young farmer spruces himself up for dinner, he does so with an ancient bar of homemade soap and a comb that's missing all its middle teeth. Grandma uses a tin sifter to flour her board and dries her flour-sack dishtowels on a rack behind the stove. The St. Louis saloon where Johnny meets his end is decorated with a garish print showing *Custer's Last Stand*, the very best of the old barroom chromos. Huck and Jim have caught no ordinary fish but a big, fat Mississippi catfish.

The catfish, the clock, the chromo, the cuspidor, and the comb all help to make the mural meaningful in a more intimate way. The wall becomes a maze, a puzzle, a grab bag full of sweet morsels to be found and savored. These snippets of true-to-life detail also make Benton's "people's history" utterly believable: abstract "masses" don't use combs with missing teeth or spit tobacco on the floor, but real, living "people" do. Benton's own tempestuous, wisecracking, Pa Kettle folksiness was often expressed in his later years by these little bits of business, squirreled away in huge murals. In the Lincoln University mural, for instance, a page of the book grasped by the teacher holds Benton's dedication of the work to the graduates of that black institution, the cover of another book contains his signature, and the title of a third—"TORY . . . RICA"—deliberately confuses American with African history. In the Joplin mural, a pair of disembodied hands—Tom Benton's?—reaches into the poker game from the viewer's side of the wall and palms three aces; the book placed on the table in the Keystone Hotel is an elaborate Gideon Bible, put there to take the sting off the low-life and the gambling seen elsewhere in the picture.[53]

Apart from the stories that objects have to tell, the sheer wealth of artifacts that Benton began to substitute for people in his drawings of the later thirties and forties, and the accessories that tend to swamp the people who appear in his later murals, strike a resonant note in a materialistic culture obsessed with the want of things in the Depression, the need for things in wartime, and the lust for new and shiny things in the consumer boom of the postwar era. The thing-ness of canvas and paint is a major component of the aesthetic of Jackson Pollock. Benton anticipates Pollock in the dense, cloying thing-ness of *Persephone*, in which cloth and leather, vine and bark, skin and fur and leaf have been studied with precisely equal attention. Benton's ultimate answer to Abstract Expressionism is the kind of hyperbolic materialism seen in the Truman Library mural, in which every inch of the wall surface is alive with guns and beads and traps and chains and a thousand other scraps of still life that whirl the eye about the picture as forcibly as any spatter of Pollock drips.

52. Quoted in Pickering, *Thomas Hart Benton on His Way Back to Missouri,*" p. 18.
53. Thomas Hart Benton, "The Mural," in Mary Curtis Warten, ed., *Thomas Hart Ben-*

14–1. Horse-drawn harrow, study for "The South" segment, New School murals. 1930; pencil; 10 × 12½; inscribed, Benton, Study for New School mural 1930.

Benton's earliest meticulous renderings of things are the various implements and machines used to represent modernism in the New School murals; technological details illustrate the differences between the slower, simpler past and *America Today*.

14–2. Coffeepot, New York(?). Circa 1930–1932; pencil; 14½ × 10½.

Done on the perforated page of a sketchbook that contains a number of New York drawings associated with the New School and the Whitney murals, this quick study of the hands of a waitress inspired a segment of the narrow frieze of "Outreaching Hands" Benton mounted over and between the two "City Activities" panels at the New School.

America Today, *The Arts of Life in America*, and the "Water Story Mural" all contain fountain or diner scenes for which Benton needed this kind of detail. The style of the pot—a far cry from the tall, sleek coffee urns in evidence in his modern soda fountains—suggests the greasy-spoon cafés that the artist visited to find the down-and-outers for the soup kitchen vignette in the left-hand corner of the "Arts of the City" panel in the Whitney cycle; in Benton's mature working procedures, no detail was ever wasted. One mural scheme fed the next.

14–3. Lab equipment, study for "Kansas City" segment, south wall, Missouri Capitol mural. 1936; pencil; 8½ × 11⅞; inscribed, not essential, can be made larger, water line canary yellow, vacuum distillation output.

The still life consisting of a Bunsen burner and several flasks joined by tubing stands for the growing chemical industry of Kansas City. The drawing is very much a quick, on-the-spot affair, with several corrections as well as notes on color and those details that are "not essential." It is surprising, then, to see how little Benton has altered this grouping during the process of translating it from sketchpad to wall. Only the angle of vision changes slightly, and the inessential details proved too interesting to omit.

14–4. Jim's catfish, study for "Huck Finn" vignette, north wall, Missouri Capitol mural. 1936; pencil; 12 × 8¾.

One of Benton's nicest studies, showing both delicacy of handling and linear inventiveness, this depiction of the fish caught by Nigger Jim presages Benton's growing interest in nature and his skill at capturing the textural qualities of natural materials.

In the mural, the fish gives the Mark Twain characters some raison d'être for being on their raft; it is also calculated to delight anyone who has fished the waters of the Mississippi and enjoyed a local delicacy often scorned elsewhere.

14–5. Oil lamp, study for "Frankie and Johnny" vignette, south wall, Missouri Capitol mural. 1935–1936; pencil; 11 × 8⅜.

The lamp helps to show that the legend celebrated in the old song took place in the past, when grandma and grandpa used such devices. The lighted lamp also indicates that it is nighttime. All the "real"—historical or modern-day—scenes in the Missouri mural are enacted in the light of day. The scenes derived from folklore, legend, and literature—Huck and Jim, the James Gang, and Frankie and Johnny—take place in the dead of night, giving them an aura of distance and romance. These nocturnes are all set above doorways, too; the dark tones help to distinguish the points of egress in the bright and busy wall.

14–6. Long rifle, bedroll, and powder, study for *The Kentuckian*. Circa 1954; pencil; 10¾ × 16½; inscribed, Benton, Benton.

The elegance of this design derives from the years of still-life study that followed Benton's completion of the Missouri Capitol mural cycle. Benton's drive for historical accuracy in the smallest detail is also evident. Similar gear is carried by the Jim Bridger–Kit Carson–Jim Beckwourth frontiersmen in the Truman Library mural of 1959–1962.

The Truman Library mural, *Independence and the Opening of the West*, is the florid apogee of Benton's fascination with "stuff." The work as a whole is the sum of hundreds of discrete parts, things painted with a hyperclarity that tends to minimize the human drama of the situation. Increasingly, in the historical murals of the fifties and sixties, Benton further deemphasized personality by using many "lost-profile" views of his actors or by placing foreground figures with their backs toward the viewer.

He became expert in finding just the right period costumes, arms, and tools for his paintings. In April 1959, for instance, he sketched such details at the encampment of the Oregon Centennial wagon train in Independence.

14–7. Lamp base, parasol, and shoe, study for Joplin mural. Late winter or early spring 1972; pencil; 12 × 10; inscribed, Benton, Lamp shade see cut.

On January 18, 1972, Benton wrote to the organizer of the Joplin mural project, reporting on his progress to date and asking for historical photographs of such items as a horse-powered hoist ("hist"). In a postscript, he asked if anyone could recall "whether the Keystone [Hotel] had electric table lamps in 1906. (Bedside Table lamps.) Or any other hotel? Find out if there were Hotel bedside table lamps in 1906 in Joplin. Just find out. I can probably run down their style—probable style." [54]

Local experts knew the hotel had been wired for electricity, but only single bulbs, hanging from the center of the ceilings, illuminated the rooms. No bedside tables. No bedside lamps. So Benton used a parlor table to represent the Keystone instead and lit it with a table lamp illustrated in a 1902 mail-order catalogue.

The same fanatical care went into the costume worn by Kay Callison, "the dressed up young lady" at the left of the mural who shows, Benton said, "that boomtime Joplin, though assiduously devoted to grosser interests, could aspire to elegance." [55]

54. Quoted in ibid., p. 38.
55. Benton, "The Mural," in ibid., p. 37.

14–1. Horse-drawn harrow, study for "The South" segment, New School murals. 1930.

14–2. Coffeepot, New York(?). Circa 1930–1932.

14–3. Lab equipment, study for "Kansas City" segment, south wall, Missouri Capitol mural. 1936.

14–4. Jim's catfish, study for "Huck Finn" vignette, north wall, Missouri Capitol mural. 1936.

14–5. Oil lamp, study for "Frankie and Johnny" vignette, south wall, Missouri Capitol mural. 1935–1936.

14–6. Long rifle, bedroll, and powder, study for *The Kentuckian*. Circa 1954.

14–7. Lamp base, parasol, and shoe, study for Joplin mural. Late winter or early spring 1972.

15 How to Paint a Picture

The studies are complete without being finicky; at the same time, they reflect a salty and serious regard for the natural objects of this world, a kind of healthy objectivity and variety of interest that smacks of some of the pages from the notebooks of Durer or Leonardo. This kind of penetrating rendering has led to Benton's increased awareness of the variety of textural contrasts.[56]

Critical appraisal of *Persephone*, 1940

THE "new Benton" was unveiled with considerable hullabaloo in 1939, when his blockbuster nudes, *Susannah and the Elders* and *Persephone*, graced the gala opening of the new New York galleries of Associated American Artists. There were some independent nature studies, too, including one picture called *Pussycat and Roses*. Had the ferocious tomcat of yore turned into a declawed tabby during his exile in Kansas City? Had the old rock-'em-sock-'em Tom Benton, with a vulgar streak a mile wide, a chip on his shoulder, and a wicked eye for social satire somehow become Thomas Hart Benton, distinguished salon painter of bland studio claptrap? The answer was "yes" *and* "no." Thomas Craven, in top-lofty tones fairly dripping with dignity, deemed *Persephone* "unsurpassed by anything thus far produced in America." E. A. Jewell, in the pages of the mighty *Times*, resented Craven's touting of some "new manner" or another, as if art were toothpaste! While he did notice a few "fine passages," even some signs of "virility" here and there, to Jewell the paintings seemed a lot like the old Benton, "cheap," "shallow," and "juvenile." Indeed, this Benton was a little more offensive than the previous model, who hadn't been "blatantly prurient."[57]

Although the experts disagreed as to whether the enormous nudes represented more of the same from a consummate vulgarian or the classy classicism of a New Master, the burnished, hair-splitting realism of Benton's style was unquestionably novel and intriguing. In the past, Benton had been noted for the number of drawings he made in preparation for a given work. Even though each element in a picture—heads, bodies, hands, costumes, accessories—corresponded to a separate sketch from life, the old Benton had rarely devoted a drawing to reworking or restudying a detail snatched piecemeal from his sketchbooks. The new Benton worked differently. He, too, made a huge number of sketches—*Life* reported that he had done four hundred studies for *Hollywood* alone—but the new Benton refined every leaf, every blade of grass, by drawing it repeatedly, until its contours were honed to a cutting edge and its surfaces quivered with the sensuous caress of texture. He drew *Persephone*'s downy breast once, and once again, and then just one more time.[58]

The obvious change in the look of Benton's work stimulated interest in the technical means whereby he had achieved such startling results. In the spring of 1940, *American Artist* ran a long case study on *Persephone*, an illustrated step-by-step analysis of the evolution of the picture, from the first rapid sketches of a Missouri mule team, made on the spot, to the completion of the nearly-six-foot-tall gesso-coated canvas after months of work in the studio. The account is not entirely coherent, but it does make note of the dramatic difference between Benton's usual, rapid, impressionistic drawings of scenes like the harvest somewhere in rural Missouri glimpsed in the distance of *Persephone* and the more recent botanical studies that surround the nude goddess. In the latter, "every leaf, each pistil and stamen has been included," and the handling of the figure is just as polished, a preliminary study from the model followed by fresh studies of every segment of the anatomy, drawn and redrawn in larger and smaller scale as the work progressed at a snail's pace from drawings to clay models to value studies to color studies to

56. Gibson Danes, "The Creation of Thomas Benton's *Persephone*," *American Artist* 4, no. 3 (1940): 5.

57. Edward Alden Jewell, "Benton Canvases Open New Gallery," *New York Times*, Late City Edition (April 18, 1939), sec. 1, p. 24, col. 1, and Thomas Craven, quoted in Danes, "The Creation of *Persephone*," p. 4.

58. See illustration and caption in *Life* 5, no. 24 (1938): 74–75.

canvas. In the end, readers learned, "the studio is littered with drawings; and as he paints he refers to them constantly."[59]

Although he had always been interested in theory, sometimes at the expense of painterly brio, Benton's teaching position in Kansas City nudged him toward his newfound obsessions with accuracy and the mechanics of methodical picture-making. Now a teacher himself, he was emulating his old teachers—all those tyrannical academicians who kept their pupils working at a single model for weeks on end—when he slaved over *Persephone*. Although Benton's classroom attitudes toward getting the likeness down cold were liberal, and even slack, his own work came to be marked by a rigid discipline. In his maturity, driven by God-knows-what insecurities of soul, Professor Benton became the model student he had never been. The Peck's-bad-boy of American art became the prime exponent of grand-manner themes and Old Master techniques.

Reginald Marsh, for one, thought the new Benton just as prone as the old to composing pictures like a layout man for the Sunday paper, cutting and pasting separate drawings together, higgledy-piggledy. Now, he had even more drawings to scissor into ambitious paintings on lofty topics. Why else, Marsh asked rhetorically, was there "a great even black trench drawn around the nude in *Persephone*?"[60] Why indeed, unless the too-emphatic contour came from a drawing made in the absence of all save the nude herself, every inch of her sinuous outline refined, reworked, and in the process hardened into steel. Yet all the twisting outlines of all the drawings added up, somehow, to pictures magical and strange, their surfaces glistening and rippling with linear movement, plastic force, and life.

15–1. Susannah's face, detail study for *Susannah and the Elders*. 1938; pencil; 18 × 11⅝.

The chin has been subjected to additional detailed scrutiny lower on the page. Although the relationship between this drawing and the finished canvas is obvious, the sketch is a far more faithful representation of the model, with a slight frown on her brow and a weak chin. The painting smoothes out these idiosyncracies into a bland and not altogether engaging perfection. The surfaces of the leaves and other objects drawn with some attention to texture are also generalized in the finished work.

Susannah was the first of Benton's large transitional paintings; he was not sure how far to push the hard, linear realism of his new drawings, whether the same technique could be used successfully in oils. Thus, there is a gulf between studies and painting that will only be bridged with *Persephone* in 1938–1939.

15–2. Susannah's arm, detail study for *Susannah and the Elders*. 1938; pencil; 17⅞ × 11⅝; inscribed, Arm of Susanna, 1938.

The musculature of the forearm and wrist and the contours of the nails are more sharply delineated in this drawing—one of four separate studies of each of the four

limbs—than they are in the flaccid corresponding passage in the painting.

15–3. Persephone's breast, study from life for *Persephone*. 1938; pencil; 7¼ × 8; inscribed, Benton.

The correspondence between drawing and painting is much closer here. Even though this is an early sketch of the upper torso, certain areas, such as the outer contours of the breasts and the rib cage, have already begun to stiffen. In the detail studies that follow, the multiple outline, traced in the manner of Delacroix or Tintoretto, has quite the opposite effect. Rather than admitting light and air to the bounded form, Benton's retraced lines harden the contour and call attention to it as an independent aesthetic force.

15–4. Persephone's legs and knee, detail study for *Persephone*. 1939; pencil; 20⅞ × 14½; inscribed, Benton '39; verso, Drawing for Persephone.

Despite Benton's close attention to the body of the model, the delicate tracery of line has taken on an independent, abstract life of its own. This is one of the loveliest of all Benton's works.

15–5. Ozark town, reportorial drawing made in rural Missouri and incorporated into *Persephone*. 1939; sepia wash, ink, pencil; 10¼ × 16⅞; inscribed, Benton '39; verso, $200.

The wagon and team, minus the driver, became the chariot of the Missouri peasant godling who peeps at Persephone from behind a tree.

The "new manner" affected Benton's reportorial sketches as well as his studies for paintings. In contrast to his earlier travel drawings, this one is far more tidy, with precise pen-and-ink contours bounding most of the forms, intricate crosshatching, and a restrained positioning of areas of wash.

15–6. Drawing from the model, probably done in a life class, Kansas City Art Institute. Circa 1938–1939; pencil; 16¼ × 8¼; inscribed, Benton.

Benton often used this standard model's pose, with one elbow raised over the head and bent, to indicate a certain mental or moral abandon. Young women watching the movies ("City Activities" panel of *America Today*) and posing for the cameras (*Hollywood*) are shown in this pose, as is Blanche DuBois, the sensuous Tennessee Williams heroine of *Poker Night* of 1948 (Mr. and Mrs. Sheldon Shapiro, St. Louis).

This drawing is noteworthy for the dark, wiry sinuosity of the contour line. The line possesses enormous tensile strength.

15–7. Wild grapevine, Martha's Vineyard. 1940; pencil; 17 × 13; inscribed, Benton '40, 77.

This is the same grapevine that spills out of the lower-left corner of *Persephone* and fills the foreground of *Jessie, One Year Old* (1940). The sharpness of vision created by the copperplate line of Benton's pencil is nightmarish, surrealistic. The studies for *Persephone* approach but do not attain this hallucinatory intensity; the finished canvas, apparently, gave Benton the confidence to experiment further with the radical implications of his "new manner."

59. Danes, "The Creation of *Persephone*," pp. 5–7.
60. Reginald Marsh, "Thomas Benton," *Demcourier* 13, no. 2 (1943): 10.

15–1. Susannah's face, detail study for *Susannah and the Elders*. 1938.

15–2. Susannah's arm, detail study for *Susannah and the Elders*. 1938.

15–3. Persephone's breast, study from life for *Persephone*. 1938.

15-4. Persephone's legs and knee, detail study for *Persephone*. 1939.

15-5. Ozark town, reportorial drawing made in rural Missouri and incorporated into *Persephone*. 1939.

15–6. Drawing from the model, probably done in a life class, Kansas City Art Institute. Circa 1938–1939.

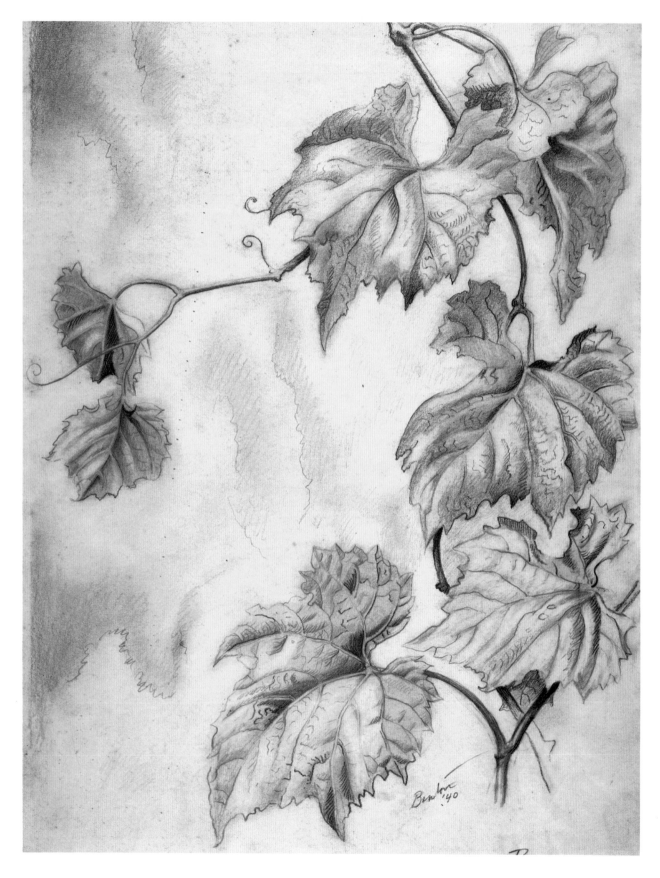

15–7. Wild grapevine, Martha's Vineyard. 1940.

16 Barroom Nudes

I went in and ordered a beer. Across from the bar hung a big painting. This was a famous painting in the locality. It depicted a naked girl with a mask on her face. She was lying across a sort of bed and appeared to be dying from a knife wound. In the background was a young man in fancy costume. He was about to stab himself. I believe that the story, which hung in gold letters beside the picture, told that the girl was his sister with whom after a night at a masked ball he had engaged in amorous play, ignorant of the relationship that existed between them. In any case, it was someone he shouldn't have been playing with in the nude, so he had stuck his knife into her and was ready to go to work on himself.[61]

Thomas Hart Benton

PERSEPHONE and *Susannah* lost Tom Benton his job. The latter, despite—or perhaps on account of—its religious theme, drawn from the Apocrypha, touched off howls of protest in the Bible Belt because, as the artist freely admitted, he had "left out nothing which the positions of my ladies permitted to be seen." The former, buck naked too, was based on an ancient myth unfamiliar to most Missouri fundamentalists and might have escaped notice had Benton not, in a flush of bourbon-soaked indiscretion, used her to illustrate a discourse to the New York press on one of his favorite themes—the preciosity and exclusivity of museums. "As for me," he trumpeted, with an unsteady bow toward *Persephone*, "I would rather exhibit my pictures in whore houses and saloons where normal people would see them." That logic appealed to nightclub impresario Billy Rose. "I've got the biggest saloon in town, down at the Diamond Horseshoe," he reasoned. "You've got the biggest barroom nude."[62] So he hung Tom Benton's *Persephone* over the bar, with all due ceremony, as the properly scandalized board of the Kansas City Art Institute voted Tom's ouster.

Although he let Billy Rose call his bluff with perfect aplomb, although he had often enough retold the story of how his youthful encounter with *The Brother's Remorse* over the bar in the House of Lords saloon began his career in art, Tom Benton's reasons for painting that pair of belated barroom nudes were far from obvious. As the thirties wore on, other Regionalists, seeking ways to impart some of the same dignity to American sights and stories that art had managed to confer upon the humblest details of daily life in Italy or France, had begun to arrange their paintings in frank emulation of famous masterpieces. They also looked to the subject matter of the Old Masters for inspiration, believing that popular episodes from the Bible and from mythology spoke to the human condition at all times, in all places, and thus had their counterparts in American life. Despite the almost automatic association by connoisseurs and museums of great art with someplace else, America, or so the covert argument of Benton's colleagues ran, was artistic after all. Under this dispensation, John Steuart Curry gave his plain old John Brown on the walls of the Kansas State Capitol the pose of a Samson or a Hercules and the head of Michelangelo's horned *Moses*.[63] Although at least one recent critic has snickered at the result— "a portrait of Robert Mitchum by Parmigianino"—Curry's mural, along with Benton's nudes, underscores the difficulties American artists of the twenties, thir-

ties, and forties faced in their drive to legitimize American art.[64]

Benton, in any case, had never abandoned his schoolboy fascination with the great art he once copied in the Louvre, an interest reinforced by the masterpieces he saw every day in the Art Institute and by the Old Masters whose works he cited in his classroom. But great art, and the attendant trappings thereof, was also on the mind of Walt Disney in 1939. Like the Regionalists, Disney recognized that, to most Americans, "high" art was not much like daily life: it meant the classical columns on the fronts of museums, the "classical" music of the marble concert halls, myths, nudes, white statues, pictures from the Louvre. When he made *Fantasia*, the great cartoon anthology released as *Persephone* was being carted off to Billy Rose's place, Disney included a long sequence in which chubby little centaurs (and centaurettes), drawn in the manner of Mickey and Minnie, gamboled to the music of Beethoven's "Pastoral Symphony" and Mickey himself mimed the theme of a nineteenth-century orchestral scherzo. The difference between Mickey Mouse directing "The Sorcerer's Apprentice" and Persephone discovered asleep on the banks of a Missouri "crick," with her high heels at her side, is one of degree. It is small wonder that Tom Benton went to work for Walt Disney, briefly, in 1946, for they shared a common dream, a dream that "high" art and "low," the art of museums and the *Arts of Life in America*, might be united at last.

For all their similarities to great art and to the nudes in the museums, however, Benton's ladies come straight out of his own deliciously "low" murals, hardly a one of which wants for a stripper, a burlesque queen, clad in a broad smile and a couple of spangles. Their job, in the social context of the *Arts of Life in America* or *America Today*, is to be looked at (like works of art) and, when Benton does not include the audience in the mural, he turns the viewer into a voyeur, out on the town for a night of wild abandon. *Susannah* and *Persephone* lack the spangles, to be sure, but, as Benton depicts them, they too exist simply to be watched by the art lover, by a pair of bug-eyed elders from a rural church, or by a graying, midwestern Pluto who is, as Benton put it, out to take "a Plu-

61. *An Artist in America*, pp. 18–19. 62. Ibid., pp. 280–83.
63. M. Sue Kendall, "Rethinking Regionalism: John Steuart Curry and the Kansas Murals Controversy," Ph.D. diss., University of Minnesota, 1983, pp. 207 ff.
64. Lawrence Alloway, "Recovery of Regionalism: John Steuart Curry," *Art in America* 64, no. 4 (1976): 72.

tonic peep at pink breasts and well-turned young asses." [65] Unlike the bar girls of wartime Natchez and New Orleans, these painted ladies never threaten or protest or object to being ogled by aging Lotharios from Missouri who just might answer to the name *Fat Old Pop*. Benton's nudes are a personal admission of such complexity and power that he returned to the theme, on and off, for the rest of his life.

16–1. Preliminary sketch for *Young Tom Benton at the House of Lords in Joplin, Missouri, 1906*. Spring or early summer 1972; pencil; 3 × 4½; inscribed verso, 11½ × 16⅜.

In November 1971, Benton made a quick trip to Joplin, where he accepted a commission to paint a mural for the new Municipal Building. The visit uncorked a torrent of memories, including his decisive confrontation with the barroom nude in the House of Lords. When he began to work up vignettes for inclusion in the mural early that summer, on Martha's Vineyard, he started by working up a canvas on that nostalgic theme from this sketch. Benton later abandoned the idea of including such a spicy incident in the mural; instead, he put himself in as a sober young cartoonist and represented the saloon by a sign in the background.

The buxom nude over the bar also set him to remembering the Joplin girls of long ago. He found a real, 1906 afternoon costume for Kay Callison to wear in her role as the "mural lady," complete down to the shoes and the parasol. But, he complained, "she's too skinny for a 1906 girl. . . . I'll pad her out in the proper places."

16–2. Sketches after Goya and after Antonio del Castillo's *Potiphar and Joseph* in the Prado, Spain. 1954 or 1955; pencil; 11⅝ × 8¾; inscribed, Prado—Spanish School, Antonio del Castillo Potiphar and Joseph, Parasol Goya.

A decade after he painted *Susannah* and *Persephone*, Benton essayed another group of nudes with classical overtones, inspired, perhaps, by the *Achelous and Hercules* mural he finished in 1947 for Harzfeld's department store. In 1948, for example, he painted several versions of *The Apple of Discord*, with a limp, reclining goddess, positioned as the infamous sister is in his re-creation of the nude in the House of Lords. He also did small oil studies of *Adam and Eve, Perseus and Andromeda, Europa and the Bull*, and *Mars and Venus* (1952, Mr. and Mrs. William Primoff, New York), the latter disguised as a cowboy and a dancehall belle.

What set him to thinking about nudes again in the early seventies was surely his trip to Joplin, but over the intervening years he had looked at such paintings, and, on occasion, sketched them. This drawing, made on a trip to Spain (Benton sometimes says the trip took place in 1954 and at other times lists 1955 as the correct date), is important because, for reasons that are not immediately clear, Benton was captivated by the theme. He did not paint his own version right away but, during the summer of 1972, after his brush with *The Brother's Revenge*, he began to do little else.

16–3. Sketches, including a version of *Potiphar's Wife* set in Missouri. Circa 1965–1966; pencil; 11⅝ × 8¾.

Suddenly, after a hiatus of a decade, Benton rediscovered the Spanish sketch among his papers and, as he had done with the story of *Susannah*, moved the setting from the ancient Near East to modern times—or almost modern times—in the American corn belt.

Not a religious man, Benton seems to have had, nonetheless, a particular interest in and affinity for the Bible story of Joseph, an "adventure" not unlike the exploits of Buffalo Bill. As a child, he recalled, "I never did remember [the stories] unless they dealt with

big doings, like putting Shadrach, Meshach, and Abednego in the fiery furnace, or with the adventures of Joseph. . . . I remember that I was considerably intrigued by the whore of Babylon who 'glorified herself and lived deliciously,' but my mouth was always shut up when I wanted the subject elaborated." [66]

In his autobiography, however, Benton clearly modeled his presentation of his younger self and his relationship with his father on the parable of the prodigal son; in 1943, he painted that subject with a Missouri setting (Dallas Museum of Fine Arts).

16–4. Compositional study for *Potiphar's Wife*. 1972; ink wash, tempera; 11½ × 17¼; image size, 7¼ × 10¾; inscribed, 5′–11″ × 4′ large, 11¼″ × 7¾ small, Benton '71.

After the passage of another half-dozen years, Benton's sudden memories of his own younger self transfixed and mightily embarrassed by the sight of a barroom nude apparently reminded him of the story of young Joseph, pursued by a seductive older woman, and of his own sporadic efforts to develop the theme into a painting. In any case, the pictorial composition he reconstructed for the image of *The Brother's Revenge* inset within *Young Tom at the House of Lords in Joplin* is the composition he adopted for *Potiphar's Wife*, a painting he worked on throughout the summer of 1972, in tandem with the Joplin mural.

The postures of the figures are identical. The only significant difference is that Joseph no longer holds the brother's knife, although his thrusting gesture remains constant. Many of Benton's painted confrontations between men and women use similar poses and that same aggressive gesture. The killer in *The Jealous Lover of Lone Green Valley* and Pablo, with his bottle of beer, in *Poker Night* exemplify the type. The configuration of *Potiphar*, with its overtones of distress, aggression, male insecurity, and traumatic youthful experience, is basic to Benton's sexual self-image.

Note the farmyard, the windmill, and the tank visible out the window, behind the protagonists. The setting recalls the farmyard John Steuart Curry used in his famous religious painting *Baptism in Kansas* of 1928 (Whitney Museum of American Art).

16–5. The shoulders and hand of Eddie Samoa, study for *Potiphar's Wife*, Martha's Vineyard. Summer 1972; pencil; 20 × 11¾.

During the summer of 1972, Benton built a stone retaining wall along the beach on his Martha's Vineyard property. Given his age, he was entitled to boast about his work on the project—and he did so. He was also proud of having lost his potbelly in the process. And, although he claimed to have done most of the work himself, he had a team of young fellows—John, Dick, Mark, and Eddie—helping on the seawall.

Eddie Samoa became the young Joseph—the young Tom, "Shorty" Benton, in effect—posing for the many detailed studies any Benton work done after *Persephone* had come to require.

16–6. Female leg, study for *Potiphar's Wife*. 1972–1973; pencil; 11½ × 14; inscribed verso, Very rough sketch of same with other leg up instead.

This anatomical study from the model is as sensual an image as Benton ever drew; the figure of the woman would be draped in further compositional studies.

16–7. Study for *Potiphar's Wife*, squared for transfer to canvas. 1972–1973; pencil; 16¼ × 21¾.

Value studies, freely brushed in ink, also exist for the figures in *Potiphar's Wife*. But these drawings give an excellent summary of just how Benton got an idea for a painting and how he went about developing a conception into a finished work of art.

65. *An Artist in America*, p. 282.

66. Ibid., pp. 11–12.

16–1. Preliminary sketch for *Young Tom Benton at the House of Lords in Joplin, Missouri, 1906.*
Spring or early summer 1972.

16–2. Sketches after Goya and after Antonio del Castillo's *Potiphar and Joseph* in the Prado, Spain. 1954 or 1955.

16–3. Sketches, including a version of *Potiphar's Wife* set in Missouri.
Circa 1965–1966.

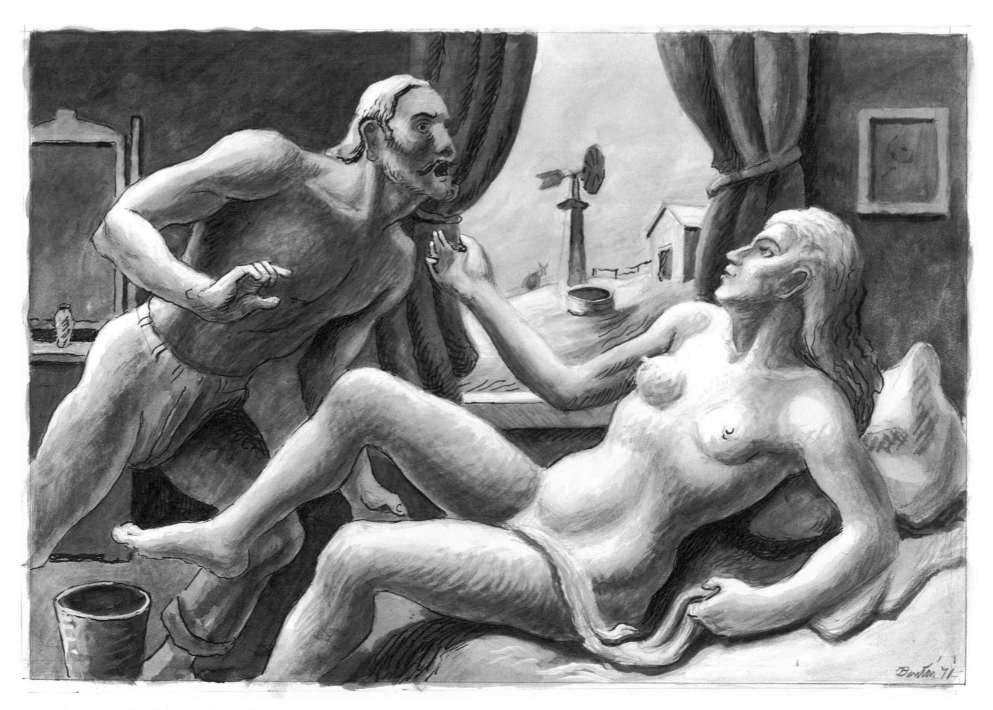

16–4. Compositional study for *Potiphar's Wife*. 1972.

16–5. The shoulders and hand of Eddie Samoa, study for *Potiphar's Wife*, Martha's Vineyard. Summer 1972.

16–6. Female leg, study for *Potiphar's Wife*. 1972–1973.

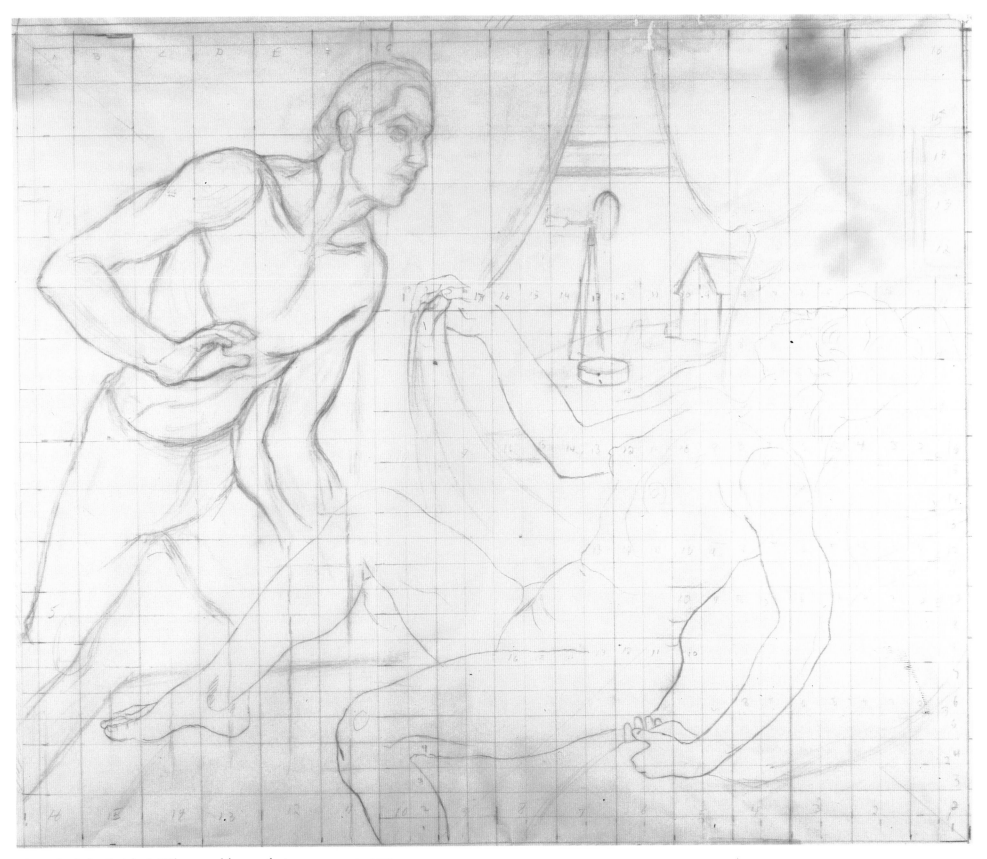

16–7. Study for *Potiphar's Wife*, squared for transfer to canvas. 1972–1973.

17 Art and the Law

The kind of uneasiness that I felt will be recognized by every artist who has come out of a family devoted to such practices as law, politics, and business, in which shrewd connivance and acute attention to courses of action are the prime matters of life. . . . The business of gratifying my pretensions to manhood, which motivated my first flights from home, did not, at any time, quite rid me of the disturbing feeling that my attitude toward things was different from that of my class and kind.[67]

Thomas Hart Benton

IN his later life, distant memories played a bigger and bigger role in Tom Benton's choice of subject matter. When he was working on his autobiography, in the midthirties, he had occasion to recall the barroom nude young "Shorty" saw in Joplin back in 1906; thereafter, at intervals that ranged from several years to a decade or more, he painted and repainted that picture over the bar at the House of Lords. He was still painting it as late as 1972. The young "Shorty" of 1906 was a rebel, defying his father's wishes and asserting his manhood as much by becoming an artist as by mixing with the riffraff at the House of Lords. The grown-up Benton spent the better part of his life trying to mend the breach: his visit to his father's deathbed began a long and painful process of realigning his art with his Missouri roots, a process that culminated in his return to his home state and the completion of the Missouri Capitol murals in 1936.

His father wanted Tom to follow in his footsteps, and the largest section of the Missouri mural shows the Bentons, all wrapped up in law and politics, except for Tom, of course, but Tom contrives to find a place for himself in the family album on the big east wall. He's the turkey right there in the middle of all the Bentons, home all right, yet still the odd man out in Nat's courtroom, the guy who paints a portrait of his Dad's old law partner but never became a partner himself. Thereafter, whether from leftover guilt for his defection from the bar or a genuine affinity for the profession he once scorned, Benton spent an inordinate amount of time in courtrooms, styling himself something of an expert on jurisprudence and on allied affairs, like politics. He befriended members of the legal fraternity. He fussed for years on end over the legal details of his will. He spouted legal jargon to the papers when he disputed an occupation tax levied on his studio by the Kansas City Division of Revenue, protesting that "art is not business" but a vocation.[68] He even started a book about lawyers, to be illustrated by Thomas Hart Benton. But mostly, Tom Benton made the law the subject of his pictures, and, as the years went by, and memories of Neosho and Joplin days seemed, sometimes, more real than life itself, the pictures grew more numerous and special.

17–1. Testimony at the Bobby Greenlease trial, Kansas City. November 1953; ink, pencil; 9⅞ × 13; inscribed, B., The Witness; verso, The Witness, The Greenlease Case.

One of the first witnesses called by the prosecution was a nun from the French Institute of Notre Dame de Sion, the exclusive day school from which a red-haired woman, posing as his aunt, took six-year-old Robert C. Greenlease, Jr. Although the senior Greenlease, a prominent figure in local business and social circles, paid a $600,000 ransom, the child was killed almost immediately and buried in the backyard of a modest home in St. Joseph, Missouri. Bonnie Brown Heady and Carl Hall entered a guilty plea but went on trial under the Lindbergh law on November 17, 1953, so that a sentence could be determined. They were promptly convicted, sentenced to death, and executed before Christmas of the same year.

The case was a sensational one, and the trial was covered exhaustively by the media. Benton, who had attended Bruno Hauptmann's kidnapping trial in 1935 as a courtroom artist, got a seat in the Jackson County Court House in Kansas City (security was tight because of fears the pair would be lynched) and did a series of masterful, quick studies of the principals in pencil. The ink strokes seem to have been added later.

17–2. U.S. Attorney Edward L. Scheufler at the Greenlease trial, Kansas City. November 1953; ink, pencil; 7⁷⁄₁₆ × 7½; inscribed, B.

67. Ibid., pp. 23–24.
68. *New York Times*, Late City Edition (November 30, 1956), sec. 1, p. 50, col. 2.

In addition to portrait sketches of the defendants, Benton also did drawings suggesting the drama of the courtroom situation. The modest little nun, confronted by a burly lawyer (probably Marshall Hoag, counsel for the defense) and viewed over the shoulders of two substantial men, makes for an affecting study in contrasts. This drawing, showing the burly prosecutor pointing his finger in accusation, is even more theatrical. Given the character of the studies, it seems probable that Benton contemplated a painting based on the trial; although the drawings would have needed some additional fortification with ink for use as illustrations, the technique and the incisive line are similar to Benton's book illustrations of the forties and fifties, especially those for *The Autobiography of Benjamin Franklin* (The Modern Library, 1944).

17–3. Value study for *Trial By Jury*. 1964; tempera; 8¼ × 12.

Benton finally did his courtroom painting in 1964, after watching his friend, Kansas City lawyer Lyman Field, defend a damage suit in a courtroom of the Jackson County Circuit Court, in Independence. Field was one of Benton's companions on the river floats the artist organized annually, before or after his summer stay on Martha's Vineyard; Sammie Feeback, the cameraman he met at the Greenlease trial, was another member of the river gang.

In the winter of 1961, when Benton was working on the Truman Library mural, he was stricken with bursitis and unable to drive. He was proud to report that "Lyman Field, an attorney and a good friend of mine who was then Commissioner of Police in Kansas City and much interested in furthering the mural, sent a police car and driver to pick me up in the morning for the trip to Independence and to bring me home when I was through work."[69]

Field is clearly the hero here, addressing the jury with a confidence and aplomb altogether missing from Benton's brother Nat in his earlier courtroom scene, the Greene County "Law" vignette in the Missouri Capitol. Otherwise, however, the compositions are similar, with as much or more attention paid to the supernumeraries at the lawyers' table as to the judge, the witness, and other protagonists.

17–4. The plaintiffs, study for *Trial By Jury*, Independence, Missouri. Spring 1964; pencil; 8½ × 14.

Benton took great pains with the details of this scene. The legal pad, left on the table by Lyman Field as he rises to address the jury, is a wonderful touch, the kind of humanizing detail Benton had used to good effect in the Capitol murals. Like those murals and unlike the first works in his "new manner," most of Benton's paintings of the fifties and sixties eschew surface texture altogether in favor of firm outlines bounding dense, almost pneumatic volumes. That tendency can be observed in the nut- or bullet-like heads of the two rival attorneys, whose features are studied in the sketches at the left and right corners of the page. Field's is the face on the left. The face on the right is a frontal rotation of the head of the lawyer seated in the center of the group at the table, scribbling furiously as Field speaks.

69. *An Artist in America*, p. 361.

Benton made this drawing, and others in the series, on one of Field's long, yellow legal pads.

17–5. The defendants, study for *Trial By Jury*, Independence, Missouri. Spring 1964; pencil; 8½ × 14.

Lyman Field's clients are listening to their attorney intently in this on-the-spot sketch. In the painting, the woman's hair has been smoothed into a formal pattern of waves, and the unbroken outlines of both bodies convey less tension than the drawing manages to suggest. The large purse to the woman's right would also be moved to the floor behind the female plaintiff, where it could be seen more easily.

17–6. Umbrella and shawl, study for *Trial By Jury*. 1964; pencil; 10½ × 13¾; verso, two sketches, one of jury and one of judge.

In Benton's initial drawing of the plaintiffs, these accessories were not in evidence. In the painting, the woman fiddles with the folds of material that fall over the edge of the table; the purse (moved from the defendants' side of the table) is on the floor to her left, and the umbrella leans against the witness box, just above the purse. There are formal reasons for the addition of some details and the shifting of another. The left-hand side of the composition is already busy and visually weighted down with all the jurors and Field's dramatic address, made with his finger pointing in the manner of the Greenlease prosecuter. The bits of genre detail concentrated on the right side of the picture serve as counterweights. And the vertical flags framing the judge would have carried the eye up and out of the composition had not the vertical of the umbrella—shaped like an upside-down version of the Missouri flag on its staff—helped to restore the top-to-bottom balance.

These objects suggest the world outside the airless atmosphere of the courtroom: somewhere, out there, it is raining. They also give some human warmth to characters who, in Benton's paintings of the period—although not in his drawings—tend to be somewhat uniform and robotlike in appearance. The characters are very still, too, except for the dynamic Field and the nervous plaintiff, who plucks her shawl as she listens to him. The drama of the scene intensifies, then, around this pair of antagonists, set at opposite ends of a sharp diagonal axis, he in deep space to the left and she in the shallow apron of foreground space to the right.

17–7. Clay Rogers, study for *Missouri Lawyer*, Kansas City. Circa 1968–1969; pencil; 10 × 6½ (image size); inscribed, Benton.

Clay Rogers, Lyman Field's partner in the firm of Rogers, Field & Gentry, drew a will for Benton in 1969, around the time he sat for a half-dozen splendid drawings of his suit, the bookcase behind him, and various facial and bodily details, sketches used in the preparation of a painting called *Missouri Lawyer*.

A year later, Benton would paint Harry Truman at eighty-six as *The Old President*, surrounded by books, in a similar pose. The Rogers portrait is remarkable for Benton's sensitivity to the marks of age—the transparency of the skin, the delicate folds of sagging musculature. These lessons were translated into the almost spectral likeness of Mr. Truman. His interest in the aging of his friends and contemporaries is a mark of Benton's gradual acceptance of his own mortality.

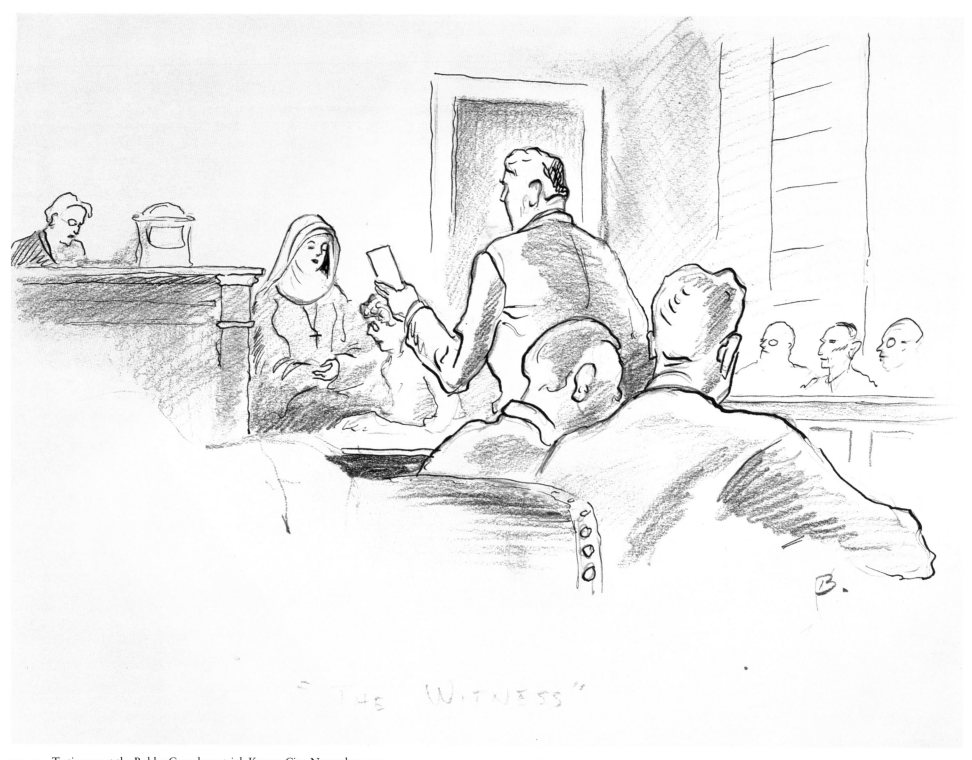

"THE WITNESS"

17–1. Testimony at the Bobby Greenlease trial, Kansas City. November 1953.

17–2. U.S. Attorney Edward L. Scheufler at the Greenlease trial, Kansas City. November 1953.

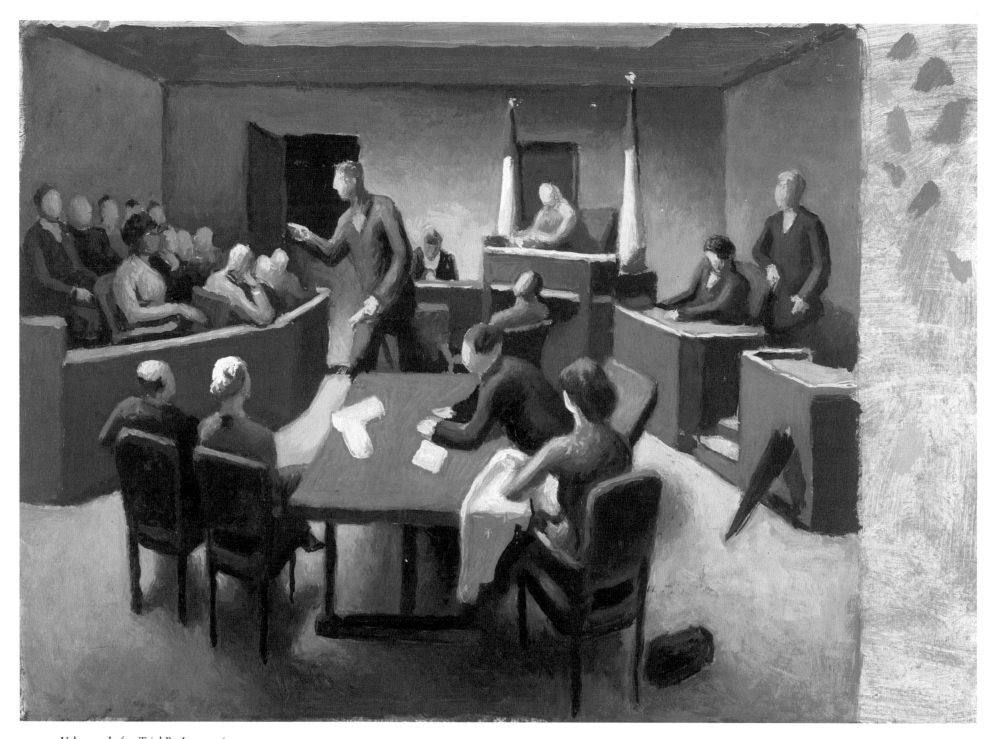

17–3. Value study for *Trial By Jury.* 1964.

17–4. The plaintiffs, study for *Trial By Jury*, Independence, Missouri. Spring 1964.

17–5. The defendants, study for *Trial By Jury*, Independence, Missouri. Spring 1964.

17–6. Umbrella and shawl, study for *Trial By Jury*. 1964.

17–7. Clay Rogers, study for *Missouri Lawyer*, Kansas City. Circa 1968–1969.

194

18 Old Friends

In May of 1962 my home town, Neosho, Missouri, honored me with a "homecoming" celebration. . . . I was embarrassed by not remembering the names of the officiating ladies, all of whom I had once known and had danced and partied with, in my Neosho days. I had also forgotten the men. The only person I remembered well enough to recognize immediately was a fellow named Dave who had had his forefinger cut off by a buzz saw when he was a kid. With the others I had to dodge around until they told me who they were, which is the worst sort of politics when greeting old companions.[70]

Thomas Hart Benton

MOST of the "old companions" of his days as a painter were still there somewhere in Benton's stacks of drawings, a graphic memory book full of lawyers and presidents, fellow artists, country fiddlers, black prisoners on chain gangs, fading Hollywood stars, kidnappers, the neighbors and their kids, drinking buddies, and all the remarkable folks he had met in the half-century since he left Neosho. Neosho called him back in his old age, but so did his memories of "Stan" Wright, an "old companion" of the heady, bygone days in Paris. And, when he saw the local sidewalk superintendents warming their old bones in the sun outside the Buffalo, Missouri, courthouse, so did memories of his Dad, and his long-ago political cronies. Benton painted both subjects in the sixties, along with scenes half-remembered from the lyrics of old songs. He took comfort from familiar things and places and faces. He took comfort from sweet memories and old friends.

18–1. Jagendorf and Joe Stella, New York. Circa 1931; pencil; 11 × 8½; inscribed, Jagendorf and Joe Stella, Benton.

The scene is the office of Benton's friend "Jagey"—Dr. M. A. Jagendorf—the literary dentist "who got you down helpless in his operating chair with your mouth propped open and read his poems to you." The patient is painter Joseph Stella. Benton, the wry observer, was most captivated by Jagey's performances on the harmonica. "If that literary nut can play on that thing," he thought, "I can too."[71] During the letdown that followed his work on the New School murals, he picked up a toy harmonica someone had given to T. P. and taught himself how to play it.

This kind of casual drawing of friends is relatively rare in Benton's work until after World War II, when his mood became both introspective and retrospective, and he came to cherish stable relationships. Before that time, Benton was a headhunter who drew his unexotic friends only when he needed a body or a face for a blank spot in a mural.

18–2. George Hough, sketch for *New England Editor*, Martha's Vineyard. 1946; pencil; 12 × 13¾; inscribed, Benton.

This preparatory drawing for a painting in the collection of the Museum of Fine Arts, Boston, is the first in a series of postwar portraits of old friends that are highly specific likenesses of real people but are intended to have a broader meaning. Clay Rogers becomes *Missouri Lawyer*. George Anthony Hough—a longtime drinking friend who Benton called "Pat"—becomes *New England Editor*, a representative specimen of a regional breed. In Hough's case, that might be "Genus: stubborn, upright Yankee," since the iconography of the painting reinforces such an image. The retired editor of the New Bedford *Standard Times*, Hough was famous for the dictum that unless a story was correct, it wasn't printed in his paper: the text of the paper on which he is writing in Benton's picture contains only the word *Unless*. The painting of the "Bark Catalfa" hanging on the wall behind Hough points to his New England seafaring heritage. The rubbery style of the head, although not of the shirt Benton drew from life, closely resembles the artist's New England portraits of the late twenties.

The seventy-eight-year-old Hough had a son, Henry, who was the editor of the *Vineyard Gazette* and author of a best-seller (*Country Editor*) about his experiences. It was through the well-connected Houghs that Benton befriended David Lilienthal, of the Atomic Energy Commission, and Bosley Crowther, who made some abortive efforts to find a place for *Hollywood* in the lobby or the men's room of Radio City Music Hall in New York.

The sale of *New England Editor* to the Museum of Fine Arts for $2,000 did not pass unnoticed. Regionalism in general and Benton (former darling of the Luce publications) in particular had become so passé by 1947 that *Time* could afford to be snotty about the sale. Calling the picture "as inert and uninspired as a coil of rope," the anonymous wordsmiths went on to note that "it had been some time since the champing champion of American-school painting had received such a boost."[72]

18–3. Stanton Macdonald-Wright, study for a portrait. 1961–1962; pencil; 11 × 14.

70. Ibid., pp. 362 and 364. 71. Ibid., pp. 256–57.
72. "Bourbon & Old Salt," *Time* 50, no. 1 (1947): 69, and Polly Burroughs, *Thomas Hart Benton: A Portrait* (Garden City, N.Y.: Doubleday & Co., 1981), p. 157.

Benton met California painter "Stan" Wright in the late fall of 1909 in Paris and admired him extravagantly, later calling him "the most gifted all-round fellow I ever knew."[73] Along with his collaborator, Morgan Russell, Wright drifted toward coloristic abstraction and eventually founded the Synchromist movement. Benton renewed his friendship with Wright in New York late in 1913, saw him again on visits from Paris in 1914 and 1915, and finally created a number of Synchromist works for exhibition under Wright's banner in the 1916 Forum show.

Apparently, the relationship continued after Wright left for California in 1919. Benton owned a 1916 watercolor by Wright, a work he kept in his studio until his death, and he also seems to have followed Wright's career on the coast, first as a painter of "spectral" studies loosely related to Eastern religions and later as an early developer of a color process for motion pictures. In fact, from the twenties through the midfifties, Wright rarely worked at the chromatic abstraction that had been his claim to fame. Given Benton's interest in Hollywood, and his frequent trips to the studios in the late thirties and forties, he had ample reason and opportunity to see Wright.

Just why Benton decided to do a large oil portrait of Wright in 1961 is difficult to establish. It was a period marked by a growing nostalgia for his youth, however, and Wright was one of the very few artistic colleagues of those years with whom Benton had not broken off contact during the ideological crisis of the thirties. But their relationship, at least on Benton's side, was an ambiguous one. Despite his professed admiration for Wright and Synchromism, when the movement was rediscovered by art historians in the midsixties Benton was eager to reclaim a bit of his former stature by stressing his role—a minor one—and, in private correspondence, was critical of Wright for quite properly minimizing it.

During the sixties, Benton also worked from time to time on an unexpurgated account of his student days in Paris that, unlike the laundered version presented in *An Artist in America* or the dull, technical data marshaled in *An American in Art*, would emphasize the sociosexual aspects of "la vie boheme" in gay Paree. An exercise in reliving the days of his flaming youth, the tale featured Wright in a prominent supporting role. Although it was mild by today's standards and positively mid-Victorian in its moral tone, Benton thought better of publishing the manuscript until all the dramatis personae were dead.

18–4. Stanton Macdonald-Wright, study for a portrait. 1961–1962. pencil; 16½ × 13⅞.

In a sense, all of Benton's late portraits of old men—his near-contemporaries—are self-portaits, means by which the artist "tried on" the notions of age and mortality he had resisted so vehemently and so long. The experiment culminated in his great, knowing self-portraits of 1970 and 1974 and the self-portrait lithograph of 1973. The soft, smooth bulk of the sleeve in this wonderful study emphasizes the shrunken flesh and the striated, papery skin of the old hand.

18–5. Mabel Look, study for *Mabel and the Goat*, Martha's Vineyard. 1961; pencil; 16½ × 12¼; inscribed, Benton; verso, Drawing for the Goat Girl.

Benton's interest in old age was balanced by a fresh interest in youth, in the generations, in his own grandchildren and the newest members of the Yankee clans he had painted for years. His finished portrait of "the Goat Girl," Mabel Look, the youngest member of the Henry Look family Benton painted often in the forties, hung over the desk in the living room of Benton's Vineyard cottage in the summer of 1974,

73. *An Artist in America*, p. 36.

his last summer in the retreat he loved.

Benton adjusted the position of the legs several times in this quick study of Mabel feeding a goat from an old saucepan; with impatient young models, as with very old ones, Benton had to work fast and often corrected one drawing rather than trying to do a sequence of details.

18–6. Study for *County Politics*. Circa 1955–1964; pencil; 18 × 19¼.

The specific scene pictured in this study is the square in front of the Buffalo, Missouri, courthouse, one of the loveliest old courthouses in the state, since destroyed; the setting recalls the central square of many an old Missouri town, including Neosho.

Between the midfifties and 1964, Benton painted several versions of this scene—a large watercolor, a pen-and-wash exhibition drawing, and an oil-and-tempera—two of which hung at various times in Rita's bedroom. Similar in feeling to the "Politics" segment of the Missouri Capitol mural (in which the old Missouri courthouses Benton associates with his brother, with the congressman, and with the great senator loom large), the subject of this composition was also revived in circa 1940–1942 in *Courthouse Oratory* (Mrs. Marjorie Paxton, Shawnee Mission, Kansas).

The nostalgic overtones of the picture are suggested by the old men, trading in favors and solving the problems of the world on the courthouse lawn, and by the old cars, sadly out of date in the fifties or the sixties. Benton always paid attention to cars as temporal symbols; in these years, he was fully capable of noticing a late-model station wagon or a brand-new school bus. Thus, these ancient relics are a deliberate feature of a backward glance at a vanishing scene—a part of Americana that would disappear with the passage of Benton's own generation. This is history painting of a highly personal nature.

In 1973, Benton turned the self-same composition, cars and all, into a lithograph.

18–7. Preliminary sketch for a painting or sculptural group on the theme of the folksong *John Henry*. 1965; pencil; 5¾ × 4½; inscribed verso, $10, along with sketch of man and wagon.

Like *County Politics*, this composition meant a great deal to Benton: he turned it into several paintings (for example, *Ten-Pound Hammer* of 1965, Mr. and Mrs. Robert E. Stroud, Shawnee Mission, Kansas), an edition of six bronze statuettes, and a 1967 lithograph. He described the subject matter of the latter as an "old story of my youth—before the steam hammer beat John Henry."[74]

Describing the black chain gangs he met on the roads in the South in the twenties and early thirties in his autobiography, Benton had also referred to the old song. "A few years ago," he wrote, "collectors found the songs more or less humorous in their content, as they did all the secular songs of the Negroes. The various 'John Henry' songs transferred from the railroad to the chain gangs carried lines of laughter and the comments in them on 'the captain,' the work boss of the gang, were always funny. Recent investigation indicates that there is more lament than humor in the genuine Negro work songs."[75]

Revived in the sixties, with the civil-rights movement, the song reminded Benton of his music, his days on the road, his own singular attention to black America, and the trains that once roared through Neosho. It reminded him of crazy old "Jagey" and his harmonica.

74. Fath, *Lithographs of Thomas Hart Benton*, p. 79.
75. *An Artist in America*, p. 186.

18–1. Jagendorf and Joe Stella, New York. Circa 1931.

18–2. George Hough, sketch for *New England Editor*, Martha's Vineyard. 1946.

18–3. Stanton Macdonald-Wright, study for a portrait. 1961–1962.

18–4. Stanton Macdonald-Wright, study for a portrait. 1961–1962.

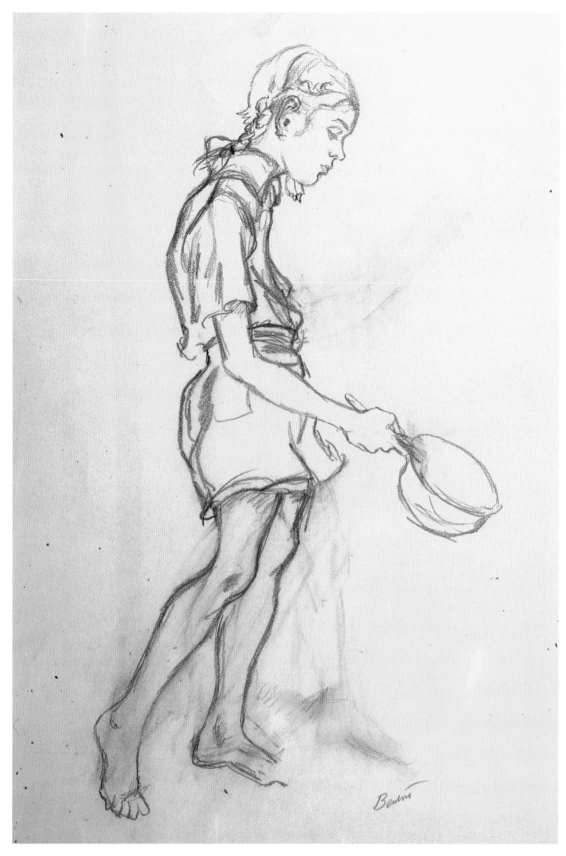

18–5. Mabel Look, study for *Mabel and the Goat*, Martha's Vineyard. 1961.

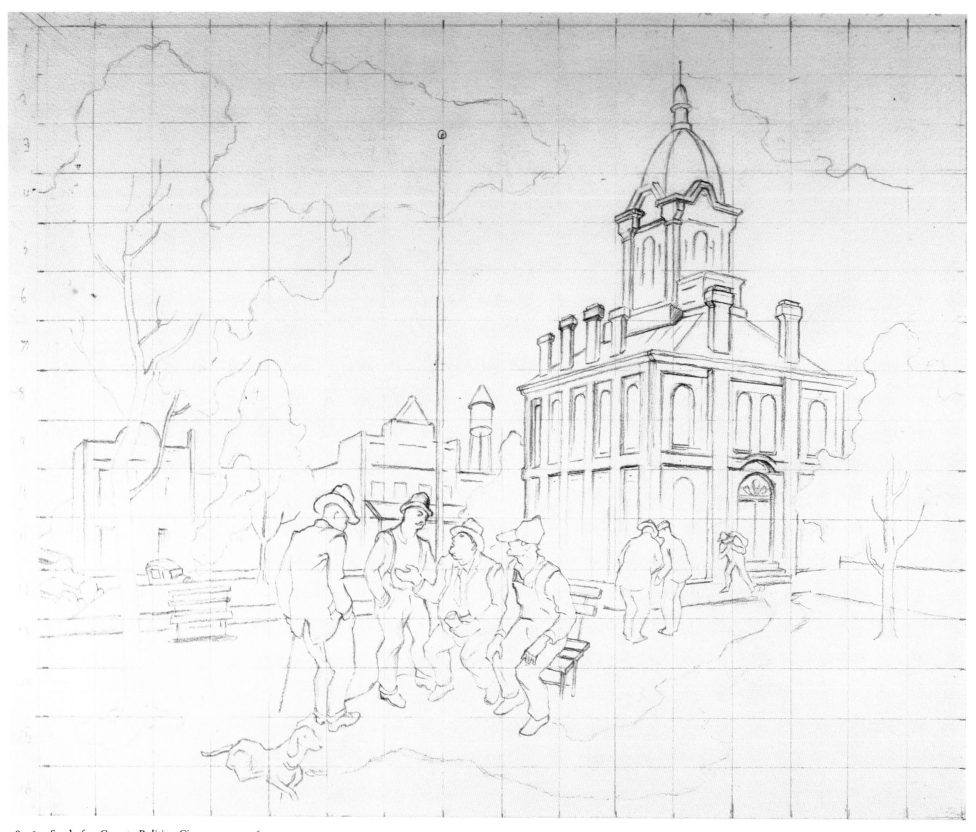

18–6. Study for *County Politics*. Circa 1955–1964.

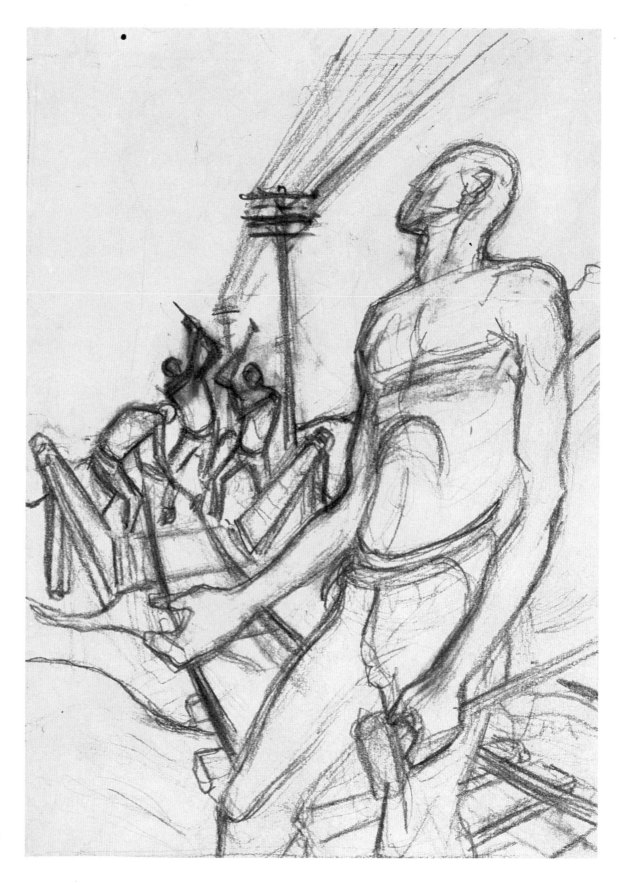

18–7. Preliminary sketch for a painting or sculptural group on the theme of the folksong *John Henry*. 1965.

19 Goin' Fishin' and Raisin' Hell

When I recovered from the mood of retirement that had gripped me as the fifties opened and once again took up my old ways of wandering around the country looking for subjects, I found these were increasingly of natural scenes. My journeys, now westwardly directed for the most part, over the Great Plains and into the Rocky Mountain country, resulted in filled sketch books, but they were largely those of a landscapist rather than of a recorder of human life. . . . Nearly every spring and often in the autumn I floated down our Ozark rivers.[76]

Thomas Hart Benton

ALTHOUGH Tom Benton was the foremost living biographer of a certain kind of long-stemmed American beauty—she was on the chunky side, truth to tell, with bright-red, bee-sting lips, and she was, variously, a steno, a burlesque queen, a movie starlet, or a sharecropper's daughter in the throes of divine revelation—he was not really at home in the perfumed domain of the ladies. He liked the sweaty world of men and bourbon and smoke and baggy old pants with torn knees and fish blood on the cuffs. There came upon him, at regular intervals, an urgent need to escape from home and hearth: periodically, like Tom Sawyer and Huck Finn before him, Tom Benton lit out for the territories, to cuss and scratch himself and stretch his legs and flirt a little (just for fun, of course). Sometimes, he was gone for months on end, off somewhere with Bill or Glen, doing God-knows-what. Fieldwork, he called it.

In the hot summer of 1939, the summer that Jessie was born, the Bentons couldn't even go to the Vineyard. Stricken with a bad case of cabin fever, Tom decided to do his masculine recreating closer to home and slipped off "down State and over into Arkansas" with T. P., for a little boys-only river floating and fishing.[77] The camaraderie and the familiar rituals of his annual river floats became more and more important to Benton as the years wore on. Little by little, with additions and subtractions from one spring to the next, a kind of Benton river crew took shape: you could count on Lyman Field and John Callison, Harold Hedges, Fred McCraw, Bernie Hoffman, and Sammie Feeback. Not an artist or a la-di-da in the bunch, either, unless you counted Tom, unshaven, ruddy-eyed, and thoroughly inartistic in a T-shirt decorated with the remains of his last six meals. Leastwise, that was how *Sports Illustrated* found him on the banks of the Buffalo River near Ponca, Arkansas, one sunny spring morning in 1970, when, at eighty-one, with a major coro-

nary to his credit, he was about to shoot the white water in the bow of an aluminum canoe, with a jug of bourbon stowed under the kapok cushions.[78]

Five years earlier another reporter, from the *Saturday Evening Post*, had found such antics remarkable in a white-haired old gent of seventy-six, and that season Tom was merely a passenger on a Corps of Engineers junket up the Missouri River to inspect sites that might be affected by a new dam. The river trips were a gesture of contempt, for old age and infirmities, and for the proprieties, too. At seventy-six or eighty-one, off on his own in a boat with the fellas, Tom was apt to say quotable things he'd pay for when he got home. "Women!" he growled to the kid from the *Post*, in one such moment of reckless abandon. "They say they are dying to get a look at the darling wilderness, and the next thing you know they are demanding flush toilets."[79] Hell, you'd never catch one of the boys yapping about how pretty the water was, when the morning sun glinted off the ripples, or whining for a privy, or a bar of soap.

19–1. Study for *The Chute—Buffalo River.* 1968–1970; ink, pencil; 10⅞ × 8⅝; inscribed, Benton '70, also see below; verso, $50.

One of Benton's favorite canoe runs was on the upper Buffalo River in the Arkansas Ozarks. The best time for a trip was in April, after the melt and the spring rains, when the water was high enough to avoid portages. Benton had a major heart

76. Ibid., pp. 327–28 and 365.
77. Ibid., p. 285.
78. Robert F. Jones, "The Old Man and the River," *Sports Illustrated* 33, no. 6 (1970): 28–29.
79. Robert Wernick, "Down the Wide Missouri with 'an Old S.O.B.,'" *Saturday Evening Post* 238, no. 21 (1965): 94.

attack while planning the 1966 trip and stayed off the river for a year. When he wrote about it in a sequel to his autobiography, he wondered if he would ever return, or if his "days of physical adventure" were over.[80] They weren't: this study and the several versions of the painting based on it commemorate his decision to live, to fight back. Most of the canvases dealing with the subject were painted between 1966–1967 and 1970, in a spirit of celebration. Sammie Feeback's film about Tom and the floats, *A Man and a River*, was released in 1973.

The text written below the sketch reads, in part: "Man has an incurable propensity to regard the network [of language] he has *himself* imposed on the variety of experience as belonging to the objective world of things."

19–2. Fishing boat, on the Buffalo River, Arkansas. 1965–1969; pencil; 11 × 14; inscribed, B.; verso, $100.

Fishing trips in shallow-bottomed boats didn't have to be timed to the spring floods, and Benton liked everything about them—skinny-dipping; making camp; sitting on a folding chair outside a tent in the twilight, sipping a weak bourbon or a Gluek's, and looking at the boats, nose-in, pulled up on the bank.

The main lines in this drawing have been gone over, as though Benton had begun to rework a sketch brought back from a fishing expedition. The sharp angles of the hands, the fish, and other pictorial components and the subtle diagonal slant of the motif are characteristic of many Benton drawings of the mid- to late sixties.

19–3. Landing at White Cliff Camp, the Missouri River. 1965; ink wash; 11½ × 14⅝; inscribed, Benton '65, Landing at White Cliff Camp; verso, $175.

While he was preparing for work on the Truman Library mural, *Independence and the Opening of the West*, Benton had become intrigued by the Lewis and Clark journals, especially those portions dealing with the Missouri River in 1805. Thus he accepted with alacrity when he was invited to join a three-week survey trip on the river mounted by the Army Corps of Engineers and the National Park Service. The group planned to re-create the travels of Lewis and Clark from Omaha to the headwaters of the river, at Three Forks, Montana: this was the kind of personalized history to which Benton had always been attracted.

Benton's sketch shows the expedition pulling into camp at the White Rocks, the soft, white bluffs eroded into "collumns [sic], . . . pyramids . . . nitches [sic] and alcoves" that Meriwether Lewis, in 1805, called "seens [sic] of visionary inchantment [sic]."[81] The quavery line and the somehow miniaturized appearance of objects in this drawing become more and more typical of Benton's late work.

These cliffs are visible in *Lewis and Clark at Eagle Creek* of 1965, a vast landscape turned into a history painting by the addition of a herd of buffalo and minor alterations to the modern boats of the Corps of Engineers.

19–4. The Assiniboine Mountains, in the Canadian Rockies. 1964; ink wash, watercolor; 11 × 13¾; inscribed, Benton '64; verso, Assinibone Mountains.

The river trips were merely the best known of Benton's outdoor adventures with his friends. After finishing his murals at Niagara Falls and the Truman Library, he made two expeditions into the Wind River Range of Wyoming and another into the

Assiniboines, near Banff. On the latter trek, he had to spend almost ten hours on horseback in rugged terrain. *The Trail Riders* of 1964–1965 is based directly upon this sketchbook page, a drawing in which the vehemence of the wash contrasts strangely with the delicate tracery of the ink lines.

19–5. Cubist study for *Forward Pass*. 1969–1970; pencil; 9 × 3⅛.

In 1968, Benton suddenly developed a new enthusiasm. Sundays found him among the ranks of pro-football fans, a rabid follower of the Kansas City Chiefs, after Dutton Brookfield, chairman of the Jackson County Sports Complex, invited him to the games. By the beginning of the following season, just back from a trip to Sicily, he had worked his way down to the team bench, where he sat during practice and pregame warm-ups, with the permission of Coach Hank Stram, who nonetheless thought the old painter too feeble to be allowed on the sidelines with a sketchpad. Players, thought the officials, might bowl him over as they tumbled out of bounds. "Hell," Tom told the *Kansas City Times*, "I can move out of the way fast enough."[82] He became something of a team mascot, professing undying admiration for Len Dawson; the day the *Times* interviewed him at the stadium, the Chiefs beat the Chargers, 27–3.

In the off-season, he planned a major composition on the subject of his hero engineering a *Forward Pass*: one version became an oil painting (1971) and another, a small bronze (1972). He based the studies on a combination of things—his drawings of the team in action and drawings he made in Europe after an Etruscan battle scene. The appeal of the subject was its vitality. "The end of any motion isn't too interesting," he decided. "It's static. You have to move on to something else. The human figure in motion. There's nothing like it."[83] It all reminded him of his younger days as a scrappy little fighter, an aficionado of after-hours fights in burlesque houses.

19–6. Life drawings, the Kansas City Chiefs in scrimmage, Kansas City. Circa 1970; pencil; 7⅞ × 5.

This page contains an interesting variety of things. At the top, Benton has reduced the motion of a blocker, hitting his opposite number on the line, to its essentials. Below are details of pads, face mask, and belt loops, the kind of accurately observed detail for which his later murals were noted.

Although popular artists, like LeRoy Neiman, have not hesitated to depict professional sports, few well-known American painters have done so. What precedents exist, however, are illustrious ones: Thomas Eakins's boating and prizefighting scenes, George Bellows's great boxing pictures, and John Steuart Curry's football series, done in 1938, during the University of Wisconsin Badgers' season.

19–7. Football practice, the Kansas City Chiefs. Circa 1970; pencil; 5 × 7⅞.

This is among the last of Benton's on-the-spot action studies, the last of the lively studies of the ins and outs of life in these United States that had made him famous almost a half-century earlier.

80. *An Artist in America*, p. 368.
81. Wernick, "Down the Wide Missouri," p. 95.

82. *Kansas City Times* (November 10, 1969), sec. A, p. 1.
83. Wilma Yeo and Helen K. Cook, *Maverick with a Paintbrush: Thomas Hart Benton* (Garden City, N.Y.: Doubleday & Co., 1977), p. 114.

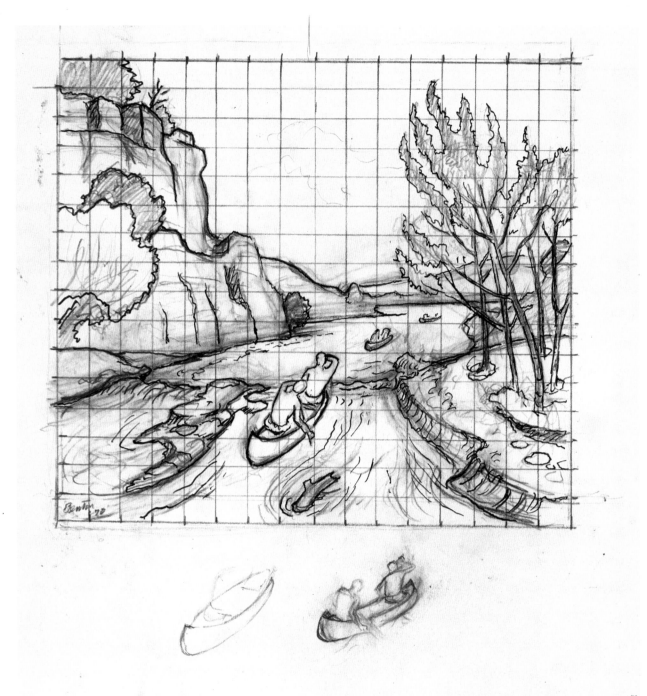

" Man — has an incurable propensity to regard the network *
he has himself imposed on the variety of experience as be-
longing to the objective world of things "

.G. —Norm & Form

* ("network" of Language)

19–1. Study for *The Chute—Buffalo River*. 1968–1970.

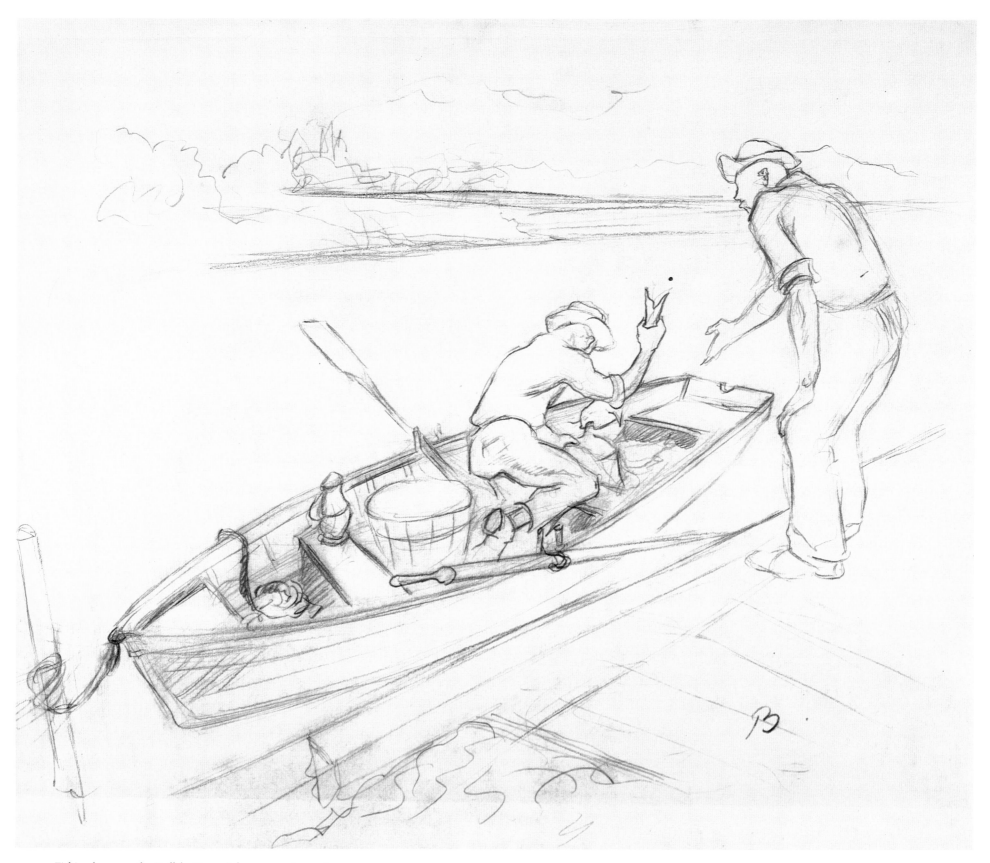

19–2. Fishing boat, on the Buffalo River, Arkansas. 1965–1969.

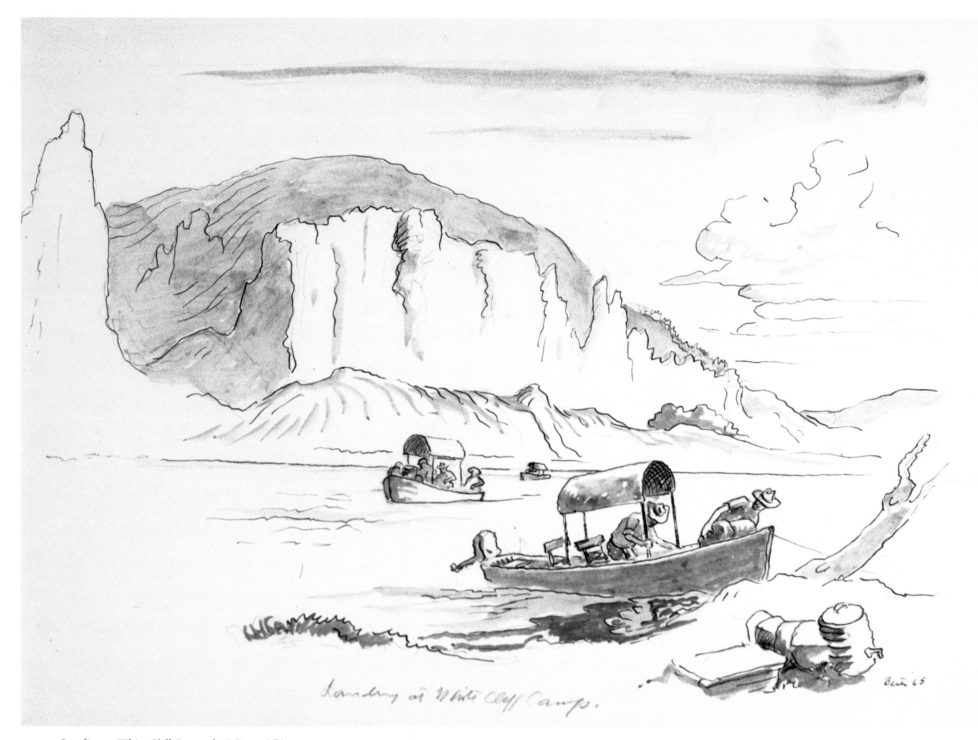

19–3. Landing at White Cliff Camp, the Missouri River. 1965.

19–4. The Assiniboine Mountains, in the Canadian Rockies. 1964.

19–5. Cubist study for *Forward Pass*. 1969–1970.

19–6. Life drawings, the Kansas City Chiefs in scrimmage, Kansas City.
Circa 1970.

19–7. Football practice, the Kansas City Chiefs. Circa 1970.

20 All the Sweet Old Songs

I have a feeling that my days of physical adventure are over. I find myself once again in a mood of withdrawal, of disinvolvement. . . . It is purely physical, coming simply from a loss of coordinative power—the power to make rapid adjustments of muscle and nerve—from the knowledge that a sudden output of muscular effort in a critical exterior situation might occasion a worse interior one.

There is no sense of what might be called spiritual defeat about this. . . . The only way an artist can *personally* fail is to quit work.[84]

Thomas Hart Benton

TOM Benton never did quit. As he began work on his last mural, the one for Nashville, he felt almost young again: it reminded him of all the other murals, all the good years, all the good friends, all the sweet old songs. He thought of friends like John and Mel and Sammie and all the rest who had posed so willingly and so patiently for earlier works. There would be portraits of his friends here, too—disguised, of course, as ancient fiddlers and hymn-singing dried-out drunks. He remembered the excitement of working out just how to bring a wall alive and how to make the old days live again in pictures; the process of sketching and trying and finally, somehow, of seeing it all come out right still brought a flush of pleasure to his cheeks. He thought back to all the times he had chased down the perfect lamp, just the right leaf or shoe or cuspidor; the thrill of the hunt still sent a shiver of anticipation down his spine. But, most of all, the Nashville mural made Tom remember the old sweet songs you could still hear, if you listened hard enough, in front of almost any Benton picture. The melodies were faint. The words were kind of muffled. They sounded like the humming of a happy old man, keeping himself company while he worked, with snatches of *John Henry, Turkey in the Straw, She'll Be Comin' Round the Mountain, The Jealous Lover of Lone Green Valley*. And, best of all, the *Wabash Cannonball*. Why, when Tom closed his eyes for just a minute—just to rest them, mind you—he seemed to hear the whistle of that engine on the wind. He seemed to be back in the corner of the last century, back in Neosho, drawing that big old train, puffing its way up Mama's brand-new wallpaper, on the big front staircase, back home . . . for good.

20–1. Study for *Old Kansas City*, mural in the River Club, Kansas City. Circa 1955; pencil; 16 × 13 ⅛; inscribed, Benton; verso, study for River Club mural.

From the fifties until his death, Benton was primarily a historical muralist, pursuing a genre that still found favor in the popular arena but was of little interest to the art world. Benton's history continued to be "people's" history, too: on those rare occasions when a commission called for the inclusion of some historical hero, Father Hennepin or Jacques Cartier would be overshadowed by anonymous but distinctive persons, stressing the role of ordinary folks in the epic of settlement.

Some critics have charged that Benton made up a whole race of handsome, unobserved people in the later murals because, with age, he found contact with people and with models difficult. His drawings prove that he faced that difficulty squarely; if he no longer roamed the highways doing documentary sketches of strangers, he was still careful to use real faces and figures for the main characters in the murals. And, for his Nashville mural, he did take to the road again.

This drawing for the figure of the white trader offering an article of jewelry to an Indian (in return for an Indian bride) was done from the model and emphasizes the fluidity and grace of the pose struck by the young man. The distinctive older trader now at the center of the mural has the portrait head of someone else but retains the model's powerful arms and torso.

20–2. Compositional studies for *Father Hennepin at Niagara Falls (1678)*, mural for the Power Authority of the State of New York, Niagara, New York. 1959; pencil; 9 × 17 ⅛; inscribed, C. First steps of final design. Spatial arrangement of cylinders (upper right) followed out in cartoon.

This sheet of sketches shows the methodical evolution of Benton's design and illustrates the use to which he put his lifelong study of Old Master techniques (the "Cubist" study at the upper left, based on the practices of Luca Cambiaso) and abstract, rhythmic design (the volumetric study at the upper right).

84. *An Artist in America*, pp. 368–69.

20–3. Skunk cabbage, study for *The Seneca Discover the French*, mural for the Power Authority of the State of New York, Massena, New York. 1956; pencil, tempera; 11⅞ × 9⅞; inscribed, Benton.

This kind of meticulous botanical detail spilled over into Benton's murals from his easel paintings and independent still-life compositions of the late thirties and forties, and it is the kind of detail that gave Benton's work credibility among ordinary Americans.

The sheer presence and the haptic power of this drawing make it easy to understand why George Washington Hill and the American Tobacco Company thought pictures of tobacco and tobacco farms by Benton might make ideal ads for Lucky Strikes. One such ad ran in 1942, and Benton did other ads, too: a cover for Standard Oil's company magazine, *The Lamp*, in February 1946; several ads for Orbach's department store; and a picture for Maxwell House coffee that ran in a June 1941 issue of *The Farmer*.

20–4. Costume notes on Pawnee Indians for *Independence and the Opening of the West*, mural in Truman Library, Independence, Missouri. May 1959; pencil; 11⅛ × 9; inscribed, Posifleche (carrying bag), design optimal, Quiver, Pawnee, Pipe, Buffalo robes decorated into skin inside, Look up Hawken rifle, Benton.

In the corner of this study of details of dress, Benton reminds himself to "look up Hawken rifle." During the period when he was working on the Power Authority and Truman commissions at the same time, Benton did a great deal of historical research like this in museums and historical societies. His works re-created the past, but he also intended them to be living histories in their own right: the visual facts needed to be as accurate or more accurate than those he read in books.

This drawing shows Benton's notational style, vastly different from his manner in works he conceived of as real drawings. He made notes on Pawnee dress in Oklahoma in the spring of 1959; his friend Charlie Wilson and Pawnee artist Brummett Echohawk found the artifacts he needed.

20–5. Preliminary study for *The Sources of Country Music*, mural in the Country Music Hall of Fame and Museum, Nashville, Tennessee. 1974; ink, pencil, sepia wash; 7¾ × 12¼; inscribed with descriptions of the seven numbered sections.

The quasi-abstract forms dividing one tableau from another in this early conceptualization of the Nashville mural hark back to Benton's first major mural, *America Today*, for the New School. Tex Ritter, still very much alive and involved with the commission, has not yet appeared in the right foreground; instead, cowboy music is represented by the figure on the horse labeled *5*. Benton broke the composition down into seven separate vignettes, including a square dance, a barefoot Ozark singer, a choir, a country church, a cowboy, a banjo player, and a still life of musical score, fiddle, and guitar. Some of these segments—most notably the church, which was borrowed from the Whitney murals, the background of *Susannah and the Elders*, and an old drawing for a magazine illustration—are not new and were minimized as the work progressed.

20–6. Square-dance skirt, study for *The Sources of Country Music*. 1975; pencil; 13 × 8¾.

This drawing is a detailed study of a dancer's costume. At the bottom, almost as an afterthought, Benton worries in pencil over whether or not to put pleats along the hemline.

The exaggerated kneecap and the strong diagonal fold of material below it are the kinds of details that make the mural pulsate with the rhythm and the twang of the music, the cry of "Swing your partner!"

20–7. Reversed contour drawing on tracing paper for *The Sources of Country Music*. 1975; pencil; 14 × 23⅜.

Tex Ritter is here, playing his celestial guitar. Sammie and Melvin and the pretty Ozark singer are all in place, too. And through the background rolls the Wabash Cannonball. "Just listen to the jingle, / The rumble and the roar / Of the mighty rushing engine / As she streams along the shore, / The mighty rushing engine, / Hear the bell and whistle call, / As you rumble off to heaven / On the Wabash Cannonball." So long, Tom.

20–1. Study for *Old Kansas City,*
Club, mural in the River Kansas City.
Circa 1955.

C. First steps of final design. Spatial arrangement of cylinders (upper right) followed out

20–2. Compositional studies for *Father Hennepin at Niagara Falls (1678)*, mural for the Power Authority of the State of New York, Niagara, New York. 1959.